The Gẹ̀lẹ̀dẹ́ Spectacle

Art, Gender, and Social Harmony

in an African Culture

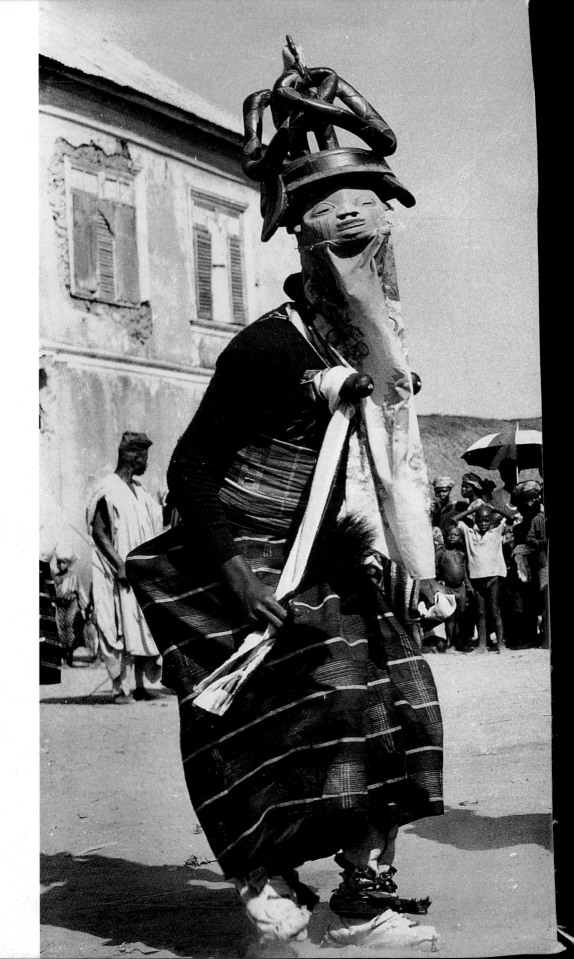

The Gẹ̀lẹ̀dẹ́ Spectacle

Art, Gender, and Social Harmony
in an African Culture

Babatunde Lawal

University of Washington Press
Seattle and London

Library of Congress Cataloging-in-Publication Data
Lawal, Babatunde
 The Gẹ̀lẹ̀dẹ́ spectacle : art, gender, and social harmony in an African
 culture / Babatunde Lawal.
 p. cm.
 Includes bibliographical references (p.) and index.
 ISBN 0-295-97527-X (cloth: alk. paper) ISBN 0-295-97599-7 (paper: alk. paper)
 1. Yoruba (African people)—Rites and ceremonies. 2. Masks, Yoruba. 3. Women,
 Yoruba. 4. Yoruba (African people)—Social life and customs. I. Title.
 DT515.45.Y67L39 1996
 966'.00496333—dc20 96-47862
 CIP

The fonts "TransSlavic" and "TransSlavic Sans" used in typesetting this book are available from
Linguist's Software, Inc., P.O. Box 580, Edmonds, WA 98020-0580 tel. (206) 775-1130.

The paper used in this publication meets the minimum requirements of American National
Standard for Information Sciences—Permanence of Paper for Printed Library Materials, ANSI
Z39.48-1984.

Title page illustration: Identical pair of Gẹ̀lẹ̀dẹ́ masks dancing in Ìjió (see page 153).

To Roy Sieber

The Teacher of Teachers,

who united the world

in the classroom

Contents

Acknowledgments

My research for this book began in 1971 when I organized an exhibition of Gèlèdé headdresses as part of the Fourth Ifè Festival of the Arts of the University of Ifè (now Ọbáfẹ́mi Awólọ́wọ̀ University), Ilé-Ifè, Nigeria. Most of the headdresses illustrated in this book are from that exhibition. I am greatly indebted to the authorities of the university for sponsoring the exhibition, and to Dr. Ekpo Eyo, the former director-general of the National Museum, Lagos. Dr. Eyo arranged the loan of several headdresses for the exhibition, and he also gave me access to the museum's records of Gèlèdé along with permission to take photographs. I am also grateful to Dr. Ade Ọbayẹmi, the director of the museum between 1987 and 1992, and Dr. Yaro Gella, the current director, for granting me the same privileges.

I wish to express special thanks to the following individuals for sharing with me their profound knowledge of the Gèlèdé tradition : Chief Fagbemi Ajanaku, the late Àràbà of Lagos; Chief Akọda Maku of Ebute-Mẹta; Ọba Samuel Adeṣina, the Olúbarà of Ìbarà; Màmá Moromisalu, the Ìyá Yemọja of Ìbarà (1971); Ìyá Kákáwàá of Kákáwàá Compound, Tinúubú Square, Lagos; Chief Loye, the regent of Ìmẹ̀kọ (1971) and his advisers; Aṣimi Ọlatunji-Onígèlèdé and Ganiyu Ṣekoni Dogá, both of Ìmẹ̀kọ; Chief Sule Akinbami of Ajílété; Chief Ọjẹlabi Ọlabimtan of Ìlaró; Chief Amudaniyu Atapupa and Biliaminu Lawal of Ìsàlẹ̀-Èkó, Lagos; Michael Labọde of Ìdòfòyí, Ayétòrò; Father Thomas Moulero of Kétu, and several other important functionaries of Gèlèdé who wish to remain anonymous because of the sensitive nature of the information they have provided.

In writing this book, I have benefited greatly from discussions with Wande Abimbọla, a renowned authority on Ifá divination literature; Afọlabi Ọlabimtan and Anthony Aṣiwaju, who put their collections of Gèlèdé songs at my disposal; and Ọba (Dr.) S. O. Babayẹmi, the Olúfì of Gbọ̀gán, for valuable information and advice.

I am grateful to Gboyega Ajayi, who served as my field assistant for many years; Frank Speed, who helped photograph most of the headdresses; Doig Simmonds and Aina Lewis for sharing with me a good part of their field notes and photographs on Gèlèdé ceremonies at Ìjió; and the University of Ìbàdàn for supporting their research. I would like to pay a special tribute

to Roy Sieber, my former teacher at Indiana University, for his constant inspiration and advice, and to Akinṣọla Akiwọwọ, Oyin Ogunba, Barry Hallen, Ọlabiyi Yai, Jay Wright, Tamara Northern, Robert Hobbs, Howard Rissati, Benjamin Ray, Roslyn Adele Walker, and Christopher Brooks, for reading the early drafts of this book and making useful suggestions. Needless to say, I should be held responsible for all the ideas and interpretations therein.

Robert Farris Thompson, Stephen Vincent, Emmanuel Odita, and Simon Ottenberg have inspired and encouraged me in various ways. I wish to seize this opportunity to express my sincere thanks to them. I also wish to thank the following people for their moral support: Chief S. O. Biobaku; Bọlanle Awẹ; Ida Wood; Sylvia H. Williams; Susan Vogel; Henry and Margaret Drewal; John Picton; Rowland Abiọdun; John Oluwafẹmi Ojo; Ade Daramọla; Christopher Awẹ; John Pemberton III; Pierre Fatumbi Verger; Kenneth C. Murray; Hans-Joachim Koloss; Ọlasọpe Oyelaran; Marilyn Houlberg; Peggy Harper; Justin M. Cordwell; Freida High Tesfagorgis; Paula Girshick; Joanne Eicher; Abiọla Irele; Robin Poynor; Bruce Haight; Theodore Celenko; Stephen High; Alison Deeprose; Doran H. Ross; Richard C. Law; Nigel Barley; William Arnett; Lamidi Fakẹyẹ; Karin Ajikẹ Barber; Frank Willett; Peter Morton-Williams; Mikelle Omari-Ọbayemi; William Fagg; William Bascom; Ulli Beier; Janet Stanley; Sidney Kasfir; Edna G. Bay; Marc Schiltz; Sandra T. Barnes; Bade Ajuwọn; Patrick McNaughton; Eric Robertson; Allen F. Roberts; Maxwell Anderson; Christopher Roy; Mike Warren; Sandra Greene; Norma Wolff; Flora H. Kaplan; Marla Berns; Jacob Kẹhinde Olupọna; Cornelius Adepẹgba; Murry N. DePillars; Avon Drake; Chinyerem Ohia; Bruce Koplin; Shirley Meade; Sharon Hill; Regina Perry; Fredrika Jacobs; Ann Crowe; Charles Brownell; James Farmer; Phyllis Green; Stephanie Downie; Katharine C. Lee; Richard Woodward, Keith Walker, and Kevin Concannon. I am grateful to Christopher Brooks for the musical notations of Gèlèdé drum texts, to Mary Taliaferro for advice on computer software, and to Christraud Geary and George Nan for help with aspects of the photographs.

I have taught African Art at Harvard University; Kalamazoo College; Michigan State University; the University of Memphis (formerly Memphis State University); the University of Sao Paulo, Brazil; the Federal University of Bahia, Brazil; and Ọbafemi Awolọwọ University, Nigeria. I currently teach this subject at Virginia Commonwealth University and as a visiting professor at Dartmouth College. Students and academic colleagues in these

institutions have contributed directly and indirectly to the articulation of many of the ideas expressed in this book. I am grateful to all of them.

The penultimate draft of this book was completed in the 1990/91 academic year, during my tenure as visiting professor and the first holder of the Dorothy Kayser Hohenberg Chair of Excellence in Art History, Department of Art, University of Memphis. I wish to thank, not only the Trustees of the University for this appointment and for giving me access to important research facilities, but also Honey Hohenberg Scheidt and Julian Hohenberg for instituting the Hohenberg Chair in honor of their mother. Special thanks to Neil Nokes, Richard Ranta, Carol Crown, Brenda Landman, Carol Purtle, and Leslie Luebbers for their encouragement; to Glenda Lucy for her secretarial assistance; and to Donald R. Ellegood, Naomi Pascal, Gretchen Van Meter, Veronica Seyd, Julidta Tarver, and Kathleen Pike of the University of Washington Press for their moral support and technical advice. I also thank the William Hazen Foundation, the Phelps Stokes Fund, and the Samuel Kress Foundation for sponsoring my graduate studies at Indiana University. Lastly, I wish to express special love and appreciation to my wife and children for their patience and understanding—virtues highly valued in Gèlèdé.

Note on Orthography and Tone Markings

The orthography adopted in this book is that of modern Yoruba, which records most of the phonemic sounds and at the same time eliminates the superfluous alphabets that characterize the old orthography. Thus, Oshogbo (name of a town) now becomes Oṣogbo, and *aiyé* (world) is now simplified as *ayé*. On the other hand, *ŏdẹ* (parrot) is now written as *òòdẹ*. The old orthography is, however, retained in quoted texts.

With the exception of quoted passages, tone markings are included in Yoruba texts to enhance readability and also for the benefit of scholars interested in literary, linguistic, semantic, and semiotic analyses. The word *Yòrùbá* and names of persons are not tone-marked, however, except where necessary for emphasis or clarification.

Key to Pronunciation: ṣ sounds like *sh*, as in shop; ọ like *aw*, as in law; and ẹ like *e*, as in pet. Acute accent (á) represents high tone, grave accent (à), low tone, and an unmarked vowel (a), middle tone. The consonant "n" is usually nasalized; "p" and "gb" are imploded, as in *kp* and *gby* respectively.

Introduction

A good majority of the books on African art are introductory surveys that, due to space limitations, can provide only brief generalizations. The religious function of the art is often emphasized at the expense of the social and aesthetic ones—which are no less important. As a result, the reader gets a distorted picture. In recent years, there has been an attempt to correct this anomaly through the publication of specialized monographs focusing on the cultural and historical ramifications of art in Africa. Some of these in-depth studies are beginning to revolutionize the scholarship of African art, forcing a drastic revision of past assumptions.

African art enjoys worldwide attention today, partly because of its unique form and partly because of the values it embodies for the people who created it. These values range from the use of body adornments to communicate status, achievements, or political power; to the decoration of buildings and utilitarian objects for aesthetic and prestige purposes; and to the use of sculpture to reinforce religious beliefs and social ideals. More often, because the arts have been so integrated into daily life, it is difficult to separate the religious from the social, as both are no more than two aspects of the same coin. Thus, a full appreciation of African art will be gained only when scholars pay serious attention to the interplay of the social, religious, and aesthetic. This book focuses on such interplay, using as an example the Gèlèdé spectacle of the Yoruba, who are one of the largest and most prolific art-producing groups in Africa.

The Gèlèdé spectacle is a public display by colorful masks which combines art and ritual dance in order to amuse, educate, and inspire to worship, all at the same time. Each mask consists of an elaborately carved wooden headdress and a costume of assorted fabrics. A typical headdress is in the form of a human head bearing a wooden tray that serves as a sort of stage for projecting in sculptural metaphors the ideals of the Gèlèdé society. These ideals, also expressed in songs and satirical performances, are designed to promote the social and spiritual well-being of a given community. The Gèlèdé social agenda rests on the Yoruba maxim *Èsò l'ayé.* (The world is fragile.) In other words, life is so delicate that it should be lived with caution and prudence. This maxim requires everyone to be consider-

ate, careful, diplomatic, law-abiding, respectful, and harmonious, and to avoid whenever possible the use of force in resolving disagreements and problems, since far more is achieved through peaceful and amicable settlements.

The Gèlèdé society also endeavors to maintain good gender relations by advocating respect for motherhood within a patrilineal culture, such as that of the Yoruba, where men dominate the institution of kingship. There are two main reasons for this pro-female stance. One is that the preservation of humanity depends on the role of the female as mother; the other has to do with the linking of motherhood to a special power, akin to witchcraft, that can be used for good or evil. Unlike other Yoruba societies, such as Egúngún and Orò, which emphasize male dominance and therefore persecute women suspected of practicing witchcraft, the Gèlèdé takes a conciliatory position in the interest of peace and social harmony. Of course, the Gèlèdé society is very much aware of the dangers that witchcraft and other antisocial practices pose to peace and human happiness. Hence it condemns, albeit obliquely, all kinds of evil by subjecting antisocial elements to public ridicule. The society, in its crusade against antisocial behavior, appeals to witches and sorcerers to use their special talents to benefit, rather than destroy, humankind. To this end, the female principle in nature has been personified as Ìyá Nlá (The Great Mother), whereby human beings can relate to one another as children of the same mother and so think less of malicious acts. The Gèlèdé mask performs not only to curry favors with Ìyá Nlá, but also to entertain the general public and, in the process, sensitize it to the virtues of social living and good citizenship.

Previous Studies

The first major article on Gèlèdé is by H. Ulli Beier (1958). Although it is essentially an eyewitness account of Gèlèdé ceremonies in Porto Novo and Kétu, the author argues that the female focus of Gèlèdé might suggest that at one time in the evolution of Yoruba culture, women wielded much more political power than they do today. The next significant works were a film on Gèlèdé ceremonies at Ìjió by Frank Speed (1968), an article by Peggy Harper (1970) on the role of dance in Gèlèdé, and a pamphlet by Jacques Kerchache (1973) featuring rare photographs of Gèlèdé night ceremonies in the Republic of Benin. An article by Jacques Bernolles (1973) analyses the motifs on eight Gèlèdé headdresses from Ṣábèé (Republic of Benin), comparing some of them with Indo-European symbols. Studies by Anthony

Aṣiwaju (1975, 1976) focus on the historical significance of Gèlèdé songs. Those by Afọlabi Ọlabimtan (1970, 1972), Gabriel Fayọmi (1982), and Benedict Ibitokun (1981, 1987, 1993) deal with the literary, linguistic, and dramatic aspects, while that of Emmanuel Babatunde (1988) is a sociological analysis. Robert Farris Thompson's publications (1971, 1974) are the first by an art historian to pay serious attention to the aesthetics of the Gèlèdé dance and costume. These have since been elaborated upon by Henry and Margaret Drewal (1974a, 1974b, 1975, 1983) and the present author (Lawal 1978).

Ever since Henry and Margaret Drewal published the first book on Gèlèdé in 1983, public interest in the mask has risen considerably. My purpose is to sustain and deepen that interest. Whereas the Drewals focus on Gèlèdé as a symbol of female power among the Yoruba, I hope to demonstrate that Gèlèdé is that and much more. The present study situates Gèlèdé within a larger framework of the Yoruba dialectic of existence, in which art functions as a metaphor for stimulating increase and for promoting spiritual well-being and social harmony within a given community. This book also throws new light on the meanings of motifs considered problematic or simply ignored in previous studies. Furthermore, it incorporates new materials crucial to a better understanding of Gèlèdé which were not available to the Drewals at the time they wrote. Finally, the observations in this book combine the knowledge and experience of an insider with the analytical eye of a researcher. I was born and reared in Ìsàlè-Èkó (Ojú Olókun Street), a district of Lagos with a strong tradition of Gèlèdé, and I participated fully in the ceremonies before developing a research interest in the subject. This background has resulted in my use of a theoretical model completely different from that of the Drewals.

Theory and Methodology

As Susan Blier has rightly pointed out, the "methodological orientations of any analysis necessarily impact on its result in a significant and enduring way. . . . They guide what is viewed, how it is seen, and the way in which it is contextualized and comprehended" (1987: 10). There is no doubt that using an appropriate theory will facilitate the understanding of a given subject. Unfortunately, some scholars have become so obsessed with theories which attempt to relate the "particular" to the "universal" that their conclusions often reflect the Eurocentric bias of the theories per se rather than the traditions of the culture they purport to analyze. Moreover, the search for para-

digms often results in intellectual fantasies that mystify rather than clarify the subject being studied (Hirschman 1970:329-43).

A number of scholars, including Hountondji (1983), Mudimbe (1988), Ben-Amos (1989), and Obiechina (1992), have called for a new critical approach that will allow African traditions to be studied on their own terms, instead of being viewed through Eurocentric lenses. Nonetheless, judging from the perceptive insights that distinguish the publications of such "outsiders" as Robin Horton on the Kalabari Ijo, Simon Ottenberg and Herbert Cole on the Igbo, Roy Sieber on the Igala, Marcel Griaule on the Dogon, Daniel Biebuyck on the Lega, and William Bascom, Ulli Beier, Robert Farris Thompson, and Henry Drewal on the Yoruba, to mention but a few, it would be unreasonable to insist that only insiders can write intelligibly about a given culture. What is urgently needed, as Henry Gates has pointed out, is a method that enables a given culture "to speak for itself about its nature and various functions, rather than to read it, or analyse it, in terms of. . . theories borrowed whole from other traditions, appropriated from without" (Gates 1988: *xix*). Thus, this book will attempt to show that Yoruba culture has its own built-in theories by which much of its artistic expressions can be studied or comprehended.

To the Yoruba, art (*ọnà*) is the creative skill manifested in such man-made forms or designs as sculpture, painting, pottery, textiles, and architecture. Nonetheless partly because much of the inspiration for art comes from nature and partly because the quality associated with it (*ẹwà*, beauty) is discernible in nature, the Yoruba associate artistic creativity with the divine. No wonder that, according to Yoruba cosmology, the universe is the handiwork of the Supreme Being (*Olódùmarè*). The human image is unique because Ọbàtálá (the artist deity) designed it. After molding the image from divine clay, Ọbàtálá took it to the Supreme Being, who infused it with life. Ògún (the iron deity) later put finishing touches to the body by adding lineage marks on the face and tattoos on the body, performing circumcision and such other surgery necessary to keep an individual in good health and to make him or her socially acceptable in Yoruba society. This imagery has a parallel in Yoruba woodcarving; in the final stage, known as *fínfín,* the carver uses a knife (symbol of Ògún) to refine and delineate the forms. That the human body is a divinely inspired work of art is implied in the prayer often used by the Yoruba to greet a pregnant woman: *Kí Òrìṣà ya ọnà ire ko ni.* That is, "May the *Òrìṣà* [Ọbàtálá] fashion for us a good work of art" (Idowu 1962:72). Thus, from the Yoruba perspective, art is a vital part of Being. The human being is reasonable and artistic partly because he or she

is a divinely ordered creation; hence the name *ènìyàn* or *ẹni a yàn*, "the specially selected one." From the beginning, the human being has been preoccupied with imposing his or her own sense of order on the earth by personifying different aspects of nature as divinities (*Òrìṣà*), organizing space for human habitation, beautifying the environment, and creating a sociopolitical framework for regulating human behavior so as to promote peace and social harmony (Lawal 1987:31-2).

Art, in its broadest sense, is central to the maintenance of this social order. It is an aspect of what the Yoruba call *Ìfọgbọ́ntáayéṣe*, literally, "using wisdom to remake/improve the world" (Akiwọwọ 1983a:4). But because it has layers of meaning in Yoruba culture, the term as employed here refers to the application of knowledge, religion, ethics, diplomacy, and creativity in all its ramifications to improve the human condition.[1] Gẹ̀lẹ̀dẹ́ exemplifies *Ìfọgbọ́ntáayéṣe* because of its quest for peace and social harmony. To this end, it appeals to everyone to cultivate a good *ìwà* (character). *Ìwà* has two levels of meaning. At one level, it refers to Being, either in a physical or metaphysical state of existence. At the other level, it points to human behavior. Such is the premium placed by the Yoruba on good character (*ìwà rere*) that their notion of ideal beauty depends on it. Hence the popular Yoruba sayings: *Ìwà rere l'ẹ̀ṣọ́ ènìyàn* (Good character adorns a person), and *Ìwà l'ẹwà* (Character is the essence of beauty). Conversely, in Yoruba aesthetics, only the good is beautiful. In other words, what is good is socially desirable because it elicits admiration, respect, and love, which in turn foster harmony (*ìrẹpọ̀*).

Although the use of Gẹ̀lẹ̀dẹ́ for social control may remind the reader of the functionalist school of social anthropology (Emile Durkheim, Bronislaw Malinowski, and others) which treats art as one of the cultural mechanisms for maintaining social equilibrium (Ben-Amos 1989:3-4), the Yoruba situation is different. Whereas the functionalists often emphasize the social factor as the primary motive for art (downplaying the influence of religion), and Durkheim himself traces the origin of religion to an awareness of social forces rather than to a perception of the spiritual Other in nature (Ben-Amos, ibid.:3-8; Layton 1991:36-8), the Yoruba consciously and subconsciously trace the beginnings of both their religion and art to divine or mythological beings. Thus the functionalist model, however relevant it may be to certain aspects of Gẹ̀lẹ̀dẹ́, cannot account fully for its origin, functions, and significance.

Since the purpose of Gẹ̀lẹ̀dẹ́ is to disseminate values deemed vital to individual and corporate survival, its form and content cannot be fully

1. For a review of the implications of *Ìfọgbọ́ntáayéṣe* for indigenous African sociological theories, see Akiwowo (1983a:24-25; 1991: 243-51); Makinde (1988:71-73); Lawuyi and Taiwo (1990:70-72).

understood unless related to their cultural contexts. In his studies of Yoruba art, Kevin Carroll has observed:

> Yoruba carving presents detailed illustration of the traditional culture—the life of the farm, the village, the palace, and the cults. It is an art of the people. . . . Its selection of themes and emphases, therefore, represents a picture of Yoruba culture (1973:165).

> In modern times objects of prestige, such as lorries, aeroplanes, and iron-sheeted houses, may be illustrated in their own right. . . . It is not possible at present to offer an assured interpretation and analysis of Yoruba carving as an expression of the people's philosophy and religious belief. African carvings have frequently been interpreted in abstract terms without any attempt to discover the people's own interpretation. . . . The museums commonly record the date of collection and place of origin of a carving and more rarely the name of the carver and its function. But records of the people's explanation and interpretation of the figures and anecdotes illustrated, or of the proverbs, songs, prayers, or praise-chants which may be associated with the object, scarcely exist (ibid.:168).

Although Carroll is right in his observation that Yoruba woodcarving mirrors all aspects of Yoruba culture, both traditional and modern, the fact that many scholars have not paid attention to the people's explanations of the motifs does not necessarily mean that the latter are mere illustrations of incidents and anecdotes of Yoruba life. As J. R. O. Ojo has pointed out, in a rejoinder to Carroll's observation, the ritual contexts of, and the songs associated with Ẹpa masquerades clearly show that the motifs embody social, religious, and other values (1973a:455-70). Studies by Abiọdun (1975:421-69), Thompson (1983:3-97), and the Drewals (1983) not only confirm Ojo's point but underscore the fact that the depth of a researcher's interpretation depends as much on the quality of data collected from informants as on his or her ability to relate them to the form, content, and context of a given work of art and the culture that produces it.

Marcel Griaule (1952:27-42) and Jan Vansina (1985:96-99) have observed that cultural knowledge among both the Dogon (Mali) and Kuba (Zaire) exists at two levels: the exoteric and esoteric. The former is accessible to the general public, and the latter is restricted to a few individuals who usually hesitate to divulge it to researchers. A similar phenomenon obtains among the Yoruba and is emphasized in the saying: Ẹ̀ta ni ti awo èjì ni ti ọ̀gbẹ̀rì. (Threeness is to the initiate as twoness is to the uninitiated.) This saying implies that the bond between two friends is not so strong as

that between two initiates sharing an oath of secrecy witnessed by a deity, who is the invisible third party to all occult transactions and who will not spare a traitor. The invisible third party, like esoteric knowledge, is known only to initiates (*awo*); it contradicts the view held by laymen (*ọ̀gbèrì*) that a third party can ruin a friendship.[2] In other words, occult or metaphysical knowledge is much deeper than empirical observation.

2. For an interpretation of the significance of the number three in Yoruba thought, see Lawal (1995:44-45).

Although Gèlèdé is not as secretive as other Yoruba masking societies, such as Egúngún and Agẹmọ, it does have two levels of knowledge. At the first or exoteric level are the songs chorused during the nocturnal concert (*ẹ̀fẹ̀*), and the motifs on wooden headdresses intended to entertain or educate the public. Almost every adult can decode the meanings or significance of these popular songs and motifs. At the second or esoteric level are myths pertaining to the origin of Gèlèdé, incantations, and certain abstract symbols. Only ritual specialists, such as diviners (*babaláwo*) and herbalists (*oníṣègùn*) and a few elders within the Gèlèdé hierarchy, know the meanings of these restricted elements. For example, Gèlèdé participants (with limited knowledge) often interpret the carved blade motifs on some Èfè headdresses (pl. 16) as mere decoration, while Henry and Margaret Drewal describe them as "medicinal camwood blades" (1983:98, pl. 45). Members of the inner caucus of Gèlèdé, however, identify the blades as miniaturized rhombs (bull-roarers) of Orò, a nocturnal spirit who empowers the headdress. A comparison of the Èfè blades with standard Orò rhombs reinforces this identification (see J. R. O. Ojo 1973b:52, pl. 3). Even then, though it is one thing to meet knowledgeable informants in the field, it is another to establish enough rapport to gain from them what is traditionally regarded as "classified information." I had the good fortune to interact with such elders as the late Chiefs Fagbemi Ajanaku and Fagbenro Beyioku of Lagos; Chief Akọda Maku of Èbúté-Mẹta; the late Màmá Moromisalu of Ìbarà; Ìyá Kákáwàá of Tinúubú Square, Lagos; Chief Sule Akinbami of Ajílété; Chief Ojẹlabi Ọlabimtan of Ìlaró; Aṣimi Ọlatunji-Onígèlèdé of Ìmẹ̀kọ; and several diviners as well as male and female heads of Gèlèdé societies in various towns who, realizing the significance of this study, shared with me much of their esoteric knowledge about Gèlèdé. In short, this book combines data from both levels of knowledge.

The data were collected between 1971 and 1993 during field trips to several towns in southwestern Yorubaland. In some cases, I stumbled on Gèlèdé ceremonies by accident or during social visits when I had no camera with me to record the events. Another set of data came from museum collections, films on Gèlèdé by Frank Speed, and published and unpublished materials

on Gèlèdé masks and dances. The now-defunct Western State Ministry of Information in Ìbàdàn provided rare field photographs of Gèlèdé ceremonies taken in 1958 at Ìbarà, Abéòkúta. In order to collect as much information as possible, I took the photographs to Ìbarà, where I was fortunate to meet individuals who recognized themselves, friends, or relations in the photographs and then provided eyewitness accounts of the recorded events, including names of the principal actors. Masks similar to those in the 1958 photographs still feature in Gèlèdé ceremonies at Ìbarà today.

While I was away in Brazil in the summer of 1980, a leaking roof in my apartment in the University of Ifè campus caused considerable damage to some of my field photographs on Gèlèdé (especially those taken at Ajílété, Ayétòrò, Ìmáṣàí, Kétu, Ìmèkọ, Ìbarà, Ìlaró, Lagos, and Òtà). As a result, I have had to fill the gaps with photographs kindly provided by Doig Simmonds. Although Doig Simmonds's photographs are fully documented, I still took them to Ìjió in order to obtain more explanations and also to compare their contents with more recent data. In many towns, I held special sessions with carvers, priests, priestesses, and elders (male and female) of the Gèlèdé society during which the meanings of motifs on Gèlèdé headdresses and costumes were discussed. I also showed informants photographs of headdresses in museum collections, to double-check provenance as well as the names of carvers already documented by the National Museum in Lagos and other collectors.

Since one of the primary aims of this book is to allow the data on Gèlèdé to speak for themselves, I have relied not only on my own field observations and interviews but also on Yoruba oral tradition and on evidence collected by other scholars. Through this method, which combines synchronic, diachronic, formal, textual, contextual, and linguistic analyses, I have attempted to place Gèlèdé in a wider temporal and cultural perspective. According to Henry and Margaret Drewal:

> While generalizations may provide an overview of the Gèlèdé phenomenon in broad cultural terms, they leave a number of questions unanswered. How does the researcher reconcile all the elements that do not fit the generality? How does one account for diversity? And equally important, how do the Yoruba themselves regard different ways of performing the same ritual? We set out in search of the norm and instead we were struck by the diversity. (1983:*xvii*)

This seeming diversity, highlighted in their book in the chapter entitled "Gèlèdé and the Individual," can be summarized as follows: (a) the use of

the Èṣù Gbángbáde mask in Ìlaró to announce the approach of the annual Gèlèdé festival and to close the Èfè night portion of the festival (ibid.:248); (b) the participation in Gèlèdé of the priests of other Yoruba deities such as Ògún, Ṣàngó, and Egúngún, and their depiction on Gèlèdé headdresses (ibid.:253-6); (c) the close association between Gèlèdé and twins in Ìlaró (ibid.:248-52); (d) the involvement of Èṣù-Ẹ́lẹ́gba and Gèlèdé in rites aimed at promoting human fertility and combating infant mortality, otherwise known as Àbíkú (ibid.:215-7, 253). According to the Drewals, "These examples demonstrate personal concerns in Gèlèdé and how these concerns diversify practice and content" (ibid.:256).

Nonetheless, I will present data which demonstrate that these supposed elements of "diversity" are in fact integral to Gèlèdé everywhere, although emphasis and details may vary from one place to another. For example, the use of the Èṣù Gbángbáde mask to announce the approach of the annual festival in Ìlaró recalls the Amukòkò (pipe-smoking) mask that performs a similar function in places like Lagos and Porto Novo. The only difference is that the Èṣù Gbángbáde or Gbogbolàkìtàn closes the Èfè night ceremony in Ìlaró, whereas the Kòrikò or Ayóko (jackal) mask does so in other areas. Second, priests of other deities are welcome to, and do participate in Gèlèdé ceremonies almost everywhere, since Ìyá Nlá, the focus of Gèlèdé, is the Mother of All Things, including the deities. The representation of other deities on Gèlèdé headdresses occurs in many areas and is not peculiar to Ìlaró. Third, the association of Gèlèdé with twins and Àbíkú is a common phenomenon. Indeed, as we shall see in chapters 3 and 8 below, the Gèlèdé mask has evolved from ritual dances for honoring patron deities of spirit children (including twins) and for preventing infant mortality (Àbíkú).

Although Benedict Ibitokun (from a Kétu Gèlèdé family) blames the inability of the Drewals to perceive a normative or a unifying thread in Gèlèdé on their descriptive, piecemeal approach, which makes their study more horizontal than vertical (1993:18-20), I am inclined to blame it on an insufficient use of Yoruba oral tradition. This criticism, however, should not detract from the contributions of the Drewals to the scholarship on Gèlèdé, also acknowledged by Ibitokun.[3]

It is important at this juncture to point out that Gèlèdé, with its emphasis on the placation of Mother Nature (Ìyá Nlá), shares a common theme with the Ògbóni society that wielded considerable political, judicial, and religious powers among the Yoruba in pre-colonial times and still does, to some extent, today. Much of the authority of the Ògbóni derives from its role as the vital link between the community and Mother Earth (Ilè) which sus-

3. In a separate publication, Henry Drewal expatiates on the approach he and Margaret Drewal employed in the study of Gèlèdé, an approach he calls "the micro-analytic" (1984:88). When used properly, and along with oral tradition, this approach certainly has some merits. One of the shortcomings, however, is that it sometimes magnifies details out of proportion, making it difficult to relate constituent parts to the whole.

tains it. In two widely quoted publications, based on the data he recently collected in Ijẹbuland on the Ògbóni, Henry Drewal has asserted, however, that the Yoruba Earth deity is not female. In his words:

> Nowhere in the oral literature, Ifa divination verse, or lore about the *òrìṣà* in Yorubaland is there a corpus of praises, prayers, stories, myths, rituals, or images devoted to an "Earth Goddess." The concept of an earth divinity has probably never been a central part of Yoruba belief. (Drewal 1989b:136; see also Drewal 1989a:151-74)

It should be emphasized that Yoruba oral tradition, most especially Ifá divination literature, abounds with references to the Earth deity as female (Verger l966:35; Daramọla and Jeje 1967:163-65; Abimbọla 1977c:240; Simpson 1980:59-60; Babayẹmi and Adekọla 1987:50-51; Adeoye 1989: 356-360). Henry Drewal's assumption that no corpus exists in Yoruba oral literature on an Earth goddess derives partly from the fact that, since much of it has been published in the Yoruba language, it is inaccessible to many scholars. Moreover, most of the myths about the Earth goddess belong in the realm of the esoteric knowledge, which Ògbóni elders are often reluctant to disclose to researchers. Although the Earth deity is regarded as male in some sections of Yorubaland and as female in others, a close study of Yoruba oral tradition and the history of the Ògbóni shows that the latter originally had a female focus. The attempt to graft a male aspect onto the Yoruba Earth goddess is a relatively recent phenomenon influenced by changes in the Yoruba body politic. Lack of space will not allow us to discuss the details here. It is enough to say that the Ògbóni society now has two factions, the Aboriginal and the Reformed, with the latter reformulating the symbolism of the society to tally with the biblical idea of Adam and Eve (Lawal 1995:39-40, 49). Nonetheless, as many communities in southwestern Yorubaland celebrate Gẹ̀lẹ̀dẹ́ in honor of Oòduà (an aspect of the Earth goddess)—a point clearly emphasized by the Drewals in their book on Gẹ̀lẹ̀dẹ́—it is not certain at present whether Henry Drewal's argument that the Earth deity is not female also applies to Oòduà. If it does, then the Drewals would need to readjust the female focus of their book on Gẹ̀lẹ̀dẹ́.

One valuable research resource not yet explored fully by students of Yoruba art is oral tradition. Jan Vansina has convincingly demonstrated in his research that oral tradition (in the form of myths, legends, divination poetry, proverbs, and songs) is a viable source for reconstructing both the art and social history of a people, since it reflects their cultural experience,

world view, philosophy, and values (1984; 1985). Among the Yoruba, art and oral tradition are so interrelated that the one is like a pictorial abstraction of the other. Nowhere is this nexus more evident than in Gèlèdé, owing to its use as a medium of mass communication. Interpreting the motifs on the mask, therefore, requires not only a good knowledge of Yoruba oral tradition, cosmology, and social philosophy but also an ability to relate verbal to cosmic and visual metaphors. For instance, many Gèlèdé headdresses depict two snakes attacking a porcupine (fig. 7.54). According to some informants, this motif is no more than visual entertainment; others identify it as a warning against foolhardiness. In Kétu, Henry Drewal documented an Èfè headdress with a cognate motif: a bird seizing a scorpion (1981:115), a motif I have also come across in Ìbarà and environs. Taking a cue from the rhetorical question "Can a bird eat a scorpion?" that this motif evoked among his informants, Henry Drewal interprets the snakes-porcupine encounter as hinting "that only supernaturally endowed serpents [since snakes are also associated with "the powerful mothers"] can successfully swallow such a spiny meal," beside the fact that it may also refer to "competing forces. . . in the Yoruba universe" (ibid.). As we shall see later, however, the snakes-porcupine motif recalls an Ifá divination verse (*Odù Ìdì méjì*) on the limitations placed on the power of "the mothers," resulting in the caveat: "Nobody eats a porcupine along with the spines" (Prince 1961:795-96). Undoubtedly, this divination verse is crucial to a full comprehension of the motif, suggesting that it is primarily a warning code (though there may be several layers of meaning) and underscoring at the same time the importance of oral tradition in the study of African art.

The student of Yoruba art is fortunate in that several volumes of Yoruba oral tradition have been published—thanks to the efforts of William Bascom, Michael Ajayi Fabunmi, Isaac Delano, Adeboye Babalola, Wande Abimbola, Oba Solomon Babayemi, Afolabi Olabimtan, Karin Ajike Barber, Olatunde Olatunji, Laogun Adeoye, Oyekan Owomoyela, and Bade Ajuwon—to name only a few. In short, an extensive use of oral tradition coupled with my own experience as a Yoruba facilitated my study of Gèlèdé from a perspective that would have been impossible had I depended solely on field observations and formal analysis. As Rowland Abiodun has put it: "Used properly, oral tradition will reveal forgotten meanings that would be hard or even impossible to obtain from the most cooperative informant" (1990:64).

My focus in this book is on the use of the Gèlèdé to promote social harmony among the Yoruba but a review of the data from other parts of Africa reveals art forms with similar functions. The first chapter brings these data

together to provide a contextual background for the Yoruba material. Chapter 2 introduces the Yoruba, taking into account their peculiar belief that the world is a delicate balance of opposing forces and noting the measures they have taken to resolve the dialectics. Chapter 3 traces the roots of Gèlèdé; chapter 4 analyzes the philosophy, methods, and organizational strategies of the Gèlèdé society; and chapter 5 presents the "Gèlèdé Spectacle," during which the ideals of the society are dramatized and beamed to the physical and spiritual worlds. Chapter 6 deals with the aesthetics and iconography of the Gèlèdé costume, and chapter 7, with the sculpted messages on the wooden headdresses. The eighth chapter presents a critical perspective on Gèlèdé, including its responses to the dynamics of social change, while the ninth and concluding chapter highlights the moral and aesthetic philosophy of Gèlèdé.

In summary, since Gèlèdé is primarily concerned with the promotion of social harmony and the avoidance of the use of force to settle human differences and problems, its lessons bear a universal relevance, especially for the modern world. The future of the human race certainly depends on the qualities inherent in *Ìfogbóntáayése,* that is, on how well individual and collective wisdom (through the humanities and sciences) can be harnessed to ensure peace and concord on Earth.

The Gẹ̀lẹ̀dẹ́ Spectacle

Art, Gender, and Social Harmony

in an African Culture

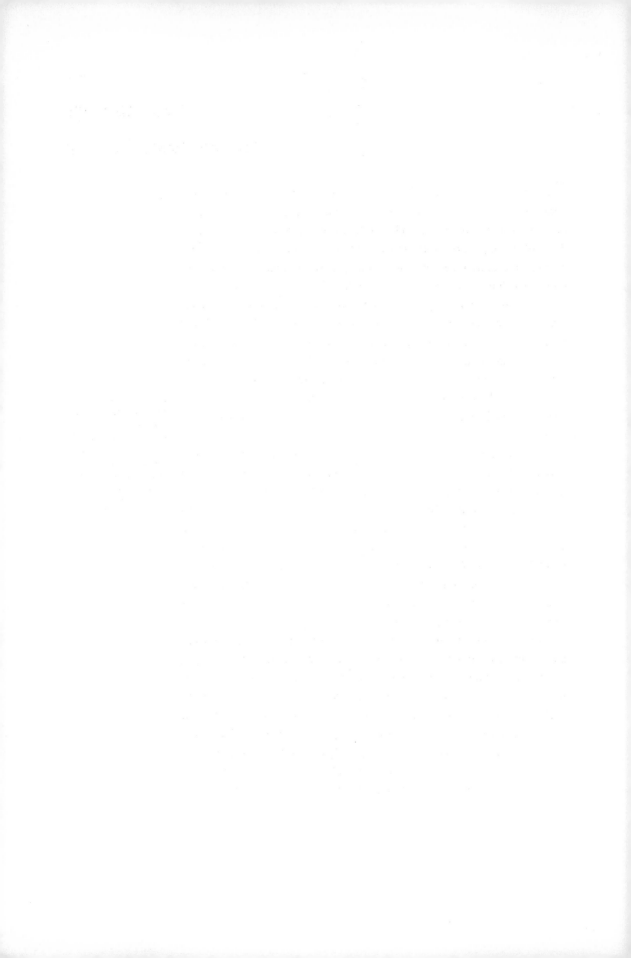

African Art
and the Social Order

The corporate existence of a given African society is apparent in the homogeneity of its art style(s)—a phenomenon intended to create a sense of oneness within the group and to differentiate its material culture from those of its neighbors, although frequent artistic interchange does occur. Through the apprenticeship system, young artists are trained to master not only the techniques of the stylistic norm but also its time-honored themes and symbols. Within the stylistic norm, however, there is room for individual creativity and the incorporation of outside influences. The physically demanding arts of woodcarving, smithing, bronze-casting, leatherwork, and weaving on the horizontal loom are the preserve of the men, while the women concentrate on the less rigorous pottery, dyeing, and weaving on the vertical loom.[1] Both men and women engage in basketry, embroidery, calabash decoration, and beadwork. Building is a communal activity involving both sexes, young and old.

Certain cultural institutions are responsible for preserving the society's corporate identity and for socializing members toward common goals and ideals. The most prominent of these institutions are the so-called initiation schools (known as "Poro" in many parts of West Africa, "Mukanda" in southern Zaire, and "Goma" among the Lovedu of the Transvaal) which educate youths about the history, ethics, and cultural heritage of the society, so that as adults they will function effectively within its customs and will refrain from acts that could threaten its existence. In the course of this socialization, the instructors use a variety of art objects to lend authority and divine sanction to their utterances and actions.

Society operates on a hierarchical order based on seniority, achievements, and status. The emphasis on the head in African sculpture, for example, corresponds with the focus on the monarch (in centralized societies) or on the highest ruling body (in noncentralized societies) as the nucleus of the social, economic, political, and religious life of the community, and as the apex of the decision-making process. Among the Dogon of Mali, a typical village is conceptualized as a human figure lying along a north-south axis. The meeting house of the council of elders (*toguna*) and the workshop of the blacksmiths constitute the head; the family compounds (*ginna*) repre-

1. There are some exceptions to this rule. Among the Hausa of Nigeria, men are more involved in pottery and dyeing, while Kuba men weave on the vertical loom. Nowadays, some Yoruba women work on the horizontal loom.

3

sent the chest and belly; the principal village altar symbolizes the male sex organ; the stone on which women crush fruits signifies the female organ; certain huts used exclusively by women represent the hands; and the communal altars at the southern end of the village represent the feet (Griaule and Dieterlen 1954:84-88). Considering that the elders meet in the *toguna* to make important political decisions affecting the life of the village, and that the blacksmith produces in his workshop the iron implements for agriculture and warfare, it is not surprising that these two structures constitute the emblematic "head" of a typical Dogon village, coordinating the activities of the entire "body" as well as influencing individual behavior and ability to cope with the existential struggle.

Among the Lega of Zaire (another noncentralized society), the Bwami association controls almost all the plastic arts. This is "a hierarchically constituted body of initiates," to which every Lega, male or female, aspires. According to Daniel Biebuyck, a leading authority on Lega art, the Bwami has five ladders for men, culminating in the highest grade, the *kindi;* and three for women, the topmost being the *bunyamwa* (1972:10-13). As an individual moves up the ladder in recognition of personal achievements, he or she acquires certain art objects that communicate the virtues associated with the office. The attainment of the status of *kindi* is a lifetime ambition of the men.

> Persons who have reached this grade have shown themselves to be masters of social relationships (since they needed much cooperation from many people to reach it). They are looked upon as outstanding examples of virtues and morality. They have successfully passed through all initiatory experiences, assimilating the teachings and values connected with them, and for that reason they are also considered the wisest. . . . Among other things, the *kindi* are said to be unifiers, men of love (*malebo*), men of peace (*kinkutu*) (1972:12).

Members of the female equivalent of the *kindi* enjoy a similar status. Some of the emblems of these offices embody didactic proverbs intended not only to reinforce the ethics of the Bwami but also to educate the public at large. One popular emblem, an ivory statuette with one arm, represents a "quarrelsome individual (which a *kindi* never should be!) who has lost an arm as a result of hot temper" (ibid.:17). Other statuettes have uplifted hands to emphasize the role of the *kindi* as peacemakers (fig. 1.1).[2] In essence, all the statuettes associated with the Bwami fall into two categories; namely those projecting positive virtues with which every Lega would like to be identi-

2. See Biebuyck (1972:18; 1973: pl. 66).

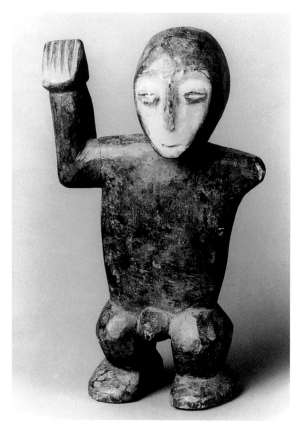

1.1 Human figurine with raised arm. Lega, Zaire. Here, the one arm does not have a negative connotation, as in the case of the statuette representing the quarrelsome individual (*Kuboko Kumozi*). Known as *kasungalala,* this figurine portrays the *kindi* as the one "who-stretches-the-arm(s)-upward," a moderator, arbitrator, and peacemaker. Some *kasungalala* have two raised arms. Wood, h. 13 inches.

fied, and those illustrating negative behaviors and phenomena to be avoided as inimical to the common weal (ibid.:15-18).

In centralized polities like the Asante, Bamileke, Edo, Fon, and Kuba, the monarch personifies the collective existence of the community. His costume is distinguished by a high degree of craftsmanship and lavish use of precious materials and sacred symbols such as leopard skins, eagle feathers, beads, and ivory—all portraying the monarch as the epitome of tradition, artistic excellence, political authority, material abundance, and spiritual regeneration. Through the costume, the monarch's individuality transforms into a corporate image projecting the hopes, unity, and social aspirations of the people. Sometimes a symbol of kingship communicates the same message. In two iron altars (*asen*) of the Fon (Republic of Benin), the king is projected as the essence of communal unity. In one *asen,* the dynamic leadership of King Glele (1858-89) is symbolized by a hand holding a bundle of grass, declaring the oneness of the Fon Kingdom during his

3. See Mercier (1952: pls. 1,9). This motif (fig. 1.2) illustrates several aphorisms, one of which is "Dahomey is between the hands of someone" (ibid.:23), alluding to King Glele as a powerful monarch and the force behind the military ascendancy of the Fon in the late nineteenth century. For other meanings of the motif, see Blier (1990:44-46).

4. For the use of the *asen* to foster harmony between the ancestral dead and their living descendants, see Bay (1985).

reign (fig. 1.2).[3] The second *asen,* memorializing King Guezo (1818-58), is a lesson on collective responsibility. Here, a perforated pot is shown resting on a human hand, alluding to the Fon saying that, if such a pot is to hold water, all the holes on its body must be plugged.[4] In this case, the pot stands for the state, of which the king is the symbol, while the hand represents the citizenry, whose fingers are required to plug the holes so the pot can hold water. In these two *asen,* the message is clear: "united we stand; divided we fall."

One of the most popular examples of the use of the visual arts to promote social harmony is to be found in the symbols of Asante kingship. Among the Asante, as in most Akan communities, a stool (*dwa*) is believed to share part of its owner's spiritual essence. The stools of a chief are identified both with the person and the office. Thus the stool of the ruler symbolizes the unity of the state and the divine authority invested in the leader (Fraser 1972:142). At the death of its owner, a ceremonial stool is blackened and consecrated to serve as a repository for the soul of the deceased. Usually carved from wood, a typical stool has three parts: a concave top for sitting, the middle support, and a flat base. The shape of the middle support varies from one stool to another. Apart from determining the name of the stool, the middle support incorporates different patterns, symbols, and carved aphorisms about the cultural life of the Asante, the ultimate aim being to

1.2 *Left* Iron altar *(asen)* representing the consolidation of the Fon kingdom during the reign of King Glele (1858-89). Iron, brass, h. 59 inches. *Right* Iron altar in memory of King Guezo (1818-58). The hand of the citizenry plugs the perforated vessel of the state—a lesson in unity and collective responsibility. Iron, brass, h. 55 inches. Author's drawings, after photos in Mercier (1952: pls. 1, 9).

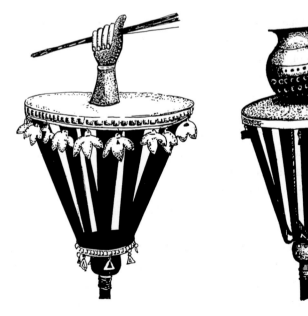

educate the public on the virtues of responsible leadership and good citizenship. For example, the middle support of the stool, known as *owo-koforo-Adobe* (the snake-climbs-the-raffia-tree), is embellished with serpentine and zigzag forms (Sarpong 1971:25, 34), implying that just as it is difficult for a snake to climb the raffia tree, so an individual must exercise prudence in human relations. In another stool known as *Baako-Ntena* (one-man-does-not-live), a small diamond-shaped motif is placed in the center of a bigger one, meaning "that a man by nature is a social being; he cannot and does not live alone but with others" (ibid.:24-25). Lastly, the stool known as *obi-te-obi-so* (someone-sits-upon-another) has its middle support divided into two sections to emphasize the fact that a hierarchical order of precedence is mandatory for the smooth running of the community (ibid.:23).

Before the seventeenth century, the kingdom of Denkyira dominated most of the Akan communities of the former Gold Coast (now Ghana). In 1701, Osei Tutu, the king of Kumasi, leading other Akan groups, defeated the king of the Denkyira. This coalition later teamed up to form the Asante confederacy under Osei Tutu. To consolidate the union, Okomfo Anokye, the chief priest of Osei Tutu, promised to conjure from the sky a special gold stool that would enshrine the soul of the new nation. As a precondition, he asked that all the ancestral stools and state regalia of members of the union be surrendered to him, and he buried these in a river. Later, during a public ceremony presided over by Osei Tutu and to which every paramount ruler of the union had been invited, the chief-priest miraculously caused a stool made of gold to appear on the lap of Osei Tutu. The chief-priest then declared Osei Tutu to be father and supreme head of the Asante nation and custodian of its soul, which the Golden Stool symbolizes. As a form of oath, all parties to the union were asked to surrender locks of hair, nail parings, and personal adornments, which were attached to the Golden Stool along with some magical objects. Finally, a formal constitution was adopted by the union.[5] Since then, the Golden Stool has been treated like a living person, with its own set of state regalia, musicians, and retainers. On ceremonial occasions, it is displayed beside the *Asantehene*, "the father of the nation," to remind all Asante of their common heritage and destiny, thus intensifying the bonds of social relationship (Fraser 1972: fig. 8.2; Cole and Ross 1977: fig. 6).

The association of the mask with the spirit world has resulted in its being used to promote amity and sodality in many communities. During initiation ceremonies, for example, the instructors sometimes wear special masks to represent those founding ancestors and other supernatural forces to which a

5. For more on the Golden Stool, see Kyerematen (1964:11-25); Sarpong (1971:29-34); Fraser (1972:137-42); on Asante stools, see Cole and Ross (1977).

given society looks for divine guidance and protection. The actions and utterances of the instructors thus become inviolable models for behavior. Among the Mende of Sierra Leone, the ideals of the Sande society (the female organization responsible for the socialization of Mende women) are exemplified by the *sowei*, a special helmet mask that manifests the guardian spirit of the society and plays a prominent role during the initiation exercise and other activities of the Sande. Only the senior members of the society may own or wear certain masks. A typical *sowei* mask (fig. 1.3) is distinguished by an elaborate coiffure and a broad forehead. Slitted eyes and a stylized nose and mouth are set on a calm, oval face with a pointed chin. The neck is characterized by pronounced "rings" to suggest maturity, fertility, opulence, and high rank. The mask has a smooth black finish, and appears serene and highly dignified. As Sylvia Boone aptly puts it, the *sowei*

1.3 Sowei helmet headdress. Mende, Sierra Leone. An idealization of all that is beautiful and desirable in Mende culture. Wood, raffia, h. 15 ³/₈ inches.

is "the good made visible" and is "a clear expression of all that is desirable and fine in Mende world" (1986:157).[6] This cultural ideal is one of the principal goals of the Sande. Not only does the Sande train girls in the fundamentals of personal hygiene as well as how to look beautiful and be attractive, but it also prepares them for the responsibilities of motherhood and teaches them how to cope with stress and individual differences in a world filled with people of diverse goals and temperaments. The Sande holds special courts to hear disputes and settle grievances among its members. Boone writes:

> All sides are heard and witnesses are called; the emphasis is on discussion, compromise and concessions. Serious wrongdoing is punishable by a heavy fine or harsh beating. Sometimes an apology or restitution of property is sufficient. Never is a woman banished, or incarcerated, or sent to coventry; the effort is toward resolution and reinstatement. Often the disputants are made to undergo a ritual bath—a scrubbing and rinsing of the physical body with herb-suffused holy water that is meant to cleanse and repristinate the spirit. A woman brings these social ills to [Sande sessions]; here they are resolved and then washed away, so the larger community, too, has been rid of crimes and wrongs and thus is healed. Resolution and reinstatement restore harmony and equilibrium (ibid.:50).

The male counterpart of the Sande is known as "Poro." It operates along similar lines, except that it is also found among the Mano, Wee, Gola, Grebo, and Loma of Liberia, and the Senufo of Côte d'Ivoire, to name only a few. Apart from being used to train male youths to become responsible adults, the masks of the Poro effect social control in a variety of ways, ranging from the enforcement of law and order to crisis management. For example, in the past, whenever a delicate issue threatened the peace of a Mano village, the elders sought the advice of the spirit world through a senior Poro mask called *Go-ge*. After the elders had thoroughly deliberated on the issue, the priest of the *Go-ge* mask would uncover the mask and call it by name. He would review the case, asking the mask to agree or disagree with the elders' decision. The priest would then cast his divination shells: if positive, the ancestral spirit represented by the mask had agreed with the decision; and if negative, the spirit had rejected it. The decision was final. If the case concerned two parties, the loser had to accept the decision in good faith (Harley 1950:11-17).

That art can promote good human relations is recognized all over Africa. Hence pottery, basketry, beaded objects, leatherwork, and fabrics of all kinds

6. For more on the Sowei (also called "Nowo" among the Temne), see Richards (1974); Phillips (1978); Lamp (1985).

are specially commissioned and presented as gifts to communicate love, affection, respect, and friendship. Among the Hausa, Fulani, and Yungur of northern Nigeria, the decorated calabash is an important symbol for commemorating the major phases of life, such as initiation, betrothal, marriage, childbirth, and burial. When presented as a gift, it contributes toward "such practical ends as the establishment, maintenance, and fostering of beneficial social relationships" (Chappell 1977:26). Among the Yungur, a plain or white calabash symbolizes peace and social concord. Since whiteness signifies "coolness," a white calabash is sacred, evoking divine authority and the absence of bitterness. As a result, the placement of a white calabash between two warring parties is intended to "cool" tempers and restore peace (ibid.:20). Cases of murder must be reported to the priest-chief of the Yungur, who has the authority to impose fines or other punishment on the murderer. To prevent retaliation and further bloodshed, the priest-chief uses a white calabash to impose a truce until the resolution of the case (ibid.). A white calabash may also be used to settle marital disputes. In the past, if a wife left her husband because of a quarrel, the husband's parents would send her a white calabash to "cool her down" and plead with her to forgive her husband. If the plea was accepted, the wife returned the calabash to her parents-in-law, filled with beer, as a sign that the quarrel was over (ibid.).

The Woyo of Cabinda, south of the Zaire River, have a different but equally effective approach to a peaceful solution of marital conflicts. A newly married couple is usually given a collection of pot lids as wedding presents. Each lid illustrates a proverb concerning the fundamentals of a successful relationship. A Woyo couple usually eats separately. In the evening, the man eats in the company of his friends or visiting relatives. The wife brings food to her husband and his guests, covering the serving pots with leaves. But whenever she has problems with her husband or if the marriage is threatened, she covers one of the pots with an appropriate lid to express her feelings. Since every Woyo adult can interpret most of the symbols depicted on the lids, the friends or relatives know immediately that something is wrong with the marriage and will consequently help the couple to effect a settlement. One pot lid shows two birds fighting over a strange object, surrounded by the sun and moon, and a knife and feather—all hinting at opposing forces (McGuire 1980:55-56). The message here is that the wife is threatening to leave her husband because of neglect and frequent disagreements (ibid.:55). Another pot lid shows two goats tied to the same stake, illustrating the Woyo proverb: "Those who hitch two goats close to each other are to blame when the ropes get tangled" (ibid.:54). According to McGuire, this lid may be

presented to a son to warn him of the unpleasant consequences of bigamy, or to a couple intending to marry despite parental opposition (ibid.). The husband also has his own collection of pot lids. If he has any grievance against his wife, he will wait until the end of the meal and will then cover an empty food bowl with an appropriate lid as the wife prepares to remove the plates.

The use of pictographs for didactic purposes obtains in other parts of Africa: for example, in the linguist staffs, gold weights, and ceremonial sword and stools of the Asante; in the figurative smoking pipes of the Bamileke and Bamum of the Cameroon grasslands; in the raffia cloth of the Kuba of Zaire; and in the decorative wooden combs of the Jokwe and Lunda, also of Zaire. The Nkisi Nkondi nail figure of the Kongo peoples (Zaire) deserves a special mention here (Sieber and Walker 1987:pl. 40). To ratify a peace pact between two parties, each one is expected to take an oath before the Nkisi Nkondi and then hammer iron nails or knives into the figure to "let bygones be bygones" and pave the way for a resumption of normal relationships (ibid.:83).[7]

In many parts of Africa, satire is recognized as an effective weapon for correcting antisocial behaviors. Since everybody in a given community knows everybody else, the disapproval of one's behavior by others is a social stigma that all sane adults try to avoid. To be subjected to public ridicule is to lose respect and bring shame to one's family members and friends (Maquet 1972:78).[8] Thus, to avoid disgrace, everyone conforms, at least in public, to the established norms. Since many of the antisocial elements are very crafty, often escaping detection, it has become necessary to invent hypothetical contexts or moralistic comedies to satirize them in public in the hope that, when confronted indirectly with their mischievous acts, they will feel guilty and eventually change for the better (Brink 1977:62-63). The Igbo of Owerri, Nigeria, always seize the occasion for building an *mbari* to glorify the "desirable" and satirize the "undesirable." An *mbari* is an architectural complex dedicated to the Earth goddess (*Ala*), depicting various aspects of Igbo religion and social life. The focus of the tableau is the earth goddess herself, surrounded by her children. Sometimes she is depicted carrying a child in one hand and holding a knife in the other, to symbolize her positive and negative attributes.

The most significant aspect of the *mbari* is its representation of the forces of good and evil in the same context. The former are represented by maternity scenes, beautiful women, expectant mothers, musicians, workers, children, and beneficent gods; the latter, by prostitutes, rapists, cannibals, ter-

7. See also Laman (1957:159-60); MacGaffey (1993:21-193).

8. See also Lambo (1961:62).

rorists, fornicators, adulterers, wild animals, monsters, and evil spirits, who then become objects of public ridicule (Cole 1982). A similar opposition of the "desirable" and "undesirable" can be observed in the character sketches of the Okorosia and Okumpa masks of the Igbo, in which satire is used as an instrument for molding public opinion and reforming antisocial elements (Ottenberg 1972:99-121; 1975; Cole 1969:24-41). At any rate, the belief that benevolent and malevolent forces are inherent in nature is widespread in Africa.[9] This has led some communities like the Wee of Liberia and the Ibibio of Nigeria to create deliberately ugly masks, so they can effectively repel evil forces (Sieber and Walker 1987: pl. 67; Messenger 1973:121-23; McClusky 1984:116-17).

9. For examples, see Fernandez (1966:53-64); Brink (1977:62-63); Roberts (1986:26-35).

Fear of Witchcraft

Witchcraft is a major cause of social tension in Africa, being suspected in most cases of sudden deaths, epidemics, drought, crop failure, flood, accidents, human infertility, snake bites, and other misfortunes. It is believed that witches and sorcerers wield enormous magical powers, which they use most of the time for diabolical purposes. With these powers they can perform wonders, such as becoming invisible to the naked eye or changing into dangerous creatures. The soul of the witch is suspected to be capable of leaving its body at night and turning into a bird, cat, or poisonous snake that invisibly attacks an unsuspecting victim, sucking the blood or consuming the flesh. For reasons not yet fully explained, the most popular image of the witch in Africa is that of a cantankerous woman who operates in the dark, killing for fun or out of envy or sheer malice. She is believed to be a member of a secret lodge that meets at night to exchange notes and plan strategies. Members travel great distances through their animal familiars to attend lodge meetings.[10] As Peter Morton-Williams has observed:

10. For more on witchcraft in Africa, see Evans-Pritchard (1937); Parrinder (1970); Middleton and Winter (1963); Forde (1954). For a critical review of the data, see Hallen and Ṣọdipọ (1986b).

> Witchcraft . . . may be defined as a capacity that is believed to exist in some individuals, enabling its possessor to cause bodily harm to another without attacking him physically, and not necessarily through the exercise of the will; in a particular instance, a witch's action may be involuntary—even unconscious—so that the witch becomes aware of it only later. (1956b:327)

As witchcraft is thought to operate at the metaphysical level, it is also combatted at that level. The cause of an inexplicable illness or misfortune is determined through divination, and the remedy combines both physical

and magical elements. Individuals protect themselves against the unknown by wearing amulets and using special prophylactics. The leadership of the community is responsible for the ritual cleansing of the environment. Among the Bangwa and Bamileke of the Cameroon grasslands, a special anti-witchcraft squad, called *kungang,* performs this function and also operates as a police force, arresting and punishing witches (Brain 1980:220). In the l940s, witchcraft suspicions became so serious among the Asante that an antiwitchcraft cult, variously known as Tigere, Tingare, and Atinga, was formed to ferret out and exorcise witches. The cult spread to Togo and the Republic of Benin, reaching Yorubaland in the 1950s (Morton-Williams 1956b:315).

One significant aspect of the witchcraft phenomenon in Africa (at least among the Nuer,[11] Lugbara,[12] and the Yoruba[13]) is the belief that it has both positive and negative potentials, and that it turns evil only in the hands of sadists or nihilists. Thus, attitudes toward those accused of witchcraft will vary from one community to another. In some communities, supposed witches are either outlawed or executed; in others, they may be fined and then purified. The Yoruba attitude toward witchcraft will be detailed in the next chapter. Robert Farris Thompson witnessed in 1973 the trial of two Mbang women accused of witchcraft. The two women had been arraigned before the antiwitchcraft mask (Basinjom), and were charged with causing the dry rot that infested the crops in the villages of Defang, Fotabe, and Ntenmbang on the Cameroon/Nigerian border:

> [The Basinjom mask] loomed over the two women accused of witchcraft. The darkness of his gown, the thrust of his crocodilian jaw, and the striking silhouette of his chest-plate made of the skin of a genet cat, all acquired momentum from his motion. . . . Basinjom lifted his knife. . . above the level of his head This silenced percussion. He began to speak, facing the two women and the crowd behind them. He related intimate things, divinatory insights, thoughts, dreams. He specified certain selfish acts, breaches of cooperative contract, lapses of generosity, unkind words, and then he said: ". . . and with this evil familiar did you go out, when the planting was under way, and sow your filth into the earth. You planted it. You! and You! You are the ones responsible. All our crops have been affected. You went to your place and all our plants have been attracted there and ruined by your power." He called their names. He asked, "Have you done this?" They answered "Yes." He asked again, "Were you at a certain place?" Again they answered, "Yes." They apologized and said that they did not know that their powers had been so destructive. They begged forgiveness. They offered material amends and these were accepted. They were purified by Basinjom,

11. Beidelman (1971:401-5).

12. Middleton and Winter (1963:271-72).

13. Hallen and Sọdipọ (1986a:1-7).

who said, "From today I do not want to see any further trouble from your house." A goat was sacrificed. The women swore not to do such evil a second time. They were purified by Basinjom and forgiven. The case was closed. (Thompson 1974:215-16)

Since the Basinjom mask (fig. 1.4) represents a powerful spirit, its decision is final. Both the sacrifice and the purification rituals are intended to reverse the havoc caused by the alleged witchcraft. Anxieties are allayed and order is restored to the community.

1.4 Basinjom antiwitchcraft mask. Ejagham-Banjang, near the Nigerian/ Cameroon border. By rebuking and purifying individuals found guilty of witchcraft, the Basinjom mask restores social harmony.

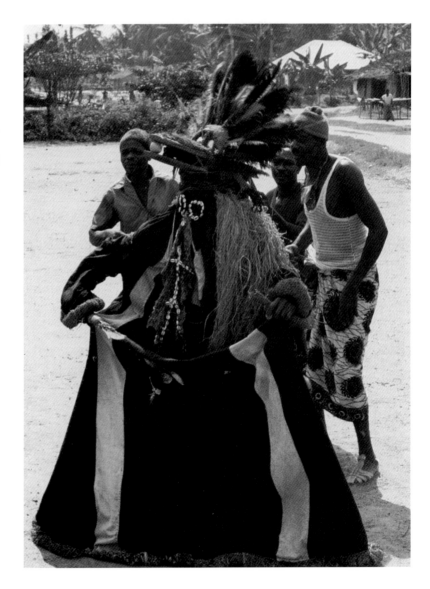

Broadly speaking, the Yoruba, like other African peoples, use art to reinforce life and to ensure social and cosmic harmony. At the religious level, art is used to honor and to communicate with divinities (òrìṣà), whose spiritual support is deemed vital to individual and corporate survival. At the secular level, art enhances appearance, projecting taste and status. The Yoruba place a high premium on dress because it determines and negotiates social relationship. Hence the popular saying: Ìrí ni sí ni ìsọnilójò (One's appearance determines the degree of respect one receives). Consequently,

1.5 A Yoruba community ruler (ọba) in full regalia. Odè Rémọ. Note the veiled and beaded crown, which links him with Odùduwà, the mythical progenitor of the Yoruba. The bird motif on the crown signifies àṣẹ, divine power.

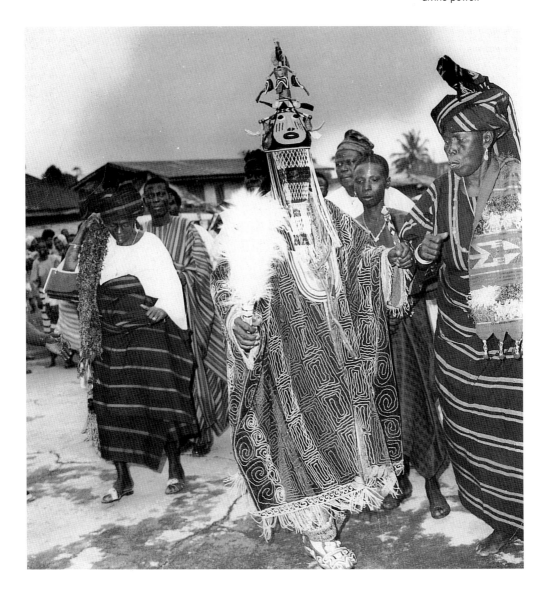

antisocial dressing (outside specific religious or festival contexts) is frowned upon by the Yoruba and may eventually lead to ostracism. To increase his charisma, the ruler (*ọba*) of a given community wears highly ornate ceremonial costumes (fig. 1.5). When appearing in public, he often dons a beaded crown with a veil (*adé*) which proclaims his divine right to rule by linking him with Òdùdúwà, the mythical progenitor of the Yoruba and a symbol of their social and spiritual oneness. The palace of a typical *ọba* has carved doors and posts, the most popular motifs being equestrian warriors and nursing mothers, which allude to the political and spiritual power of the ruler to protect, and care for, his subjects.

Several religious festivals take place in a given community every year to promote the spiritual well-being of the people, providing a forum for celebrating and reaffirming their unity. One of the most popular of these festivals (particularly among the Ọ̀yọ́) is the Egúngún. This features colorful masked figures representing the spirits of deceased ancestors who are visiting the earth to renew acquaintance with their living descendants (fig. 1.6). As the word of the ancestor is law, some Egúngún masks serve as judges, helping to adjudicate outstanding quarrels in the family or the community, or warning against antisocial behaviors. Others bless the sick and the barren, or officiate at rituals aimed at cleansing the society of witchcraft and disease. Some entertain the living with songs, acrobatic dances, and magical performances. Thus, the annual Egúngún festival is a time of rejoicing among the Yoruba. By dramatizing the Yoruba belief in an afterlife, the Egúngún mask not only celebrates the triumph of the human spirit over Death, but it also links the present with the past, thereby enabling the living to face the future with hope. A typical Yoruba extended family comprises both the living and the departed ones. In this context, the Egúngún functions as a social unifier, promoting cordial relations within a community, and between it and the Living Dead.[14]

14. For more on Egúngún, see Beier (1959); Morton-Williams (1956a: 90-103); Adedeji (1970:70-86); Lawal (1977:50-61); Babayẹmi (1980).

In summary, African art in its societal and spiritual roles projects values aimed at making the world a better place in which to live. The Gèlèdé spectacle of the Yoruba can be understood within this context as an active expression of the Yoruba idea of *Ìfọgbọ́ntáayéṣe*; that is, the development of social strategies for promoting community peace, happiness, and togetherness (*àṣùwàdà*). According to the Gèlèdé society, the success of these strategies depends on such virtues as love, tolerance, fairness—all subsumed under the term *ìwà* (ideal character).

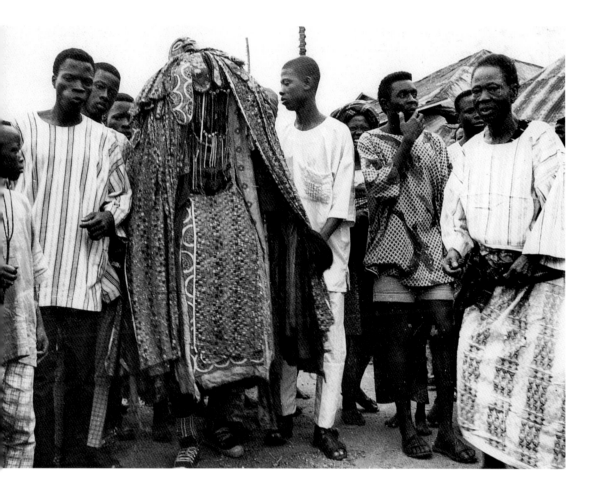

1.6 An Egúngún mask representing the spirit of a deceased ancestor visiting the Earth to interact with the living, blessing them and helping to settle outstanding disputes. Ìpetumodù, near Ilé-Ifè (1972).

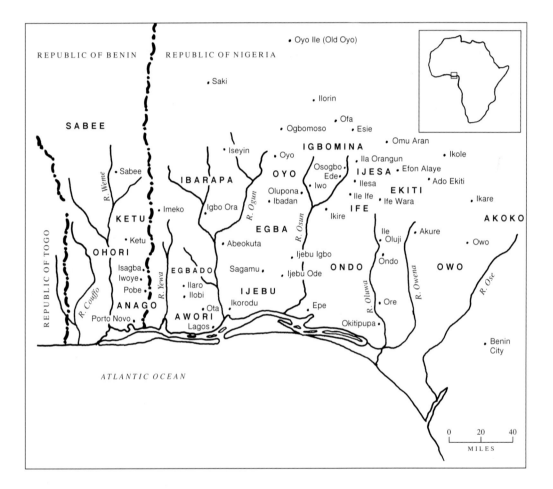

Map 1. Yorubaland, showing major towns
(e.g., Ile Ife) and subgroups (e.g., **IFE**).

Ìwà

The Dialectics

of Yoruba Existence

Numbering over twenty million people, the Yoruba inhabit the present-day republics of Nigeria, Benin, and Togo in West Africa (map 1). More than three quarters of the Yoruba live in southwestern Nigeria. Although their society is divided into many independent kingdoms and subgroups (such as the Ẹ̀gbá, Ẹ̀gbádò, Ìjẹ̀bú, Kétu, Àwórì, Ifẹ̀, Ìjẹ̀sà, Ìgbómìnà, Ọ̀yọ́, Ọ̀wọ̀, Èkìtì, and Àkókó, to mention only a few), they are united, to a large extent, by a common language and culture and also by a common tradition of origin which regards the town of Ilé-Ifẹ̀ as the cradle of their civilization.[1]

Abundant natural resources enabled the Yoruba to develop one of the most advanced and urban cultures in sub-Saharan Africa. The Yoruba art corpus ranges from naturalistic bronze and terracotta portraits, dated between the twelfth and fifteenth centuries A.D., to highly stylized woodcarvings, iron staffs, and beaded crowns.[2] By the twelfth century A.D., Ilé-Ifẹ̀ had become a metropolis with highly developed religious, social, economic, and political institutions that encouraged the creation of some of the most sophisticated art forms in Africa. Between the seventeenth and the early nineteenth centuries, Ọ̀yọ́-Ilé, another kingdom located north of Ilé-Ifẹ̀, near the Niger River, rose to become one of the richest and most powerful states in West Africa, controlling a vast empire that included some non-Yoruba groups.

These developments suffered a major setback during the trans-Atlantic slave trade, between the sixteenth and nineteenth centuries, when hundreds of thousands of the Yoruba were transplanted to the New World to work on plantations. Today, significant survivals of Yoruba culture abound in North and South America and the Caribbean.[3] According to William Bascom, "no African group has had greater influence on the New World than the Yoruba" (1969a:1). This influence is most pronounced in religion. In addition to preserving many of its ancestral traditions in the New World, Yoruba religion has influenced the birth of new religions such as *Candomble* and *Macumba* in Brazil; *Sàngó* in Trinidad, Tobago, Granada, and Barbados; *Kele* in St. Lucia; and *Santeria* in Cuba, Venezuela, and the United States. Yoruba influ-

1. The literature on the Yoruba is very extensive. The most comprehensive bibliography is Baldwin and Baldwin (1976), although it needs updating.

2. For more on Yoruba art, see Cordwell (1952); Willett (1967); Thompson (1971b); Fagg and Pemberton (1982); Drewal, Pemberton, and Abiọdun (1989).

3. For a survey, see Hunt (1979); Verger (1981); Thompson (1983:3-101, and 1993); Holloway (1990); Omari (1991:66-75); Galembo (1993).

ence is also evident in the *Voodoo* (*Vodou*) religion of Haiti and New Orleans. In West Africa, survivals of Yoruba culture also exist in Sierra Leone, where some repatriated slaves settled in the nineteenth century, following the abolition of the slave trade (Nunley 1987).

To the Yoruba, the physical world (*ilé ayé*) has a metaphysical counterpart in heaven (*òrun*), where lives the Supreme Being, Olódùmarè, the creator of existence (*ìwà*). Olódùmarè is rarely worshipped directly, but rather through a host of lesser divinites, the *òrìṣà* (numbering over 400), who represent different aspects of his essence and are therefore directly concerned with human affairs. The most prominent of the *òrìṣà* are: Ọbàtálá, the artist deity whom Olódùmarè commissioned to mold the first human body from divine clay, after which it was charged with life; Odùduwà, who was commissioned to create the earth, which he did by pouring divine sand on the primeval waters below the sky until the sand hardened to form the physical world *(ilé ayé)*; Ọ̀rúnmìlà, a great sage and master of the Ifá divination system who witnessed all the acts of creation and thus knows all the secrets of the universe; Èṣù, the divine messenger; Ògún, a great hunter and the iron deity, and Yemọja, "the mother of all things." In addition to Olódùmarè and the *òrìṣà,* the Yoruba believe in life after death and in reincarnation.[4]

According to one of the Yoruba myths of creation, the *Àyájọ́ Àṣùwàdà* (i.e., community incantation or poem,) usually recited at the consecration of a new human settlement to ensure peace and togetherness), all beings are destined to exist in clusters. In the following example, Ọlọ́fín Ọ̀tẹ́tẹ́ (line 5) is a mythical ruler sometimes identified with Odùduwà.

Please note that here and in poems throughout the book, the lines are numbered consecutively, despite ellipses, for ease of cross-reference to the translation:

> Ìrì tu wílí, tu wílí.
> Ìrì tu wìlì tu wìlì.
> Ìrì tu wílí wílí
> Kó o tú rẹ́kẹrẹ̀kẹ.
> [5] A dá fún Ọlọ́fin Ọ̀tẹ́tẹ́
> Tí yíò tú Ìwà wá sílé ayé
>
>
>
> Hóró èèpẹ̀ kan ṣoṣo
> Ó wá dagbọ̀n èèpẹ̀ kan
>
>
>
> Ọlọ́fin Ọ̀tẹ́tẹ́ ló ru agbọ̀n èèpẹ̀ wá sílé ayé.
> [10] Ọlọ́fin Ọ̀tẹ́tẹ́ gbé agbọ̀n èèpẹ̀

4. For more information on Yoruba religion, see Verger (1957); Idowu (1962); Morton-Williams (1964:243-61).

Dá Ilé-Ifẹ̀.

Ire gbogbo wá dàṣùwà.

Irun pé ṣùṣù, wọ́n gborí

.

Igi pé ṣùṣù, wọ́n di igbó.

[15] Erúwà pé ṣùṣù, wọ́n dọ̀dàn

.

Àṣùwà ni toyin.

Àṣùwà leéran n hù nínú oko.

Àṣùwà ni tòṣùṣù ọwọ̀

.

Aláṣùwàdà mo bẹ̀ ọ́ o,

[20] Rán ire gbogbo wáá bá mi.

Dews pour lightly, pour lightly.

Dews pour heavily, pour heavily.

Dews pour heavily

So that you may pour lightly.

 [5] Thus Ifá [divination] was consulted for Ọlọ́fin Òtẹ́tẹ́.

Who would pour myriads of existence upon the earth

.

One particle of dust became

A basketful measure of dust

.

Ọlọ́fin Òtẹ́tẹ́ it was who carried a basketful of dust to the earth.

[10] Ọlọ́fin Òtẹ́tẹ́ used a basketful of dust

To create the land at Ifẹ̀.[5]

Myriads of goodness took the shape of togetherness.

Strands of hair came together to occupy the head.

.

The clumping of trees became the forest.

[15] The clumping of *erúwà* grasses became the savannah

.

Bees always cluster together.

Eéran leaves grow in a bunch.

The broom exists as a bundle

.

The creator of togetherness, I invoke you

[20] Let myriads of goodness come to me.

5. This refers to Ilé-Ifẹ̀, the sacred city of the Yoruba.

(Akiwọwọ 1986a:116-17.

My translation, adapted from Akiwọwọ 1986b:350-51)

The main thrust of this verse is that although all the constituents of nature were created individually, nothing can survive alone. As Akinṣọla Akiwọwọ, the Yoruba sociologist, has summarized it:

All things continue-in-being as communities, throughout the whole realms of nature from ants to elephants, from algae to whales, from plants to giant trees; man-made objects continue-in-being in communities or systemic wholes, from dyads to congregations, from families to nations. It is this community of creatures that is the substance of *goodness*. (Akiwọwọ 1966:352)

In sociological terms, the *Àyájọ́ Àṣùwàdà* postulates that, while the individual is the unit of social life, he or she is also an integral part of a whole (a family or community) and therefore needs the fellowship of others to feel whole and complete.[6] There is, however, a fundamental difference between *Àṣùwàdà Ẹranko* (Animal Community) and *Àṣùwàdà Ènìyàn* (Human Community). Literally "a creature of the bush," *ẹranko* refers to the wild and unrefined, so that animal community is nature governed by the basic biological needs of subsistence and survival. *Ènìyàn*, by contrast, is the handiwork of the artist-deity, Ọbàtálá, and so is a divinely ordered being and an embodiment of reason. Humans, living together, constitute a civilized society (*àwùjọ ènìyàn*) subject to self-imposed rules and conventions. Nonetheless, the Yoruba notion of Being recognizes the uniqueness of every creature; hence the popular saying: *Àbùdá àti àyànmọ́ olúkálukú yàtọ̀* (Each individual has a different nature and destiny).

The diversity in human constitutions and potentials often generates behavioral impulses sometimes at variance with the *Àṣùwàdà* principle, threatening the corporate existence of a given community.[7] Moreover, the Yoruba view the cosmos as a dynamic interplay of such opposites as heaven and earth, day and night, male and female, physical and metaphysical, body and soul, inner and outer, hot and cold, hard and soft, left and right, life and death, success and failure, and so on (Ajuwọn 1984:93-95). This oppositional complementarity is evident in the popular saying: *Tibi, Tire la dá ilé ayé* (the physical world evolved out of Good and Evil). Known as *ibọ* (the worshipped), the benevolent forces comprise the *òrìṣà* and spirits of deified ancestors (*ará ọ̀run*). If worshipped properly, these beings will ensure good health, long life, wealth, and happiness. The malevolent forces are the earthly calamities militating against human happiness and well-being. Known as *ajogun* (warriors against humanity), these negative forces include, death, paralysis, disasters, diseases, loss, trouble, barrenness, drought, curse, and demons (Abimbọla 1971:75; Ajuwọn 1984:89-98).

6. *Àyájọ́* = incantation or poetry; *Àṣùwàdà* = "togetherness." For an attempt to relate the *Àyájọ́ Àṣùwàdà* to Edmund Sinnot's theory of "purposiveness" in nature (1961), see Makinde (1988:62-63). For a critique of *Àyájọ́ Àṣùwàdà* and its interpretations by Akiwọwọ and Makinde, see Lawuyi and Taiwo (1990:58-62). For Akiwọwọ's response, see Akiwọwọ (1991:243-51).

7. For more on the Yoruba idea of destiny, see Alade (1972:8-10); Ajanaku (1972:11-13); Abimbọla (1971:73-89); Lawal (1985:95-103); Makinde (1985:53-68); Abiọdun (1987:252-70).

To reconcile the two forces, Olódùmarè reportedly gave special powers (àṣẹ) to Ọ̀rúnmìlà and Èṣù. As the divination deity, Ọ̀rúnmìlà helps fellow òrìṣà and human beings to diagnose and find solutions to problems. He also foretells the future, offering appropriate advice and remedies to avert impending trouble.[8]

On the other hand, Èṣù, in his capacity as the divine messenger and the keeper of Olódùmarè's power (àṣẹ), acts as a "spy" for Ọ̀rúnmìlà. As the bearer of messages and sacrifices aimed at promoting order and harmony in the universe, he mediates between opposing forces (dos Santos and dos Santos 1971; Pemberton 1975:20-27). Paradoxically, several myths portray Èṣù as a troublemaker who delights in mischief by making enemies of close friends and even causing misunderstanding among fellow òrìṣà, if only to create an opportunity for himself to serve as a mediator. As an agent provocateur, he instigates human beings into offending the òrìṣà, thus giving the latter the opportunity to demand sacrifices of atonement, a portion of which must be given to him (Wescott 1962:337-54). These negative aspects of Èṣù prompted Islamic and Christian missionaries to identify him with the devil of the Koran and the Bible, which he is not. It suffices to say that since (in collaboration with Ọ̀rúnmìlà) he eventually resolves all the conflicts in the universe, including those incited by himself, Èṣù is a paradigm for the "opposites" inherent not only in the Yoruba cosmos but also in the Aṣùwàdà principle. Under the circumstance, maintaining an equilibrium is no easy task.

Human Society

Olódùmarè's decision to create human beings (ènìyàn) was reportedly influenced by his desire to transform the newly created Earth from a primeval wilderness into an orderly estate. According to Chief Fagbemi Ajanaku, the late Àràbà (head of Ifá priests) of Lagos:

Àwa gẹ́gẹ́bí ènìà, àwa ni
Olódùmarè yàn láti lọ
Tún ilé-aiyé ṣe. Ẹni a yàn ni wa'.

We, as human beings, were the ones
Selected by Olódùmarè to go and
Develop the Earth. We are the specially selected.[9]

(Ajanaku 1972:11. My translation)

8. For details of the role of Ọ̀rúnmìlà in Yoruba religion, see Bascom (1969b); Abimbọla (1976).

9. According to the Ifá divination verse (Odù Ìrosùn Ìwòrì), the beings appointed "to convey goodness to the earth are those we refer to as ènìyàn." (cited in Akiwọwọ 1983a:11). Ènìyàn is sometimes pronounced eníyán to describe the wicked ones, or those working against human goodness.

In other words, the human image, a masterpiece by Ọbàtálá, embodies a special power (àṣẹ), inspiring and sustaining the creativity manifest in the visual, performing, and applied arts, and transforming Ilé Ayé, the physical world, into the civilization it is today. Interestingly enough, all the òrìṣà are said to have assumed human form in order to accompany the first mortals to the newly created earth, where they taught them the rudiments of the culture now known as Yoruba. The cradle of this culture is Ilé-Ifẹ̀, the spiritual capital of the Yoruba, where Odùduwà (the Earth deity) first settled and established a ruling dynasty. In view of the fact that the Yoruba now consider themselves as "Ọmọ Odùduwà" (Children of Odùduwà), it is difficult to differentiate a real òrìṣà from a deified ancestor or culture hero. Not only is the Yoruba religion cumulative, but the line between the human and the divine is so thin as to make it possible for a deity to become human, and vice versa.

Another conundrum in Yoruba religion is that Odùduwà has two identities. In one section of Yorubaland he is perceived as male, but in another, as female. The confusion over the sex of Odùduwà (also called Oòduà) has been interpreted by some scholars as possibly reflecting a dynastic change at Ilé-Ifẹ̀ in the distant past, as a result of which a conquering group, after imposing itself on the aboriginal population, either altered the image of their earth deity or replaced it with a new one.[10] Although there is as yet no concrete evidence to back up this theory, it is not implausible. This is because the same Odùduwà of the Yoruba creation myth features in other legends as the leader of a group who invaded Ilé-Ifẹ̀, conquering the aboriginal population and establishing a new dynasty there (Johnson 1921:3-14; Smith 1988:3-12; Beier n.d.:25-32).

Hints about a dynastic conflict persist in another version of the creation myth which alleges that it was Ọbàtálá, not Odùduwà, whom Olódùmarè first commissioned to create the Earth. After receiving the sacred instruments of his commission, Ọbàtálá got himself drunk with palm wine and fell asleep by the roadside. Noticing this, his rival, Odùduwà, stole the sacred instruments, descended from the sky, and created the Earth. When Ọbàtálá recovered from his slumber and discovered what had happened, he challenged Odùduwà. A big fight ensued. Olódùmarè eventually settled the crisis by giving Ọbàtálá another assignment—to mold the image of the first human being (Idowu 1962:22). This conflict is commemorated annually during the Ọbàtálá festival in Ilé-Ifẹ̀, when the devotees of Ọbàtálá and Odùduwà engage in a mock battle (Stevens 1966:187; Adedeji 1972:325-30). Although the Odùduwà faction wins the mock battle, both sides eventually arrive at

10. See for example, Idowu (1962:26-27).

an amicable settlement in the interest of peace and social harmony. In any case, one of its moral lessons is that excessive intake of alcohol intoxicates and beclouds human reason. Hence, palm wine is taboo to the worshippers of Ọbàtálá and is taken only in moderation by the generality of the Yoruba.[11]

Every Yoruba community, regardless of its size, has a set of cultural mechanisms for regulating human conduct and settling group and interpersonal differences that otherwise could lead to a breakdown of law and order. A typical Yoruba town (*ìlú*) consists of many patrilineal clans (*ìdílé*), each living in a compound (*agbo-ilé*). Each compound is responsible for maintaining law and order within. A collection of compounds in a section of the town constitutes a ward (*itún* or *àdúgbò*) administered by a head (*olórí itún* or *olórí-àdúgbò*). Serious disputes or offenses are referred by compound heads to the ward heads, and those which cannot be resolved by the latter are referred to the king (*ọba*), who rules in consultation with a council of elders sometimes called Ògbóni or Òṣùgbó. To maintain law and order, an elaborate code of conduct and taboos is binding on all inhabitants, regardless of sex, social status, or rank. A child is brought up to respect tradition and the authority vested in the elders, to acknowledge precedents, and to give honor to whom it is due (Fajana 1966:16-28; Abimbọla 1975b:389-420). These expectations are summed up in the popular saying:

Àìfàgbà fẹ́nìkan
Kò jẹ́ ayé ó gún.

Lack of respect for constituted authority
Destabilizes the world.

(Awoniyi 1975:380. My translation)

However, in the proverb *Ọwọ́ ọmọdé kò tó pẹpẹ; ti àgbàlagbà kò wọ akèrègbè* (The child's hand is too short to reach the high shelf; that of an elder is too big to enter the narrow mouth of a gourd), all members of a given community, young and old, are reminded of their responsibilities to one another and of the need for mutual respect and cooperation because no one is self-sufficient.[12] Through direct instruction, practical demonstrations, proverbs, folktales, myths, riddles, and jokes, the young ones are brought up to cultivate the virtues of truthfulness (*òtítọ́*), good character (*ìwà rere*), courage (*ìgbóyà*), moderation (*ìwòntúnwọnsì*), caution (*ẹsọ̀*), perseverance (*ìforítì*), and tolerance (*ìfaradà*). Positive social interactions are encouraged through the formation of various clubs (*ẹgbẹ́*) that cut across kinship lines,

11. According to another myth, Ọbàtálá got drunk again while molding the human body and, as a result, created cripples, hunchbacks, and other malformed people.

12. This notion is amplified in the following divination verse:

Ọwọ́ èwe ò tó pẹpẹ
Ti àgbàlagbà ò wọ
 akèrègbe
Isẹ́ èwe bẹ àgbà
Kó mọ́ ṣe kọ̀
Gbogbo wa la níṣe a jọ
 mbẹ 'raa wa.

A child's hand is too
 short to reach the
 high shelf;
An adult's hand is too
 big to enter the mouth
 of a gourd.
The work a child begs
 an adult to do,
The adult should not
 refuse.

We all need one
 another's services.

(Abimbọla 1971:83.
 My translation)

enabling individuals with common interests to come together and share one another's fellowship. Those who deviate from the norm or the established moral code are punished through fines, chastisement, ostracization, or public ridicule. There is a strong belief in retributive justice: the *òrìṣà*, it is believed, will catch up with and punish criminals who escape human detection. Ṣàngó (thunder deity) and Ògún (iron deity), as the chief guardians of human morality, will deal ruthlessly with anyone who swears falsely in their names (Fadipẹ 1970:278-79).

Since Èṣù is reputed to be an instigator of disagreements and conflicts, most compounds have a shrine dedicated to this *òrìṣà*, where his sacred symbol must be "cooled" constantly with palm oil to minimize his mischief in the household (Fadipẹ 1970:285-86). For the same reason, almost every market has a special shrine dedicated to Èṣù, since the market is the center of economic and social activities in any town and a place of constant conflicts (Pemberton 1975:25). The divination priests (*babaláwo*) mediate between the community and Ọ̀rúnmìlà, the *òrìṣà* of wisdom, who is believed to have a complete knowledge and understanding of, and all solutions to, human problems.

Ethics and Aesthetics

13. Although the Yoruba distinguish good character (*ìwà rere*) from bad character (*ìwà burúkú*), *ìwà*, when used without any qualification, means "ideal character."

14. Ajibọla (1979:23). See also Abiọdun (1983:27).

The ultimate aim of the Yoruba moral code is to inculcate in the citizenry the elements of ideal character (*ìwà*).[13] Hence, the popular saying: *Ìwà l'òrìṣà—bí a bí a bá ti hù ú sí ni í fí í gbe ni si.* (Good character is like an *òrìṣà*—the more we cultivate it, the more it favors us.)[14] In other words, since good character generates admiration and love, it paves the way for success in life. It also adds to the beauty (*ẹwà*) of a person. To the Yoruba, beauty has two aspects: the outer (*ẹwà òde*) and the inner beauty (*ẹwà inú*). Outer beauty has to do with surface quality or outward appearance, and inner beauty, with intrinsic worth. In human beings, inner beauty is synonymous with virtue, the equivalent of high efficiency in utilitarian objects. As a result, inner beauty (*ẹwà inú*) or good character (*ìwà rere*) looms large in Yoruba aesthetics. We have earlier noted the popular saying: *Ìwà l'ẹwà* (Character is the essence of beauty). Although this saying is crucial to a full appreciation of Yoruba aesthetics, the relationship between *ìwà* (character) and *ẹwà* (beauty) has not been fully explained (Abiọdun 1990:66). According to a recent attempt:

> *Iwa* derives from the word for "existence" and by extension from the concept that "immortality is perfect existence." *Iwa* has no moral connotations; rather it

refers to the eternal constancy, the essential nature, of a thing or person—it is a specific expression of *ase*. Thus when art captures the essential nature of something, the work will be considered "beautiful." That is the significance of the saying *Iwa l'ewa*—"essential nature is beauty." (Drewal, Pemberton, Abiọdun 1989:39-42)

Lawuyi and Taiwo, on the other hand, hold the view that

> *Iwa* is Being *sans* determinations. All things that are have *iwa* (being). However, each thing is in accordance with its peculiar form of being. For each thing is a particular with its own identity and attributes which define it. Each *iwa* (being) has an essence which defines it and differentiates it from other beings. (1990: 70-71)

These two perspectives derive from Wande Abimbọla's analysis:

> The word *ìwà* is formed from the verbal root *wà* (to be, to exist) by the addition of the deverbative prefix *i*. The original meaning of *ìwà* can therefore be interpreted as the fact of being, living or existing. . . . It is my impression that the other meaning of *ìwà* (character, moral behavior) originates from an idiomatic usage of this original lexical meaning. If this is the case, *ìwà* (character) is therefore the essence of being. A man's *ìwà* is what can be used to characterize his life especially in ethical terms. (1975:393-94)

In view of Abimbọla's emphasis on the ethical or moral implications of *ìwà*, Lawuyi and Taiwo conclude:

> What is absent is an awareness that we need a middle term between *iwa* as an ontological category and *iwa* as a value epithet. We believe that an essentialist reading can yield this middle term. (1990:70)[15]

To begin with, the saying "Ìwà l'ẹwà" is an abbreviation of *"ìwà l'ẹwà ọmọ ènìyàn"* (Good character is the beauty of a person), and so *ìwà*, in this context, does not apply to works of art, though the latter may possess *ẹwà* (beauty). Second, the very fact that the Yoruba stress the importance of good character in their notion of human existence shows that the one is an aspect of the other. The indigenous term for the "essential nature" of a person is *èdá* or *àbùdá*, not *ìwà*. While the word *èdá* refers to a living being and its "essential nature," *àbùdá* (could this be the "middle term" sought by Lawuyi and Taiwo?) emphasizes the innate physical and behavioral aspects defin-

15. In their "essentialist reading," the authors liken *ìwà* to what Socrates called *erga*, the characteristic activity of a thing (Lawuyi and Taiwo 1990:70).

The Dialectics of Yoruba Existence 27

ing an individual or a category of living things. On the other hand, *ìwà*, at the ontological level, denotes "presence" or the fact of being which in itself is either beautiful or ugly, depending on inherited traits or *àbùdá*. As a result, the Yoruba put more premium on the ethical aspect of *ìwà* because it has the potential to refine a creature (*èdá*) and its "essential nature" (*àbùdá*). It is in the latter sense that *ìwà* may contribute to *ẹwà*, the physical and moral worthiness of a person and to *àṣùwàdà*, the wellness and togetherness of a community. Admittedly, though the phrase *ìwà l'ẹwà*, is often translated as "Character is beauty," it ultimately means "Character determines beauty." Thus, the term *ìwà* undoubtedly has moral implications in the phrase *ìwà l'ẹwà*, just as it does in a cognate adage such as *ìwà l'ẹ̀sìn* (Character is the essence of religion). The following poem, often recited by parents to educate their children, underlines this fact:

> Ọmọ t'ó dára tíkò n'íwà
> Ọmọ-langidi ni i
> Ìwà rere l'ẹ̀ṣọ́ ènìà
> B'óbìrín dára bí Ẹgbara
> [5] Bí kò n'íwà
> Ọmọ-langidi ni i
> B'ọ́kùnrin suwọ̀n, suwọ̀n
> Bí ẹja inú omi
> Bí kò n'íwà rere
> [10] Ọmọ-langidi ni i

16. A beautiful rat.

> If a child is beautiful but has no character,
> He is no more than a wooden doll.
> Good character is the beauty of a person.
> A woman can be as beautiful as *Ẹgbara*.[16]
> [5] If she has no character,
> She is no more than a wooden doll.
> A man may be very very handsome,
> Like a fish in the water.
> If he has no good character,
> [10] He is no more than a wooden doll.

(Fajana 1966:25 n.5)

In short, *ìwà* (good character, in the above poem) is the ethically positive behavior of a being, distinguishing its existence, lending it beauty, and making it admirable. To the Yoruba, *ìwà* is the very stuff that makes life a joy, because not only does it please the Supreme Being (Olódùmarè), also known as Olú Ìwà (Lord of Character and Existence), it also endears an individual to the hearts of others (Idowu 1962:154; Lawal 1974:240); Adeoye 1979:77-78), engendering companionability. An ideal person is regarded as *Ọmọlúwàbí* (Offspring of the Lord of Character). Even if an *Ọmọlúwàbí* is physically unattractive, his or her good character will compensate. Hence the popular saying: *Ẹni ayé nfẹ́ kì í l'ábùkù lára* (Admirers often overlook the physical shortcomings of a favorite). On the other hand, a person who is outwardly beautiful but inwardly ugly is called *awọbòwà* (skin hides character) or *ojú l'arí, ọ̀ṣọ́ ò dé nú* (superficial beauty). The physical beauty of such a person may be admired at first, but it will turn repulsive as soon as the inner ugliness surfaces (Lawal 1974:241).

To ensure success in love, business, negotiations, games, and in the visual and performing arts, some Yoruba make use of good-luck charms called *àwúre*. Yet, according to popular belief, no good-luck charm, however powerful, can help a bad person (*ènìyàn burúkú*) because of the prejudice others already have against him or her—whereas a good reputation enables an *Ọmọlúwàbí* to get along with most people. This phenomenon is expressed in the popular adage: *Ìwà l'ọba àwúre* (Character is the most powerful good-luck charm). Although it is sometimes genetic, *ìwà* is a consciously cultivated and continually developing moral quality, differentiating a human being (*ènìyàn*) from an animal (*ẹranko*).[17] As Wande Abimbọla puts it, "*Ìwà* (good character) is needed to achieve dignity, purpose, and meaning in life. Any person who lacks *ìwà* is. . . a failure." (1977c:238). Therefore, when the Yoruba say *ire àìkú parí ìwà* (Immortality is the ultimate existence. Abimbọla 1975b:393), they mean the quantitative and qualitative achievements that perpetuate the memory of an individual long after death. In the words of a popular Ifá divination song:

Tójú ìwà rẹ
Ìwà l'aṣọ, ìwà l'ẹwù
Nítorí bí a bá pé l'áyé pé pé pé
Bí a bá dàgbàdàgbà t'á ò le rìn mọ́
Ijó tí a bá kú, ìwà ní kù

17. It should be emphasized that *ìwà l'ẹwà* is an abbreviation of *ìwà l'ẹwà ọmọ ènìyàn* (character is the beauty of a person); thus the phrase does not apply to animals or art objects.

Take care of your character
Character is clothing, character is dress
For if we live long, long, long on earth,
If we become too old to walk,
The day we die, it is character that remains.

(Adewale 1988:113)

The Problems of Antisocial Elements

The magnitude of the threat which antisocial elements pose to corporate existence is highlighted by the following Ifá divination verse:

Olóoótọ́ tí mbẹ láyé ò pógún
Ṣìkàṣìkà ibẹ̀ wọn mọniwọn ẹgbẹ̀fà.
Ọjọ́ ẹsan ò lọ títí
Kò jẹ́ kọ́ràn dun ni

The honest people on Earth are not up to twenty,
But the wicked ones are no less than a hundred and twenty.
The days of reckoning are not too far away,
Which is why one is not aggrieved.

(Abimbọla 1971:81. My translation)

Unexpected misfortunes or illnesses that do not respond to the usual treatment are often attributed by the Yoruba to the evil machinations of known and unknown enemies who operate in the dark, using magic to frustrate the efforts of their victims, sometimes maiming or killing them. To make oneself immune against this evil, frequently attributed to jealousy, vendetta, or outright wickedness, most Yoruba in the past sought the assistance of medicine-men (oníṣègùn) and diviners (babaláwo), who diagnosed problems and offered remedies. In the imagination of the general public even today, the "super-powerful ones" called àjẹ́ are responsible for many of the misfortunes in the community. The Yoruba word àjẹ́, has no exact equivalent in the English language, its closest synonym being the "witch." But unlike the European conception of the witch as a personification of the devil, an àjẹ́ does not do evil all the time. If properly appeased, an àjẹ́ can contribute positively to the social and spiritual well-being of the society. However, an àjẹ́ can be extremely wicked when bent on evil, inflicting wasting diseases

or death on victims by sucking blood and eating up the heart, liver, and entrails, causing psychiatric disorders, impotence in men, barrenness in women, and crop failures in the farm. Because of these negative tendencies, the *àjẹ́* are thought to be in league with the *ajogun* (warriors against humanity), using them as tools to wreak maximum destruction on their victims (Abimbọla 1971:75). Although some men (called *oṣó*) may possess powers comparable to those of the *àjẹ́* (Hallen and Sọdipọ 1986a:103), the term *àjẹ́* commonly refers to the female.

The *Àjẹ́* in Yoruba Mythology

According to a story from the Ifá divination verse *Odù Ọ̀sá Meji*, it was the Supreme Being himself, Olódùmarè, who gave the power of *àjẹ́* to the first woman (Verger 1965:200-19). After the creation of the Earth, Olódùmarè sent three *òrìṣà*, including two males (Ọbàìṣà and Ògún) and one female (Òdù), to administer it. To Ọbàìṣà (another name for Ọbàtálá, the artist deity), Olódùmarè gave a special *àṣẹ*, with which to command and make things do his bidding, and to Ògún he gave the power of iron, hunting, and warfare. At first, the female *òrìṣà* was not given any special power. Dissatisfied, she returned to Olódùmarè to ask for her own power. Olódùmarè replied, "You will be their mother forever. . . . You will sustain the physical world" (ibid.:202). With these remarks, Olódùmarè gave her a closed calabash (an image of the world) containing a special *àṣẹ* symbolized by a bird (ibid.). When asked how she would use her power on Earth, Òdù replied that she would use it to fight those who insult or disrespect her, but would not hesitate to use it to help those who adore her. This partly explains the popular belief that the *àjẹ́* are capable of both good and evil.[18] Although Olódùmarè agreed with Òdù's intentions, he nevertheless warned her to be careful with the power. He also said it would be withdrawn if misused. On reaching the Earth, Òdù wielded the power as she wished, favoring those who humbled themselves before her and dealing ruthlessly with her opponents (ibid.:204-8).

A second story, from the Ifá divination verse *Odù Ìdì Méjì*, alleges that it was Èṣù who gave the *àjẹ́* their lethal power. But before handing it over, he referred them to Ọ̀rúnmìlà, who made these women promise to honor certain signs and materials to be used by human beings as protection against their power. Eventually, the *àjẹ́* agreed to a pact based on the following axioms: (1) that nobody eats a tortoise with the shell; (2) nobody eats a ram along with the horn; (3) nobody eats a porcupine along with the spines; and

18. Hence the *àjẹ́* are called *Awọn Alayé* (the superpowers of the physical world). At the esoteric level, the terms *ayé*, *ayé un*, and *ayé àkámarà* refer to the "powerful mothers" as well as the evil that lurks in the physical world. See also Idowu (1962:177-79) and Ibitokun (1981:55).

(4) nobody eats a fowl along with the feathers. After the *àjẹ́* had accepted these "limits" to their power, the pact was ratified in the presence of Olódùmarè (Prince 1961:795-96).[19]

19. Scholars interested in other myths about the *àjẹ́* should consult Pierre Verger's comprehensive and excellent article on the subject (1965:143-243).

In any case, the general public views the *àjẹ́* with tremendous awe and believes them responsible for most misfortunes and mysterious deaths in the community. The *àjẹ́* stereotype is an old woman who wields astounding telepathic powers. She is thought to conceal the source of her power in a closed calabash containing a bird. Hence her nickname *ẹlẹ́yẹ,* wielder of bird power. At night, her soul enters the bird and flies away to attend meetings or to suck the blood of unsuspecting victims, who then eventually die of some undiagnosable disease. Because of a mysterious object that lies in her stomach, the *àjẹ́* does not require any other medicine to accomplish her objectives. She needs only to dream or wish evil, either consciously or unconsciously, and evil will happen! She operates invisibly, hears the slightest whisper, and possesses a kind of "x-ray" eyes. Thus she can penetrate the tightest enclosure; can frustrate human hopes and ambitions; can prevent, arrest, or destroy pregnancy; and can negate virtually anything associated with success or goodness. She is capable of neutralizing any medicine just as it is being prepared. In fact most Yoruba medicine men would rather plead for their clients than risk a possible confrontation with an *àjẹ́* (see also Prince 1974:93).

Now and then, an *àjẹ́* may confess openly to killing some people and may even mention names. The public interprets such confessions as evidence of a loss of power due to her breaking a taboo.[20] Passers-by then seize the opportunity to stone her to death. Otherwise, no ordinary mortal would dare look an *àjẹ́* in the face, let alone point an accusing finger at her. Only the collective power of the ancestral spirits institutionalized in the Orò and Egúngún cults can subdue her, but this is no easy task (Morton-Williams 1960:38). Indeed, some Ifá divination verses portray the *àjẹ́* as being more powerful than many of the *òrìṣà* (Abimbọla 1975:292-322). Public use of the word *àjẹ́* is avoided as much as possible for fear of attracting their attention and offending them. They are euphemistically addressed as *àwọn ìyá wa* (our mothers), *àwọn ẹnití ó ni ayé* (the owners of the physical world), or simply as *àwọn ìyá* (the powerful mothers) in order to promote a mother-and-child relationship with them and thereby reduce the chances of incurring their wrath (see also Prince 1961:797).

20. Women have been lynched in many parts of Yorubaland for confessing publicly that they were *àjẹ́*. In numerous cases, they have confessed to killing twins unknowingly, whom, according to popular belief, the *àjẹ́* must not harm.

Since women, in their role as mothers, are idealized as loving, caring, and irrevocably committed to protecting the human lives they have helped to bring into the world, it is ironical that women are also accused of witch-

craft. According to Peter Morton-Williams, the identification of witchcraft with women may not be unrelated to the polygamous setting of a typical Yoruba compound and the attendant rivalries, jealousies, and mutual suspicions among co-wives and their children, on the one hand, and between co-wives and their in-laws, on the other. Under such an atmosphere, barrenness, delayed pregnancies, sudden abortions, and misfortunes often appear as acts of foul play engineered by co-wives or hostile in-laws. These suspicions sometimes develop into a permanent "Cold War" in which everybody takes protective or aggressive ritual measures (1956b:326-30). Although a situation like this may compel a woman to acquire occult powers to protect herself and her children, it does not fully account for the stereotyping of women as potential àjé.

It is easy to suspect that the men might have fabricated the àjé phenomenon to make a scapegoat of women for most of the misfortunes in a male-dominated society such as that of the Yoruba. Interestingly enough, almost all the women I interviewed on the subject affirmed that womanhood has a built-in spiritual power with positive and negative aspects. According to them, there are two types of àjé, the good one (àjé rere) and the bad one (àjé burúkú). A good àjé uses her power to attract all the good things of life—to heal, to restore men's and women's fertility, to ensure safe childbirth, good harvest, and so on. A bad àjé acts in the opposite direction. These female informants disagreed with the widely held notion that every woman is a potential àjé. According to them, a woman becomes an àjé only after being initiated into a "secret" association of women (ẹgbẹ́ ìmùlẹ̀) who cultivate the power for various purposes, including personal vengeance, or to dominate others, or to prosper in business, or to protect one's children from evil spells. As it is normal for a mother to transfer the power to her daughter, even young women can become àjé. Such women may not know that they are àjé until they begin to notice that their negative wishes always come true.

The tendency of most Yoruba to link the dual powers of àjé with the female sex may also derive in part from the enigma associated with motherhood. For concealed mystical power is suggested not only by the seductiveness of the female body but also by the mysteries of menstruation, pregnancy, and childbirth. The menstrual blood, for example, is thought to have dangerous emissions. Women may sometimes use their menstrual cloth to threaten the men who offend them. Flogging a man with this cloth, they believe, can render him impotent or unlucky for life.[21] Also, the imagery of ìkúnlẹ̀ abiyamọ (the kneeling pose of a mother) is often used by Yoruba

21. See also Prince (1961:798).

women not only to plead for mercy but also to curse or to invoke retributive justice on anyone who disrespects motherhood (Lawal 1970:39).

The women themselves are thus clearly aware of their alleged innate power and often use it in their dealings with the men. But certainly fabricated by the men is the notion that women are secretive, deceitful, and vindictive.[22] As a Yoruba elder once confided in me: "Only Olódùmarè can save a man from an unforgiving wife. Since women prepare our food, we [men] are at their mercy. Anything can happen: one's food passage can easily become one's exit to heaven."[23] No doubt, men are physically stronger than women. To the Yoruba, nature has compensated the women in other ways by giving them cunning (ọgbọ́n ayé)[24] with which to level up with the physical advantage of the men. The female develops faster and matures more quickly than a male of the same age, so that most men marry women several years younger to balance the maturity differential. Also, as Yoruba society is patrilineal, every father desires to have more sons than daughters. A powerful and influential woman who gives birth to only females becomes suspect and is, from the Yoruba perspective, deliberately conceiving daughters so that she can transfer her witchcraft to them. This belief is implied in the proverb: *Kàkà kó sàn lára àjẹ́ ó nbí ọmọ obìnrin jọ́ ẹyẹ wá nyí lu ẹyẹ.* (Instead of the *àjẹ́* changing for the better, she continues to have more daughters, producing more and more "birds.") (See also Delanọ 1966:83)

In short, the notion that certain women wield special powers capable of disrupting and undermining the male-dominated community has resulted in a diplomatic compromise. The men publicly acknowledge the mystical power of the female, but they use it, at the same time, to reinforce their dominance in the political arena (Lawal 1978:69).[25] Realizing that there is nothing they can do successfully without the women who, as mothers, are the pillars of the community and the source of its regeneration, the men allow some females to become privileged members of otherwise exclusively male associations such as Orò and Egúngún. It is interesting to note that Orò, the ancestral spirit used in executing women convicted of witchcraft, is the executive branch of the Ògbóni, one of the most powerful religious and political institutions in Yorubaland. Yet the Ògbóni derives its divine authority from Ilẹ̀, the earth goddess whose propitiation is crucial to peace, happiness, social stability, and human survival.

The concern of the Ògbóni with survival is evident in its name. Although it has several layers of meaning and commonly refers to a gentleman (ọ̀gbẹ́ni), the term Ògbóni means an elderly and matured person. It can be etymologized as *ogbó* = aged; *ẹni* = person. Even *Òṣùgbó,* its synonym

22. See Drewal (1977:547).

23. For a similar observation, see Morton-Williams (1956b:326). The possibility of death through food poisoning is implied in the popular saying: *ọ̀nà ọ̀fun, ọ̀nà ọ̀run* (the food-passage, the road to heaven).

24. *Ọgbọ́n ayé* also means deceit or slyness. The cunning of women is expressed in the saying: *Ọgbọ́n ayé, ti obìnrin ni.* (Worldly wisdom belongs to women.) See Verger (1965:218). In general, *ọgbọ́n* means wisdom, which may be positive (*ọgbọ́n rere*) or negative (*ọgbọ́n burúkú*). Even *Ifọgbọntáayéṣe* (using wisdom to remake/improve the world) sometimes entails diplomacy or cunning if deemed necessary for individual or corporate survival, or to ensure peaceful coexistence.

25. For a similar argument for the use of Gèlèdẹ́ in Kétu, see Babatunde (1988:45-64).

among the Ìjèbú and Ègbá, has the same connotation: *òsù* = tufts of hair on the head; *gbó* = old or gray. The paramountcy of the maternal principle in Ògbóni symbolism is apparent in the term *Àbíyè*, the cognomen of the Erelú (the titled female members of the society) which embodies the prayer "May the young live to old age." Also meaning "born to live," this cognomen not only identifies the female members of the Ògbóni as being good midwives but as having the spiritual powers to minimize the incidence of infant mortality (*Àbíkú*) in the community. This power links the female members directly with Ilè, the Earth goddess, otherwise known often as Ìyá (mother), underscoring yet again the principle of societal harmony, because all Ògbóni members regard themselves as *Omo Ìyá* (children of the same mother).

The most popular symbol of the Ògbóni is the *edan,* two brass figures, one male, the other female, joined by a chain (pl. 1). Often, the female figure of the *edan* holds her breasts or, occasionally, breastfeeds a baby—suggesting an entreaty to the Earth goddess to be as generous to humanity as a mother is to her child. The imagery recalls the popular Ògbóni slogan: *Omú ìyá dùn ú mu* (Mother's breast milk is sweet), usually recited by Ògbóni members when touching the ground or the *edan* with their tongue (Lawal 1995:46). Paradoxically, the same "generous mother," like Earth goddesses in other cultures (Lederer 1968; Matthews 1991; Campbell and Muses 1991), brings death to her children. Highly irascible and vindictive, she is the grandmatron of the *àjé.* Hence her cognomen, Ògérè:

Ilè, Ògérè, Af'okóyerí
Alápò ìkà.
Arí ikùn gbé ènìyàn mì

.

A je Òràngún má bì
Òdù yí gbiri gbiri má fó o. . . .

Earth, Ògérè, who combs her hair with a hoe,
The owner of a bag full of evil.
She has a stomach big enough to swallow human beings

.

She swallowed the Òràngún without vomiting
The big pot that rolls on and on without breaking. . . .

(Adeoye 1989:359. My translation)

This ambivalent attitude of the Yoruba toward the Earth goddess underscores the potentially explosive nature of male-female relations in a male-dominated society and the necessity for exercising tact and diplomacy. The Gèlèdé society elaborates upon the Ògbóni paradigm of Ọmọ Ìyá (children of the same mother) in an attempt to sensitize Mother Nature (Ìyá Nlá) to the problems of "her children," to remind women of their maternal responsibilities, and to encourage all members of a given community to love and interact with one another like children of the same mother. The Gèlèdé ceremony has two parts, a night concert (èfè) and a series of afternoon dances (ijó òsán) that runs for three to seven days. During the night concert, a special mask called Èfè (the humorist) prays to Ìyá Nlá to bless the community with peace, happiness, and all the good things of life such as good health, long life, wealth, plenty of children, and at the same time to prevent diseases, disasters, infant mortality, and premature deaths among adults. In addition, the Èfè mask entertains the public with satirical and didactic songs. The afternoon dances, featuring male and female masks, focus on the aesthetics of the costume and on choreographic excellence.

Ìpilèsè

The Roots of Gèlèdé

In order to understand the nature and significance of Gèlèdé, we must be aware of its roots.[1] Among the Yoruba, two types of oral tradition concern the source or origin (*ìpilèsè*) of any phenomenon: the mythical, which attributes the creation of all things to divine beings; and the historical, which attempts to locate origins in time and space. For example, the same *òrìsà,* Odùduwà, is portrayed in mythology as the creator of the earth and is also identified historically as the one who led a group of refugees from "Mecca" to Ilé-Ifè, the cradle of Yoruba culture. Myths are relatively easy to interpret in terms of their social or religious significance. Historical narratives, on the other hand, are difficult to reconstruct with any exactitude because the details become blurred and sometimes confused in the process of being transmitted orally from one generation to another. Nevertheless, as Jan Vansina (1985) has shown, oral tradition in all its aspects is a valuable record of the past if subjected to careful analysis and augmented with other evidence. This chapter examines all the oral testimonies that I have been able to gather on Gèlèdé with a view to tracing the cultural impulses that gave birth to it.

1. An earlier draft of this chapter appeared as "New Light on Gèlèdé" (Lawal 1978).

Mythical Traditions of Origin

The bulk of Yoruba myths of origin is to be found in the divination narratives known as *Odù Ifá.* In all, there are about 256 *Odù Ifá,* each of which contains a considerable number of poems or cantos, called *esè Ifá.* The latter cover a wide range of subjects ranging from cosmogonic stories and details of time-honored rituals to quasi-historical accounts and philosophical commentaries. In the course of his training, which may take between five and ten years or more, the diviner (*babaláwo*) commits to memory as many *esè Ifá* as possible, for they constitute the means by which he interprets the divination figures to the client.[2]

A typical *esè Ifá* is a narrative about an *òrìsà,* an animal, or a person with a problem, and the steps taken to resolve that problem. Often the oracle in the tale recommends specific sacrifices and ritual actions. Sometimes Òrúnmìlà himself, the *òrìsà* of divination, is the hero of the story. A compe-

2. For details of Ifá divination procedures, see Bascom (1969b; 1980); Abimbola (1976; 1977a; 1977b).

tent diviner should be able to choose an appropriate verse from the numerous chapters (*odù*) in the Ifá divination corpus that will mention a mythical character who once had a problem similar to that of a client. The diviner then advises the client to repeat the action of the mythical character, that is, to perform the same sacrifices and ritual actions in order to achieve a similar result (Idowu 1962:8-9; Adedeji 1970:71; Bascom 1980:5). Occasionally, the mythical character did not heed the advice of the oracle and met with disaster (Abimbọla 1976:51). This is a warning to the client. In any case, the *Odù Ifá* attempt to provide a mythical model for all phenomena, therein demonstrating the Yoruba belief in the existence of a cosmic process easily activated or influenced by a repetition of archetypal actions or examples. As scholars of myth and rituals have pointed out, one of the purposes of repetition is to establish extraterrestrial connections and a framework for order and predictability (Eliade 1954:10-22; Moore and Myerhoff 1977:17). This phenomenon is encapsulated in the popular Yoruba saying: *Ẹ ṣe é bí wọ́n ti nṣe é, kí ó ba à lè rí bí ó ti nrí.* (Follow precedents in order to obtain the same result.)

In response to my inquiry about the roots of Gẹ̀lẹ̀dẹ́, the late Àràbà of Lagos, Chief Fagbemi Ajanaku, narrated the following *ẹsẹ̀ Ifá* from *Odù Ìwòrì Méjì:* (An *ẹsẹ̀ Ifá* is normally rendered as a poem, which is followed by a narrative elaborating on the poem):

O nwò mí, mo nwò ọ́
Tàní ṣeun nínú ara wa
A dífá fún Yewajọbí
Tí nsọkún aláìríbí
[5] Tí nsọ̀gbọ̀gbọ̀ aláìrípọ̀n
Nwọ́n ní kó rúbọ
Nwọ́n ní kó rú ọ̀pọ̀lọpọ̀ ègbo
Nwọ́n ní ko rú ọ̀pọ̀lọpọ̀ àwo
Nwọ́n ní tó bá rúbọ tán
[10] Kí ó bẹ̀ wọ́n ni ọ̀pọ̀lọpọ̀ igi
Kí wọ́n gbẹ fun
Kí ó má a gbe jo
Kí ó fi aro sí ẹsẹ̀
Nwọ́n ní á ṣe abiyamọ
[15] Yewájọbí ṣe bẹ́ ẹ
Nígbàtí ó yá
O bẹ̀rẹ̀ síí bímọ

Orin: Yewájọbí d'Àwòyó
Ọlọ́mọ à gbé ṣeré
[20] O d'Àwòyó
Yewájọbí d'Àwòyó onígi à gbé ṣeré
O d'Àwòyó.

"You are looking at me, I am looking at you.
Who has something up his sleeves between the two of us?"
Thus declared the oracle to Yewájọbí,
Who was weeping for not being able to bear children
[5] And who was broken-hearted because she could not have a baby to
 carry on her back.
She was advised to offer sacrifices.
She was advised to sacrifice plenty of mashed corn
And plenty of crockery
After offering these sacrifices,
[10] She should commission from carvers
Plenty of wooden images.
She should dance with these wooden images
With metal anklets on her feet.
The oracle said she will become a nursing mother.
[15] Yewájọbí did as she was told.
Soon after,
She started bearing children.

Song: Yewájọbí has become Àwòyó,[3]
The mother of the child to dance with.
[20] She has become Àwòyó.
Yewájọbí has become Àwòyó, the owner of the wooden images to
 dance with.
She has become Àwòyó.

(Ajanaku, interview, 1971. My translation)

3. *Àwòyó* means "that which one looks at and is satisfied." But in this context, it means "a big body of water" and alludes to Yemọja, who is known as *Àwòyó omi ṣẹ̀ lódò; ṣigidi nínú egbódo* (*Àwòyó*, water from the sea; slices of boiled, dried yam).

The narrative accompanying this *ẹsẹ̀ Ifá* explains that, once upon a time, Yewájọbí (another name for Yemọja), "The Mother of all the *òrìṣà* and all living things," could not have a child after marrying Olúwẹri, a native of Kétu.[4] As she had had many children before marrying Olúwẹri, she became worried and consulted the Ifá oracle. The oracle advised her to offer as sacrifices plenty of mashed corn (*ègbo*) and clay dishes (*àwo*), and to dance

4. Olúwẹri is a popular water deity in Yoruba myths and folktales who is associated with rainfall.

about with wooden images on her head and metal anklets (*aro*) on her feet. After performing this ritual, she became fertile again. Her first child was a boy who was later nicknamed "Èfè" (the humorist) because he was a jocular person. On growing up, he took after the stature of his mother, huge and handsome. The Èfè mask emphasizes songs and jests, because Èfè was very famous for his jokes. Yewájọbí's second child was a girl, later nicknamed "Gèlèdé" because she was obese. Like her mother, she loved dancing. For this reason, most female Gèlèdé masks look bulky and dance a lot. When Èfè and Gèlèdé were young, Yewájọbí put metal anklets (*aro*) on their feet; hence, all Gèlèdé masks wear the metal anklets today. It was Ògún, the *òrìṣà* of iron, who fashioned the anklets for Yewájọbí.

After getting married to different partners, both Èfè and Gèlèdé could not have children for a long time. The Ifá oracle later advised them to offer the same sacrifices as had their mother, and to dance about with wooden images on their heads and metal anklets on their feet. No sooner did Èfè and Gèlèdé perform these rituals than they started having children. Because of their effectiveness, these rites gradually developed into the Gèlèdé masked dance, having been perpetuated by the descendants of Èfè and Gèlèdé. The dance is one of the most effective means of placating the "powerful mothers," because Yewájọbí is their matron, and because she loved dancing (Ajanaku, interview, 1971).

Another interesting myth on the origin of Gèlèdé is from *Odù Ọ̀sá Méjì*, which runs thus:

Pèlé ní nṣ'awo wọn l'óde Ẹgbá.
Pèlé ní nṣ'awo wọn l'óde Ìjèṣà.
A dá f'Ọ̀rúnmìlà, ó nṣ'awo re Ìlú Ẹléiyẹ
Nwọ́n ní kó rú àwòrán, ọ̀já àti ìkù.
[5] Ó gbọ́, ó ru u.
Ó dé Ìlú Ẹléiyẹ, Ó yè bọ̀.
Ó wá nsùnyèrè wípé:
Mo bá'kú mulè, ngò kú mọ́.
Ikú, ikú gbọingbọin.
[10] Mo bá'rùn mulè, ngò kú mọ́.
Ikú, ikú gbọingbọin.[5]

Caution is the secret of the Ẹgbá.[6]
Caution is the secret of the Ìjèṣà.[7]

5. See also Drewal and Drewal (1983:17).

6. A Yoruba subgroup.

7. Another Yoruba subgroup.

Thus declared the Ifá oracle to Ọ̀rúnmìlà, who was going to visit the
 haven of the-wielders-of-bird-power.[8]

8. The *àjẹ́*.

He was advised to sacrifice a wooden image, a baby sash, and
 metal anklets.

[5] He performed the sacrifice.

He visited the haven of the-wielders-of-bird-power and returned safely.

Then he rejoiced, singing:

I have entered into a covenant with Death, and never will I die.

Death, no more.

[10] I have entered into a covenant with Sickness, and never will I die.

Death, no more.

 (Beyioku 1946. My translation)

This divination verse tells of a journey which Ọ̀rúnmìlà, the divination
deity, made to the haven of the *àjẹ́*. Before embarking on the journey, he
consulted his oracle, who advised him to disguise himself with a wooden
mask and to put on a baby sash and metal anklets. Ọrúnmìlà heeded the
advice, and the "powerful mothers" did not harm him. Thus began the Gèlèdé
masking tradition as a means of seeking protection from the *àjẹ́*.

The following two testimonies from Ìbarà, Abẹ́òkúta, are significant in
that they complement the Ifá divination verses. The first is from the late
Olúbarà (king) of Ìbarà, Ọba Samuel Adeṣina. According to him, Gèlèdé
started as a form of thanksgiving to Yemọja, a water goddess and the mother
of all *òrìṣà*, well known for giving children. A diviner had advised a barren
woman looking for a child to offer as sacrifice plenty of foodstuff (*onjẹ*), a
female headwrap (*gèlè*), baby sash (*òjá*), and woodcarvings (*ère*), all to be
deposited on the bank of the Ògùn River, the domain of Yemọja in Abẹ́òkúta.
After the sacrifice, the chief priestess of Yemọja petitioned the goddess on
the woman's behalf. Not long after, the woman became pregnant. Over-
whelmed with joy, she returned to the bank of the Ògùn River to thank
Yemọja. She saw some of the items she had earlier deposited on the bank of
the river. Tying the baby sash (*òjá*) round her waist and turning the headwrap
(*gèlè*) into a load pad (*òṣùká*), she put one of the woodcarvings on her head.
The women who accompanied her did the same, and they all danced back
to the town. This ritual dance was later formalized, and it evolved into what
we know today as Gèlèdé (Adeṣina 1971). It is noteworthy that the theme
of barrenness also recurs in legends on the origin of Gèlèdé collected by
Henry and Margaret Drewal in northern and central Ẹgbádò areas. These

legends recall an ancestress who could not have children at first, but who later became exceptionally fertile after performing rituals recommended by Ọ̀rúnmìlà, the divination deity (1983:214-18).

The second testimony from Ìbarà on the roots of Gẹ̀lẹ̀dẹ́ was collected from Màmá Moromisalu, the high priestess of Yemọja (Ìyá Yemọja), during a 1971 interview. It is given below verbatim, followed by my translation from the Yoruba:

Ère tí a nrù jáde nínú ọdún Yemọja ni Gẹ̀lẹ̀dẹ́

Ará'gbó ni Gẹ̀lẹ̀dẹ́ jẹ fun Yemọja

Gẹ̀lẹ̀dẹ́, ẹgbẹ́ ọmọ Yemọja ni

Ẹni má a bọ Yemọja, a á bọ Ará'gbó

.

[5] Yemọja fun rarẹ̀, Ọ̀kẹ̀rẹ̀ ló fẹ́.

Ó ti kọ́ fẹ́ Ògún

Nígbàtí ó fi Ògún sílẹ̀, ó fẹ́ Òrìṣà Oko

Nígbàtí Òrìṣà Oko kò lè ba gba eèwọ̀ iṣu, o fi í sílẹ̀

Ó sì ti fẹ́ Ọbàtálá rí

[10] Ọbàtálá ló bí Ṣàngó, Yemọja ló bi fun u.

Ẹní fẹ́ bọ Yemọja kó gbà

Tó bá fẹ́ bọ ọ́ l'ódò, a á mú ẹyẹlé dání

Àti obì àti orógbó; a á kó wọn sínú igbá

À wá gbe f'ọlọ́kọ̀, kí wọ́n gbe lọ s'ódò

[15] Ẹní má a bọ Ará'gbó, a á se àsáró àti ègbo

Àti oúnjẹ bẹ́ẹ̀ bẹ́ẹ̀ lọ

Ère tí a nrù jáde nínú ọdún Yemọja ni Gẹ̀lẹ̀dẹ́

The woodcarvings carried by the women during the Yemọja festival
 are the real Gẹ̀lẹ̀dẹ́.

Gẹ̀lẹ̀dẹ́ are spirit children (*Ará'gbó*) to Yemọja.

Gẹ̀lẹ̀dẹ́ is the association of Yemọja's children.

Anyone who wants to worship Yemọja, must also worship *Ará'gbó*

.

[5] Yemọja herself was once married to Ọ̀kẹ̀rẹ̀.[9]

She had earlier been married to Ògún.[10]

When she left Ògún, she married Òrìṣà-Oko (agriculture deity).

Because Òrìṣà-Oko could not do without eating yams, she left him.[11]

Also, she was once married to Ọbàtálá.

9. Ọ̀kẹ̀rẹ̀ is the official title of the king of Ṣakí in northern Yorubaland. Several legends link him with Yemọja. In one (Bascom 1969a:88; 1980:488-93), Yemọja married Ọ̀kẹ̀rẹ̀ after divorcing Ọbàtálá. She later divorced Ọ̀kẹ̀rẹ̀ because he made insulting remarks about her big breasts.

10. Although Yemọja is the mother of all the gods, she allegedly had incestuous relationships with some of her sons.

11. Yemọja is the grandmatron of the *àjẹ́*, whereas the popular image of Òrìṣà Oko is that of an antiwitchcraft crusader (Johnson 1921:37-38). For a survey of myths relating to Yemọja, see Verger (1957:291-95).

[10] Ọbàtálá sired Ṣàngó (thunder deity); Yemọja was the mother.
Anyone who wants Yemọja to accept his or her request
And wants to offer sacrifices to her by the river, must hold a pigeon,
Kola nuts, and bitter kola, all of which should be put inside a calabash
Which would be given to a boatman, who would deposit it in the river.

[15] Anyone who wants to worship *Ará'gbó* (spirit children)
must cook yam porridge and mashed corn
And similar dishes.
The woodcarvings that we carry during the Yemọja festival are the real Gèlèdé.

This account is significant because during the Yemọja festival (which, in Ìbarà, immediately precedes that of Gèlèdé) female devotees of the goddess carry woodcarvings on their heads in a dance procession round the town (fig. 3.1).[12] As part of the festival, nursing mothers take their babies to Odò Onídá, a local stream, where Yemọja priestesses bathe them (fig. 3.2) to prevent sickness and premature death (*Àbíkú*).

According to a senior member of the Gèlèdé society at Igbóbi-Ṣábèè, on the outskirts of Lagos, Gèlèdé originated in ancient Kétu from Ìyá Nlá's practice of dancing about with a woodcarving balanced on her head. Occasionally, she covered her face with a carved calabash called *kàràgbá*. Her public dances attracted many women and small children. When Ìyá Nlá died, it became the lot of her husband, Bàbá Abọrè, to continue the dance in her memory. Strangely enough, soon after Bàbá Abọrè took over the dance, the fortunes of the community changed drastically for the better: barren women became pregnant; the farms yielded abundant harvest; hunters and fishermen had more catch; the sick regained their health; and there was a noticeable reduction in premature deaths (*Àbíkú*). The elders of Kétu dedicated a shrine to Ìyá Nlá and implored Bàbá Abọrè to hold the dance annually. After Bàbá Abọrè's death, his image was placed beside that of Ìyá Nlá on the same altar. Since then, it has become a tradition to have male and female masks to represent the couple during the annual Gèlèdé ceremony to honor Ìyá Nlá (Ayọrinde, interview, 1972).

At Ìlaró, Ìmèkọ, Ajílété, Ìbàtẹfọn, Igbó-Ọrà, Ìmáàlà, Ìgbógílà, Ìpókíá, Kétu, and other towns, senior male and female officials of the Gèlèdé society allege that the Gèlèdé ceremony has evolved from ancient fertility dances staged by women in honor of *òrìṣà ọlómọwéwé*, the generic name for patron deities of small children. During ceremonies in honor of any of these deities (which include *Ẹgbé, Ẹgbérun, Ará'gbó, Ẹgbé Ọ̀gbà, Koórì,*

12. This corrects the impression given in Lawal (1978:pl.1) that the procession takes place during the Gèlèdé festival.

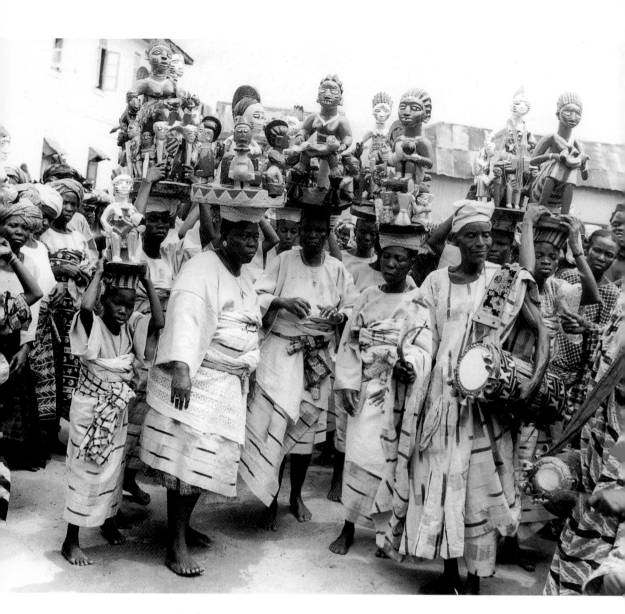

3.1 Devotees of Yemǫja (with baby sashes tied
to the waist) dancing with woodcarvings during
the Yemǫja festival in Ìbarà, Abéòkúta (1958).
When dancing with the woodcarvings, the
devotees must not talk or sing. In Ìbarà, the
Yemǫja festival ushers in that of Gèlèdé.

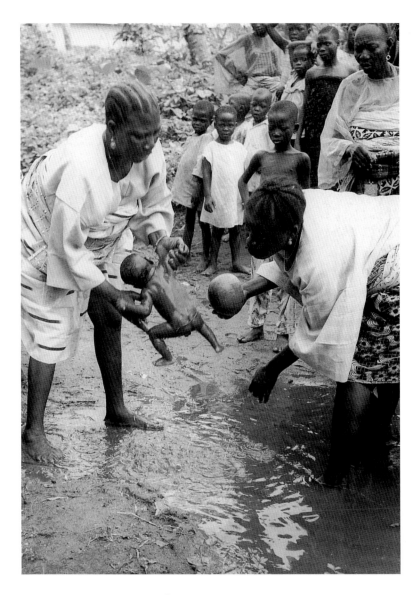

3.2 During the Yemọja festival in Ìbarà,
Abẹ́òkúta (1958), devotees use water from the
Onídá stream, sacred to Yemọja, to give babies
a ritual bath that will protect them against infant
mortality *(Àbíkú)*.

Kónkóto, Ìbejì, Dàda, and *Elérìkò*), mothers, spinsters, and youths, carrying woodcarvings and ritual pots on their heads and adorning their bodies with beads, dance round the town, singing and praying for female fertility, male virility, safe delivery of children, long life, and prosperity.[13] According to Aṣimi Ọlatunji-Onígèlẹ̀dẹ́, a retired Èfè masker from Ìmẹ̀kọ, many old women liked these public celebrations because of their association with motherhood. Soon it transpired that the "powerful mothers" in the community would like to have a similar ceremony staged in their honor. It was at this point that the community elders took over an ordinary "fertility play" and elaborated on it. At first, the celebrants wore ordinary dresses and no face mask. But as this play spread from town to town, new ideas crept into it, including the use of improvised calabashes as face masks (*kàràgbá*). The earliest costumes consisted of banana leaves, and the anklets were shells (*òkòtó*) collected from the sea. It was the jingling of these seashells during the dance that gave the Gèlẹ̀dẹ́ mask the epithet: *Olókun dé é é é é é o; Àjàró ò ò ò Òkòtó!* (Here comes the sea goddess, the roaring eddy of seashells!) Over the centuries, and as human civilization advanced, sophisticated wooden headdresses, colorful fabrics, and metal anklets replaced the calabash masks, banana-leaf costumes, and seashells, respectively. The dance steps and musical accompaniment became more and more intricate as one community tried to outshine another (Ọlatunji-Onígèlẹ̀dẹ́ 1971).

Historical Traditions of Origin

All the historical traditions collected so far point to three possible places of origin for Gèlẹ̀dẹ́. These are Old Ọ̀yọ́, Kétu, and Ìlóbí.

According to David Adeniji of Ìwó, the word Gèlẹ̀dẹ́ is a distortion of Gbàràdá (the one who stole the show). Gbàràdá was the nickname of a Nupe man who won the prize as the best entertainer at a theatrical contest sponsored in the capital city of Old Ọ̀yọ́ by Aláàfin Àjàgbó, who reigned probably in the mid-seventeenth century (Law 1977:58-59; Smith 1988:29-41). Aláàfin Àjàgbó had asked all the masking societies in the Old Ọ̀yọ́ Empire to come to the capital to entertain him. For the occasion, Gbàràdá produced two spectacular masks, a male and a female, which sang, danced, cracked jokes, and performed all kinds of wonders during the competition.[14] In the end, Gbàràdá stole the show. Hence the saying: *Ojú tí ó wo Gbàràdá ti d'ópin ìran.* (The eyes that had seen Gbàràdá had seen the ultimate spectacle.) Over the years, the word *Gbàràdá* was distorted into *Gbèrèdẹ́,* then *Gbèlẹ̀dẹ́,* and finally *Gèlẹ̀dẹ́.* Gbàràdá was a close friend of Ọ̀jó Àṣo, one of the grand-

13. For more information on Koórì, see Abimbọla 1979-80: 6-23).

14. According to David Adeniji (interview, 1972), both the wooden headdress and drums used by Gbàràdá were carved from *pàndidi* wood.

sons of Aláàfin Àjàgbó. When Òjó Àṣo decided to go and settle among the Ẹ̀gbádò, he took Gbàràdá along with him, thus introducing Gẹ̀lẹ̀dẹ́ tradition to southwestern Yorubaland.[15]

Another legend, collected by Emmanuel Babatunde in Ìjio, traces the origin of Gẹ̀lẹ̀dẹ́ to a hunter named Òkèhìnkòdòmùdomù, who was a native of Idahin (pronounced Idi-ayin) near Kétu. According to the story, in the olden days the people of Kétu used to have an annual festival. The best performers in the community would display their talents before the king and "the powers that be." The hunter Òkèhìnkòdòmùdomù, while hunting in the forest one day, came across a group of gorillas covering their faces with tree branches and dancing to the claps of their mates. Òkèhìnkòdòmùdomù enjoyed the spectacle so much that, during the next annual festival, he organized a group of masqueraders to imitate the gorilla dance. Everybody liked it, and that was how the Gẹ̀lẹ̀dẹ́ dance was born (Babatunde 1988:53).[16]

The town of Kétu is widely acknowledged as the cradle of Gẹ̀lẹ̀dẹ́ for three main reasons: first, it is one of the oldest Yoruba kingdoms; second, it is the biggest town in the Kétu-Ẹ̀gbádò division and has one of the most senior Yoruba kings; and third, its Gẹ̀lẹ̀dẹ́ ceremony is the most elaborate. Yet most of the people I interviewed in Kétu allege that the Gẹ̀lẹ̀dẹ́ tradition originated in Ìlóbí, an offshoot of Kétu.[17] Robert Thompson (1971:ch.14/2), the Drewals (1983:225-28), and Ibitokun (1993:32n.4) have also collected oral evidence in Kétu tracing the origin of Gẹ̀lẹ̀dẹ́ to Ìlóbí. According to a story collected by Father Thomas Moulero of Kétu, when Alákétu (king) Akibiohu died sometime in the eighteenth century, his twin sons Ẹdun and Akan vied for the throne. When Akan realized that Ẹdun was the more popular candidate, he decided to kill him. Ẹdun got wind of the plot and fled to Ìlóbí, where he devised a ruse to ward off his assailants. He gathered many snail shells, strung them together, and tied them to posts on both sides of the path leading to his hiding place. In the middle of the two posts he placed a tree trunk topped with a carved human head, with dry banana leaves wrapped round the body. On top of the carved head, he placed a calabash carved in the form of a mask. Akan and his men arrived in Ìlóbí on the night of the fourth day, looking for Ẹdun. When the latter knew that they were around, he pulled the strings of the snail shells, sending a weird noise through the still of the night. Frightened, Akan and his men fled, vowing never to come back to Ìlóbí. Ẹdun later returned to Kétu to ascend the throne. Not long afterward, he taught the people of Kétu the "secrets" of the strange noise which eventually developed into Gẹ̀lẹ̀dẹ́. Father Moulero identifies the Ẹdun of the story with Alákétu Adebiya, of the Mẹfu royal

15. David Adeniji gave the same information to Doig Simmonds (1969-70).

16. According to a story collected by Peggy Harper (1970:74), in the late 1960s, Gẹ̀lẹ̀dẹ́ was introduced to Ìjio from the Republic of Benin (presumably from Kétu) by one Jagun Aríbikófá.

17. For a history of Kétu, see Smith (1988:56-58) and Parrinder (1967).

line, who reigned about 1816-1853. Moulero suggests this period for the origin of Gèlèdé (Drewal and Drewal 1983:227). On the basis of Father Moulero's interpretation and data collected from Idahin, Ọfia, Ìgán-Òkòtó, Jògá, and other towns to the effect that Gèlèdé was introduced there in the early nineteenth century, Henry and Margaret Drewal have attributed the beginning of Gèlèdé to the period just before the reign of Alákétu Adebiya or Ẹdun, that is, between 1795 and 1816 (ibid.).[18]

18. The late Father Moulero of Kétu first discussed the story with me in Ilé-Ifè in January 1974, while attending the conference on Yoruba Oral Tradition at the University of Ifè, Nigeria. However, Henry and Margaret Drewal were privileged to see and take notes from Father Moulero's unpublished manuscript on Gèlèdé. Thus I have relied on the details given in their book (1983:226-31).

Although the elders of Ìlóbí confirmed the general outline of Father Moulero's account when I was there in 1971, they gave a different detail. According to one of the elders, a Kétu prince founded the present ruling dynasty in Ìlóbí following a succession dispute between two twin brothers in Kétu. With the support of his friends and some well-placed persons, one of the twins usurped the throne. He plotted to kill the other twin, who fled with his supporters and later founded the kingdom of Ìlóbí. Before leaving Kétu, however, the fleeing prince took certain sacred symbols of Kétu kingship with him, thereby preventing his brother from performing all the necessary installation rites. After settling in Ìlóbí, the exiled prince decided to seek vengeance on his brother. He commissioned a special mask and despatched it to Kétu. The jingling of the mask's metal anklets in the still of the night scared the people of Kétu, who mistook the jingling for the sound of demons (iwin). The Kétu people consulted a diviner, who advised them to reconcile with their Ìlóbí brothers. After the reconciliation, the exiled prince returned the sacred symbols to Kétu, but he stayed behind in Ìlóbí as the king (ọba). Later, the people of Ìlóbí taught their Kétu brothers the secrets of "the mask that made the strange" noise. This mask later became known as Gèlèdé. Another account claims that the exiled prince eventually returned to Kétu from Ìlóbí to ascend the throne (Ibitokun 1993:31).

A related story collected by Kọla Fọlayan in the 1960s states that Kétu was originally founded by two princes from Ilé-Ifè. For some time, succession to the Kétu throne rotated between two ruling houses. But after about five reigns, a succession dispute occurred. The two most senior Yoruba kings, the Ọòni of Ifè and the Aláàfin of Ọyọ́, intervened and advised the loser, identified as Adekambi, to leave Kétu. He complied and went on to found the kingdom of Ìlóbí. Later, Adekambi sent a message to the Ọòni of Ifè, who, in reply, presented him with the igbá Ògún (the sacred calabash of the iron deity), which helped the people of Ìlóbí to become experts in ironworking (Fọlayan 1975:92). Present-day Ìlóbí is about two hundred kilometers from Kétu. The first site was destroyed during the Yoruba civil wars of the nineteenth century (ibid.:110 n.6; Aṣiwaju 1976:18).

Critical Analysis

In analyzing the foregoing accounts for what light they might shed on the possible origin and significance of Gẹ̀lẹ̀dẹ́, let us begin with the historical tradition. Although the Ọ̀yọ́ story traces the origin of Gẹ̀lẹ̀dẹ́ to Old Ọ̀yọ́, there is no other concrete evidence to corroborate it. To begin with, present-day Ọ̀yọ́ (founded by refugees from Old Ọ̀yọ́ when the latter was destroyed by the Fulani around 1837) has no Gẹ̀lẹ̀dẹ́ society. Notwithstanding the fact that many Ẹ̀gbádò and Ìfọ̀yìn groups, as well as towns like Igbó-Ọrà, Idọ̀fin, Ìjió, Òkèehò, Ìgànná, and Èrúwà have strong historical ties with Old Ọ̀yọ́, they trace the origin of their Gẹ̀lẹ̀dẹ́ traditions to Kétu. I have cited the Gbàràdá story here only for the record, and to encourage other scholars who have corroborative materials to publish them. Similarly, the legend tracing the origin of Gẹ̀lẹ̀dẹ́ to a gorilla dance is being held in abeyance until it can be substantiated with more evidence. On the other hand, the fact that the historical traditions from Kétu and Ìlóbí agree on several points, differing only in details, tips the scale in favor of ancient Ìlóbí as the birth place of Gẹ̀lẹ̀dẹ́.

Why, then, do some informants continue to regard Kétu, rather than Ìlóbí, as the cradle of Gẹ̀lẹ̀dẹ́? There are three main reasons: first, the originator of Gẹ̀lẹ̀dẹ́ in ancient Ìlóbí and the founder of its ruling dynasty was a Kétu prince, so that, to most people, ancient Ìlóbí was an extension of Kétu (see also Ibitokun 1993:34); second, soon after adopting Gẹ̀lẹ̀dẹ́ from Ìlóbí, Kétu overshadowed the latter with its elaborate annual festivals that eventually became the model for other towns;[19] and third, ancient Ìlóbí was destroyed during the Yoruba civil wars of the nineteenth century. Present-day Ìlóbí, founded by the refugees, is several miles from Kétu, and many informants are reluctant to accept as the cradle of Gẹ̀lẹ̀dẹ́ this relatively new settlement, preferring to give the credit to Kétu. Moreover, Gẹ̀lẹ̀dẹ́ has become obsolete in present-day Ìlóbí because most of the inhabitants have converted to Islam and Christianity.

19. See also Drewal and Drewal (1983:225-26).

Gẹ̀lẹ̀dẹ́ and Patron Deities of Small Children

That Gẹ̀lẹ̀dẹ́ came into being as a result of a succession dispute between twin brothers is sharply contradicted not only by the fact that this dispute hardly features in the annual Gẹ̀lẹ̀dẹ́ festival, which focuses on the placation of Ìyá Nlá and the *àjẹ́*, but also by the widespread, though vague, testimonies that Gẹ̀lẹ̀dẹ́ evolved from dances formerly performed in honor of the patron deities of small children. Indeed, Henry and Margaret Drewal

also collected data linking Gèlèdé with these deities. The following account given to them by L. O. Adebọwale, a former king of Ìlóbí, is revealing:

> Gèlèdé cult worship was òrìṣà ọlọ́mọwẹ́wẹ́, [god-of-ones-with-small-children] . . . which the Ilobis of ages instituted. . . Gèlèdé dancing spread to Ofia. . . and then to Ketu, homestead of the Ilobis. Today, whenever an Èfè/Gèlèdé has to be made anywhere in Yorubaland, Ilobi must be mentioned in splitting the kolanut. (Drewal and Drewal 1983:229)

Another Ìlóbí legend traces the origin of the mask to a couple who had lost many children as a result of being afflicted by the spirits of Àbíkú. On consulting the oracle, the husband was advised to wear metal anklets and dance with a mask. After this ritual, the couple bore many healthy children (Ibitokun 1993:32).

These testimonies from Ìlóbí relating the mask to òrìṣà ọlọ́mọwẹ́wẹ̀ and Àbíkú suggest that the Gèlèdé tradition is much older than the succession dispute between the twin brothers, although the dispute may have influenced the evolution of the Gèlèdé costume or the details of its performance. No concrete evidence is now available, so one must turn for clues to the mythical traditions which, while difficult to ascertain in time and space, nevertheless provide us with rich data for reconstructing ritual origins and for relating form to function. It is significant that all the myths corroborate on one point: either that a female originated the ritual of Gèlèdé, or that the male who did so assumed a female aspect. For example, the mask worn by Ọ̀rúnmìlà, the divination deity, during his visit to the haven of the "powerful mothers" (as mentioned in the divination verse Odù Ọ̀sá Méjì) included a baby sash (ọ̀já). His wooden headdress and metal anklets have parallels in the dance paraphernalia of Yewajọbi, as mentioned in the divination verse Odù Ìwòrì Méjì. The testimony of Ìyá Yemọja of Ìbarà is relevant at this juncture. According to her, the real Gèlèdé are the carved images carried by the women (fig. 3.1) during the Yemọja festival at Ìbarà (Abẹ́òkúta), and also that Gèlèdé is Ará'gbó (spirit child) to Yemọja.

First of all, the ritual performed by Yewájọbi/Yemọja (as mentioned in the divination verse, Odù Ìwòrì Méjì) is common in Yorubaland. A housewife eager to have a child may consult a diviner, who sometimes advises her to dance with or simply carry a wooden doll (ọmọlangidi) on her back to attract a child, in much the same way as Asante women use the aku'aba doll in Ghana.[20] The housewife usually carries the doll to the market because of the belief that the souls of unborn children come there to choose mothers, and she may be lucky enough to attract one of them. These souls,

20. Sometimes a woman may be asked to dance about with a buffalo horn that has been smeared with camwood ointment. See Oyeṣakin (1982:16).

according to popular belief, love music and the dance—a belief influenced by the fact that some women who have given birth to many children happen to be good dancers.

In a non-Gèlèdé context, the term *Ará'gbó* (spirit children/forest beings) or *Elégbé* (one with spirit companions) refers to a child suspected to have unborn spirit partners to whom it will return after a short sojourn with a particular parent. These spirit partners, also called *Egbé* or *Egbérun,* dwell in the water or the woods. The Yoruba believe that a woman who has lost several successive children is being troubled by *Egbérun* or *Ará'gbó,* and that the spirit or soul (*èmí*) of the same child has been dying and returning to the same woman. The most popular name for this category of spirit children is *Àbíkú* (born to die). Any of the following symptoms could be used to identify an *Àbíkú:* frequent fainting, absent mindedness, soliloquizing or sleep-talking, somnambulating, and abnormal behavior (Beier 1954:328-31). A child identified as an *Àbíkú,* receives preferential treatment to encourage it to stay with the parents. Special charms and amulets are used to break the link between the child and its unborn spirit companions. The most popular way of preventing the *Àbíkú* child from returning to these companions is to put an iron anklet on one or both legs, to function as a sort of shackle, anchoring the child to the physical world (Morton-Williams 1960a: pl. 1). The jingling of the anklet, it is believed, will frighten off the unborn spirit companions, preventing them from coming near enough to converse with or harm the child.

It is significant that the iron anklet of the *Àbíkú* child is a miniature of that worn by the Gèlèdé masker (fig. 3.7). As noted, in the divination verse *Odù Ìwòrì Méjì,* Yewajobi reportedly put metal anklets on the feet of the first two children she bore after her dancing ritual, thus identifying these children, Èfè and Gèlèdé, as spirit children. In fact, metal anklets (*aro, ìkù,* or *ṣaworo*) similar in size to those of Gèlèdé constitute the principal symbol in many shrines dedicated to *Àbíkú, Ará'gbó,* and *Ègbérun* (fig. 3.3). These anklets also abound on the altars of river goddesses such as Òṣun, Òbà, and Yewa—all associated with Yemoja and linked with *òrìṣà olómowéwé.* When I asked a Gèlèdé masker at Ìjió about the significance of the metal anklets he wore, his reply was that "the Gèlèdé mask wears them in imitation of children," but the jingling of the anklets, according to him, is the "soul" of the Gèlèdé dance (Adeleke, interview, 1977).

Spirit children are sometimes called *elére* (owner of the wooden image or statue) (Leighton 1963:80), apparently because of the popular belief that their prenatal souls (and those of their invisible companions) dwell in the

3.3 Shrine dedicated to spirit children (*Ará'gbó* or *Àbíkú*) in Kòso Quarter, Òyọ́ (1972). Note the iron anklets, similar to those worn by Gèlèdé masks (fig. 3.7).

woods. The term *elére*, however, has different pronunciations and meanings in different parts of Yorubaland due to the tonal and dialectal variations in the Yoruba language. At Igbóbì-Ṣábẹ̀ẹ́, one informant said that spirit children are called *elére* partly because they like wooden dolls (*ọmọlangidi*) and partly because it is customary to use statuettes (*ère*) to honor and localize the souls of departed twins (fig. 8.2), the most esteemed among this category of children (Ọlayiwọla, interview, 1972). In his *Dictionary of Modern Yoruba Language*, Abraham (1958:162) translates *elére* or *eléère* as "one who wears a mask," which accords with the image of a spirit child as a soul masquerading in a borrowed human body, and also with the Yoruba idea that twins or triplets have sacred ties with the ancestral Egúngún mask (Abimbọla 1977a:2,3; Babayẹmi 1980:4). Most of the Ọ̀yọ-speaking Yoruba use the term *eléréè* (instead of *elére*), meaning "one who is fond of beans." This is because the black-eye bean *(erèé)* is held to be the favorite food of twins. A third pronunciation for the word is *elérè* (one getting profit or advantage), which is said to allude to the special treatment given to *Àbíkú* (see also Abraham 1958:162). Despite variations in the pronunciation and interpretation of the term, one element is constant: that spirit children enjoy many privileges, including the use of images and masks to honor them.

It is pertinent at this juncture to note that, in Yoruba thought, all the *òrìṣà* are capable of giving children to their devotees. Children born under normal circumstances often lead a normal life. Those born under abnormal circumstances (i.e., in multiples, or through special rituals such as the one performed by Yewajọbí, or after a frantic appeal to, or the direct intercession of, an *òrìṣà*) sometimes turn out to be spirit children.[21] Associating multiple birth with a bad omen, the Yoruba formerly killed twins and triplets and sent the mother into exile. Sometimes these children were not killed but were abandoned in the forest (Abimbọla 1982:9-63). In some cases, according to the divination verse *Odù Ọ̀kànràn Méjì*, parents preserved one twin, killing the other and burying the corpse in the forest. The parents and the surviving twin, however, were required to offer sacrifices to the spirit of the deceased twin in the forest as long as they lived (Bascom 1969b:347). In the course of time, the negative attitude of the Yoruba to these children changed, because some of those abandoned in the forest managed to survive. When they later returned, they displayed special talents and mystical powers. Thereupon, parents of twins and triplets started keeping all of their children, overindulging them in the hope that they would use their supernatural endowments for positive ends (Abimbọla 1982:60-63).

Traditionally, although twins are physically double, they are regarded as

21. This is also hinted at in the following divination verse:

Ìwákúwá n níí mú wọ́n rí ìríkúrìí.
Dífá fún Àgànòríbí
Njọ́ tí nlọ lèé tọrọ ọmọ lọ́dọ̀ òrìṣà

An unscrupulous and desperate search leads to regrettable results. Thus declared the oracle to the barren woman When she was going to beg *òrìṣà* for a child.

This verse refers to a barren woman called Àgànòríbí, who frantically begged Ọbàtálá for a child. She was given an *enfant terrible*. See Abimbọla (1975a:364-85).

spiritually one. Thus if one of them should die, a statuette (*ère ìbejì*) is made to house the deceased soul; otherwise the surviving twin may die, since they are inseparable. The statuette, reflecting the sex of the deceased twin, is commissioned from a carver on the recommendation of a diviner. A miniature anklet, similar to that of Gèlèdé, is sometimes put on the leg of the statuette to prevent the soul in it from being lured away by *Ará'gbó* (fig. 3.4).

One of the most effective ways of persuading spirit children to stay with their parents is by pampering them regularly with music and dance and organizing an annual feast for them. Twins, in particular, are believed to love music and the dance so much that tradition requires their mother to dance with them almost every day:

Òmótáyé ijó l'orò
Èjìrè, ijó l'orò yín.

Òmótáyé (the first of twins), dance is your ritual
Twins, dance is your ritual.[22]

(Abimbola 1982:73)

22. See also Thompson (1971a:79 n.3). In certain cases, the diviner may advise a mother of twins to dance with the children round the town for three years or more to prevent them from dying prematurely.

One should note, in this context, that women carrying twin statuettes in trays dance with Gèlèdé masks during the annual festival in Ìlaró. This is because, as one informant told the Drewals, "The *òrìsà* of Gèlèdé and twins are the same" (1983:252). In other towns, women carrying ordinary carv-

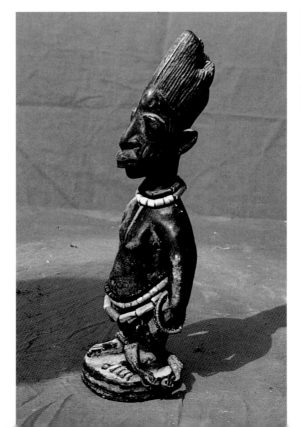

3.4 A miniature metal anklet (*aro*), similar to that of Gèlèdé, adorns the leg of this twin statuette (eré ìbejì) to secure its soul. Compare fig. 3.7.

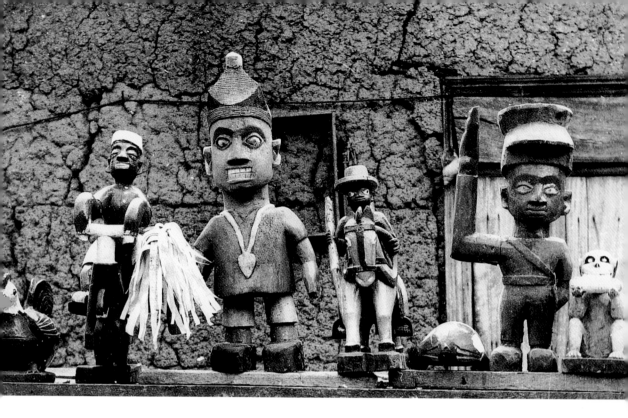

ings on their heads and fastening headwraps (*gèlè*) or baby sashes (*òjá*) round their waists, sometimes accompany Gèlèdé masks to the dance arena, singing, dancing, praying for children, good health, long life, and prosperity. Some of these carvings come from the *aṣè* (the Gèlèdé shrine) or from the shrines of the family *òrìṣà*. Others are specifically created for the women to carry only during the annual festival, to be stored away until the next year (fig. 3.5).

Occasionally, a female attendant (*atọ́kùn* or *akódan*), carrying a colorful woodcarving, dances in front of Gèlèdé masks (pl. 2, fig. 3.6).[23] When I asked the elders of the Gèlèdé society in Lagos, Ìgán Òkòtó, Ìlaro, and Ìdòfòyí (Ayétòrò) why some women dance with woodcarvings during the annual festival, they replied that these women were engaging in *ìṣèrí* (having fun), that is, imitating the men under the masks. Yet the elders encourage young girls, supposedly barren women, and recently married ladies to carry these woodcarvings because dancing with them relaxes the body (*ó ndẹ ara*) and induces fertility (*ó nfa ọmọ*). It follows that the mask, supposedly being imitated by the women, embodies these values, as well. In any case, if we compare a female devotee of Yemọja carrying a woodcarving on the head, and a Gèlèdé mask with a superstructure on its headdress, the

3.5 Woodcarvings carried by women during the Gèlèdé festival at Ìdòfòyí, Ayétòrò. From left to right: hen, cyclist, king holding horsetail whisk, horseman, tortoise, traffic policeman, and monkey eating maize. Images carved by Michael Labọde (1971).

23. *Atọ́kùn* means "guide." I am grateful to Moses Ọlaiya Adejumọ for these illustrations.

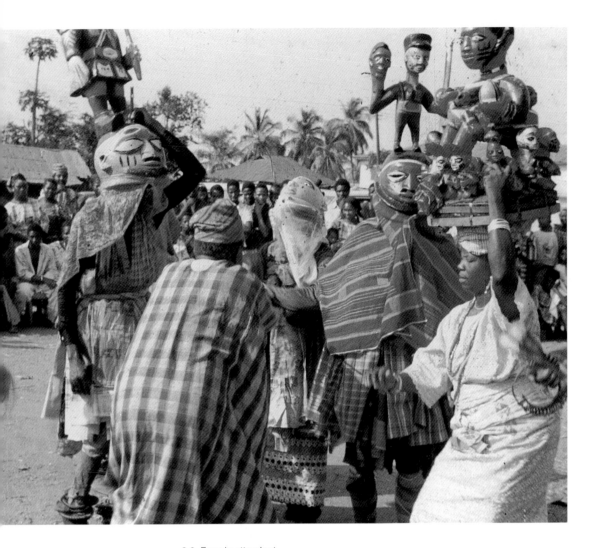

3.6 Female attendant
(see also pl. 2) dancing
with Gèlèdé masks from
Ìbóòro (1982), linking
the archetype with its
theatrical interpretations.

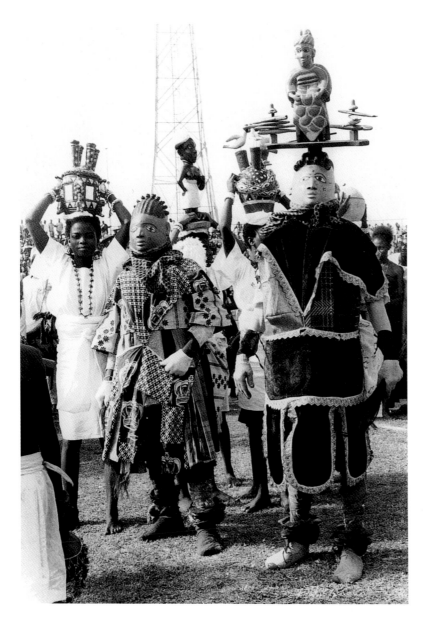

3.7 Yemọja dancers
from Lagos (with
carved images) posing
with two Gẹ̀lẹ̀dẹ́
masks (also from
Lagos) during the All
Nigerian Festival of the
Arts, Ìbàdàn (1972).

men would appear to be imitating an archetypal female dancer. Indeed, the
Yoruba terms for the Gẹ̀lẹ̀dẹ́ masker—*arugi* (wood carrier), *agbẹ̀rù* (load
bearer), *ajógi* (he who dances the wooden image), and *ajó*-Gẹ̀lẹ̀dẹ́ (he who
dances Gẹ̀lẹ̀dẹ́)—betray the derivation of the mask from an ancient fertility
ritual performed by women dancing with woodcarvings balanced on the
head (figs. 3.1, 3.6, 3.7).

These terms recall the fertility dance of Yewajọbí (a.k.a. Yemọja) as described in the divination verse *Odù Ìwòrì Méjì* and the *Àwòyó* song associated with it:

Yewajọbí has become Àwòyó,
The mother of the child to dance with.
She has become Àwòyó.
Yewajọbí has become Àwòyó,
The owner of the wooden images to dance with.
She has become Àwòyó.

(Ajanaku, interview, 1971. My translation)

This song underscores the historical importance of a unique pair of Gẹ̀lẹ̀dẹ́ headdresses donated to the British Museum in London in 1887 (fig. 3.8); one of the pair features a kneeling female, and the other, a standing male devotee. Both figures carry carved images on the head, just as in the Yemọja dance (figs. 3.1, 3.7). The female devotee wears a carved beaded necklace (*ìdè* Yemọja), clearly identifying her as a Yemọja priestess (fig. 3.9). The male figure, apparently a Yemọja priest, ties a baby sash (*òjá*) round the waist in the same manner as the Ọ̀ṣun priest in fig. 3.10. The male figure corroborates the widespread testimony that the men once carried carved images with which they danced, masking in Gẹ̀lẹ̀dẹ́ being a later development. Evidently, the term for the masker—*Arugi* (wood carrier) or *Agbẹ̀rù* (load bearer)—is a carryover from the "pre-masking" period (plates 2, 3).

Another song on the origin of Gẹ̀lẹ̀dẹ́, documented by Fayọmi (l982:4, my translation), is quite revealing. For purposes of discussion, we will refer to it as the Kétu song:

Ọmọ ọba Kétu,
Ọmọ Olúwa ọjà,
Ọmọ tó wúwo bí akọni òkúta,
Ọmọ Gẹ̀lẹ̀dẹ́ tó gorí oyè lójọ́ sí,
[5] L'Ọ̀họ̀rí ilé,
Tó bọ ẹ̀gbà onídẹ s'ẹ́sẹ̀ rẹ̀,
Oníjó, ọmọ ère tó n m'ọ́lá wá.

Prince of Kétu,
Child of the lord of the market,
The child who is heavy like solid rock,

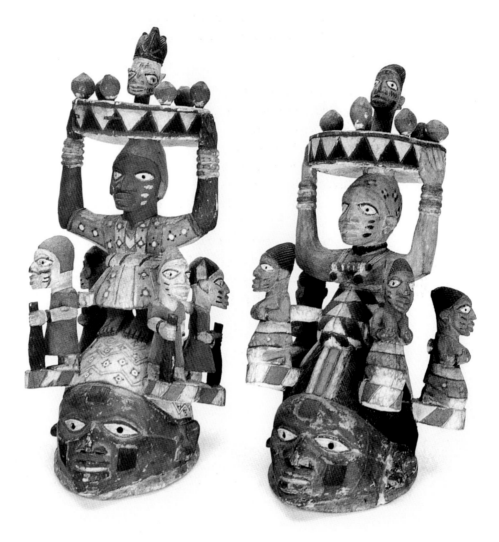

3.8 Nineteenth-century headdresses featuring Yemọja priest (left) and priestess (right,) harking back to the pre-masking phase of Gèlèdé, when both men and women reportedly danced with woodcarvings on the head. The ball-like objects on the trays represent ritual pots (*ọ̀tùn*) such as the one held by the Yemọja priestess in figure 3.2. The breast-holding gesture of the small female figures signifies welcome, generosity, and nurture. The men's guns symbolize protection and also recall the gun salute that often welcomes the Èfè mask to the performance arena (see fig. 5.2) Wood, pigment, h. 23 inches (left), 21 inches (right).

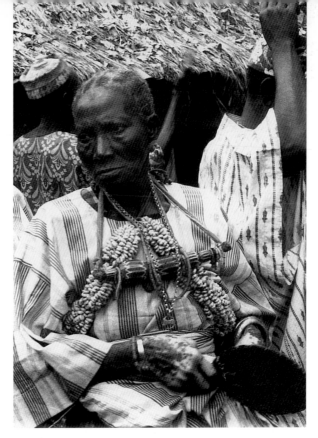

3.9 The carved coral necklace (*idè* Yemọja) worn by this woman identifies her in Yorubaland as a Yemọja priestess. The cowrie shell emblem under the necklace signifies Òrìṣà Oko (the agricultural deity), who interacts with Yemọja to ensure human, animal, and plant fertility. Òṣogbo (1972).

The child of Gèlèdé who ascended the throne long ago
[5]　At Òhòrí Ilé,
Who wore brass bracelets on the legs,
The lover of the dance, child of the wooden image that brings honor.[24]

24. For another version of this song, see p. 125, lines 17-19, and Thompson (1971b: ch.14/2).

The heaviness mentioned in the third line of the Kétu song may allude to the bulkiness of the costume as well as the weight of the woodcarving balanced on the head of the archetypal female dancer—also implied in the fifth line of the *Àwòyó* song. The reference to "brass bracelets on the legs" recalls the popular image of spirit children as *awọn ọmọ ẹlẹ́gbà onídẹ l'ẹ́sẹ̀* (children with brass bracelets on the legs). Hence the following song in their honor:

Ẹ wá wo àkùkọ mi onídẹsẹ̀,
Ṣaworo jìngbìnì, jìngbìnì ṣaworo.

Behold my "rooster" with brass anklets,
Jingling anklets, jingling anklets.

(Elewude, interview, 1984. My translation)

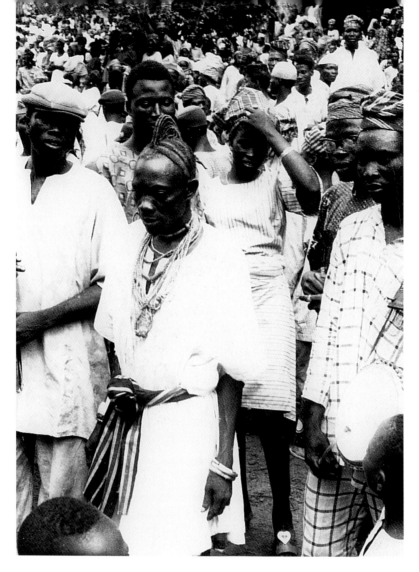

3.10 An Ọṣun priest with a female hairdo (*agògo* style) and baby sash (*òjá*) tied round the waist to reinforce the image of Ọṣun (river goddess) as the most generous and protective mother. Òṣogbo (1972).

Anklets worn by spirit children are of two types: one is in the form of an idiophone (*aro* or *ṣaworo*) which jingles as the child walks; the other, called *ẹ̀gbà*, is an ordinary bracelet and does not jingle. The fact that the Gẹ̀lẹ̀dẹ́ mask wears larger versions of both anklets not only identifies it with *òrìṣà olómọwéwé* but shows that the functions of these anklets in both contexts are similar. The last line of the Kétu song indisputably links Gẹ̀lẹ̀dẹ́ with twins whose popular nickname is *Oníjó* (the lover of the dance), and whose statuettes (*ère ìbejì*) are believed to bring honor and prosperity to parents who take good care of their twins.

Equally relevant is the theme that dominates Gẹ̀lẹ̀dẹ́ masks. As Ulli Beier observed in Kétu:

Most of them represent women. . . . Others represent mothers. The dancer does not only carry a wooden mask representing a woman's head, but he has a carved breast plate showing protruding breasts and belly and a backplate on which a child is carved. Usually these dancers carry another carved child in their hand. (1958:13) (See also fig. 6.16a, b.)

Other masks portray a nursing mother breastfeeding a child. These examples relate Gèlèdé to a quest for procreation and survival. According to Yoruba historian Samuel Johnson, such was the preoccupation of the Yoruba with fertility and increase that Koórì (one of the òrìṣà ọlọ́mọwẹ́wẹ́) was at first "the only object of worship" among them (1921:26-27). The belief that the "powerful mothers" can influence human fertility and are responsible for many premature deaths in the community may explain why a "fertility dance" for òrìṣà ọlọ́mọwẹ́wẹ́ was transformed into an elaborate masked performance aimed at persuading these women to use their power for corporate survival. Moreover, the "powerful mothers," according to popular belief, control all the deities under òrìṣà ọlọ́mọwẹ́wẹ́ (especially Ẹgbẹ́ Ọ̀gbà, the spirit double of an individual), manipulating them for good or evil.

The association of the earliest phase of Gèlèdé with òrìṣà ọlọ́mọwẹ́wẹ́ shows that it is no more than a regional variation of a phenomenon found in different forms all over Yorubaland. For instance, in Ìbàdàn, Ẹdẹ, Ọ̀ṣogbo and environs where Gèlèdé does not exist, there are special masks for Ẹgbẹ́, a tutelary goddess of Àbíkú. Also known as Elérìkò, she is an ambivalent goddess. When properly appeased, she gives children to barren women and plays with small children in daylight without anyone seeing her (Simpson 1980:17). But when displeased, she harasses children in their sleep, afflicts them with diseases, or kills them by luring away their souls to join Ará'gbó (beings of the forest). During the annual festival for this goddess, special masks, called Elérìkò, dance round the town, receiving gifts and praying for the well-being of all, both young and old. As George Simpson observed:

Although this òrìṣà is thought of as the female counterpart of Egúngún, Ẹgbẹ́ is impersonated by men wearing costumes resembling women's dresses, and masks are worn. There are, however, women followers of Ẹgbẹ́. Bàtá and dùndún (talking) drums are played, but no agogo (iron gong), rattles or ṣẹ̀kẹ̀rẹ̀ are used. (ibid.:48)

The musicians accompanying the Elérìkò usually do not play percussion instruments such as iron gongs and rattles because these instruments have

implications similar to *Àbíkú's* metal anklet, and there is no need to hold the goddess at bay during a festival that honors her. Since she is unpredictable, however, some worshippers do not want to take chances; hence they sometimes wear ceremonial anklets resembling Gèlèdé's when dancing along with Elérìkò masks, the rattle of the anklets being drowned amid the drumming. In Èdè, spirit children not only have male and female Elérìkò masks, worn by adults (fig. 3.11), but there is a special ceremony at night when masked heavenly comrades are escorted from the forest into the town to interact with their earthly counterparts (fig. 3.12). In Òwò, eastern Yorubaland, women anxious to have children, pregnant housewives, and mothers of sickly children affiliate with a female mask called *Àghòbí* (the thing one looks at to give birth to a baby) reputed to have the power to make men virile, women fertile, and children healthy and well formed. The mask wears anklets of brass crotals that jingle as she dances. Because of her association with procreativity, Àghòbí is also known as Egúngún Olómoyoyo (ancestral spirit of small children). Legend has it that when the first *òrìsà* were coming from heaven to earth, they did not bring the Egúngún mask along. As a result, all the children born on earth had no eyes, nose, or mouth and could not talk. Olúwayé Olókun (the divinity of the sea) consulted a diviner, who revealed that the "facelessness" of the newborn babies was due to the absence of Egúngún on earth. In short, only after Olúwayé Olókun brought Egúngún to the earth did women become fertile and bear normal children. This is why Egúngún is also known as Àghòbí (or Àwòbí).[25] According to my informant, the Àghòbí mask of Òwò wears *saworo* (crotals) as anklets "because their jingling repels danger."[26]

The female headwrap (*gèlè*) and baby sash (*òjá*) tied to the Gèlèdé costume (plates 2, 3; fig. 6.10) also feature prominently in rites associated with female fertility and *Àbíkú* all over Yorubaland (fig. 3.11). For instance, at Asípa near Ilé-Ifè, barren women and the mothers of *Àbíkú* children tie *gèlè* and *òjá* to the trees in the shrine of Ewúrù (the local patron deity of spirit children) to reinforce their prayers. This rite is called *ìgbàjá*, that is, "tying the baby sash." During the annual Òsun festival in Òsogbo, women sing and dance in the temple of the river goddess, imploring her to let them use their *òjá* to carry and nurture children. Some male devotees of Òsun not only sport female hairstyles but also tie *gèlè* or *òjá* to their waists (fig 3.10), reinforcing the image of the goddess as the generous mother who gives children and nurses them to maturity. At Lálúpon, women appeal to Egbé, the goddess of spirit children, with the following song:

25. Robin Poynor (1974) reports that Àwòbí is also called Gbogboìgbà (a being of all seasons). It is significant that the name Àwùbí is one of the cognomens of the Òyó Egúngún, namely, *Omo Ikúlodò, Àwùbí.* (lit., son of the man who died in the river, Àwùbí). See Babayemi (1980:58-59).

26. Interview with the Àghòbí masker, who gave a special performance in Ilé-Ifè for the Òwò Cultural Union, Ilé-Ifè Branch, 1972. I am grateful to the late Mr. Akinola Lasekan for arranging the interview.

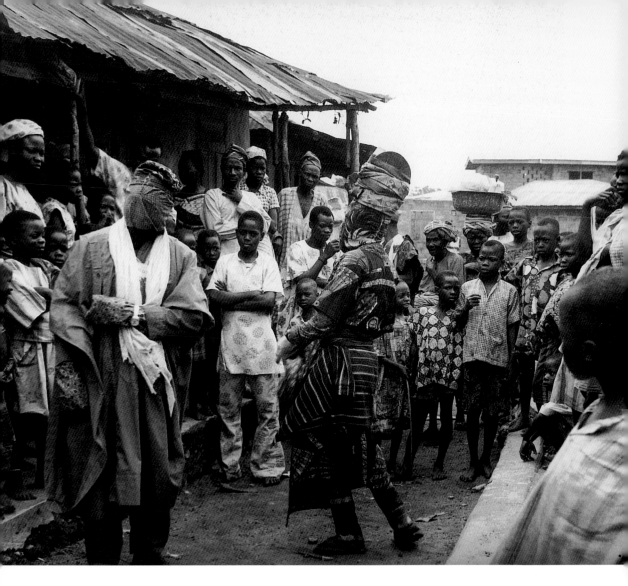

3.11 Male and female Elérìkò (*Àbíkú* spirit masks) entertaining the public. The baby sash (*òja*) around the neck of the male mask and on the waist of the female signifies the maternal indulgence given to spirit children to encourage them to stay with their parents. The carved wooden crest (agògo) worn by the female mask (partly concealed by the head tie) is similar to that of the Gèlèdé headdress in figure 7.1. Ẹdẹ (1972).

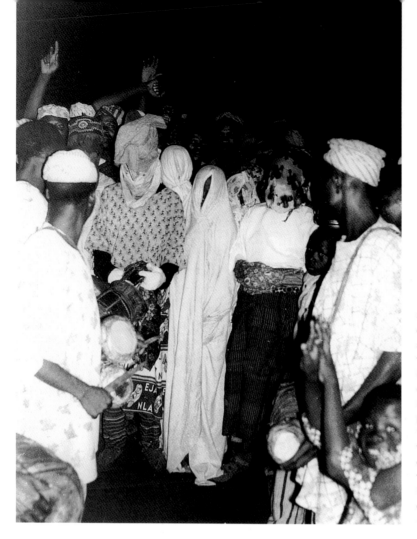

3.12 Nocturnal ceremony for summoning from the forest the unborn heavenly companions of spirit children. By inviting, feasting, and placating these "visitors from the forest" (Ará'gbó), the community expects them to stop harassing their earthly counterparts. Ẹdẹ (1972).

Gba gèlè, gba gèlè
Gèlè la fi npọn'mọ

.

Ìyá inú eèsún
Fún mi l'ọmọ t'èmi

.

Please have a headtie, please have a headwrap.
The headtie is used for tying children on our backs

.

The mother [Ẹgbẹ́] who lives among the grasses
Give me my own children

(Simpson 1980:48)

From Ìbàdàn comes the following appeal to Ẹgbé:

Ìyá, gbà mí, n ó rodò
Emèrè ọmọ kó máa ba mi wálé

.

Olúgbọ́n lọ, ó fọmọ sáyé
Arẹ̀sà lọ, ó mà fọmọ sáyé
[5] Olúkòyí lo, ó mà fọmọ sáyé
Èmi kò ní lọ láì fọmọ sáyé
Èmi kò ní lọ lapàpàndodo

Mother, save me, I shall go to the river
Do not allow a demonic child to follow me home

.

Olúgbọ́n died and left children in this world.
Arẹ̀sà died and left children behind.
[5] Olúkòyí died and left children behind.
I shall not die without leaving children behind.
I shall not die empty-handed. (Simpson 1980:48)

According to the Ifá divination verse *Odù Ọfún Ọwọrin*, the people of Àwáyè solved the problem of infant mortality by offering a special ritual that included 1,400 female headwraps. After Aláwáyè, the future king of Àwáyè, had died seven times, the people of Àwáyè consulted a diviner, who advised them to offer as sacrifice 1,400 headwraps, 1,400 hats, and a piece of cloth dyed in camwood ointment. The dyed cloth was hung on top of a tree inside the *Igbó Àbíkú*, the grove of spirit children. After this ritual, the souls of unborn spirit children in Àwáyè met in the *Igbó Àbíkú* and resolved to stay with their parents when born, provided the latter would entertain them with dances every year (Verger 1968:1478-82).

Lastly, among the coastal Ìjẹbú Yoruba, masks similar to Gẹ̀lẹ̀dẹ́ abound. Known generically as Àgbó, these masks perform to honor Olókun (the goddess of the sea). Although Àgbó masks usually dance in threes (whereas Gẹ̀lẹ̀dẹ́ dance in twos) and wear mats (whereas Gẹ̀lẹ̀dẹ́ use fabrics), they have other things in common with Gẹ̀lẹ̀dẹ́. For instance, Àgbó masks wear anklets (though made of seed pods), have male and female aspects (the buttocks of the female mask being exaggerated like that of Gẹ̀lẹ̀dẹ́), and they use headdresses similar in form and style to those of Gẹ̀lẹ̀dẹ́. So striking is the similarity between Gẹ̀lẹ̀dẹ́ and Àgbó or Màgbó headdresses that it is sometimes difficult to differentiate one from the other, especially in a mu-

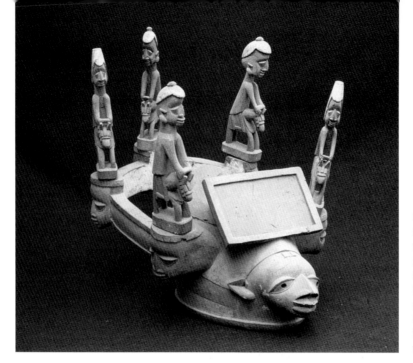

3.13 Màgbó head-
dress from Ìkòròdú,
carved by Onabanjo
(alias Kónkórugudu)
of Itúnmèkó (ca. 1940).
Note formal and
stylistic similarity to
Gèlèdé. Wood, h. 16
inches, l. 25 inches,
w. 14 inches.

seum context if there is inadequate documentation (pl. 11, fig. 3.13). Like Gèlèdé, Àgbó masks perform to beseech Mother Nature (or Olókun) to give her offspring all the good things of life—plenty of children, good health, wealth, and long life—creating a forum for all members of a given commu- nity to celebrate their common interests, although the same occasion is used to ridicule antisocial elements.[27] The celebration also honors certain chil- dren called Èkìnè or Molóku (offspring of the sea goddess) because they were born through the intercession of water spirits. These children, regarded as special gifts from the sea goddess, receive preferential treatment from their parents. At times, anxious parents put metal anklets, similar to those of Àbíkú, on the legs of these children to prevent them from dying prema- turely. Dàda, the most popular of the Ìjèbú spirit children, is a baby born with knotted hair. Some Yoruba regard Dàda as an Ará'gbó,[28] while others regard the child as a personification of the patron deity of newborn babies (Abraham 1958:121) and an offspring of Yemoja.[29] In short, the association of Àgbó masks with spirit children is indicative of a genetic relationship with Gèlèdé. The differences observable in their myths of origin and dance steps of Àgbó and Gèlèdé may probably be due to local contingencies and syncretism. For instance, the Èkìnè society of the Ìjèbu is also found among the Ijo of the Delta (Horton 1960), with whom the riverain Ìjèbu have had several centuries of close interaction.[30] Thus, cultural influences would seem to have flown in both directions.

27. See Okesola (1967:300); Drewal (1986:32-41, 99-100). In Ìkòròdú, there is a similar society called Màgbó which uses wooden headdresses similar in form and style to Gèlèdé's (Celenko 1983:112-13). The Màgbó, however, is a male society. Dur- ing one of its public ceremonies, all women in the town are con- fined indoors (Ìsémó).

28. For instance, Dàda is also known as Àwúrú ya ilè ya igi oko! (the one that ploughs up the earth and mows down the trees in the forest). See Sowande and Ajanaku (1969:43).

29. Dàda is considered as one of the three issues of the marriage of Yemoja and Òrànmi- yàn, the founder of the Òyó-Ilé (Old Òyó) empire. The other two

children are Ṣàngó and
Ṣòpònó (the smallpox
deity). See also
Houlberg (1979:376).
In other myths, Yemoja
is said to have given
birth to Ṣàngó when she
was Ọbàtálá's wife.

30. In view of the fact
that some of the Ijo
Èkìnè masks also wear
anklets (although made
of seedpods) and have
exaggerated buttocks,
both of which suggest
relationship of some
sort with Gèlèdé, there
is an urgent need for a
comparative study.

31. This is indicated in
their praise name: Ọmọ
Ìlóbí, Ọmọ a fi idẹ gbá
idẹ (son of Ìlóbí; son of
the one who dances
with brass anklets).

Gèlèdé and the Succession Dispute

By and large, the foregoing examples from other parts of Yorubaland clearly suggest that the roots of Gèlèdé go much deeper in time than the succession dispute in Kétu. But if this is so, if Gèlèdé evolved from dances originally associated with human increase and survival, how has it come to be linked with a succession dispute between two twin brothers? Given the scantiness of the evidence at our disposal, the answer to this question must await further investigation. What is most intriguing about the succession dispute story at the moment is the allegation that the first Gèlèdé mask was used to frighten the people of Kétu at night. Could the "strange" sound of the dancing "night" mask be due to the use for the first time of metal anklets? It will be recalled that the first Gèlèdé anklets were reportedly made of seashells (òkòtó); hence, Gèlèdé's epithet "Olókun dé é é é é é o; Àjàró ò ò ò Òkòtó" (Here comes the sea goddess Olókun, the roaring eddy of seashells!) Thus, could it be that it was at Ìlóbí, following the alleged succession dispute, that metal anklets were first used in a mask context in southwestern Yorubaland? If the answer is in the affirmative, it would tally with the reputation of the inhabitants of ancient Ìlóbí as "users of brass anklets."[31]

Ancient Ìlóbí is also said to have been a major center of iron smelting, a knowledge that its founders reportedly imported from Ilé-Ifè, which is also famous for its ancient brass castings. As Kọla Fọlayan has observed, the reference to Ìgbá Ògún (the sacred calabash of the iron deity) in the Ìlóbí tradition of origin might suggest that the Adekambi faction (according to the Ìlóbí version of the succession dispute), introduced a new technology (iron smelting) to the area (Fọlayan 1975:92). Indeed, the first iron anklets used by Gèlèdé masks in Ìmèkọ, an offshoot of Kétu, were, according to one informant, imported from Ìlóbí (Ọlatunji-Onígèlèdé 1971; see also Ibitokun 1993:30). It is also possible that, with its iron technology, Ìlóbí replaced the carved calabash (kàràgbá) with elaborately carved wooden headdresses that distinguished the Gèlèdé mask from its predecessors in southwestern Yorubaland. Unfortunately, it is difficult in the absence of concrete data to determine which preceded the other, the brass or iron anklet, although the two Ifá divination verses cited on the origin of Gèlèdé claim that its founder (Yewajọbi or Òrúnmìlà) wore iron anklets from the beginning. In view of the popular story that Gèlèdé evolved from the dance formerly staged in honor of òrìṣà ọlómọwéwé, it may very well be that what we now know as Gèlèdé is a conflation of two previously separate elements; namely, the night concert (èfè) and the daylight dance (Gèlèdé).

In that case, the reference in the succession dispute story to the "strange sound" at night could indicate that the èfè night concert came into being as a result of this event and is therefore a later addition to the (older) daylight dance. Also, could the emphasis on pairing and identical costume in the Gèlèdé dance commemorate the reconciliation of the twin brothers and cessation of hostility between Ìlóbí and Kétu? The picture is not clear at the moment. It is hoped that future research will clarify the situation.

On the basis of the alleged succession dispute in Kétu, which they have dated to the eighteenth century, Henry and Margaret Drewal believe that Gèlèdé might also have originated about the same time (1983:229-31). As the dispute occurred between twins, the Drewals support this date with T. J. H. Chappel's hypothesis that the Yoruba seem to have stopped killing twins about the middle of the eighteenth century, consequent upon Ọyọ́ traders settling among the Ègùn people of the southwest who did not kill their twins (1974:258-59). In my view, this date is simply too late for the origin of Gèlèdé. First of all, there is strong evidence that the Ègùn and Yoruba had substantial cultural exchanges before the fifteenth century A.D. (Akinjogbin 1967:11). And since the southwestern Yoruba, who originated Gèlèdé, share common borders with the Ègùn, the chances are that they stopped killing twins much earlier than the Ọyọ́, who lived in the north, assuming that the Yoruba had adopted the cult of twins from the Ègùn.[32] Second, Yoruba historian Samuel Johnson identifies Aláàfin Àjàká, who reigned before the sixteenth century, as the Ọyọ́ king who abolished twin infanticide. One of Àjàká's wives had given birth to a set of twins. Reluctant to kill them or abandon them in the forest, Àjàká ordered that both the mother and her twins be banished to a remote part of the kingdom, where the twins later became rulers. One of the twins founded the ruling dynasty of present-day Òndó (1921:25). Although the people of Òndó agree that the founder of their town, a woman called Púpùpú, was a twin, they trace her origin to Ilé-Ifè, not Ọyọ́.

According to the Òndó version, Púpùpú's mother was the wife of Odùduwà, the first king of Ilé-Ifè. Expelled from the town because she gave birth to twins, she lived in the forest with her children. The female twin later founded the town of Òndó sometime in the sixteenth century, while the brother founded another town about ten miles away (J. O. Ojo 1976:40; Smith 1988:52; Olupona 1991a:23-24). An Ifá divination verse (Odù Òkànràn Ìrosù) seems to corroborate the Òndó version of the legend. The verse traces the origin of the Òndó monarchy to Òsẹmọ̀wé, one of the twins born to a wife of Odùduwà. Instead of killing the twins, as required by tra-

32. It is significant to note that the Ègùn and the Fon, like the Yoruba, regard twins as "forest beings." See also Herskovits and Herskovits (1933:59); Blier (1988:82-83). For information on Àbíkú (called *venavi*) among the Ègùn, see Merlo (1975:30-35). Of the twelve *venavi* statuettes illustrated by Merlo, ten carry a bowl or tray on the head, recalling the Yoruba devotees of Yemọja and Òrìsà Ọlómọwéwé who dance with pots or carved images on their head, as in figs. 3.1, 3.7, and 3.8.

dition, Odùduwà sent the mother and her children into the forest. Later, one of the twins became the Òṣemọ̀wé, the first king of Òndó (Abimbọla 1982:62-67). Although some historians have suggested that Odùduwà is a mythical rather than historical figure, his reign, if he ever lived, is usually assigned to the first millennium A.D.

While we cannot determine exactly when the Yoruba started preserving twins, there is no doubt that the change occurred at different times in different parts of Yorubaland, much earlier than the eighteenth century in some, and later in others (Lawal 1988). The widespread testimonies that Gẹ̀lẹ̀dẹ́ evolved from dances associated with òrìṣà ọlọ́mọwẹ́wẹ́, however, suggest a pre-eighteenth-century date for the origin of the mask. Frank Willett has drawn attention to the similarity between the pierced eyes of a typical Gẹ̀lẹ̀dẹ́ headdress and those of the Nok terracotta heads dated between the fifth century B.C. and third century A.D., implying some kind of historical or stylistic relationship (1993:69). He has cautioned, however, that the similarity may be accidental, as there is no other evidence to link the two traditions (ibid.). Also using stylistic evidence, Robert Farris Thompson has related the facial features of Gẹ̀lẹ̀dẹ́ to some Benin bronze heads of the sixteenth and seventeenth centuries, suggesting that the two traditions may be contemporaneous (Thompson 1971b:ch.14/1). This is not impossible, given the fact that some Ànàgó and Àwórì groups trace their origin to Benin (Aṣiwaju 1976:9-19; Smith 1988:87). The Ìlóbí version of the succession dispute also points to a date prior to the eighteenth century. Kétu is one of the oldest Yoruba kingdoms, the date of its founding being placed somewhere in the twelfth and fourteenth centuries A.D. (Smith 1988:103-4). According to the data collected by Kọla Fọlayan, the succession dispute seems to have occurred after the reign of the sixth king of Kétu (1975:92). Using historic lists of the Kétu kings, Robert Smith has worked out an average reign of 18.5 to 21.5 years per king (Smith 1988:103). This average would put the reign of the sixth king about 125 years after the founding of Kétu. Thus, we can tentatively assign to the same period (i.e., between the fourteenth and fifteenth centuries) the succession dispute which allegedly led to the inauguration of Gẹ̀lẹ̀dẹ́ or an aspect of it. The nineteenth-century records of Gẹ̀lẹ̀dẹ́ performances by liberated Yoruba slaves in Sierra Leone, Brazil, and Cuba (Thompson 1971b:ch.14/1; dos Santos 1976:115; Nunley 1987: 108-16) also point to a date much earlier than the Drewals have suggested for the beginning of the tradition. Evidently, enslaved Yoruba took Gẹ̀lẹ̀dẹ́ to the New World between the sixteenth and eighteenth centuries, when the slave trade was at its peak.

Ìrépò

Gender and Social Harmony
Through Gèlèdé

Although the Yoruba have many masking traditions, the most popular are Egúngún, Ẹpa, and Gèlèdé. Found all over Yorubaland but mainly among the Ọyọ́ communities who occupy the central and northern areas, the Egúngún (fig. 1.6), as earlier mentioned, dramatizes the Yoruba belief in life after death. Its masked figures represent the spirits of deceased ancestors who return to the earth to visit their living descendants and to purify the land, bless the sick, and help settle outstanding disputes. The Ẹpa mask (fig. 8.12) predominates in eastern Yorubaland, especially among the Èkìtì, Ìgbómìnà, and Ìjèṣà, who use it to honor culture heroes, placate supernatural forces, and promote the social and spiritual well-being of a given community.[1]

Homage to Ìyá Nlá

Gèlèdé occurs mainly in the western and coastal areas (map 2) occupied by the Kétu, Ṣábèè, Ọ̀họrí, Ẹgbádò, Ànàgó, and Àwórì.[2] Despite the fact that Gèlèdé may be performed in honor of any òrìṣà or culture hero, its most popular function is to placate Ìyá Nlá (the Great Mother), and her earthly disciples, the "powerful mothers."[3] Often identified as the first female in the Yoruba universe and the wife of the artist deity Ọbàtálá (alias Bàbá Nlá, the Great Father) (Beier 1956:10; Idowu 1962:29), Ìyá Nlá remains an enigma. This is because she is Mother Nature. She is *Yewajọbí, Ìyàmi, Ìyá* (the Mother of All and the mother of mothers), epitomizing the maternal principle in the Yoruba cosmos, combining in her nature the attributes of all the principal female deities—Yemọja (mother of all waters), Olókun (sea goddess), Ọ̀ṣun (goddess of Ọ̀ṣun river), Òdù (founder of witchcraft), Oòduà (Earth goddess), Ilè (Earth goddess), and Ọya (goddess of the Niger River). Little wonder the Yoruba of Brazil address Yemọja as Òdù-Ìyámi (de Castro n.d.:20), while the Yoruba of Cuba once celebrated Gèlèdé in honor of Yemọja-Olókun (Thompson 1971b:ch 14/3).[4] As Olókun (spirit of the sea) and Yemọja (mother of all waters), Ìyá Nlá was the primeval sea out of which

1. For more information on Ẹpa masks, see J. R. O. Ojo (1974); Heyden (1977).

2. For a history of these groups, see Fọlayan (1967); Parrinder (1967); Akinjogbin (1967); Aṣiwaju (1976).

3. Thus at Ayétòrò (Ìdòfòyí), Gèlèdé is performed in honor of Onídòfòyí, a divine ancestor associated with snakes; at Ìbarà, in honor of Yemọja, who is associated with the Ògùn River; at Ìlarò and Kétu, in honor of Oòduà, an Earth goddess; at Owódé-Kétu, in honor of Ọmọlú (smallpox deity), and at Ìbóòrò, in honor of Eyinni, a deity associated with twins, among others.

4. For the identification of Yemọja with Olókun in Yorubaland, see Ladele, et al. (1986:63).

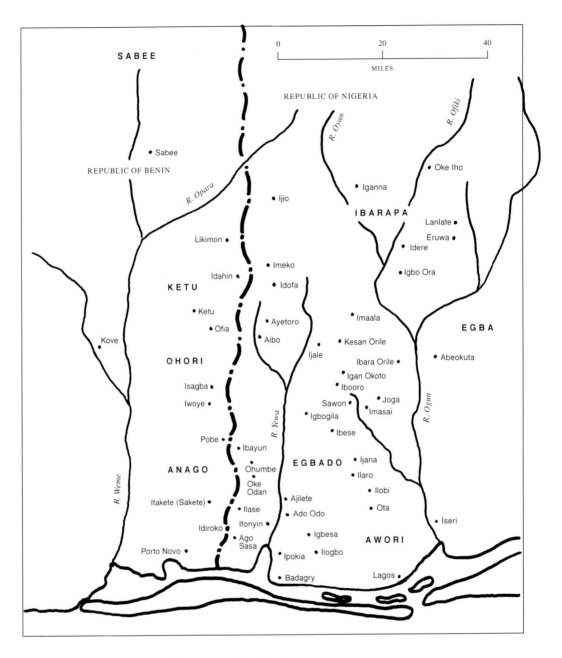

Map 2. Southwestern Yorubaland.
Important Gèlèdé communities.

habitable land emerged at Ilé-Ifè, the cradle of Yoruba civilization. As Ilè (the Earth), venerated by the Ògbóni, she sustains life, humanity, and culture. As an embodiment of the good and evil of the physical world, she is Olúwayé (ruler of the world), and Ìyámi Òṣòròngà, the first female to whom the Supreme Being gave a special power *(àṣẹ)* in the form of a bird enclosed in a calabash, copies of which she presented to her disciples, the "powerful mothers." In her popular aspect as Yemọja, she is the generous and the dangerous mother:

Ìyá ọlóyọ̀n orùbà
Oní'run abẹ́ òṣíkí
A b'òbò fún ni l'ọ́rùn bi ègbẹ iṣu.

The pot-breasted mother
With much hair on her private parts;
The owner of a vagina that suffocates like dry yam in the throat.[5]

(Verger 1957:297-98. My translation)

As a big body of water, she is:

Olókun Àjẹtìayé, Alagbalúgbú omi
Àjàwó òkòtó
Afàilórogún pariwo
Ṣẹ́ẹ́ ṣẹ́ẹ́ ni gbẹ̀dẹ̀.

The inexhaustible sea, immense water,
Roaring eddy of seashells,
Querulous, though she [Olókun] has no rival
Vibrations from the deep.[6]

(Atapupa, interview, 1972. My translation)

The phrase "inexhaustible sea" has the same import as the milk flowing endlessly from the generous "pot-breasted mother." The mystery associated with the female genitalia echoes in "vibrations from the deep," although this phrase also evokes the sound of the Gẹ̀lẹ̀dẹ́ dance anklets, originally made of seashells. The term "querulous" reflects the public image of an *àjẹ́* (called *iyá un* in Kétu dialect) as a highly irascible female, difficult to please. Notwithstanding, most myths portray Ìyá Nlá, the grand matron of the *àjẹ́*, as a pleasant and fashionable woman and a lover of the arts:

5. It is interesting to note that in Ìlaró, Oòduà (Earth goddess) has exactly the same cognomen as Yemọja, confirming the fact that Ìyá Nlá has a multiple identity. For example, while the Ifá divination verse (*Odù Ọ̀sá Méjì*) identifies the first female goddess as Òdù (Verger 1965:200-10), another verse (*Odù Ogbè átè̩*) identifies her as Yémọwò (Idowu 1962:75; Yemitan and Ogundele 1970:31). On the other hand, J. O. Lucas (1948:96) regards Yémọwò as another name for Oòduà, Earth goddess. But since both divination verses (*Odù Ọ̀sá Méjì* and *Odù Ogbè átè̩*) agree that Ọbàtálá, alias Ọbàrìsà and Bàbá Nlá (the Great Father) is the husband of the first female goddess or Ìyá Nlá (the Great Mother), it is apparent that the names Òdù, Oòduà, Yemọja, and Yémọwò refer to different manifestations of the same phenomenon.

6. I am grateful to Chief Amudaniyu Atapupa, the late Bàbálásè̩ of the Ìsàlè̩-Èkó Gẹ̀lẹ̀dẹ́ society, for this information.

Ìbà Ìyámi Òṣòròngà

Ìyá ẹléyinjú ẹgẹ́

Onírun abẹ́ òṣíkí

Ìyá ọlópọ́n idẹ

Alábẹ̀bẹ̀ idẹ

Afínjú ẹyẹ òru tí nfò lẹ̀gẹ̀lẹ̀gẹ̀.

Homage, my mother, the Òṣòròngà

Mother with the beautiful eyes,

Who has a bunch of hair in her private part,

The mother who owns a brass tray

And a brass fan,[7]

The famous bird of the night that flies gracefully.[8]

(Akinbami, interview, 1972. My translation)

7. Although the brass fan is normally associated with Òṣun, the goddess of a river bearing that name, Ìyá Nlá partakes of the attributes of all her daughters.

8. Recited by Chief Sule Akinbami. Àgọ́-Ìlóbí quarter, Ajílété, August 1972.

To the coastal Yoruba, the movement of the sea is a reverberation of the drumming, dancing, and feasting going on in the rambling palace of Ìyá Nlá at the bottom. Hence, the popular saying: Gbogbo ìlù ní mbẹ l'ókun, Olókun Ṣẹníadé Àjífilùpẹ̀, Ọba Omi. (All kinds of drumming occur beneath the sea, Olókun Ṣẹníadé The-one-who-wakes-up-to-the-rhythm-of-drums, lord of the waters.) As the Mother of All, she receives and entertains visitors all day, all night—the òrìṣà, spirits of the newly dead, spirits of plants and animals, souls of thousands of children waiting to be born onto the earth, and souls of "returning" Àbíkú, all flock around her as she dances through her huge reception hall dressed in immaculate white cloth and decked in white coral beads, welcoming one group after another. As one informant put it, "Ìyá Nlá likes music and dance so much that she can celebrate for weeks without caring for food."[9] Her earthly disciples, the "powerful mothers," have a similar love of the performing arts. Indeed, in one Ifá divination verse (Odù Ogbè ìyónú), the "powerful mothers" disclose to Ọrúnmìlà that they would favor all those who honor them with music and dance (Verger 1965:186). Little wonder that the Gẹ̀lẹ̀dẹ́ performance is considered one of the most effective means of seeking their favors.

9. I am grateful to Aṣimi Ọlatunji-Onígẹ̀lẹ̀dẹ́ of Ìmẹ̀kọ for this information. August 1971.

Using Art to Dissolve Tension

Among the various informants, there are three common explanations of the word Gẹ̀lẹ̀dẹ́. One, that it is an onomatopoeia for the leisurely and relaxed gait of an obese woman, alluding to the mythical image of Ìyá Nlá as the

plentiful, pot-breasted mother; the nursing mother with the rolling buttocks (*Ìyá ọlọ́yọ̀n orùbà; Abiyamu a bìdí jẹlẹ́nkẹ́*). Some female Gẹ̀lẹ̀dẹ́ masks recall this image in the bulkiness of their costume, emphasizing big breasts and buttocks that rock voluptuously with each step (fig. 4.1). Two, that it connotes a phenomenon treated with indulgence (i.e., Gẹ̀—lẹ̀—dẹ́). Three, that it refers to something that cools and relaxes (i.e., Gẹ̀-ẹ̀—lẹ̀-ẹ̀—dẹ́-ẹ́). In addition, some informants etymologize the word as follows: *Gẹ̀* = "to pet or indulge"; *Ẹ̀lẹ̀* = "carefulness"; *Dẹ́* = "to relax." As Ibitokun has pointed out, however, this etymology cannot be taken too seriously, since *Gẹ̀lẹ̀dẹ́* is a single rather than a compound word (1993:28).[10] In any case, both the semantic and onomatopoeic implications of the word *Gẹ̀lẹ̀dẹ́* tally with the principal objective of the mask: the use of poetic humor to pacify the Great Mother and the *àjẹ́,* on the one hand, and to dissolve social tension, on the other.

As a result, the aesthetic of the Gẹ̀lẹ̀dẹ́ mask is completely different from those of Egúngún and Ẹpa. Not only do the headdresses and costumes of the Egúngún and Ẹpa masks frequently display frightening sacrificial materials or charms, but the maskers often carry cudgels or dangerous weapons in an aggressive manner (Carroll 1967:pl. 50). The Gẹ̀lẹ̀dẹ́ costume affords a complete contrast, being an assemblage of women's headwraps (*gèlè*) and baby sashes (*ọ̀já*) contributed by female members of the society. The Gẹ̀lẹ̀dẹ́ headdress seldom displays sacrificial materials or dangerous charms. The masker does not carry weapons but holds only a ceremonial horsetail whisk for dancing, acknowledging ovations, and blessing admirers (fig. 5.5). Also, while the costume of the Egúngún rarely reflects gender (fig. 1.6) it nonetheless projects maleness through behavior and dance steps.[11] The Gẹ̀lẹ̀dẹ́, on the other hand, reflects gender through distinct male and female costumes, thus publicly acknowledging the complementarity of the two sexes.

Yet another important difference is that the identity of the Egúngún maskers, for example, is a closely guarded secret, because this mask represents the spirits of deceased ancestors. Women especially must not know who the maskers are, and even if they do, they must pretend not to know. This is not the case with the Gẹ̀lẹ̀dẹ́. The identity of the masker is not a secret. The masker is free to unmask in public, if he feels like so doing. Sometimes the veil covering the face of the masker is so transparent that he does not need to unmask before being recognized (fig. 4.2). Thus, what the Egúngún masks conceal from the women becomes public knowledge through Gẹ̀lẹ̀dẹ́. It is significant that the symbol (bull-roarer) of the much-dreaded

10. The word *ẹ̀lẹ̀* also means the vagina. The latter is the definition adopted by the Drewals (1983:*xv*) in their interpretation of the word *Gẹ̀lẹ̀dẹ́.*

11. Among the few exceptions are the theatrical Egúngún (Apidán), which specialize in character sketches (Gotrick 1984: pl. 8) and some masks from Ìjẹ̀búland (M. Drewal 1992: pl. 7.1) and Ọ̀wọ̀ representing specific female characters.

4.1 Two female
Gẹ̀lẹ̀dẹ́ masks from
Lagos during the 1972
All Nigeria Festival of
the Arts, Ìbàdàn. The
emphasis on corpu-
lence recalls the image
of Ìyá Nlá as the pot-
breasted mother with
rolling buttocks. The
mask on the right
carries on its super-
structure a portrait of
Màmà Ibidunni
Onílẹ̀gbálẹ̀ (alias Ìyá
Àgbẹ̀dẹ), a famous
fish merchant of the
Onilẹ̀gbálẹ̀ Chieftaincy
House, Ìsàlẹ̀-Èkó,
Lagos.

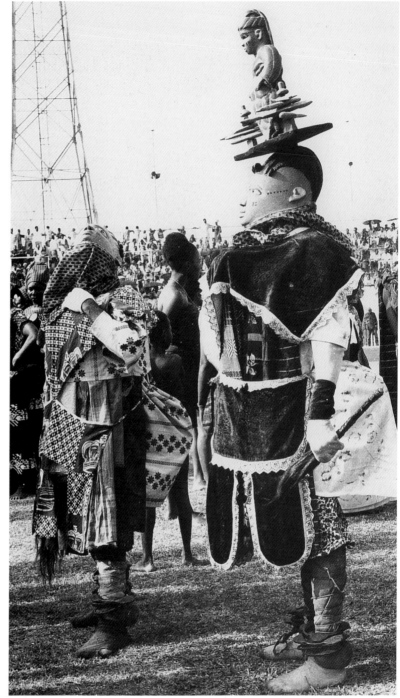

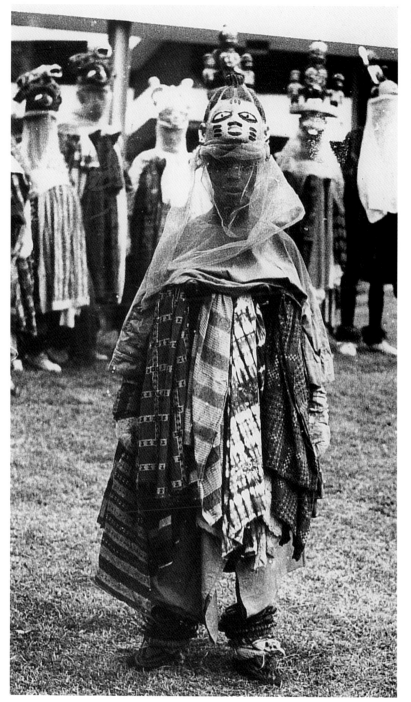

4.2 The veil covering the face of the Gẹ̀lẹ̀dẹ́ masker is sometimes transparent. Fourth Ifẹ̀ Festival of the Arts, Ilé-Ifẹ̀ (1971).

nocturnal spirit Orò, which the uninitiated must not see on pain of death, appears on the Èfè headdress (pl. 16), though so miniaturized that only the initiated can recognize it. At any rate, these examples indicate that the Gèlèdé masking tradition is the more democratic institution, providing a broader basis for male-female interaction (fig. 4.3). Moreover, although it is the men who wear and dance with Gèlèdé masks, they are under the control of the Ìyáláṣè, the woman who holds the highest title in the society.

Given these facts, why is it that only the men dance with the masks? Why do women not have the same privilege? The male elders of the Gèlèdé society gave the following reasons: first, since the mask is performed to honor the women, the honorees should not be asked again to play the role of an entertainer; second, dancing with a mask, like working in wood or metal, is

4.3 Intimate male-female interaction in Gèlèdé—Èfè mask unveiling in order to converse with a female. Ìjió (1991).

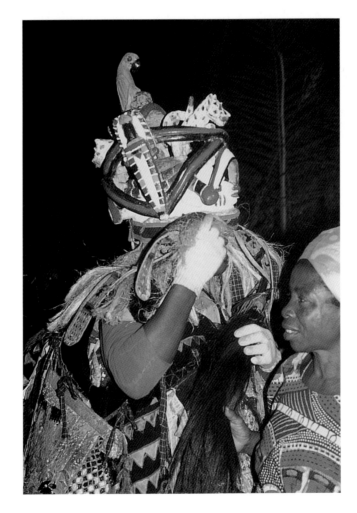

too strenuous an exercise for the female sex; and third, masking, because of its male association, can metaphysically interfere with the innate reproductive powers of a woman. All the women I interviewed concurred with these views, some adding jocularly that the female, with her big breasts and buttocks, would look ridiculous jumping and stamping in those tight Gèlèdé costumes. When I reminded them that some Ṣàngó priestesses are as agile as their male counterparts when dancing to *bàtá* drums, the women immediately replied that, more often than not, such priestesses do so in a state of possession. On the other hand, a Gèlèdé masker must be in full control of his faculties and actions during performance to enable him to respond artfully to the message of the drums. Thus, from all indications, the women do not feel cheated by not being allowed to dance with masks. Rather, it is the men who humble themselves by dancing with masks specifically dedicated to the maternal principle (see also Ọlabimtan 1972:37). The prominence given to the female image in Gèlèdé, coupled with the fact that the maskers are men, apparently bespeaks an attempt by the "male establishment" to appease women in general, and the "powerful mothers" in particular. It is a public acknowledgment of the vital contribution of the female sex to the community; for as mothers, they embody the procreative power of *àṣẹ*, on which depends the survival of organized society as well as the human race.

One significant aspect of Gèlèdé has to do with its approach to the problems posed by witchcraft and other antisocial behaviors. Whereas both Orò and Egúngún enforce the law, executing murderers, traitors, witches, and other dangerous criminals, Gèlèdé takes a less aggressive position, treating witchcraft and other crimes as something that can be overcome with love and goodwill (Morton-Williams 1956:332) in the interest of peace and social harmony (*ìrépò*). It puts more premium on dissuasion and reform than on punitive action because, though the latter may succeed in eliminating one or two culprits at a time, it does not deter others who may become even more virulent and vengeful, thus creating more tension. The strategy adopted in Gèlèdé is twofold: (a) creating a shrine for placating Ìyá Nlá and exhorting her to make life more pleasant for humanity, and (b) staging theatrical performances to entertain and educate the public, and, at the same time, reform antisocial elements.

As all members of the community are welcome to any of its performances, regardless of age, sex, rank, or social status, the Gèlèdé is a social unifier, creating a convivial atmosphere for all and sundry to interact as members of one family, the children of Ìyá Nlá. The introduction of Islam and Christianity to Yorubaland has fragmented families by turning new converts

12. See, for instance, Simpson 1980:123-24.

against friends and relations who still practice traditional religion. Although there are no reliable statistics, it is estimated that over 60 percent of the Yoruba now profess either Islam or Christianity,[12] and many of the latter often distance themselves from traditional festivals because of the public rituals and sacrifices associated with them. Moslems and Christians identify openly with Gẹ̀lẹ̀dẹ́, however, not only because of its popularity as an effective antiwitchcraft remedy but also because it places more emphasis on entertainment and less on public rituals. Indeed, a good number of contemporary maskers are practicing Christians and Moslems. At a ceremony in Ìjió (1991), the Èfẹ̀ masker, Ayélabọ́lá (being a Moslem), mixed verses from the Holy Koran with Yoruba incantations while praying for the community. It is true that some associate with Gẹ̀lẹ̀dẹ́ purely for expedient reasons. As one masker put it: "Fear of death made us join this society. Because the witches cannot harm anybody inside the society" (Beier 1958:6). Ironically, this "fear" has had a positive influence, facilitating social interaction and artistic collaboration among people who would otherwise have been at loggerheads with one another over religious or other differences. Figure 4.4 shows a Christian cleric and a *mallam* (Moslem priest) among

4.4 Two Gẹ̀lẹ̀dẹ́ masks performing before an audience that includes a Moslem priest (turbaned) and a Christian clergyman (in white, next to table). Ìjió (1991).

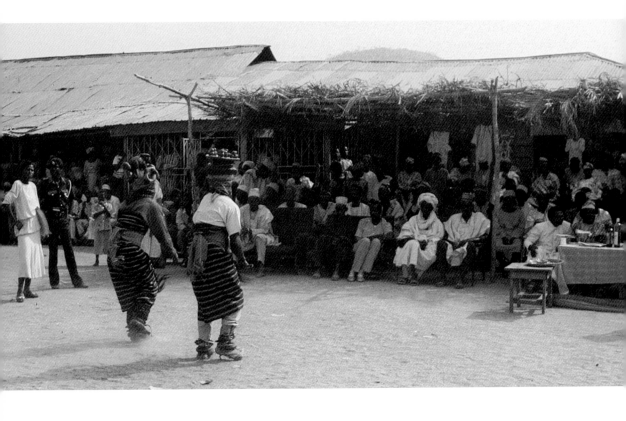

the guests of honor during a Gẹ̀lẹ̀dẹ́ performance.[13] Eliot Elisofon has also photographed a turbaned Moslem cleric watching a Gẹ̀lẹ̀dẹ́ ceremony in Ìmẹ̀kọ.[14]

Membership

Since it is intended to foster social harmony, membership in the society is open to everyone in the community. As Ìyá Nlá is the Mother of All, priests of almost all the òrìṣà participate actively in Gẹ̀lẹ̀dẹ́ ceremonies. Many people derive membership from being born into families with a strong Gẹ̀lẹ̀dẹ́ tradition, while several others become affiliated so as to be in favor with the àjẹ́, the "powerful mothers," the popular suspects whenever an unexpected misfortune befalls an individual. The women tend to outnumber the men in the membership, partly because Gẹ̀lẹ̀dẹ́ celebrates the sacredness of motherhood and partly because of the popular belief that participation in the ceremony can make a woman more fertile. For not until a wife has had a child for her husband is a marriage consolidated. Besides, infertility carries with it a social stigma, an insinuation that a woman "has not fulfilled her primary function in life."[15] This is why the worship of òrìṣà ọlọ́mọwẹ́wẹ́ is popular among Yoruba women. It is pertinent at this juncture to recall the frantic appeal by anxious women (in Ìbàdàn) to Ẹgbẹ́, one of the deities in the complex (mentioned in chap. 3):

Èmi kò ní lọ láìfọmọ sáyé.
Èmi kò ní lo lápàpàndodo.

I shall not die without leaving children behind.
I shall not die empty-handed.

(Simpson 1980:48)

Although the men are equally concerned about their potency—and dancing with the mask, according to popular belief, improves it—they are not as anxious as their wives, because the traditional Yoruba marriage is polygamous. So long as the other wives have children for him, there is little a husband can do about a particular wife who has problems conceiving, except to advise her to see a herbalist or diviner. In addition to treatment, the affected woman may be advised to join the Gẹ̀lẹ̀dẹ́ society in order to win the goodwill of the àjẹ́, in case they are the cause of her problem. Men suffering from impotence may be given the same advice.

13. In 1991, the occasion of the annual Gẹ̀lẹ̀dẹ́ festival at Ìjió was used to launch a development fund for the town. Important members of the community (including non-Yoruba settlers) were invited as special guests. The Christian cleric is an indigene of Ìjió, while the mallam attended as a representative of the Fulani community in the town. A middle-aged Alhaji (Moslem who has performed the holy pilgrimage to Mecca) in the audience told me that he had been attending the Gẹ̀lẹ̀dẹ́ festival since he was a small boy, and that participation in the ceremonies does not conflict with his Islamic faith.

14. See slide No. E2 Yrb. 24.1/EE.70.1., Eliot Elisofon Photographic Archives, National Museum of African Art (Smithsonian Institution), Washington, D.C.

15. Ward (1938:4); quoted in Wolff (1979:125).

Organizational Strategies

To ensure a successful and efficacious performance of all the Gèlèdé rites and ceremonies, special officials, groups, and professionals are charged with specific responsibilities. The titles of these functionaries vary from one community to another, but the following are the most common:

Ìyáláṣẹ̀: The Chief Priestess

The title Ìyáláṣẹ̀ means "mother in the shrine." She is the highest priestess and is the overall head of the society. She is the intermediary between Ìyá Nlá and members of the society and the community at large. She is often thought of as a benevolent àjẹ́. She is in charge of Aṣẹ̀, the Gèlèdé shrine, and is the only one who can enter its innermost recesses. Because of her close interaction with Ìyá Nlá and other powerful women in the community, she must be a woman who has passed the age of childbearing and who has a deep knowledge of Yoruba herbs and liturgy. Whenever sacrifices are offered to appease Ìyá Nlá, it is Ìyáláṣẹ̀ who will inform the supplicant as to whether his or her request has been granted. In the shrine, she offers regular prayers to Ìyá Nlá for the well-being of the community. At the approach of the annual festival, she and her male counterpart, the Bàbáláṣẹ̀, will consult the oracle to determine the exact time. The position of Ìyáláṣẹ̀ is so important in Kétu that her opinion must be sought on important state and religious matters, and she plays an important role during the burial of a deceased king and the installation of a new one (Beier 1958:7; Babatunde 1988:58).

Bàbáláṣẹ̀: The Chief Priest

The title Bàbáláṣẹ̀ means "father in the shrine." As the male counterpart of Ìyáláṣẹ̀, he participates in most of the rituals in the shrine.[16] But his most important function is to organize the program for the Gèlèdé dance ceremonies, most especially during the annual festival. It is his responsibility to inform members of the exact date of the festival, collect levies for organizing it, and assemble materials for costuming the principal masks such as Ìyá, Ẹ̀fẹ̀, and Tètèdé. He is the official keeper of Gèlèdé headdresses and costumes, and he is responsible for their preservation until the next festival.

The Bàbáláṣẹ̀ is essentially an assistant to the Ìyáláṣẹ̀ and a coordinator

16. The Gèlèdé society of Ìsàlè̀-Èkó (Lagos) has no Ìyáláṣẹ̀, but rather the Ìyá Aláràán (mother of the velvet cloth). The Bàbáláṣẹ̀, however, performs most of the rituals in the shrine, wherein a woman may not enter.

of social activities, so his position does not require him to have stopped fathering children. Nevertheless, his appointment must be ratified by Ìyá Nlá and the "powerful mothers." This is done through divination. If the position is vacant and no candidate is readily available, a suitable person in the community may be conscripted. He will, according to popular belief, receive a message in his dreams that the "powerful mothers" require his services. Should the individual ignore the message, he will begin to notice negative changes in his life, ranging from nervousness and sleeplessness, to occupational hazards like carelessly cutting himself with the matchet while working on the farm, or stepping on a thorn and incurring a festering sore. More serious misfortunes may follow, forcing him to consult a diviner, who then traces the cause of his problems and advises him to comply with the request of "the mothers." The Bàbálás̩e̩ is a highly respected person in the community. He is expected to have a deep knowledge of rituals and herbalism. Because of his close contact with Ìyálás̩è, the general public believes that he knows all the "powerful mothers" in the community; many people look up to him for spiritual guidance in times of crisis.

Abọrè: The Male Priest

Also known as Ìwọ̀lé (intermediary) in some communities (Fayọmi 1982:14), this male official is usually in his late forties or early fifties. He is a priest who assists individuals seeking the favors of the àjẹ́ to perform their rituals, such as placing sacrificial offerings in the marketplace, at the crossroads, or by the riverside. In many Gèlèdé communities, this title is hereditary and demands a high knowledge of Yoruba liturgy. This experience qualifies the Abọrè to perform rituals similar to those being done by Ìyálás̩è.

E̩léfè: The Humorist

Also known as Olóṛò̩ È̩fè̩, Òrò̩ È̩fè̩, or Òs̩èfè̩ (poet or wordsmith), this is the man who carries the È̩fè̩ mask on the eve of the annual Gèlèdé festival. During his performance, he prays for the well-being of the society and satirizes antisocial elements in the community. The E̩léfè occupies a vital position in the Gèlèdé society; not only does he represent the collective voice of the people but he also speaks with the unquestionable authority of Ìyá Nlá. He can even ridicule the ọba of the town during his performance with no fear of reprisal.

Two incidents in Ìmèkọ illustrate the powerful position enjoyed by the Ẹlẹ́fẹ̀ in a given community. The first was the arrest by the police of an Ẹlẹ́fẹ̀ known as Ìṣọ̀lá for ridiculing the colonial government during an èfẹ̀ ceremony in the 1940s. But Ìṣọ̀lá was later released from jail on the argument that the seditious songs were authorized by the àjẹ́. In the second incident, one Samuel Akinṣaapọn went blind soon after seducing the wife of Ọdẹmuyiwa Aṣanpaọla, a famous Ẹlẹ́fẹ̀ in the town, and the community interpreted his misfortune as a punishment meted out by the àjẹ́ (Aṣiwaju 1975:203).

To qualify for the position of Ẹlẹ́fẹ̀, a man must be in his middle age or older. He must be experienced, mature, bold, eloquent, sweet-voiced, and poetically inclined, and must be versed in oral literature, aphorisms, and proverbs. These qualities are evident in the various nicknames given to the Ẹlẹ́fẹ̀, such as *Akérédùnlóhun* (small, but sweet-voiced), *Olóhùuniyọ̀* (the one with the salty voice), *Ajíkọigbaorin* (he who wakes up to sing two hundred songs), *Akọmákọtàná* (he who does not sing old songs), *Ayékòfégàn* (the world dislikes contempt), and so on. In some towns, the title Ọmọ́ṣẹ́yùn is conferred on a retired Ẹlẹ́fẹ̀.

Despite its many privileges, the position of Ẹlẹ́fẹ̀ is risky and delicate. Because the Ẹlẹ́fẹ̀ is the only one who can voice in public what no other person in the community would dare to say, he is an object of open or surreptitious vengeance. Unless he is well protected with personal charms, he may not live long, the more so when he also admonishes the àjẹ́! Therefore, by accepting this important responsibility, the Ẹlẹ́fẹ̀ offers himself as a sacrifice for the well-being of the community.[17]

17. I am grateful to Chief Ọjẹlabi Ọlabimtan, the Ọmọ́ṣẹ́yùn of the Gẹ̀lẹ̀dẹ́ society, Ìlaró for this information and for introducing me to other senior members of the society, who provided further valuable data. He also led a group of Gẹ̀lẹ̀dẹ́ dancers to the University of Ifẹ̀, Ilé-Ifẹ̀, to perform at the formal opening of an exhibition of Gẹ̀lẹ̀dẹ́ masks as part of the Fourth Ifẹ̀ Festival of the Arts, December 1971.

Agbẹ́gi: The Carvers

The *agbẹ́gi* are the carvers (fig. 4.5). They do not have to be members of the Gẹ̀lẹ̀dẹ́ society. Apart from relying on local talents, the society may commission headdresses from carvers in other towns, especially if the local talents cannot cope with the magnitude of the work. Although patrons usually specify the themes, the carver enjoys much creative freedom and may add any decorative elements that he feels will enhance the visual appeal of a given commission. The favorite materials for carving are light wood such as *igi ọ̀mọ̀* (*Cordia millenii*), *igi arère* (African white wood), *igi irẹ́* (African rubber tree), and *ẹ̀rìnmàdò* (oil nut tree). These woods are light, compact, and easy to carve.

The carver works with freshly cut wood while it is still moist. A typical

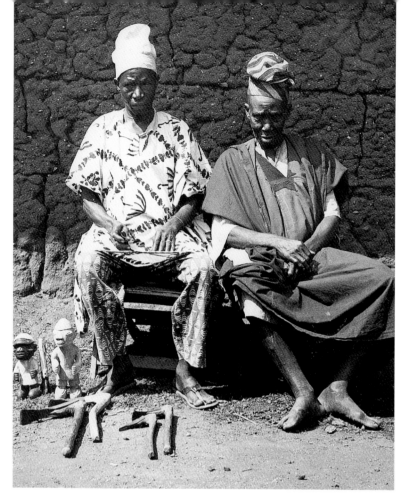

4.5 Two carvers (*agbégi*) with their carving adzes (*àhón*) in the foreground, Ìjió (1969).

headdress is created from one piece of wood, although elaborate ones may have attachments. For blocking out the main forms and scooping out the hollows—a process known as *onà lílé*—the carver uses a big adze (*àhón nlá*) and a matchet (*àdá*). The clarification of forms (*alétúnlé*) is done with a smaller adze (*àhón kékeré*). Smoothing (*dídón*) requires a small knife (*òbẹ*) and an abrasive leaf called *ewe eépín* (*Ficus asperifolia*). A sharp knife is then used to incise surface decorations and to further delineate the features (*fínfín*). After smoothing, the headdress is painted.

The work of a master carver is recognized by the clarity, balance, and relative realism of his form, and by the originality and craftsmanship apparent in the overall composition.[18] Recognition as a master carver commands respect, attracting commissions from far and wide. Famous master carvers include Taiwo Onipaṣan-ọbẹ and Akinwande Ọmọ Onikẹ of Ìlarò; Labimtan and Ọnanẹyẹ of Òtà; Arọbatan of Pobe; Dogá, Adegoke, and

18. For a comprehensive survey of Yoruba aesthetic criteria, see Thompson (1973: 19-61).

Gender and Social Harmony through Gèlèdé 85

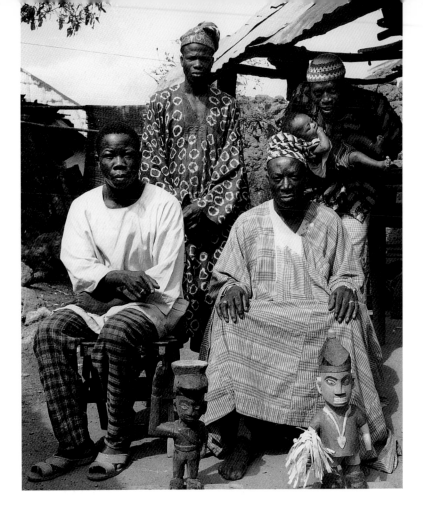

4.6 Michael Labọde, renowned carver, seated right. He sculpted the figures and headdresses in figures 3.5, 6.19, 7.1, 7.33, 7.55, 7.56, and probably 8.7. Ìdòfòyí, Ayétòrò (1971).

Mọṣudi Ọlatunji of Ìmẹ̀kọ; Ọlamide of Ìgbẹ̀sà; Lamidi Alagbẹdẹ of Ìpókíá; Adeiṣa Etuọbẹ and Otọọrọ of Kétu; Fagbitẹ of Idahin; and Michael Labọde of Ìdòfòyí, Ayétòrò (fig. 4.6), to mention only a few.

Akunbẹ̀: The Painter

Ordinarily, a Yoruba carver paints any new work himself. As the annual Gẹ̀lẹ̀dẹ́ festival approaches, however, carvers may have so many headdresses to produce that they do not have enough time and patience to paint each of them. As a result, the Bàbáláṣẹ̀ usually sets up a task force consisting of a few master carvers and their apprentices to paint newly carved headdresses and repaint all the old ones in his custody. Members of this task force, known as *akunbẹ̀* or *amutí* (painters), work under the supervision of one of the most experienced carvers in the area who bears the title of Olórí Akunbẹ̀ or

Olórí Amutí (head painter). Natural colors are produced from leaves, seeds, fruits, stones, charcoal, and kaolin. Dark blue (*àwò jélú*) is obtained from the leaves of the indigo vine; black (*dúdú*) from charcoal (*èédú*); white (*funfun*) from chalk or kaolin (*efun*); green (*àwò ewéko*) from *réré* (*Cassia occidentalis*) or *apako* leaves (*Cleistophilis patens*); red (*pupa*) from assorted seeds, nuts, and mineral stones; and yellow (*tópolá*) from a mixture of yellowish stones and flowers. Each color is prepared in a small pot or calabash and is applied with the tip of a stick that has been chewed or pounded to function like a brush.[19] The repainting takes place inside the compound of the Bàbáláṣè or in an enclosure outside specially erected for the purpose. In recent years, the use of synthetic European colors and also laundry blue (bluing) is becoming popular, giving the headdresses a rather garish finish.

19. For more details on carving and painting materials, see Cordwell (1952); G. J. A. Ojo (1966:236-38); Bascom (1973b:70-74).

Arugi: The Masker

Meaning "wood carrier," the term *arugi* refers to the masker (fig. 4.2). He is also called *agbérù* (load bearer), *ajógi* (he who dances the wooden image), and *ajógèlèdé* (he who dances Gèlèdé). As mentioned earlier, these terms suggest the derivation of the Gèlèdé mask from an ancient tradition of dancing with statues on the head. In any case, an *ajógi* must not only be a good dancer but he must also be familiar with popular Yoruba proverbs and local slogans to enable him to interpret the language of the drums. The acquisition of the drum language starts from childhood, when children imitate the adult dancers during rehearsal. Those who have developed some skills are allowed to wear masks during the annual festival, being thereby given an opportunity to entertain the audience before the adults come on stage. This arrangement enables every able-bodied youth in the community to acquire all the necessary skills by the age of eighteen or so. Only experienced dancers are allowed to wear specialized masks such as the Ògèdè (gorilla) (fig. 5.10), Ẹ̀fòn (buffalo) (fig. 6.18), and Aboyún (the pregnant one) (fig. 6.14), because manipulating these requires exceptional skills.

Onílù: The Drummers

The *onílù* are the drummers whose families specialize in Gèlèdé music. A typical ensemble consists of four wooden, pot-shaped, or cylindrical drums. The biggest drum (about three to four feet high) is called *Ìyá ìlù* (mother drum), and the next in size, *Omele abo* (female *omele* drum). The two smaller ones are known as *Omele ako* (male *omele* drums). In Ìmèko and environs,

the two big drums, called Ọ̀ṣọ̀ṣọ̀ (assistant lead drum) and Ìyá ìlù (mother drum), are approximately of the same size; the smaller ones are called *omele akọ* and *omele abo*. In Ìsàlẹ̀-Èkó (Lagos), the biggest drum is called *Ìyá ìlù* and the next in size is *Èṣọ*. The two small drums are called *Aférẹ́*. Placed very close to each other during performance, the two big drums are beaten with hands, and the smaller ones are beaten with sticks (fig. 4.7).[20] The smaller drums provide steady background rhythms against which the bigger ones speak and interlace a variety of tonal solos in the form of proverbs, popular songs, and slogans. Sometimes the two big drums (mother drum and assistant lead drum) engage one another in a duet, as in the following example from Ìsàlẹ̀-Èkó (Lagos):

20. It is not a rule, however, that the two smaller drums (*Omele akọ*) must be beaten with sticks, as some are beaten with hands.

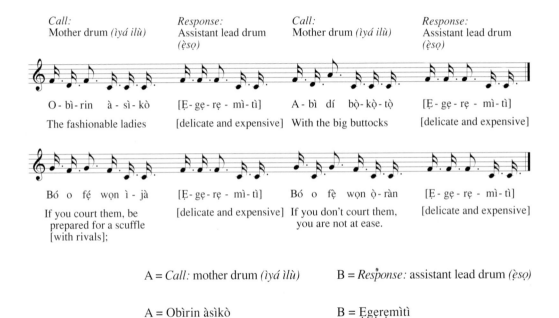

Call:
Mother drum *(ìyá ìlù)*

Response:
Assistant lead drum *(èṣọ)*

Call:
Mother drum *(ìyá ìlù)*

Response:
Assistant lead drum *(èṣọ)*

O - bì- rin à - sì- kò [Ẹ̀- gẹ- rẹ - mì - tì] A - bì dí bọ̀- kọ̀- tọ̀ [Ẹ̀- gẹ- rẹ - mì- tì]

The fashionable ladies [delicate and expensive] With the big buttocks [delicate and expensive]

Bó o fẹ́ wọn ì - jà [Ẹ̀- gẹ- rẹ - mì - tì] Bó o fẹ̀ wọn ọ̀- ràn [Ẹ̀- gẹ- rẹ - mì- tì]

If you court them, be [delicate and expensive] If you don't court them, [delicate and expensive]
 prepared for a scuffle you are not at ease.
 [with rivals];

A = *Call:* mother drum *(ìyá ìlù)* B = *Response:* assistant lead drum *(èṣọ)*

A = Obìrin àsìkò B = Ẹ̀gẹrẹmìtì
A = Abi ìdí bọ̀kọ̀tọ̀ B = Ẹ̀gẹrẹmìtì
A = Bó o fẹ́ wọn ìjà B = Ẹ̀gẹrẹmìtì
A = Bó ò fẹ́ wọn ọ̀ràn B = Ẹ̀gẹrẹmìtì

A = The fashionable ladies B = Delicate and expensive
A = With the big buttocks, B = Delicate and expensive
A = If you court them, be prepared
 for a scuffle [with rivals]; B = Delicate and expensive
A = If you don't court them, you are
 not at ease. B = Delicate and expensive

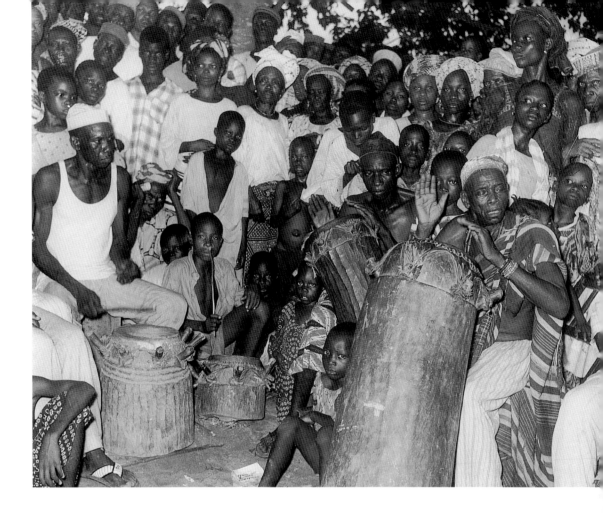

The drums perform two major functions. First, they provide background accompaniments for *èfè* songs during the nocturnal concert. Second, they communicate with the Gèlèdé maskers during the diurnal dances, who respond by synchronizing the jingling of their metal anklets with the drumbeats.

Although other drum ensembles such as *dùndún* (hourglass talking drums), *bèmbé* (double-face barrel drums), or *bàtá* (double-face conical drums) may be present at the dance arena, these perform only during interludes or during the procession to and from the dance arena.

4.7 The Gèlèdé orchestra, Ìbarà, Abéòkúta (1958). The two big drums are beaten with hands; the smaller ones, with sticks. On the extreme right is the lead drummer, Chief Bamgboye Agbégèndè (d. 1971).

Agberin: The Chorus

The *agberin* are the men and women who serve as the chorus during the *èfè* concert and who also accompany Gèlèdé masks with songs on their way to and from the performance arena. Other names for this singing group are

21. Akíjèélé (holder of
the iron rattle); Akódan
(holder of the brass
rattle).

alágbè, abánirò, akíjèélé, akódan, [21] and bòlòjò. The lead singers are called adárin. During the annual festival, members of the Gèlèdé chorus frequently wear dresses made of the same fabric design (aṣọ ẹbí) to project themselves as a social unit (fig. 5.12).

Other Functionaries

Other principal officers of the Gèlèdé society include the Olóri Agbérù, (head of the load carriers), a retired master dancer who coordinates the activities of the maskers, carvers, painters, and costume designers. If the female headwraps and baby sashes are not enough, the Olóri Agbérù helps to collect more from the housewives. Another important official is the Ìya Ijó (dance mother), Ìyá Agbérù (mother of the load carriers), or Ìyálájà (mother of the iron rattle) who acts as the "spiritual mother" of the maskers (fig. 5.15). Her duty is to protect them with her mystical power. In Ìsàlè-Èkó (Lagos), Ìlaró, and other communities, a special title (Gbóndù) refers to the "spiritual father" of the Gèlèdé dancers.

The Ọba and His Chiefs

In Kétu, Ìmèkọ, Ìtakété (Ṣákété), Ayétòrò, Pobe, Ṣábèè, Ìbarà, Ìlaró, Ìjió, Ọtà, and other towns, important chiefs and priests in the community are members of the Gèlèdé society. Although these individuals need not participate directly in its rituals, they are required to identify publicly with the society, since its aspirations are for the common good. The ọba is the chief patron (although he plays a similar role in all the other religious institutions in his domain), and he is required to contribute morally and materially to the success of the annual festival.

Aṣè: Shrine

22. This term (aṣè) is
often confused with àṣẹ
(divine command or
authority) in some
publications on Gèlèdé.

The word aṣè means "the divine source."[22] Usually located in a secluded spot or sacred grove, but not too far from the performance arena, the aṣè is a temple dedicated to Ìyá Nlá. Frequently it has an antechamber for displaying Gèlèdé headdresses. The inner chamber is out of bounds to the uninitiated because it houses the most sacred symbol of Ìyá Nlá, either buried in the ground or covered with a pot. In some shrines a hollow female figure, such as the one illustrated in plate 10, may be placed over the pot.

When they are not in use, Gèlèdé headdresses are usually stored in the

precincts of the *aṣẹ̀*. In Ìsàlẹ̀-Èkó (Lagos), a special altar at the entrance of the *aṣẹ̀* is dedicated to Èṣù and Ògún, so that both deities can expedite action on prayers addressed to Ìyá Nlá. On the eve of the annual festival, or on any other occasion requiring the performance of the *èfẹ̀* concert, the Èfẹ̀ masker dons his costume inside the shrine. In some towns, the Ìyáláṣẹ̀ (chief priestess) places the wooden mask on his head. Where the shrine is too far from the performance arena, a special enclosure, serving as a substitute for the shrine, may be erected nearby, and it is here that the Èfẹ̀ and other maskers put on their costumes.

Ojú Agbo: Performance Arena

Ojú agbo means "the performance arena." As the nocturnal concert and the diurnal dance usually take place in the marketplace (*ọjà*), the performance arena is also called *ọjà* Èfẹ̀ (Èfẹ̀'s market) during the nocturnal concert and *ọjà* Gẹ̀lẹ̀dẹ́ (Gẹ̀lẹ̀dẹ́'s market) during the diurnal dance. The principal market in the town is the most appropriate venue because it is controlled by women (to whom Gẹ̀lẹ̀dẹ́ is dedicated) and is close enough to the *ọba's* palace to enable the *ọba* and the important chiefs to attend. It is the most spacious and centrally located arena and, above all, is the hub of social, cultural, and economic activities in the town. To the Yoruba, the market is a microcosm of the physical world. Hence the saying: *Ayé l'ọjà; ọ̀run ni ilé.* (The world is a market; heaven is home.)[23] Moreover, the trees surrounding a typical market, providing shade in the afternoon, are thought to be inhabited by spirits (G. J. A. Ojo 1966:107). The Yoruba believe that supernatural beings of all sorts—the *òrìṣà,* ghosts, demons, and the spirits of deceased ancestors and those of unborn children and even animals— frequent the market under different guises to do business with human beings or simply to watch the goings-on. Thus, the market is a meeting point between the visible and the invisible, the known and the unknown. And as every market has a shrine dedicated to Èṣù, the divine messenger, to ensure peace and orderliness, it is the ideal place for projecting the message of Gẹ̀lẹ̀dẹ́ onto the physical and the metaphysical planes.[24]

The size of the open space available in the market determines the extent of the performance space. A temporary double arch made of palm leaves (*ẹnu aṣẹ̀*) marks the entrance to the performance space (fig. 4.8). The Gẹ̀lẹ̀dẹ́ orchestra occupies the opposite end. The masks enter the performance arena through the double-arch entrance termed the *ẹnu aṣẹ̀*, or "gateway to the

23. See also Lawal (1977:54).

24. See also Drewal and Drewal (1983:10).

4.8 The double arch of palm leaves (*ẹnu aṣẹ̀*) marking the entrance to the performance arena (*ojú agbo*).

shrine," which declares the marketplace, the performance arena, to be a hallowed ground, forbidden to normal commercial activities until the festival is over. (This tradition has been modified in some towns as a result of modernization. The hawking of essential commodities is allowed in some venues so as not to hamper economic growth. In the past, spectators brought their own refreshments to the venues. Today, many depend on food vendors who prepare and sell special snacks for the occasion.) In effect, the *ẹnu aṣẹ̀* symbolically annexes the performance venue to the Aṣẹ̀ (shrine), converting it into a kind of ritual theater and thereby bringing Ìyá Nlá herself closer to the masses during the festival.

Ètùtù: Gèlèdé as Ritual Pacifier

As noted in chapter 3, the Yoruba cosmos is a delicate balance of benevolent and malevolent forces sustained by Èṣù and Ọrúnmìlà, whose ultimate mission is to protect the human interest. Although the àjẹ́ have the power to do both good and evil, it is their negative image that looms large in the mind of most Yoruba, who therefore associate them with the *ajogun* or malevolent forces. Further increasing the awe with which the general public holds the àjẹ́ is the belief that they are more powerful than most of the òrìṣà. For example, the Ifá divination verse *Odù Ọ̀sá Méjì* reports that the àjẹ́ arrived naked at the border between heaven and earth. So, they implored three deities (Ọbàtálá, Egúngún, and Ọrúnmìlà) to lend them some clothes. Ọbàtálá and Egúngún refused. Ọrúnmìlà, on the other hand, took pity on the àjẹ́, agreeing to transport them to the earth in his stomach. But on reaching the earth, the àjẹ́ refused to come out of Ọrúnmìlà's stomach, preferring to stay there permanently. After pleading with them for a long time to no avail, Ọrúnmìlà warned that hunger would soon drive them out. The àjẹ́ replied that they would never be hungry because they would be feeding on Ọrúnmìlà's intestines and liver! Ọrúnmìlà then realized his predicament. He ran to the house of one of his diviners, who recommended that he offer a special sacrifice. When Ọrúnmìlà offered the sacrifice and asked the àjẹ́ to exit from him, they did so voluntarily. After the last one had left, Ọrúnmìlà ran into his bedroom and did not come out for three months (Abimbọla 1975a:35-40). As a result of this event, Ọrúnmìlà advised humanity to exercise great caution when dealing with the àjẹ́.

The most important message in this myth is that Ọrúnmìlà solved his predicament through the offering of a sacrifice (*ẹbọ*). Yoruba religion places much emphasis on sacrifice because of the belief that it has very strong placatory, prophylactic, and curative powers (Abimbọla 1976:37; Awolalu 1979). Indeed, almost all prescriptions by Yoruba diviners to their clients involve some type of sacrifice. To the Yoruba, sacrifice is a ritual pacifier uniting all the forces of the cosmos, canalizing them toward the realization of the objectives of the sacrifice (Abimbọla 1976:37; Prince 1964b).[25]

Being pacificatory in nature, the Gèlèdé spectacle is a form of ritual (*ètùtù*). Its main objective is to use aesthetics to neutralize evil (*ibi*) and stimulate warm affection (*ìyọ́nú*) at the same time. A Gèlèdé performance is called *ètùtù àdáṣe* when sponsored by a household, family, neighborhood, or an individual to accompany a prayer, or as an act of thanksgiving. Normally recommended by a diviner or the Ìyálásẹ̀, and staged at any time of the year,

25. For other interpretations of Yoruba rituals, see Olupọna (1991a); M. Drewal (1992); and Apter (1992).

the individually sponsored performance is usually on a small scale, although much depends on the resources at the disposal of the sponsor. If, for example, a diviner or the Ìyálásè reveals that the *àjé* or the *ajogun* are responsible for the persistent misfortunes in the life of an individual, the family members are expected to provide all the moral and material supports they can muster to ensure an impressive Gèlèdé performance. According to several informants, the more impressive an individually sponsored performance, the greater one's chances of winning the favors (*ìyónú*) of Ìyá Nlá and the *àjé*. On the eve of the performance, the Ìyálásè worships Ìyá Nlá on behalf of the sponsor. This is followed by a mini-concert of songs (*orin èfè*), invoking the blessings of the *àjé* and other supernatural forces. On the second day, colorful masks stage dances in front of the sponsor's house, or in the nearest marketplace. Sometimes the night concert is omitted altogether, with both singing and dancing being done the same day. At times, it is not the *àjé* who is responsible for an individual's misfortunes. The oracle may reveal that a neglected deity or ancestor is the cause, and that the individual should sponsor a Gèlèdé performance to placate the offended spirit. On the other hand, an individual who has been successful in business or other ventures may sponsor a special performance to express his or her gratitude to the *àjé* and the ancestors. In Igbóbì-Sábèé in 1972, I witnessed a ceremony sponsored by a mother of twins to honor her children and her deceased parents, to whom she attributed her success in life and her recent profits in the retail business (fig. 8.1). On the occasion, she presented a gift of one black goat and several tins of palm oil and assorted foodstuffs to the Gèlèdé society. In addition, individuals may sponsor special performances to celebrate a wedding ceremony, to mark the laying of the foundation stone of a house, or to commemorate the death of important personalities in the community.

Unlike the smaller ceremony sponsored by an individual, which is restricted to a few members, the communally sponsored ceremony (*ètùtù gbogbo ìlú*) is more elaborate, being the concern of the entire Gèlèdé society. Organized at any time of the year, it is a ritual aimed at enlisting the spiritual support of Ìyá Nlá, the *òrìsà,* and deified ancestors to ensure victory in warfare, or to prevent and combat catastrophes such as disease, premature deaths, drought, invasion of locusts, crop failure, flood, and forest fires. The annual festival (*ijó odún*) usually takes place during the dry season; that is, between November and April. In some communities, it falls toward the end of the yearly cycle of religious festivals, its colorful displays providing a fitting finale to the ritual calendar. In others, it comes after the Egúngún and Orò festivals, relaxing the tension generated by their

aggressive anti-witchcraft rituals and the night curfews that sometimes accompany them. In any case, because the communal Gèlèdé festival takes place during the dry season when there is little to do on the farm and many people are at home enjoying the year's harvest, there is plenty of food to eat and less likelihood of the rain disturbing the festival. This is an occasion for offering thanks to Ìyá Nlá, in particular, and all the deities for protecting the interests of the community: for ensuring good harvests, good health, abundant births, and safe delivery of children, and for reducing the incidence of natural disasters and premature deaths. The success of the festival depends on the participation of all and sundry, since this will demonstrate to all the supernatural beings believed to be watching the ceremony that the community is indeed grateful. The demonstration of gratitude (ìmọ ore) is a major principle in the Yoruba code of ethics and in the relationship between the individual and his òrìṣà (Lawal 1981:335). Hence the proverb: Ẹni tí a ṣe l'óore tí kò dúpẹ́, bí ọlọ́ṣà kó ni l'ẹ́rù lọ ni. (Helping an ingrate is as good as losing property to a robber.) But to show gratitude is to kindle greater acts of compassion and philanthropy: Ẹ ní dúpẹ́ ore àná, á gbà míràn si i. (A person who shows gratitude for the last favor will surely receive a new one.)

Ètò Ìṣúná: The Economics of Gèlèdé

Individuals or families sponsoring private ceremonies (either to honor their dead relations, or for ritual purposes) normally shoulder the expenses (ìnáwó) of feasting both the performers and invited guests. On the other hand, the cost of staging a major ceremony, or festival in honor of Ìyá Nlá, is the full responsibility of all members of the Gèlèdé society. In the past, the festival was celebrated with much feasting and rejoicing because it was also the time for formally installing (ìjoyè) new Gèlèdé officials and for giving honorary titles to those retiring due to old age. Important Gèlèdé families prepared large meals (àṣè ọdún) every day of the festival, distributing portions to neighbors, friends, and close relations. This involved almost the whole community or village in a series of gift exchanges designed to promote fellowship and goodwill. The king, his senior chiefs, and the elders of the Gèlèdé society (particularly Ìyálásè, the chief celebrant) also entertained important guests, especially invitees from other towns. To reduce the expenses of feasting the public continuously for seven days or more, the hunters' guild usually organized "cooperative" hunting expeditions several weeks before the festival. The catch would be taken to the house of the

Ìyálàṣè, who apportioned it among the chief hosts. The rich and the famous contributed foodstuffs like yam, yam flour, garri (ground cassava), roasted meat, dry fish, vegetables, palm oil, and spices. The head of the palm-wine tappers normally organized his men to ensure that locally brewed beer flowed freely during the festival. The drummers performed free of charge. All the professional carvers in a given community who were active members of the Gèlèdé society provided some free services for other members, such as helping to repair slightly damaged headdresses and charging much less for producing new headdresses. If the professional carvers in a given community could not cope with the number of headdresses required, the Bàbáláṣè could procure the services of reputable carvers from neighboring towns. In pre-colonial times, the carvers received payments for their services in form of goods, such as foodstuffs, fabrics, beads, pottery, iron implements, and other valuable commodities, or the monetary equivalent in cowrie shells (*Cypraea moneta*), the ancient Yoruba currency—contributed by Gèlèdé members. As a result, most of the headdresses formerly belonged to the society, not to individuals. Certain families, however, may claim ownership of some of the major masks by virtue of being descendants of their founders or first custodians—in which case these families are responsible for almost all the expenses involved in costuming such masks during the festival. For example, in Ìbarà the Agbépọ family is in charge of the Ògèdè (gorilla) mask, and the Olúwo family owns the Ẹfọn (buffalo) mask. In Ìlaró, three wards—Modeolu, Iluata, and Ọnọlà—share the responsibilities for different aspects of Gèlèdé, each controlling a set of masks (Drewal and Drewal 1983:248). In Ìsàlè-Èkó (Lagos), the Agbolé Ẹléfẹ̀ (Ẹléfẹ̀'s compound) controls the Èfẹ̀ masks, while Agbolé Gbóndù (Gbóndù's compound) organizes dance rehearsals for Gèlèdé maskers in preparation for the annual festival.

The principal materials for the Gèlèdé costume consist of female headwraps (*gèlè*), baby sashes (*ọ̀já*), and metal anklets (*aro, ìkù*). Tradition requires each masker to borrow the *gèlè* and *ọ̀já* from family members (namely, his mother, sisters, wives and other relations), and to procure the metal anklets from a local blacksmith. If, for any reason, a particular dancer finds it difficult to obtain any of these materials, he is free to contact the Olórí Agbẹ̀rù (the coordinator of the maskers) or the Bàbáláṣè for assistance.

The introduction of modern currency and a new economy by the French and the British colonial administrations at the turn of the century has since changed the picture. Faced with new financial responsibilities such as taxes,

payment of house rents, and the rising cost of food, transportation, and manufactured goods, the carvers now demand hard currency for their services. Responding to the situation, the Gẹ̀lẹ̀dẹ́ society imposes a general levy on members to meet the costs of the festival. Although certain headdresses continue to be communal property, more individuals are commissioning headdresses directly from carvers. Such headdresses belong to the individuals rather than to the group. In many communities, the structure of the society has been modernized. New posts of honorary secretary (akọ̀wé ẹgbẹ́) and treasurer (akápò ẹgbẹ́) have been created (and held by literate members) to keep records of meetings and financial transactions. In some cases, gifts of money received by a masker during performance go to the coffers of the society; but in others, the masker receives a certain percentage of the gifts. In Lagos, the maskers are responsible for all aspects of their costumes, some of which they hire for a fee. As a result, these maskers keep almost all their earnings to help defray some of their expenses. Also, each masker is required to pay a token fee to the drummers before being allowed to dance, with the proceeds being used to maintain the drums. Gẹ̀lẹ̀dẹ́ societies in urban areas generate additional income from honoraria received for performing on radio and television, and at arts festivals sponsored by government agencies and universities. Some talented members of the Gẹ̀lẹ̀dẹ́ orchestra have gone solo or have formed dance bands, performing for a fee on social occasions and producing commercial records.[26]

26. For instance, Fasco Dagama, an Ẹ̀gbádò-born Jùjú musician, uses the Bọ̀lọ̀jọ̀ rhythm of Gẹ̀lẹ̀dẹ́. See Waterman (1990:95).

To summarize, the dedication of Gẹ̀lẹ̀dẹ́ to Ìyá Nlá, the maternal principle in the Yoruba cosmos, not only unites culture with nature, the sacred with the profane, the temporal with the timeless, the mythical with the historical, the living with the dead, and the male with the female but it also provides a focal point for all members of a given community to relate as children of Yewájọbí (the Mother of All), and to appreciate the importance of fellowship and connectedness to human survival. Above all, the Gẹ̀lẹ̀dẹ́ festival, dramatizing ifọgbọ́ntáayéṣe (the application of human skills and intelligence to improve the world) creates a unique opportunity for the celebrants to use art (ọnà)—itself an integrated phenomenon—to reinforce their corporate identity by creating a spectacle (ìran) that delights the senses, elevates the soul, and nourishes the human spirit.

Ìran

The Gẹ̀lẹ̀dẹ́ Spectacle

Kí l'à npè l'onjẹ ojú?
Kí l'ó nyó ojú bi ọkà ti nyó ikùn?
Ojú kò l'onjẹ méjì bíkòṣe ìran

.

Méjì pàtàkì n'irúfẹ́ rẹ̀
[5] Idán, oríṣi ìran ni
Ẹwà, orísi ìran mí l'èyí
Ojú kì írẹ́wà k'ó máá ki i
Ènìà kì íko adárabíegbin k'óma wò ó

.

"Eégún npidán l'ọ́jà, jẹ́ á lọ wò ó."
[10] Onjẹ ojú la fẹ́ fi fún un. . . .

What do we call the food for the eyes?
What pleases the eyes as prepared yam flour satisfies the stomach?
The eyes have no food other than a spectacle.

.

There are two types.
[5] Magical performance is one type of spectacle;
Beauty is another.
Never will the eyes fail to greet the beautiful one;
Never will the eyes fail to look upon one-as-elegant-as-a-kob-antelope.

.

"Egúngún masks are performing in the market; let us go
 and watch them."
[10] It is because we want to feed the eyes. . . .

(Babalọla 1970:39. My translation)

This poem by Adeboye Babalọla, the renowned Yoruba scholar of African oral literature, shows the importance attached by the Yoruba to artistic, acrobatic, or magical display as a means of securing attention and thereby influencing both the human and the divine. The ultimate aim of such displays is to create a spectacle (*ìran*) seldom occurring in everyday life, and

hence a relish for the eyes. Conversely, *ìran* is a memorable experience (*ohun ìrántí*), lingering, visually and aurally, in the subconscious, as the individual recalls with wonder and admiration the inventiveness of a performer or artist. As Babalọla has rightly pointed out, there are two types of *ìran:* the performative (magical or choreographic display), and the visual (beauty or *ẹwà* in natural and artistic forms). In the visual arts, *ìran* is manifest in a well-painted, embroidered, or sculpted image called *àwòrán* (picture). The term *àwòrán* is a contraction of *à-wò-rántí*, literally, "what we look at and remember" or "a visual reminder." It has two levels of signification. At one level, it refers to a representation that directly or indirectly reminds the viewer of the referent, such as when an anthropomorphic carving recalls a human being.[1] At the second level, it refers to that ingenuity of execution which so strikes the senses as to create an unforgettable experience. The two levels intersect in Gẹ̀lẹ̀dẹ́, through a synthesis of painting, sculpture, textile design, music, and the dance, not only to delight the senses but also to establish a framework for regulating the social and cosmic orders.[2] To this end, masks, representing different aspects of visible and invisible nature, entertain and educate during the festival.

Ọdún: The Festival

As noted in chapter 4, although the Gẹ̀lẹ̀dẹ́ ceremony may be staged at any time of the year (i.e., to better the lot of an individual, to cleanse the society of pestilence, to induce rain, to enrich human fertility, to enlist the support of supernatural forces and the "powerful mothers" in wartime, and to honor the dead), the most elaborate performance occurs during the annual festival (*ọdún* Gẹ̀lẹ̀dẹ́). But partly because of the huge expenses involved and partly because of the long time required for planning it, some communities do not hold the festival annually, but do so once in every two or three years, or only when crisis requires the intervention of Ìyá Nlá. In any case, once the exact dates are fixed (usually through divination), the Ìyálásẹ̀ notifies the head of the community and the important chiefs. In Lagos, the message is sent through a male mask called Amùkòkò (the pipe smoker). Wearing a headdress adorned with carved medicinal gourds (*àdó*) and with a black smoking pipe (*ikòkò*) jutting out of the mouth (fig. 5.1), the Amùkòkò dresses in a white flowing robe (*agbádá*) and holds a long staff (*ọ̀pámbàtà*).[3] The mask is accompanied by two or more guides and several youths, all singing and clapping:

1. In essence, *àwòrán* or *àwòrántí* signifies a pictorial abstraction or a representation that recalls its referent. For more on this, see Lawal (1981:318-25).

2. For a different interpretation of *ìran,* see Drewal and Drewal (1983:1-2) and M. Drewal (1992:13-14). As Babalọla has clearly shown in the above-quoted poem, *ìran* (spectacle) has secular and religious dimensions. It is not always an "otherworldly" phenomenon, as some scholars have suggested.

3. The *ọ̀pámbàtà* is normally used by the Èyọ̀ mask.

5.1 Headdress of Amùkòkò (pipe smoker), the mask whose arrival in the streets announces the approach of the Gẹ̀lẹ̀dẹ́ festival in Lagos. Ìsàlẹ̀-Èkó, Lagos (1993).

Amùkòkò
Ṣ'ẹnu gbàndù gbándú,
Oní iṣẹ́ nlá,
Amukòkò
Ṣ'ẹnu gbàndù gbándú.
Ikú mà ṣòro.

The pipe smoker
With the big mouth,
The great messenger,
The pipe smoker
With the big mouth.
Death is a painful thing.

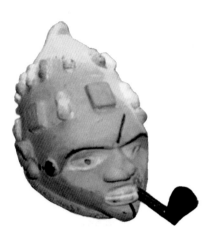

The mask represents Èṣù, the divine messenger of all the *òrìṣà*. The carved gourd on its headdress recalls the praise-name of Èṣù as *oníwọ̀wọ́ àdó* (the one with magical gourds). The smoking-pipe motif usually identifies Èṣù in Yoruba iconography. The headdress has welts and deep cuts on the face, deriding the facial marks of the Fon of the Republic of Benin, whose army raided southwestern Yorubaland during the nineteenth century. In any case, once the Amùkòkò appears in the streets, everybody knows that the Gẹ̀lẹ̀dẹ́ festival will soon begin. The Èṣù Gbángbáde mask performs a similar function in Ìlaró. A few days later, a town crier goes round the town, announcing the exact dates. The mode of announcement varies from one town to another, but whatever form it takes is a signal for preparations to start.

Messages go out to all members of the Gẹ̀lẹ̀dẹ́ society outside the town or working in distant farms to return home. Maskers, singers, and drummers report to the Bàbáláṣẹ̀ or the Olórí Agbẹ́rù (who is in charge of costuming). If the headdresses are not enough, more are commissioned from the carvers; old ones are cleaned, repaired, and repainted. Meanwhile, the Ẹlẹ́fẹ̀ (the Èfẹ̀ masker), assisted by one or two elders of the Gẹ̀lẹ̀dẹ́ society, updates his information on current affairs and past events. Members of the Gẹ̀lẹ̀dẹ́ chorus, Bọ̀lọ̀jọ̀ or Agberin, meet regularly to rehearse new songs. Drumming fills the air every evening as prospective maskers practice in the compound of the Olórí Onílù (the head drummer). Moved by the beats, nonmembers of the Gẹ̀lẹ̀dẹ́ society living in the same neighborhood sometimes echo the drum texts, mimicking the dance movement of a typical mask inside their houses.

As the week of the festival draws near, considerable excitement fills the air as relatives living in distant places return home. It is a time of family reunion and for renewing acquaintance with old friends and members of one's age group. Individuals with problems such as ill health, persistent misfortunes, impotence, barrenness, or business failure throng the Gèlèdé shrine (Aṣẹ̀), petitioning Ìyá Nlá through the Ìyáláṣẹ̀. Those whose lots seemed to have improved during the year present her with offerings of gratitude. In general, everybody is thankful to Olódùmarè (Supreme Being) for having spared his or her life to witness the beginning of yet another festival.

Ẹ̀fẹ̀: The Nocturnal Ceremony

The festival begins with an all-night concert called èfẹ̀ (night of fun), because the star performer of the night is the Ẹ̀fẹ̀ male mask (the humorist), who entertains Ìyá Nlá, the àjẹ́, and the general public with songs, poetry, and satire. In the afternoon, before the èfẹ̀ ceremony, a series of rites (ètùtù) takes place inside the Aṣẹ̀. The Ìyáláṣẹ̀ prepares a large meal, offering a portion to Ìyá Nlá and sharing out the rest among the officiants as well as important personalities in the town. Important Gèlèdé families also prepare meals (Àsè ọdún), part of which they distribute to friends, neighbors, and relations to promote amity and reinforce communal ties. There is a general belief that these meals, also called sààráà (redemption food), generate good luck and wellness.[4]

In most communities, the èfẹ̀ ceremony is celebrated in the marketplace (ọjà). Early in the afternoon, selected women sweep the grounds, after which the men erect the double-arch entrance (ẹnu aṣẹ̀) made of palm leaves. This gateway immediately sacralizes the entire area. In some cases, a section of the grounds is fenced off with palm leaves to provide a measure of privacy for the maskers, especially when they are putting on or removing their costumes. Late in the afternoon, the drummers position themselves on the opposite end of the double-arch entrance, warming up for the night's ceremony. At this time, it is the apprentices or the sons of the master drummers who perform, and soon small children and youths cluster round the orchestra, some seizing the opportunity to learn the basic dance steps. The drumming further heightens the festive mood that has already enveloped the town. People hasten to complete their household chores. The sick and the aged arrive about two or three hours early to secure vantage positions, although

4. The word *sààráà* is an Arabic loan word in the Yoruba language meaning "charity" or "alms."

the ceremony does not normally begin until about ten o'clock at night. Special places near the double-arch entrance are reserved for the ọba, the chiefs, and other important personalities, as well as the old women suspected to have mystical powers. In the past, a small fire in front of the drummers lit the arena, and in towns such as Pobe, the whole concert took place in total darkness (Beier 1958:15). Today gas lamps, kerosene lanterns, or electric installations are common.

As the time for the formal opening draws near, tension mounts among the audience. There is much pushing and elbowing as latecomers struggle to secure a good view. At times, a sudden push from behind sends a strong ripple through the throng, causing the people in the front to stagger forward, crossing the imaginary line that circumscribes the space reserved for performance. This immediately attracts the attention of the crowd controllers (atúnagboṣe), a group of able-bodied men with whips in hand. They rush to the scene striking the ground with their whips, ordering the people to move back. There is brief pandemonium, but order is soon restored. In the course of the disorder, some people have been displaced from their original positions—some husbands from wives, brothers from sisters, children from their parents. The person now standing or squatting next to you is a stranger. Who this person might be, you do not know.

Of course, all sorts of spectators will attend this concert, otherwise known as ọjà Èfè (Èfè's market). Demons, forest beings, spirits of deceased ancestors, and even some of the òrìṣà are expected to attend, all disguised as human beings. Ìyá Nlá herself, some speculate, will be present incognito among the old women. If there are big trees near or around the market, people imagine that they harbor supernatural beings in their branches. The strange flicker of light on the mass of human bodies coupled with the overwhelming shadow of the night often transforms the market into a completely different place. This setting is probably responsible for the popular belief that the utterances of the Èfè mask during the ceremony will come true, being endorsed by all the supernatural forces present. Thus, when Ida Alaba and Bankọle Ọkanilẹkẹ—two chefs de canton imposed by the French colonial administration on Kétu—died under tragic circumstances about 1919 and 1947, respectively, many people attributed their deaths to the curses uttered on them during èfè ceremonies (Aṣiwaju 1975:258n.7). Conversely, any propitious event that follows the ceremony is owing to the goodwill of the same supernatural forces.

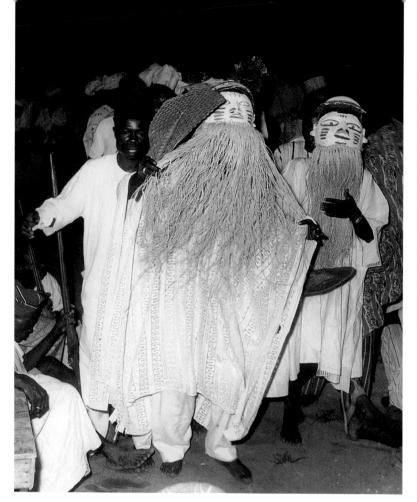

5.2 Ẹ̀fẹ̀ mask and his assistant (with hand fans) arriving at the performance venue. Called *owó so* (money fruits), the lace material for the Ẹ̀fẹ̀'s robe (*agbádá*) was in vogue among the Yoruba in the 1950s. The men holding Dane guns (*ìbọn*) belong to the local hunters guild. In many communities, the guild welcomes the Ẹ̀fẹ̀ mask with a gun salute. Onídá marketplace, Ìbarà, Abẹ́òkúta (1958).

The Preamble

The *èfè* ceremony begins as soon as word reaches the shrine that the chairman of the occasion (usually the *ọba* of the town) has taken his seat. Meanwhile, all the masks to perform during the night assemble in the shrine or in an enclosure near the marketplace. After putting on his costume, the Ẹ̀fẹ̀ moves toward the Ìyálásẹ̀, who blesses him, assures him of the support of the "powerful mothers," and then puts the headdress on his head in the same manner as an *ọba* is crowned. In Ìmẹ̀kọ, the Ìyá Ijó (dance mother) performs a similar function, assuming the role of Ẹ̀fẹ̀'s spiritual mother during the festival. In other towns, it is the Bàbálásẹ̀ who "crowns" the Ẹ̀fẹ̀, after which the Ìyálásẹ̀ blesses him. When everything is ready, the elders of the Gèlèdé society lead all the masks performing that night out of the shrine, singing and dancing as they head for the performance venue (fig. 5.2). In Ìmẹ̀kọ, the following processional song (*Orin ìpìlẹ̀*) is sung:

Pẹ̀lẹ́, pẹ̀lẹ́ l'alẹ́ ílẹ́.
Pẹ̀lẹ́, pẹ̀lẹ́ l'oòrùn íwọ̀.
Pẹ̀lẹ́, pẹ̀lẹ́ o,
Ìyá Nlá, Ìyá Agbo

.

[5] Ògún 'Jàyè,
Ẹ̀sọ̀ l'ayé.
Ìyá,
Ayé kò gbe èle o.

Gently, gently descends the night.
Gently, gently sets the sun.
Gently, gently,
Great Mother, Mother of All

.

[5] Ògún 'Jàyè,
The world is fragile.
Mother,
Life should not be lived with force.

(Recorded in Ìmẹ̀kọ, 1971. My translation)

While the masks stay behind in a special enclosure in the marketplace, elders of the Gẹ̀lẹ̀dẹ́ society and the chorus singers troop into the performance arena, dancing to the pulsating rhythm supplied by the master drummers (fig. 5.3), who have since taken over from their apprentices. The audience joins in the singing; everybody, including the aged and the sick, swings along, charging the atmosphere with heavy vibrations. The sound of a gong soon brings the preamble to an end. There is perfect silence as the preliminary masks prepare to enter the arena.

The Preliminary Masks

The sequence and names of the preliminary masks vary from one town to another. In Kétu, where the most elaborate ceremony takes place, the order is as follows. The first mask to enter the arena is Ọ̀gbàgbá. It makes two appearances, in two guises. First it appears as a young boy wearing a raffia skirt and carrying a small image on the head. The audience welcomes him with a song identifying him as a representative of Èṣù, the divine messenger. The boy soon disappears, and the same Ọ̀gbàgbá returns to the arena as

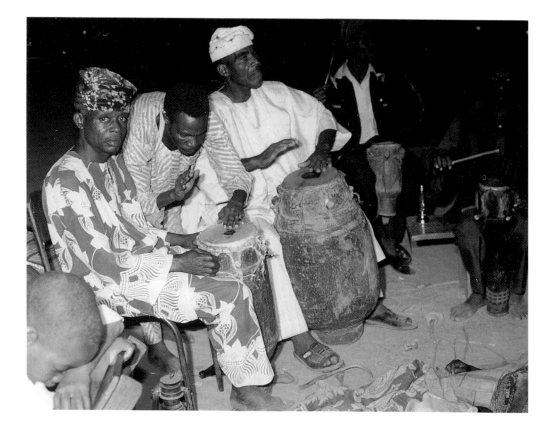

an adult wearing metal anklets and a skirt of banana leaves. The audience welcomes him again; this time with a song describing him as a collector of leaves from rubbish heaps.

5.3 Gẹ̀lẹ̀dẹ́ master drummers during ẹ̀fẹ̀ ceremony. Ìjió (1991).

After Ọ̀gbàgbá comes the Àràbí Ajígbálẹ̀ (Àràbí, the morning sweeper), whose costume consists of dry palm fronds. He represents Ògún, the iron deity, who uses his cutlass to clear the way for the other òrìṣà. The audience welcomes Àràbí Ajígbálẹ̀ with a song portraying him as the one "who sweeps the floor with his dress." The next two masks appear in quick succession; the first, called Agbéná (fire carrier), carries a pot of fire on his headdress and moves swiftly across the arena, warning farmers to beware of bush fire; the second, Apaná (the fire extinguisher), orders that all lights be put out because "the bird of the night" is approaching. According to Afọlabi Ọlabimtan, Agbéná and Apaná represent Ṣàngó, the thunder and lightning deity, and Ọya, his wife, the goddess of the storm and the Niger River (1972:39). In any case, the appearance of the Apaná (the fire extinguisher) plunges the performance arena into darkness, as all lights are put out, sig-

naling the approach of Ìyá, the sacred mask representing Ìyá Nlá, the Great Mother.

The blackout heightens the awe. Soon the Ìyá mask arrives; she wears an all-white costume with a long train of cloth trailing on the ground behind her. Elders of the Gèlèdé society cluster round the mask, all singing the praises of Ìyá Nlá and the "powerful mothers," inviting them to descend onto the arena and participate in the ceremony. After dancing round the performance arena and encircling the marketplace—a ritual aimed at warding off negative forces—the mask retires to the Gèlèdé shrine.[5] The lights return, and the audience awaits the appearance of the Tètèdé mask, who will introduce Èfè, the "king" of the night.

It is important to emphasize at this juncture that the details of the preamble vary from town to town. For instance, in Ìlaró, only the bird mask, Ọ̀ṣọ̀ṣọ̀bí, representing the power of the *àjẹ́*, precedes the two principal performers, the Ajákùẹnà (the path clearer) and Èfè. Since the Ọ̀ṣọ̀ṣọ̀bí represents Ìyá Nlá, it performs the same function as the Great Mother masks of Kétu, Kove (fig. 5.4) and other areas. The Ajákùẹnà is synonymous with

5. See also Ọlabimtan (1972); Drewal and Drewal (1983).

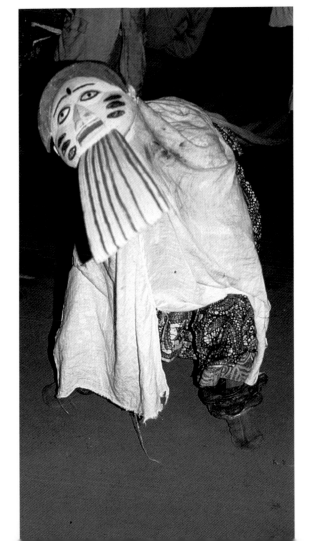

5.4 The Ìyá mask, representing Ìyá Nlá, the Great Mother. Kove, Republic of Benin (1972).

Tètèdé. In Ìmẹ̀ko, Ìjió, Ìbarà, Ìtakété, and Lagos, among other towns, no other masks appear before Tètèdé and Èfẹ̀.[6] But in Pobe, there is no Tètèdé. In most communities only one Èfẹ̀ mask performs throughout the night; however, in towns such as Ṣákẹ́tẹ́ and Ìsàlẹ̀-Èkó (Lagos), between three and four masks, representing different houses, may perform in turns at the same venue or at different places the same night (see also Beier 1958:15; Thompson 1974:201). In Ìsàlẹ̀-Èkó, two or more masks, performing at the same venue, bear special names such as Abóṣùpálà (the one who appears with the moon); Ayékòfẹ́gàn (the world dislikes contempt); Ajénifújà (wealth begets luxury); and Ẹnujọpéwò (all mouths gather to watch). Experience and seniority determine the order of appearance of the masks, with the most junior performing first. In view of the variations within the festival program, a case study of one festival cannot do justice to the richness of the Gẹ̀lẹ̀dẹ́ spectacle. Therefore, what follows is a composite account (comprising my own field observations and those of other scholars), highlighting what I consider to be the essentials of the festival.

6. In the past, some masks did precede Tètèdé and Èfẹ̀ in these communities; but due to a number of factors, which include the need to have more than one Èfẹ̀ mask to represent different wards or interests in the community, the original tradition has had to be modified over the years. For instance, the Àràbí Ajígbálẹ̀ mask (also known as Agbálẹ̀ Ọjà— the market sweeper) appears in Lagos during the *èfé* ceremony only "once in a blue moon," when the oracle demands that special rituals must be performed.

The Mask of Tètèdé

Almost everywhere, the main duty of Tètèdé, a female mask, is to introduce the Èfẹ̀. As Tètèdé prepares to enter the performance arena, the Gẹ̀lẹ̀dẹ́ orchestra changes the beat, using the drum to sing the praise of the mask, welcoming it to Èfẹ̀'s market. Tètèdé responds by greeting the audience with the horsetail in her hand, bending her knees occasionally as a sign of respect for the elders. Now and then she entertains the audience with intricate steps, synchronizing the jingling of her metal anklets with the drum beats. After the dance, the music stops. There is a short silence, after which Tètèdé begins a series of chants, paying homage to the principal Yoruba deities, the *àjẹ́*, the ancestors, the *ọba,* and the chiefs. In Ìjió, the Tètèdé mask intersperses her chants with social commentary:

Mo nkìlọ̀ fún yín o, e kétí ẹ gbọ́.
Ọlọ́mọge ṣá, aṣọ tí kò tó l'ẹ̀ nfi nṣ'òde
Òní, èyin nsọ pé kó mọ́ ró ò.
B'ó bá mà lọ ró ò b'ó di ní yàrá a ee
[5] Á ṣẹlẹ̀ á diré olóyún b'ó bá ma lọ ró b'ó di ní yàrá
 b'ó ṣẹlẹ̀ bó di eré olóyún
 Sóò ẹ ó fi yẹ̀èrì gb'ọ́mọ pọ̀n?

I have something to say to you girls.
You wear a cloth that is not the size of a towel
And you say "come on, come on."
If it happens inside the room
[5] It will lead to conception.
If it happens inside the room and you conceive
Will this underskirt be adequate to tie around the child?

(Harper 1970:82)

Here Tètèdé warns teenage girls of the negative consequences of sexual promiscuity, reminding them of the hardship and ridicule that await those who get pregnant and become single mothers with little or no means to support themselves or the babies. Indirectly, Tètèdé is also appealing to parents to give their children a good moral education; after all, "charity begins at home."

At the end of her performance, the Tètèdé mask approaches the double-arch entrance to summon Èfè. She must call him three times. At the first call, there is no answer. There is an interlude of music. She calls a second time. Again, Èfè does not answer. There is dead silence. The audience is anxious. Could the Èfè have fallen prey to the evil schemes of rival groups in the town, or of people who suspect that he would satirize or expose them during the concert? Indeed, there have been reports of Èfè maskers suddenly developing fever or losing their voice at this critical moment. For instance, Òsénì Lógo, a famous Èfè masker in Lagos during the 1940s and 1950s, allegedly lost his voice during performance.[7] This is why most Èfè maskers wear amulets under their costumes. The Èfè of Ìjió carries a medicinal horsetail whisk for protection, while the Èfè of Kétu is protected by a symbolic replica of himself, or a calabash of medicine carried by a maiden (see also Beier 1958:11; Ọlabimtan 1970:39; Drewal and Drewal 1983:136). Breaking the short silence, Tètèdé calls the Èfè for the third time.

7. I am grateful to Chief Amudaniyu Atapupa, the late Bàbáláṣè of Ìsàlè-Èkó Gèlèdé Society, for this information. August 1972.

The Mask of Èfè

At Ìjió (1991), the Èfè mask answers at last from the shadows behind the double-arch entrance, stamping the ground repeatedly, causing his metal anklets to vibrate:

Mo ní e e e e; mo jé e e e e.
Ẹ má pè mi mọ́!

I say yes. I have answered.
Do not call me again!

There is a long pause.

The jingle of metal anklets fills the air again as the Èfè approaches the double-arch entrance. Standing in the middle of the arch, he surveys the audience, sometimes leaning forward, sometimes crouching, as if observing something—perhaps some supernatural guests among the audience not visible to ordinary mortals (pl. 5). A wave of excitement sweeps through the stillness of the night. Some in the audience look sideways and backwards, wondering and trying to figure out what it is the Èfè has seen. But as far as the eye can see in the partial darkness, there is nothing unusual. Tree leaves rustle occasionally in the distance along with the cry of some birds. Suddenly the night explodes as hunters fire guns into the air to welcome the Èfè, catching the audience unaware. The ground trembles. Smoke and the smell of gunpowder fill the atmosphere, adding to the excitement and momentarily turning the spectacle into a trancelike experience.

At this juncture, the Èfè steps out into the soft light of the electric bulbs festooning the arch (an electric power generator is now a status symbol and evidence of modernity in rural Yorubaland). He holds a microphone, an-

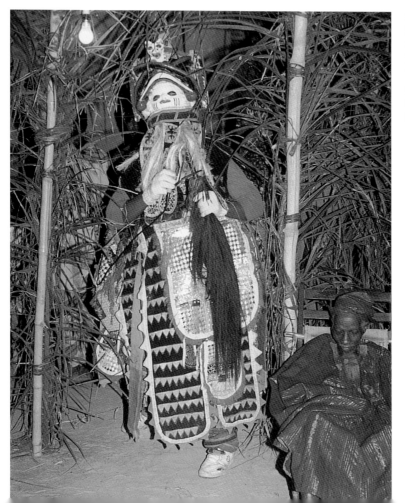

5.5 An Èfè mask in full regalia, holding a horsetail whisk, recalling images of majesty. The design of the appliqué panels is reminiscent of Islamic leatherwork. Ìjió, 1991.

other status symbol, to boost his voice far and wide, beyond the physical world. Under the light, the Èfè mask in his bulky, multicolored costume recalls the image of a Yoruba king in full regalia; he looks gorgeous— majestic and iconic. Like the beaded crown that conceals the identity of the king (fig. 1.5), the white-faced headdress invests the Èfè with an other-worldly aspect (fig. 5.5). A voice coming from behind the double-arch entrance sings the praise of the Èfè. Now and then, the Èfè bends forward slightly, lowering the headdress as though to allow its leopard and parrot motifs to communicate directly with the audience. The message is clear: the long-awaited night has come; the king of the Èfè's market is here. The leopard denotes his authority while the African gray parrot underscores his liminal status as the "pet-child" of Ìyá Nlá as well as the eyes, ears, and voice of the community, exposing scandals and antisocial behaviors. The audience looks on, spellbound. There is complete silence. Nodding thought-fully and surveying the audience a second time, the Èfè begins to chant:

Àyíká odó kan kì í p'odó.
Àlòká ọlọ kì í p'ọlọ.
Ariwo sùsù kì í p'ọjà.
[O-l-ó-k-u-n ò ò ò ò ò ò ò ò ò!] *A voice from the audience*
[5] Moní e e e e; Mo jẹ́ e e e e. Ẹ má pè mi mọ́.
Ta ní rán ni á pe ọba awo sí ìta Ìrebi?
Taló dèn dèn á rán ni wá pe èmi Òṣèfè
Ẹ sì rara kígbe èmi Òṣèfè.

.
Èmi rè é é é.
[10] À ní kí lẹ npè mí ní ìpèkúpè pèpèrepè?
Kí ẹyẹ odídẹrẹ́ wọn má gbé orúkọ mi lọ
Ìye kọn lọmúsọ ọmọ rẹ̀ lá bẹ́ igbó.

.
Ẹ pè mí; mojẹ́ e e e, ẹ má pè mí mọ́.
À pè ì yanu kọ́ ni t'olú ẹyẹ Mòdẹ.

Rolling the mortar does not kill the mortar.
Grinding does not kill the grindstone.
The noise from bargaining does not kill the market.
[T-h-e G-o-d-d-e-s-s—o-f—t-h-e—S-e-a!] *A voice from the audience*
[5] I say yes. I have answered. Do not call me again!
Who sent for the king of the secrets to appear at Ìrebi?

Who sent for me, the humorist?

Please mind how you call me, the humorist.

.

Here I am.

[10] Why were you calling me so carelessly?

You know, their parrot could easily relay my name to the other world

And the spirits could easily mistake me for one of their children in
the forest

.

You called me. I have answered. Please do not call me again.

Mòdẹ, the king of birds, does not open its beak to answer a call.

<div align="right">(Recorded in Ìjió, 1991. My translation)</div>

In Kétu, the Èfè mask explains why it takes him some time to answer:

Tètèdé, mo gbọ́ 'hùn ẹ.

Nígbà o pè lẹ́ẹ̀kíní

Apá l'ó rán mi l'íṣẹ́.

Nígbà o pè lẹ́ẹ̀kejì

[5] Ìrókò ló wọlé bẹ̀ mí l'ọwẹ̀.

Nígbà o pè lẹ́ẹ̀kẹta

Mo jẹ́ ẹ fún rere

.

Mo dé bí mo tí ndé.

Mo di ẹni àríyọ̀.

[10] Bí ẹ rí mi, ẹ yọ̀ mọ́ mi.

Ṣẹ̀ṣẹ̀ l'ọmudé nyọ̀ m'éyẹ, ṣẹ̀ṣẹ̀. . .

Tètèdé, I heard your voice.

When you called the first time,

The mahogany tree asked me for a service.

When you called the second time,

[5] The ìrókò tree gave me some work to do.

When you called the third time,

I answered well.

I have come like I always do.

I have become the one you see and welcome with joy.

[10] When you see me, welcome me with joy.

Joyfully, joyfully, the child welcomes a bird. Joyfully, joyfully.

<div align="right">(Recorded in Kétu, 1983. My translation)[8]</div>

8. For an earlier version
of this chant, see Beier
(1958:11).

The delay in Èfè's appearance and the references to the deep forest, especially to the ìrókò (*Chlorophora excelsa*) and apá (*Afzelia africana*) trees—both associated with the àjé and spirit children—portray the mask as a "forest being" (Ará'gbó) and as an intermediary between the physical and spirit worlds. In most cases, the Èfè will recite some protective incantations (ọfọ̀) before passing through the double-arch entrance.

In Ìjió the orchestra welcomes him with a fast, polymetric rhythm. Elated by the rousing reception, the Èfè displays his dancing skills, thrusting his huge trunk forward, stamping, shoving, swinging his arms and the horse-tail whisk in his hand to the beat and to the shouts of "Òrọ̀ Èfè!" from the audience, many of whom rise to their feet and dance along with the mask (fig. 5.6).

5.6 Members of the audience dancing along with the Èfè mask. Ìjió (1991).

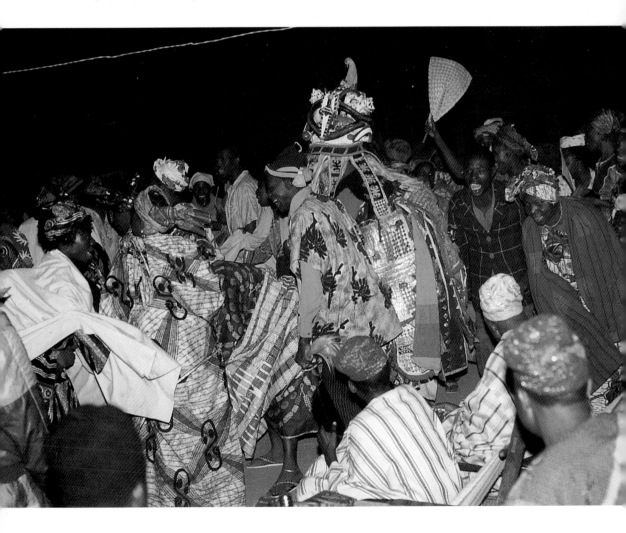

After this initial dance, the Èfè begins his program of songs, prayers, and satire which will last until dawn. Intermittently, or whenever the Èfè takes a short break to rest his voice, different dancing groups, accompanied by *dùndún* or *bèmbé* drums, entertain the audience (fig. 5.7). In Ìjió in 1991, the Èfè seized the opportunity provided by one of the interludes to change his headdress, putting on another that had only a parrot motif on top.

As Afolabi Olabimtan has pointed out, the technique of chanting the *èfè* poems varies from one area to another, depending on local dialects.[9] For instance, in standard Yoruba, the "head" is *orí;* but in the *Kena* or *Mofoli* dialect of Kétu and environs, the same word is pronounced *erí.* In standard Yoruba, the "child" is *omo,* the dialectal form is *omu* (Fayomi 1982:*xvii-xxiv*). The term *mojáwéré* refers to the rapid technique of chanting poems, while *èwó* refers to slow or slurred chanting (Olabimtan 1970:21-22). As is to be expected, the chanting style determines the tempo of the musical accompaniment and dance steps. During the concert, there is much emphasis on the call-and-response style: the Èfè mask initiates a song (*lílé orin*), and a select group (*agberin*) or the entire audience repeats the song or sings the refrain. In this way, the voice of the collective reinforces the message of the song.

9. Quoted by Asiwaju (1975:201).

While the *èfè* ceremony is in progress, one or two Gèlèdé functionaries keep the vigil inside Ìyá Nlá's shrine, performing special rites and offering prayers. In some shrines, a ritual lamp illuminates the altar all night long. It is a bad omen, should the light go off by itself before the *èfè* ceremony is over.

Èfè Poems and the Uses of Satire

Recognizing its importance as a character-molding device among the Yoruba, the Èfè masker uses satire to entertain and educate. The term *èfè* itself refers, first, to the mask; second, to the mask's songs, poems, and actions; and third, to the entire concert. Èfè thus comprises everything connected with the uses of satire to deal with social issues. One major function of satire in Yoruba society is to help dissolve tension. For example, in the settlement of disputes, the judge often concludes by making fun of the parties involved, "so that they can laugh off their grievances" (Adedeji 1967:63). The court jester sometimes ridicules the *oba,* not only to put him in good humor but also to hint at his inadequacies or the complaints of his subjects. The Èfè mask employs the same device to deal with secular and spiritual matters. Thus, the Èfè of Ìlaró, when paying homage to Èsù, the divine messenger,

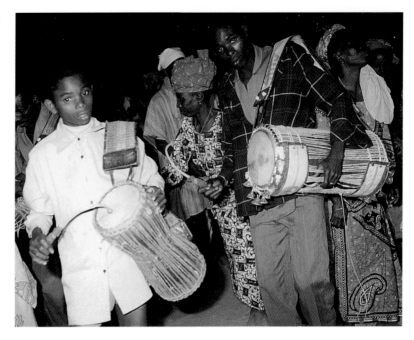

5.7 Whenever the Èfè mask takes a short break, different dance groups entertain the audience. Here, *dùndún* drummers lead some dancers around the performance arena. Ìjió (1991).

describes the latter as "the one with the big penis and big scrotum" (see below), while the Èfè mask of Kétu implores the *àjé* to "protect his head only and not to lick his skull" (Ibitokun 1987:12). The poems are loaded with metaphors, simile, puns, proverbs, onomatopoeia, and tongue-twisters. The masker switches easily from the serious to the banal, the sacred to the profane. At one moment, the Èfè of Ìjió declares himself a two-hundred-year-old man, and, at another, a small child (Harper 1970:86).

All told, since they cover practically all aspects of human experience, *èfè* poems cannot easily be classified into watertight categories, as some may fall under more than one heading. Nevertheless, the following are recurrent themes: (1) opening incantation; (2) homage; (3) blessing; (4) riddles and jokes; (5) current affairs; (6) moral instruction; (7) praise singing; and (8) commemorative singing.

Ọfọ̀: Opening Incantation

One of the first tasks of the Èfè on stepping out of the double-arch entrance is to put the performance arena under his spell. This he does by chanting a series of incantations to neutralize all potential opposition. Two examples are given below; the first is from Imẹ̀kọ and the second from Ìjió:

A. (Ìmèkọ)

Kogékogé ní í ṣohùn agogo.

Kògèkògè ní í ṣohùn akèrègbè

Gbàngan, gbàngan ní í ṣohùn àjà.

A kì í f'àjà í kéde ìlú.

[5] Njẹ́ ikú d'erí agogo kògekòge?

L'ó dífá f'ójúòríbi tí í ṣe àrèmọ Ọsanyìn.

Ojú ẹfun ò ríbi ní Ìlárá.

Ojú osùn ò ríbi ní Ìjẹbú Òde

Ògòdomùgbò.

[10] Njẹ́ oṣó tó np'erí mi níbi,

Òtúràìrá bá mi ràràn mọ́ wọn l'ọ́rùn.

Àjẹ́ tó bá p'erí mi n'íbi,

Òtúràìrá bá mi ràràn mọ́ wọn l'ọ́rùn,

Biribiri. . .

"Kogékogé" is the sound of the iron gong.

"Kògèkògè" is the sound of the gourd.

"Gbàngan, gbàngan" is the sound of the iron rattle.

The iron rattle is never used for public announcement.[10]

[5] Has death ever silenced the sound of the iron gong?

So declared the oracle to The-one-immune-to-evil, the eldest son
 of Ọsanyìn [deity of herbal medicine].

White kaolin will never suffer in Ìlárá town,

Neither will camwood ointment suffer in Ìjẹbú Òde town,

Ògòdomùgbò.[11]

[10] Any wizard who wishes me evil,

Òtúràìrá will hold him by the neck.[12]

Any *àjẹ́* who wishes me evil,

Òtúràìrá will hold her by the neck,

Swiftly, swiftly. . . .

 (Recorded in Ìmèkọ, 1971. My translation)[13]

B. (Ìjió):

Agbaragbojo ló ni inú igbó.

Ìjàwùn ìrẹ Ìjòkùnwẹlẹ̀wẹlẹ̀ ṣóhun ló l'ẹ̀bá ọdàn.

Òròbú'dìẹ àkùkọ bó jáde l'ówurọ̀

Ẹyin àgbà a gb'aya lówọ́ orogún

10. This is because the iron rattle is not loud enough.

11. This is one of the cognomens of Mother Earth.

12. One of the spirits associated with the Odù Ifá.

13. The Èfè masker, Aṣimi Ọlatunji-Onígèlẹ̀dẹ́, used this chant in the 1970s. The same version was recorded by Fayọmi in 1982 (p. 90).

.

[5] À l'émi í şa ewé ìyá lọ o o o o o!

'Mì í şa ewé ìyá, Òşèfẹ̀ Ọ̀tà

.

Agbónlé ẹyẹ, ẹ má ì léjọ́

.

Ekukéeku kì èní lé è j'asínrín

À ní kòkòrò kí kòkòrò kan kò mà lè rùn kó jù ìkamùdù

[10] Àgbògìnìjà kò ní f'orí balẹ̀ kó la kí Şàngó

.

À lí oşó tí npe 'rí ì mi líbi

Ọ̀rọ̀ mí á d'àpè sùnlọ

Alájogun tí ó pe òun á sà mí

À l'ọ̀rọ̀ mi á d'àpè sùnlọ

[15] À pè i sùn lọ là í p'odó

À pè i sùn lọ là í pe ẹyin àgbà

.

Ọ̀rọ̀ mí lẹ í sọ tẹ é le sùn

Èmi kò lè sùn lérí ọ̀rọ̀ mi

Ìbà Ajógijógbìn ọmọ Àjìnì Ọ̀tà

[20] Eeeríwo yà, ọba awo l'ójọ́ ijó pé

À lẹ́nu wọn ò ní ràn mí o

Ẹnu wọn ò lè ràn mí láyé

Ẹnu ọ̀bọ ò rẹ̀ ẹ̀kùnkùn

[25] Ẹnu òbò ò ràn àkísà

À şé ọwọ́ adẹ́tẹ̀ kò ràn kókó igi

Ẹnu wọn kò lè ràn mí láyé. . . .

14. A woody tropical vine.

15. A type of weed.

16. A type of weed.

Agbaragbojo[14] owns the forest.

Ìjàwùn[15] and Ìjòkùnwẹ̀lẹ̀wẹ̀lẹ̀[16] own the savanna.

When the chicken comes out in the morning

You "elderly ones" [àjẹ́] will deprive the senior wife of the junior wife.

.

[5] I say, I am going in search of the leaves of the mothers

I am going to pick the leaves of the mothers, I, the humorist of Ọ̀tà [haven of witches]

.

"The-bird-that-grows-old-in-the-house," do not complain.

No house mouse can kill the poisonous stink rat.
No insect can smell more than the stink ant.
[10] A beheaded ram cannot stand up again to greet
Ṣàngó [thunder-deity]

.

Any wizard who thinks evil of me,
The very thought of me will send him into "endless sleep."
Any agent of destruction who attempts to harm me,
I say, my case will send that person to "endless sleep."
[15] "Endless sleep" is the name we give to the mortar.
"Endless sleep" is the name we give to you, the Mothers

.

My case will send you to "endless sleep,"
But I cannot go into "endless sleep" for my own case.
I salute you, "The-One-Who-Dances-the-Wooden-Image-to-Ìgbìn-
Drums," the offspring of Àjìnì Òtà.
[20] Eríwo, the Lord of Secrets, I ask you to descend; the long-awaited
dance has come.
I say, their mouth will not be able to bite me

.

Their mouth will not be able to bite me forever.
The snail's mouth cannot eat wood.
The monkey's mouth cannot eat èkùnkùn leaves.[17]
[25] The vagina's mouth cannot chew rags.
The leper's hand cannot crush the knot of a tree.
Their mouth will not be able to bite me. . .
(Recorded in Ìjió, 1991. My translation)

17. A tough-leaved plant.

These two incantations (also called ògèdè, àṣúé, and àfọ̀ṣẹ) are enough
to show that by the time the Èfè masker appears on stage, he is no longer an
ordinary mortal. On the one hand, he represents the will-force of the whole
community which no individual would dare to challenge and, on the other,
he speaks with the divine authority (àṣẹ) of Ìyá Nlá, having been costumed
inside her shrine and blessed by Ìyálásẹ̀. For the night, he is the favorite son
of Ìyá Nlá, and the àjé cannot harm him. He wields a special àṣẹ, so power-
ful that his utterances, according to popular belief, will activate the cosmic
elements. He can say or do anything with impunity. Hence in Imẹ̀kọ, the
Èfè masker has the nickname Ògbójú lé òògùn tí s'ọmọ àjé ní'kó (He who is
so sure of his medicine that he can hit an àjé's child on the head and damn

the consequence) (Fayọmi 1982:60). Indeed, such is the immunity conferred by the costume on the masker that Ìjió's Èfè could declare openly that he is "the humorist of Òtà" (a town widely regarded as the headquarters of the àjẹ́), and that he is about to embark on a search for "the leaves" (secrets) of the àjẹ́. Here, the Èfè seems to be building upon a precedent set by the oracular deity Òrúnmìlà, who, in the divination verse (Odù Òsá Méjì) on the origin of Gẹ̀lẹ̀dẹ́, reportedly disguised himself with a mask while on a spying mission to the haven of the àjẹ́.[18] The Èfè mask is more aggressive, not only because he has the authority of Ìyá Nlá behind him but also because, as a satirist, he enjoys a "poetic license."

18. For an interpretation of Yoruba ritual as a journey, see M. Drewal (1992).

In any case, the power of these two incantations seems to derive mainly from certain truisms: the sounds of the iron gong, the gourd, and the iron rattle are too distinct to be mistaken one for the other; being associated with "coolness," both the kaolin and camwood ointments are greatly treasured by the Yoruba (and are in great demand at Ìlárá and Ìjẹ̀bú-Òde, respectively); the house mouse cannot challenge the poisonous stink rat (Asínrín), let alone kill it. Neither are the Yoruba aware of any insect whose odor surpasses that of the stink ant (Ìkamùdù); the snail has no teeth with which to gnaw a piece of wood; the ẹkùnkùn leaves are too tough for the monkey to chew; the leper's hand cannot hold the knot of a tree, let alone crush it; neither can the vagina chew rags. Therefore, any attempt to harm the Èfè mask is tantamount to challenging these truisms and thus attracting divine retribution.[19] In some cases, these incantations are chanted in the course of paying homage (ìjúbà) to the supernatural forces; their content also varies. Some Èfè maskers avoid open references to the àjẹ́ and just concentrate on the themes of "love" and "welcome."

19. For more on Yoruba incantations, see Ọlatunji (1984).

Ìjúbà: Homage

After the opening incantations, the Èfè masker begins to pay homage to all "the-powers-that-be" in the universe; namely, Ìyá Nlá; the àjẹ́; the òrìsà; the spirits of departed ancestors; the ọba and his chiefs; lineage heads; past Èfè maskers; important members of the community; the ordinary folks; and the youths. He asks for their cooperation, protection, and goodwill so that his performance can be a successful one. The ìjúbà is a recitation of the praise poems (oríkì) of these beings, so that they may respond in a favorable manner.[20] Recorded by Afọlabi Ọlabimtan (1970) in Ìlaró, the following ìjúbà is typical:

20. For more on oríkì, see Babalọla (1967); Barber (1991).

Oooo

.

K'ó ṣe kére o.

Kó ṣe kére, ẹ gbóhùn mi o.

Ìbà o.

[5] Ìbà èsí ng bá jú o?

Ìbà èsí ng bá hàn kọ́ jú?

Ìbà Ògún Onírè Odò.

Awẹ́nnẹ́, Eji Olúmakin o

Ògún l'ó ṣá mi ní kẹ́kẹ́ ojú npélenpéle.

[10] Ògún l'ó bù mí l'ábàjà ẹ̀kẹ́.

Ògún náà l'ó d'átọtọ ìdí mi tí mo fi nṣoge.

Òrìṣà o

I'yó bá wí p'erí t'Ògún ò sí,

A f'ẹru hó'ṣu jẹ.

[15] Ìbà o.

Ìbà èsí ng bá jú o?

Ìbà èsí ng bá hàn kọ́ jú?

Èṣù Láàlú, mo mà júbà rẹ

.

Orúkọ méje l'Èṣù ijẹ́,

[20] Àní bí ng bá kà á bí ó bá pé,

Ẹgbẹ́ gbogbo k'ó bọ́ mi l'áṣọ,

Ọ̀gbà ó gbà mí ní ṣòkòtò

Ẹ má mà tú mi ní bàntẹ́ wò

Iwu mo mú wáiyé mbẹ l'ábẹ aṣọ

[25] Akógọ

ARÒgọ

Asùngbọọrọtògọ

Agọngọ-ògọ

Agbéléjògọ-'óde

[30] Agbóde jògọ-'lé

Akógọrùtọmọnínú oko

Bara l'o 'ẹpọ̀n jánná o

Èṣù bímọ sí Ijàn-n-ná

O ṣ'okó dododo bímọ sí Dodo

[35] Ìbà Èṣù tí kò níkà nínú

Bara f'ọwọ́ ata m'ọ́mọ orogún rẹ̀ ní ṣónṣó idọ

Ẹni Èṣù bá nṣọ́, nwọn è é mọ̀ o

Ìbà o

Ìbà èsí ng bá jú o?

[40] Ìbà èsí ng bá hàn kọ́ jú

Ìbà Àwòyó, Ààwòyoó

Omijorí, alagbalúgbú omi

Ìbà Ìyá Ọlọ́yàn Orùbà

[45] Yemọja k'ó o fún mi l'áwo ṣe

Ìbà o

Ìbà èsí ng bá jú o?

Ìbà èsí ng bá hàn kọ́ jú

Ìbà ẹnyin ìyá mi Òṣòròngà

[50] Alágogo esúrú

Alajogun ẹiyẹ

Ìyá mi Atẹ̀dọ̀jọkàn

Opépé atẹ́lẹ́hìn o

Ó torí epo ó ṣ'ọwọ́ gbọgbọrọgbọ

[55] Gbogbo yín kí ẹ ẹ fún mi l'áwo ṣee

.

Ìbà o

Ìbà èsí ng bá jú o?

Ìbà èsí ng bá hàn kọ́ jú

B'a bá k'ẹ́gbọ́n tán o

[60] L'a tó k'abùrò

B'a bá kí baba ọmọ tán, l'a tó k'ọmọ.

Ìmẹ́lẹ́ òun ọfun ọ̀lẹ kìkì aṣọ

Àwa l'ọmọ ọ̀lẹ bá iṣẹ́ tí ó p'òṣé

Iṣe gbogbo ní íwu alágbára íṣe

[65] Ìbà Àrẹgbaajàgbó.

Fìlà òkìkí kan là ídá

Ẹní y'ó ra méjì ó ṣe yọnu fun un.

Arílégbolókèsí ọkọ olóòṣà oko.

Ba l'atẹ̀páásílẹ̀ jó Gẹ̀lẹ̀dẹ́, ọkọ Mọ́yẹlé

[70] Agopẹbíẹnígẹ̀fọ́

Aríseeregbẹ́ja l'ójú omi.

Baba, k'ó o fún mi l'áwo ṣe

.

Ẹní kọ́ ni l'órin l'à bá kì o

Ẹní kọ́ ni l'órin l'à bá kì o

[75] Ẹní kọ́ ni l'órin l'à bá kì tantan.
Ìbà Àkànbí o
Àkànbí Awẹ́lóhùn, Ọba Ẹ̀fẹ̀.
Abẹ̀rùàgbà-mú-t'Ọlọ́run-pẹ̀lú.
Owónikókó, Baba Ẹfundoyin.
[80] Baba, k'ó o fún mi l'áwo ṣe.
B'a bá np'akódan l'ọ́tún o
A bá p'akíjẹ̀ẹ̀lẹ́ l'ósì o.
A bá p'onílù láàrín k'a tó ṣ'awo
.
Gbogbo yín kí ẹ tún mi ṣe.
[85] Enu l'abẹ́rẹ́ fi ítáṣọ ṣe.
Gbogbo yín kí ẹ tún mi ṣe.
Ẹnu l'adìẹ òkòkó fi ítẹyin ṣe
Gbogbo yín kí ẹ tún mi ṣe.
B'o bá yẹ mí l'éni
[90] Gbogbo wa l'ó jọ yẹ. . .

Oooo
.
Let there be perfect silence.
Let there be perfect silence, and listen to me.
My homage.
 [5] To whom do I pay homage?
To whom do I first pay homage?
I pay homage to you, Ògún Onírè Odò.
Awẹ́nnẹ́, Eji Olúmakin o
Ògún makes the *pélé* marks on my face.[21]
[10] Ògún makes the *àbàjà* marks on my cheeks.[22]
Ògún cuts the foreskin of my penis, that which I use to bluff.
The god,
Who looks down on Ògún,
Will use his mouth to peel cooked yam.[23]

[15] My homage.
To whom do I pay my homage?
To whom do I first pay homage?
I pay homage to you Èṣù Láàlú
.

21. *Pélé* are the three vertical lineage marks on the face. See fig. 7.59.

22. *Àbàjà* are the three horizontal lineage marks on the cheeks. See fig. 7.60.

23. This shows the importance of iron implements to Yoruba civilization. To the Yoruba, cutting of lineage marks on the face and the foreskin of the penis (made possible by the use of iron blades) is an index of human refinement. Using the knife to peel cooked yam is also a more civilized approach than using the teeth. The message of this last line is that, but for the iron implements of Ògún, even the other deities would have had to use their teeth to peel yam offerings given by their devotees.

There are seven names of Èṣù,

[20] And if I fail to enumerate them correctly

Let cult members take away my clothes,

Let men of my age group remove my trousers,

But do not take off my pants!

That thing which I brought to the world is under the pants.

[25] Akógọ

Aròḅgọ

Asùngboọrọtòḅgọ

Agọngọ-òḅgọ

Agbéléjòḅgọ-'óde

[30] Agbóde jòḅgọ-'lé

Akógọrùtọmọnínú oko.[24]

Bara was the one with a big scrotum.

Èṣù had a child at Ìjànná.

The one with the long penis had a child at Dodo.

[35] My homage to you, Èṣù who is not at all wicked.

Bara touched the clitoris of his wife's daughter with ground pepper. . .

Those whom Èṣù is after never know. . .

Homage,

To whom do I pay my homage?

To whom do I first pay my homage?

I pay my homage to Àwòyó, Àawòòyó

Omijorí, the vast-expanse-of-water.

I pay my homage to the big-breasted mother,

The one with much hair in her private part.

[45] Yemọja, let me have a successful performance.

Homage,

To whom do I pay homage?

To whom do I first pay my homage?

I pay homage to you Òṣòròngà, my mothers.

[50] You Alágogo esúrú[25]

O birds Alajogun.[26]

My mothers, you start your feast with the liver and end with the heart.

Opépé, the broad back,

You who stretched all hands for red palm oil,

[55] I pray you help me to succeed

.

24. These seven names are tongue-twisters. Their meanings are as follows:

Akógọ = Cudgel carrier
Aròḅgọ = Cudgel bearer
Asùngboọrọtòḅgọ = He who sleeps alongside his cudgel
Agọngọ-òḅgọ = He who has a heavy cudgel
Agbéléjòḅgọ-'óde = He who stays inside and throws his cudgel outside
Agbóde jòḅgọ-'lé = He who stays outside and throws his cudgel inside
Akógọrùtọmọnínú oko = He who carries his cudgel right into the farm to meet people.

25. This means "One whose beak is for èsúrú yam." This yam is yellow in color.

26. This alludes to the fact that the àjẹ́ are thought to be in alliance with the ajogun, the malevolent forces.

Homage,
To whom do I pay homage?
To whom do I first pay homage?
It's after the senior brother
[60] One goes to the junior.
It's after the praise of the father one praises the son.
The idle and the lazy always quarrel with their stomach.
We are the offspring of The-lazy-unhappily-sighs-for-his-inability-
to-work.
It is Every-work-that-appeals-to-an-industrious-man.
[65] I pay homage to Àrẹgbaajàgbó.
It's one cap of fame a man should have.
He who has two invites trouble.
He who-has-room-for-òkè-worshippers, husband of Òòṣà-oko priestess.
Father, you are the one who uses an expensive walking stick to dance
Gèlèdé music, husband of Móyẹlé.
[70] You are the one who climbs the palm tree as one climbs a vegetable.
You are the one who uses curses to hunt for fish.
O Father, let me have a successful performance.

.

It's he who taught us [that] to sing we must praise.
It's he who taught us [that] to sing we must praise.
[75] It's he who taught us [that] to sing we must greet and greet.
I pay homage to Àkànbí.
Àkànbí, the soft voice, lord among the Èfè.
He-who-respects-elders-and-also-God.
Money-is-the-source-of-trouble, father of Ẹfundoyin.
[80] O Father, let me have a successful performance.
When we greet the *Akódan*[27] on the right,
Let us greet the *Akíjèẹlé*[28] on the left.
Let us call on the drummers in the center before we start our display

.

Let me have your goodwill.
[85] It's with the needle's own mouth that the needle grants favor to the cloth.
Let me have your goodwill.
It's with the hen's mouth she takes care of her eggs.
Let me have your goodwill.
If for today's performance, I win any honor,
[90] The honor is for all of us. . . .[29]

27. The *Akódan* are the females who accompany the mask, shaking brass rattles (*ẹdan*).

28. The *Akíjèẹlé* are male or female mask attendants who shake iron rattles (*àjà*).

29. Although I documented *èfè* songs in Ìlaró between 1972 and 1974, my recordings are not as comprehensive as those compiled by Professor Afọlabi Ọlabimtan, who is researching into their literary and stylistic features. I am grateful to him for allowing me to quote from his unpublished seminar paper (1970).

The order of paying homage and the number of beings to whom honor is paid vary from one community to another. In Kétu, for instance, Èṣù comes first, but at Ìdahin, it is Òrìṣa-Oko, the deity of agriculture. In most cases, however, Ògún, Èṣù, and the *àjẹ́* are among the first to be honored. Ògún is important partly because he is one of the most senior deities in the Yoruba pantheon, and partly because he is the patron deity of iron, which is used both for making Gẹ̀lẹ̀dẹ́'s metal anklet and for carving the headdress. Moreover, he is the one who clears the way with his matchet. Èṣù's importance lies in the fact that he is the divine messenger and the principle of dynamism. Without his cooperation, no ritual process can be effective. The marketplace, the venue of the *èfẹ̀* ceremony, is his domain. The *àjẹ́* feature early in the *ìjúbà,* not only because they are the guests of honor, but also because the women, whose power they represent, control the marketplace, both economically and ritually. It is after the invocation of the òrìṣà, ancestors, and the "powerful mothers" that ordinary mortals come up for mention. The Èfẹ̀ usually concludes the *ìjúbà* by reciting his own praise-names (*oríkì*), in which he highlights, among others, his own personal attributes, his rich voice, artistic sensibilities, commanding presence, and noble ancestry:

 Èmi mà ti d'àgbà òṣèré

 Èmi ti d'àgbà òpìtàn

 Èmi Ajénifújà, adájọ́ kọrin f'ọba

 Póro, póro l'àdán nṣarọ́

[5] Bí àkàlàmàgbò bá ké, ìlẹ̀ a mì tìtì

 Mo tó n'ílé, mo dẹ̀ tó l'óde

 B'ọmọdé f'ojú k'ẹkùn, nwọn kò ma gbèrò àdá

 B'ágbà f'ojú k'ẹkùn, nwọn kò ma gbèrò ibọn o

 Kò si ẹran bí ẹkùn

[10] Emi Àlàbí awo ló dé

 Mo ti fì ìtọ̀ gba'jù bí i kìnìún ẹranko ní'gbó

 Erin ní i ṣ'ọba ẹranko

 Ko dẹ̀ sí ọmọdé ejò

 Emi ni a pìtàn àgbà

[15] Bàbá mi, Òṣẹ̀fẹ̀gbayì, Òsenì Lógo

 Ọba nínú awo Kétu

 Ọmọ Gẹ̀lẹ̀dẹ̀ tó joyè l'Óhọ̀rí Ilé

Ó kó idẹ s'ọ́wọ́, ó kó idẹ s'ẹ́sẹ̀
Idẹ ndún girinṣin girinṣin. . .

I am a leader among performers,
I am a leader among historians,
I, Ajénifújà, who chooses a special day to sing for the king.
Póró, póró cries the fruit bat.
[5] Whenever the ground hornbill cries, the ground trembles.
I am important at home and outside

.

If a child sees a leopard, he will forget all about a matchet.
If an adult sees a leopard, he will forget all about a gun.
There is no animal like the leopard.
[10] I, Àlàbí, the knower of secrets, am here.
Everything is under my control, just as a lion uses its urine to cast a
 spell in the forest,
The elephant is a king among animals.
There is nothing like a small snake.[30]
I am the senior historian.
[15] My father, Òṣẹ̀fẹ̀gbayì,[31] Òsenì Lógo
Was a force to be reckoned with among Kétu performers,
Offspring of Gẹ̀lẹ̀dẹ́ who ascended the throne at Ọ́họ̀rí Ilé,
The one with brass bracelets and anklets,
Brass ornaments jingle rhythmically.
 (Recorded in Ìsàlẹ̀-Èkó, Lagos, 1993. My translation)

30. The poison of a
small snake is as deadly
as that of a big one.

31. Òṣẹ̀fẹ̀gbayì = The
honorable *èfè* performer.

At times, the Èfẹ̀ provides his own musical accompaniment while sing-
ing by stamping with his feet, causing the metal anklets to jingle rhythmi-
cally. A Gẹ̀lẹ̀dẹ́ official strikes a gong to mark the end or the beginning of a
theme. In between, a flutist may sing the praises of the Èfẹ̀ mask, to which
the latter responds by waving the horsetail whisk in his hand or by stamp-
ing the ground to rattle his metal anklets. Most Èfẹ̀ masks move or dance
round the arena during performance, but at Ìbarà, the Èfẹ̀ mask sits perma-
nently on the roof of a market stall, singing into a microphone to the audi-
ence below (fig. 5.8). In some towns, such as Ìgànná, the Èfẹ̀ mask does not
perform in the open. Instead he stays inside the community head's com-
pound (facing the marketplace), from where he sings to the audience out-
side. But inside or out, having paid homage to all whom it is due, the Èfẹ̀
becomes more confident and proceeds to exercise his "poetic license."

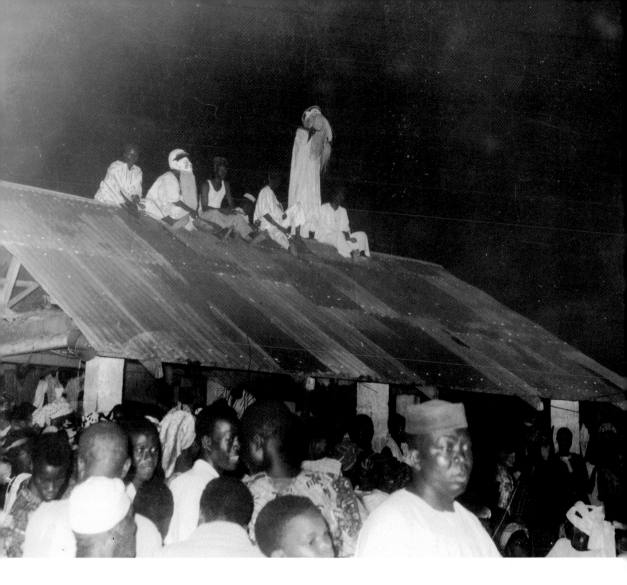

5.8 Èfè mask singing
from the roof of a stall
at the Onídá market.
Ìbarà, Abéòkúta
(1958).

Ìwúre: Blessing

Ìwúre means "utterances intended to bring goodness." Because the Èfè speaks
with the voice and authority of Ìyá Nlá, the audience takes the *ìwúre* part of
the concert very seriously. It is a moment of open and silent prayers. The
sick pray for good health; the barren, for children; the traders, for more
profits; the farmers, for better harvests; and the poor, for better means of
livelihood. In order not to be left out of Èfè's blessings, everybody responds
loudly with *àṣẹ* (let it be!) at the end of each verse, and participates actively
in the singing. The following *ìwúre,* recorded by Gabriel Fayọmi, is from
Imèkọ:

Ijó Ọdún mo jó fún yín o
Àgàn ẹ tiwọ́ bosùn o
Aboyún ilé ẹ bí tibi tire
A kò ní náwó ọsibítù
[5] L'ágbára Ọlọ́run, l'ágbára Ọlọ́run, l'ágbára Ọlọ́run
Ijó a jó yìí, òjò àsìkò ẹ mẹ́ ẹ̀ rò fú ni o
Iṣu ẹ mẹ́ ẹ ta o
Ọ̀pọ̀ ẹ́ gbé'yàwó, ẹ ẹ́ mẹ́ bi'mu gbé wá'lé.
Gbígbè: Àṣẹ o!
[10] L'ágbára Ọlọ́run, l'ágbára Ọlọ́run, l'ágbára Ọlọ́run
Ijó a jó yìí, òjò àsìkò ẹ mẹ́ ẹ̀ rò fú ni o.
Iṣu ẹ mẹ́ ẹ ta o
Ọ̀pọ̀ ẹ́ gbé'yàwó, ẹ ẹ́ mẹ́ bi'mu gbé wá'lé. . .

(Fayọmi 1982:99)

Èfè: Èmi Ìṣọ̀lá Akérédùn mà tún dé
[15] Àníkún owó ẹ, àbílà ọmu
Ohùn èmi ná à kọ́,
Ohùn ìyá à mi ni, alágogo ògú

.

Ó lí ẹ kè ṣẹ́kú l'ọmudé
Ohùn iya à mi ni alágògo ògú.
[20] Ìyámi abiyamu bìdí jẹ̀lẹ́nkẹ́
Ló li n wá 'kùnrin
Ó lí ẹ kò ní s'ẹ́kú, ẹ kẹ̀ d'àgbà òṣì
Ẹ̀ kẹ̀ rí hun gbé sọnù bí ò ṣebi ọmu
I mẹ ẹ pé àmín, I mẹ ẹ wí pé àmín àṣẹ
[25] Ohùn ìyá à mi ni. . . .

(ibid.:112)

Èfè: À a ọmu Òkè-Ọlá, mo gbọ́ṣẹ́ i yín o
E mọ̀ gbọ́ṣẹ́ i yín

.

Gbígbé: Òkè-Ọlá, mo dé mọ̀ wá jú'bà àgbà

.

Bílá bá f'orí ba'lẹ̀ á gbóko á gbó

.

[30] Gbogbo àgàn kó t'ọwọ́ b'osùn paá jójó olómi ẹ̀yẹ

.

Ọní ti bímu, àbílà li kó jẹ́
Aboyún ilé kó sọ̀ kalẹ̀, ka bimu rẹ̀

Ọni ó ṣiṣẹ́, kó f'owó ẹ̀ ṣe hun ire

.

Àgbà yokù n mi kí un kó gbó kó tọ́

.

[35] Ẹléyinjú ẹgẹ́ o, Ìyà mi ìyá

Apákẹ́ṣẹ́, Arìnkẹ́ṣẹ́

Ìyà mi ìyá

Olókìkí òru

Olómi nlé f'epo fọ'ṣọ

[40] Ìyà mi ìyá.

Gbogbo ìlú d'ọwọ́ ẹ.

(ibid.:115-16)

I am celebrating this Gèlèdé festival for you.

32. Camwood ointment (*osùn*) is used to rub the body of a newborn baby.

The barren shall dip her hands into camwood ointment; [32]

The pregnant ones will deliver safely.

May we not waste our money on hospital bills.

[5] In the name of God, in the name of God, in the name of God

This Gèlèdé festival shall bring adequate rainfall.

May the yams in the farms grow well.

May newly married couples have children.

Chorus: Let it be!

[10] In the name of God, in the name of God, in the name of God,

This Gèlèdé festival shall bring adequate rains.

May the yams in the farms grow well.

May the newly married couples have children. . .

Èfè: I, Ìṣọlá, The-Small-But-Sweet-One, am here again.

33. Àbílà is a synonym for *Àbíyè* (born to live).

[15] May we have more money; may children live to old age.[33]

This is not my voice.

It is "My Mother's" voice, the one with the beak of iron

.

She said, You will not die young.

It is "My Mother's" voice.

[20] "My Mother," the nursing mother with the rolling buttocks

Who badly needs a male partner.

She said, You will not die young, and neither shall we grow into a wretched
 old person.

We will not throw away the baby with the placenta.

Everybody say Amen. Everybody say Amen; let it be.

[25] It is "My Mother's" voice

Èfè: A, a, the residents of Òkè-Olá,[34]

I received your message

.

Chorus: Residents of Òkè-Olá are here to pay homage to the elders

.

If the okra pays homage, it will be ripe in the farm

.

[30] May the barren dip their hands in camwood ointment and dance
with honor.

.

Those who have children, may their children live to old age.

May the pregnant ones deliver safely.

May workers spend their earnings on good things.

.

May our elders live long.

[35] The one with the beautiful eyes, "My Mother" of mothers

Who kills stealthily, and walks surreptitiously

"My Mother" of mothers,

The famous one of the night,

Who has water in the house but uses palm oil for her laundry.[35]

[40] "My Mother" of mothers,

The entire community is in your hands.

(Fayomi 1982. My translation)

34. There are three Gèlèdé societies in Ìmèko: namely, Òkè-Olá, Òwún, and Ìsàlè-Odò.

35. This is an indirect reference to blood; the palm oil is reddish in color.

Lines 16-25 are very important, because the Èfè mask makes it absolutely clear here that he is not speaking with his own voice but with that of Ìyá Nlá. Thus, if the community has any major problem, such as an epidemic, a threat of war, or frequent disasters, this is the time to pray for a solution. But if anyone is threatening the corporate existence of the community or betraying its cause, the wrath of Ìyá Nlá is invoked against that person during this part of the program. Many Èfè masks are known to have seized this opportunity to report or curse their personal enemies. For instance, in an unusual case at Ayétòrò, an Èfè mask asked the *àjé* to punish those who burnt down his house during the 1965-66 political disturbance in Yorubaland (Drewal and Drewal 1983:51). But in Ìmèko (in 1982), another Èfè mask seized the same opportunity to inform the public of his personal problem:

Kiní kan n bẹ l'íkù m, àwòrò.
Ẹ bá n wá'yàwó, bó jọmú ṣínkínní.
Nnú Síkírá, n nú Ráfátù.
Kó sá ti j'ọmubìnrin kan jòjòló.

Something has been bothering me, priest.
Help me to look for a wife, even a small-breasted one will do.
Anyone bearing a name like Síkírá or Ráfátù is welcome.
All I want is a fine maiden.

(Fayọmi 1982:51. My translation)

As already mentioned, gratitude is an important part of Yoruba ethics:
Ẹní dúpẹ́ ore àná, á gbà mí ì si i (A person who shows gratitude for the last
favor will surely receive a new one). This is why songs of gratitude (*orin
ìdúpẹ́*) often accompany the *ìwúre*, acknowledging Ìyá Nlá's blessings dur-
ing the past year so as to induce her to be all the more generous.

Àwàdà: Jokes

As noted earlier, the language of *ẹ̀fẹ̀* poetry is loaded with humor, with ridi-
cule (*yẹ̀yẹ̀*), jokes (*àwàdà*), and jest (*àpárá*), even when dealing with a seri-
ous matter. For instance, the seven names of Èṣù given during the *ìjúbà* are
tongue-twisters; also funny is the Ẹ̀fẹ̀'s request (p. 122, lines 20-24) that his
trousers be removed in public should he fail to pronounce correctly the cog-
nomen of Èṣù. To keep the audience in high spirits, the Ẹ̀fẹ̀'s performance
is punctuated with a lot of jests and jokes. Sometimes, as in the following
song from Ìjió, the Ẹ̀fẹ̀ mask tells an allegorical story or parable (*òwe*) that
ends in a special prayer for the community:

Àwọn ọ̀rẹ́ mẹ́ta nwọ́n njà láyé o
À kò m'àgbà; ni'wọ́n bá bèrè l'ọ́wọ́ mi
Arọ́bayọ̀, nkà ṣìnà
.
Ṣe ẹ́ rí Owó, Ọmọ, Àlàáfíà
[5] Nwọ́n njà s'ágbà o
Owó nsọ p'óun l'ẹ̀gbọ́n
Ọmọ nsọ p'óun l'ẹ̀gbọ́n
Àlàáfíà np'óun ṣá ni baba
Ó rú mi l'ójú gbogbo ènìyàn.

[10] Mo ní tí ó bá d'òla

.

Ki nsùn, ki ntún ro'nú
Ní kùtù ni mo jí

.

Ni nwọn sọ pé awọn dé
Mo ní Owó ègbọ́n lo jẹ́

[15] Ọmọ l'àjùlọ
Àlàáfía ṣ'óun ló mà ṣe pàtàkì o.
Ẹdá tó l'ówó, tí ó bímọ, tí kò gbádùn
Oníyẹn kì í pẹ́ l'áyé
Àdúrà, Olúwa má jẹ́ ká pàdánù o

.

[20] Ṣ'ẹ́yin métẹ̀ta, ẹ pé tìmí o
K'áyé mi kó gún gẹ́gẹ́.

Three friends are engaged in a dispute on earth
Over which among them is the most senior, and they sought my advice.
I, Arọ́bayọ̀,[36] will not make any mistake

.

You see, "Money," "Children," and "Good Health"
[5] Are fighting over seniority.
"Money" says he is the most senior.
"Children" says he is the one.
"Good Health" says he is the one.
My audience, I was confused at first.
[10] I asked to be given until the next day

.

So that I can sleep over the question

.

I was awakened early in the morning
The three disputants had come.
I said, You, "Money," you are a senior.
[15] I said, You, "Children," you are a senior.
But having "Good Health" is very crucial.
He who has Money and Children, but lacks Good Health,
That person will not live long on the earth.
O God, may we not suffer loss

.

36. This is the nickname of the Èfè masker, meaning "He who rejoices at the sight of the King."

[20] All these three blessings should be with me.
 Let me live long.

<div align="right">(Simmonds 1969-70:n.p. My translation)</div>

As the Èfè concludes the prayer, members of the audience would typically wish themselves the same blessings. This aspect of the program is a socialization process; not only does it contain moral lessons for the community (that is, one should not run after wealth and children at the expense of his or her health) but it also educates the youths about Yoruba parables and their use-contexts.

Ọ̀rọ̀ T'ónlọ: Current Affairs

In the course of the year, the Èfè masker makes a mental note of major events within and outside the community. A few weeks prior to the annual festival he reviews his mental diary with some confidants, who also give him additional information. Songs and poems are composed around newsworthy events such as thefts, sex scandals, corruption, wickedness, abuses of office, and political oppression. If the events happened a long time ago, the Èfè not only refreshes the people's memory but also livens up his presentations with rich metaphors. More often, the public learns about an episode for the first time from "Èfè's market," to the embarrassment of the characters involved. This is why, as Anthony Aṣiwaju has pointed out, "Èfè's market" is comparable to the modern radio or newspaper. Even so, the Èfè does not stop at merely reporting an episode or exposing a scandal. He also attempts a philosophical analysis, like the editorial column of the press. His intention is to shape the moral conscience of the community and its rulers, and to influence public opinion on social, religious, cultural, economic, and political matters (1975:204-5). Below are excerpts from several èfè ceremonies:

37. Àgbàsowúnù (elders cast away jealousy).

In the following commentary, Àgbàsowúnù,[37] the Èfè mask of Ìsàlè̩-Èkó, reports a friend of his who recently brought stolen goods to him for safekeeping, but he turned the rascal away:

Akíyèsi o
Mo fẹ́ fi ẹjọ́ ọ̀rẹ́ mi kan sùn yín
Olórí burúku l'ọ̀rẹ́ mi
O ti mọ̀ pé ilé tí mo ngbé kò l'ẹhìnkùlé
[5] Níbo lo fé kí i nf'ẹran pamọ́ sí?

Mo ní olóríburúkú, ọlọ́sà, abèṣe

Ọmọ àlè ṣ'ẹnu gbàngbà

Mo ní l'Èkó o

Kò yẹ k'áma sọ̀ yí sí gbàngbà

[10] Ó dára, olóríburúkú, ọlọ́sà abèṣe

À ṣé ọgbà èwọ̀n ni yàrá è

Ẹní bá rí wọn ní Ìkòyí o

Ẹní j'orí ahun á sun kún.

Please, lend me your ears.

I want to report a friend of mine.

My friend is a bad-headed person.

He knows that my house has no backyard.

[5] Where does he want me to hide a stolen goat?

I say he is a bad-headed person, a thief and a villain,

A gargantuan-mouthed bastard.

I say, in this city of Lagos

Something like this should not be said openly.

[10] It's all right, this bad-headed person, this thief and villain,

I did not realize that his bedroom was in the prison yard.

If you see them [prisoners sentenced to hard labor] at Ìkòyí,[38]

Even the person who has eaten the head of a tortoise [the heartless]

 will be moved to tears.

(Recorded in Ìsàlè-Èkó, Lagos, 1993. My translation)

38. The location of a maximum security prison in Lagos.

The commentary below, from Ìbarà, Abéòkúta, concerns a woman who was caught stealing fish at night in the Onídá area of the town (Adedeji 1967:63):

Mo róhun tuntun, ará Onídá

Obìnrin tàn àtùpà l'óru

Ẹ̀yin ará Ìbarà

Obìnrin tún dẹ panpẹ́!

Mo róhun tuntun, ará Onídá.

I have seen something new, people of Onídá,

A woman held a lamp at night.

You people of Ìbarà,

A woman now sets traps![39]

I have seen something new, people of Onídá.

39. Since hunting is a male profession, and since only hunters do legitimate business after midnight (that is, looking for game to kill), any woman found outside at this hour of the night is suspected.

The following song, from Emado Quarter, Àyétòrò, draws public attention to a disputed pregnancy involving the wife of one Ajélẹ̀ (Drewal and Drewal 1983:52)

Taní l'ọmọ, taní l'oyún rí?
Oyún ṣe d'ijà n'ile Ajẹlẹ
Taní l'ọmọ, taní l'oyún rí?
Oyún ṣe d'ijà n'ile Ajẹlẹ
[5] O yi ṣe nan pe ji l'ojọkọ rẹ
Àí l'oyún kan f'ènià meji
Ìyàwó Ajẹlẹ talo p'oloyun ni ri?
Àí l'oyún kan f'ènià meji.

Who owns the child? Who owns the pregnancy?
Pregnancy caused a fight in the house of Ajẹlẹ.
Who owns the child? Who owns the pregnancy?
Pregnancy caused a fight in the house of Ajẹlẹ.
[5] *O yi ṣe nan pe ji l'ojọkọ rẹ* [bis]
You can't have one pregnancy by two persons.
Wife of Ajẹlẹ, to whom does the pregnancy belong?
You can't have one pregnancy by two persons.

This *èfè* song from Kétu lampoons the French colonial administration for compelling tax payers, in the 1920s to wear their tax receipts round the neck like a pendant. Those found not wearing the tax plates (nicknamed *kangé*) were beaten up by the police (Aṣiwaju 1975:220-22):

Ìlèkè̀/Gbẹ̀dẹ̀ ayé so lóyẹ ká bá a so
Ka rí hun pìtàn bo ṣe díẹ̀
Ọmu i Kétu, e mẹ́ ẹ gbọ́
Fílàní l'ògbà i tiẹ̀, ó lọ
[5] A gbọ́ 'tàn ẹ lọ́wọ́ ọni ó dàgbà
Ìdàùmẹ́ ṣe tiẹ̀ ó ré kọjá
A gbọ́ 'tàn ẹ lọ́wọ́ ọni ọ́ dàgbà
Òyìnbó/Farasé l'àwa n sìn
A kò kọ̀ ọ́
[10] Ká má a sanwó erí
Ògbóni má a gbọ́

Wo'rú ìlèkè mọ kó pọ́ùn kan rà l'ọ́wọ́ i Dàdí Òkú

Bàbá mi ké n tanná yànyàn láyà ẹ?

Ìlèkè i Kangé

[15] Ṣówó a ti nsan lérí Ọyèngen Olíbọ̀rọ̀mú

 Aṣákáiṣà látijó

A kó so yí wò o, Ìlèkè i Kangé

È so o kọ́ yá e

I kè rin lí Kétu gbádùn

Bí i kò so kọ́bọ̀ a-tàn yànyàn.

It is the bead that the times offer that one must wear,

So that the experience may become history tomorrow.

Hark! You children of Kétu,

The Fúlàní had their own time and they passed away.

[5] We heard about them from the elders.

Dahome also had their turn

 And had similarly passed away.

We also heard of this phase from the elders.

We are now subject to European/French rule.

We have not rejected this.

[10] We have accepted the paying of tax.

Hark! You elderly one!

Look at the bead I bought for a pound from Dàdí Okú.

Father! What is it that shines frightfully on your chest?

It is a Kangé bead.

[15] Isn't it all for the tax we have been paying since the reign of

 Ọyèngen Olíbọ̀rọ̀mú Asákáiṣà?

We never put on this type of bead!

But please hasten to fasten it round your neck.

For you cannot move freely in Kétu

Except and unless you put on the frightening bead.

The following song, from Ìmèkọ, was composed in the 1940s and directed against those Ìmèkọ youths who rushed into modern politics, abandoning agriculture. Not only did the Èfè masker warn against the disastrous consequences of neglecting the farm but he also detested the fact that inexperienced youths now occupied positions formerly reserved for experienced elders (Aṣiwaju 1975:244-45):

Àwùn yí í bẹ roko
Kọ́ sabà ìgbàdo ká bẹ̀ ẹ́ wò
Gbogbo kò tún roko mọ́.
La jókòó lá n fùyà ṣèlú
[5] Lá n fàkísà aṣọ bora

.

Ẹyin n hẹyin ayé jẹ́ Ìmẹ̀kọ
Mọ bẹ̀rẹ̀ fayé e

.

Ayé má wò tàwa èdá

.

Ẹ tányé ṣe. . . .

Those who should farm hard
To produce an admirably robust corn harvest
No longer go to the farm.
They stay idle behind in the town and indulge in a career of politics
 and poverty.
[5] They clothe in rags and roam the streets

.

You people of Ìmẹ̀kọ, you are doing the forbidden.
I fear and respect age-old traditions.
May we not be dealt with for our imprudence

.

Let them make reparations. . . .

Èfè songs cover virtually all the goings-on in the society, at the local, even at the regional, national, and international levels. Topics featured have included, for instance, the two World Wars (Aṣiwaju:223-31); the imprisonment in 1964-67 of Chief Ọbafẹmi Awolọwọ, one of the leading Nigerian politicians (Thompson 1974:201); the Nigerian Civil War, 1967-70 (Simmonds 1969-70: n.p.); and the assassination in 1976 of the Nigerian head of state, General Murtala Mohammed (Fayọmi 1982:126). In addition, the Èfè may recall any past event for didactic or entertainment purposes, so that, as Anthony Aṣiwaju has pointed out, all aspects of the concert are valuable to the historian (1975:202).

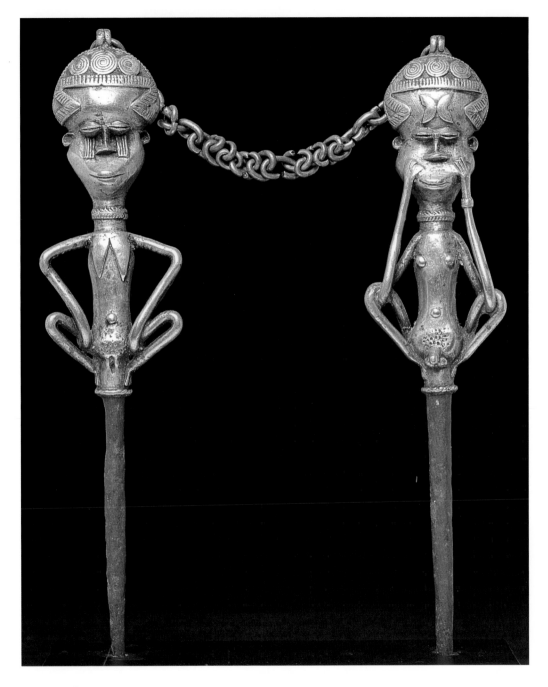

Pl. 1 Ẹdan Ògbóni, the brass staff consecrated to Ilẹ̀, the Yoruba Earth goddess, signifying the interdependence of male and female in the perpetuation of life and preservation of the social order. The Gẹ̀lẹ̀dẹ́ society expatiates on this theme to inspire respect for motherhood, foster gender collaboration, and encourage members of a given community to cherish and interact with one another like offspring of the same mother, so as to minimize the incidence of evil and violence in human society. Brass, h. 11³/₄ inches.

Pl. 2 Female Gèlèdé attendant from Ìbóòrò (1982). Note the use of the baby sash (*òjá*) to amplify the message of the mother-and-child icon on her head, stressing the community's desire for fertility, nurture, protection, and longevity.

Pl. 3 Two Gèlèdé masks from Ìmèkọ, 1970. Mask on right suggests female dancer with a wood-carving on the head. Compare the baby sash on the headdress and waist of this mask with that of the female attendant in pl. 2. The crescent motif identifies this headdress with Èfè and the night.

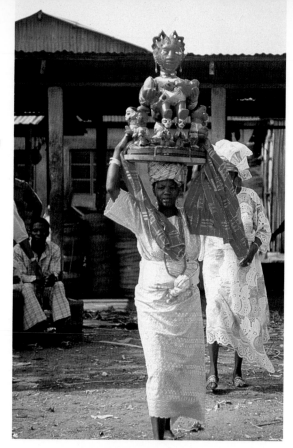

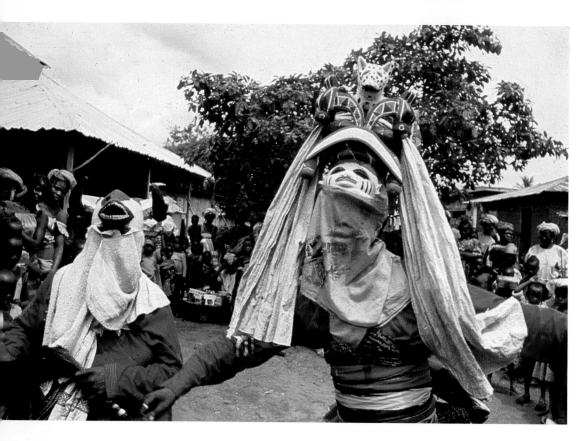

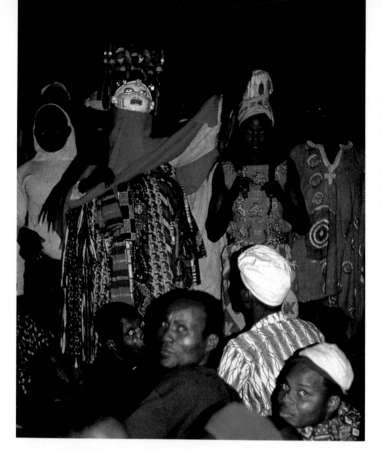

Pl. 4 An Ẹ̀fẹ̀ mask, majestic in his costume of multi-colored head-wraps and baby sashes, recalling the Yoruba equation of the rainbow (òṣùmàrè) with a colorful baby sash. Kove, Republic of Benin (1972).

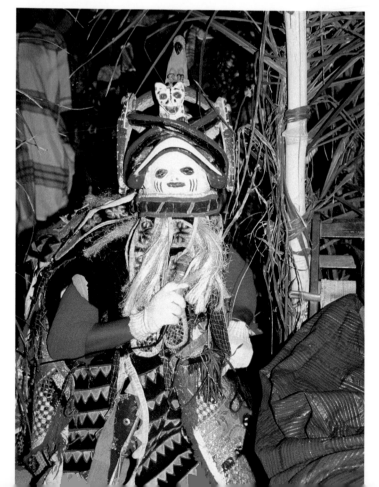

Pl. 5 The Ẹ̀fẹ̀ mask crouches upon entering, as if observing guests among the audience not visible to ordinary mortals. Note the crescent, parrot, and leopard motifs on the headdress. Ìjió (1991).

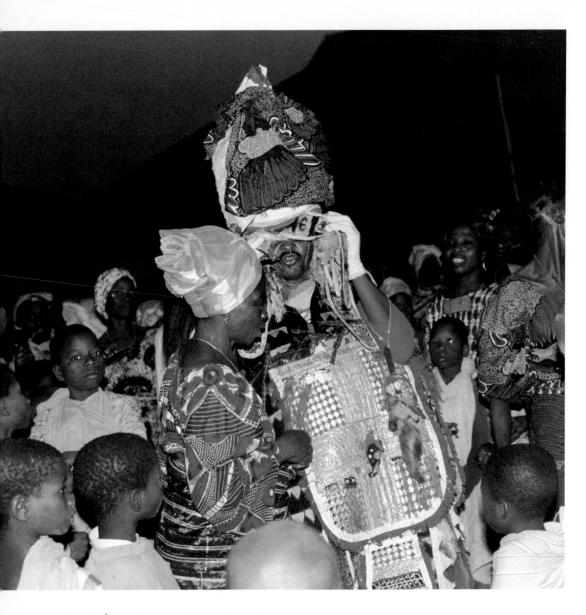

Pl. 6 An Èfè mask at dawn. The headdress is wrapped in cloth (female headtie) at this time. According to several informants, since this mask is associated with the night, the rays of the sun must not shine on its headdress. Ìjió (1991).

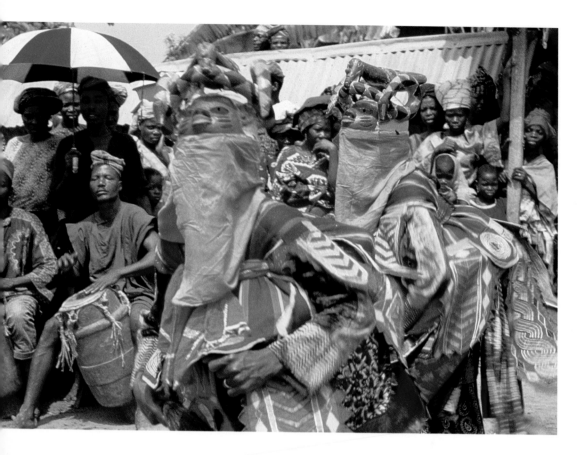

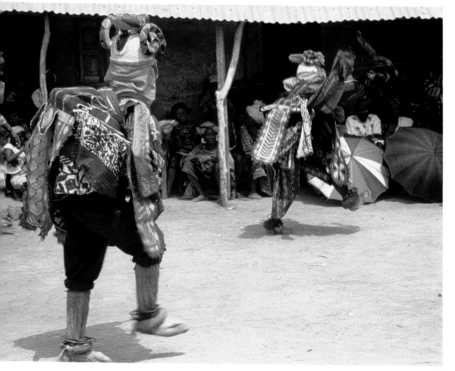

Pls. 7 a, b Identical pair of masks dancing in Ìmẹ̀kọ (1970).

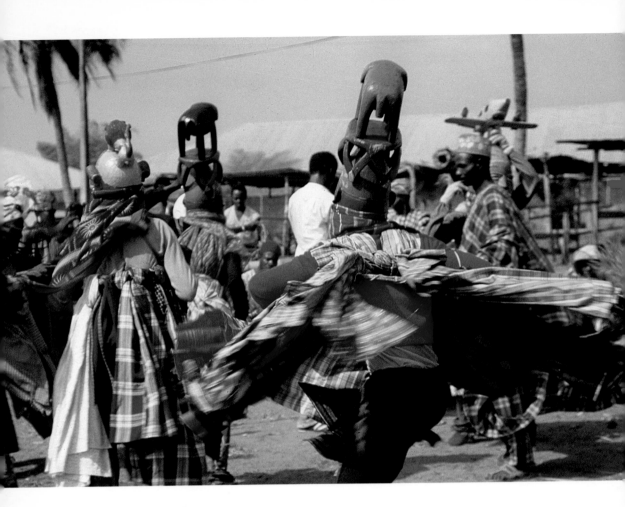

Pl. 8 Gèlèdé masks from Ìbóòrò, 1982. The colorful headties and baby sashes on the hoop fan out during the dance, enriching the Gèlèdé spectacle.

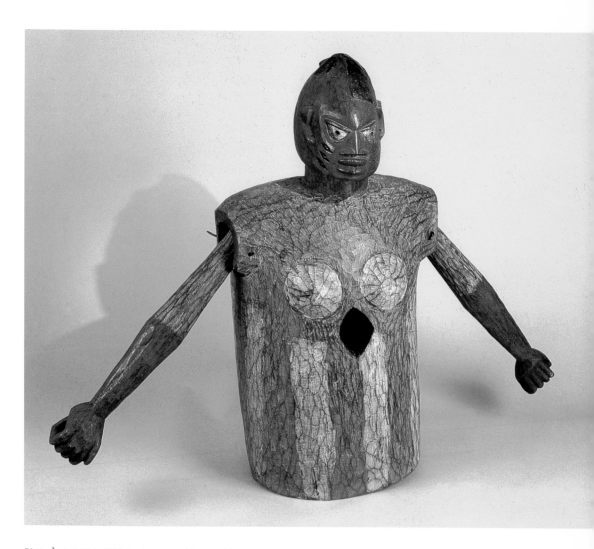

Pl. 9 Ògèdè/Alápáfújà body mask with movable
arms. The hairstyle, with one side of the head shaved,
identifies this mask as a royal messenger (*ìlàrí*) and,
symbolically, as a forerunner of the Gẹ̀lẹ̀dẹ́ dance.
Wood, pigment, iron, fiber, h. 41^{11}/$_{16}$ inches.

Pl. 10 Female Gẹ̀lẹ̀dẹ́ figure. Figures like this are not "danced" (the bottom opening of this one—about 13 in.—is not wide enough to accommodate the human body) but are usually kept inside the Gẹ̀lẹ̀dẹ́ shrine, sometimes placed over an inverted pot. The baby sash (ọ̀jà), full breasts, and big loins identify this woman as a nursing mother (abiyamọ) and an epitome of female procreative power. Wood, pigment, h. 44¹/₈ inches.

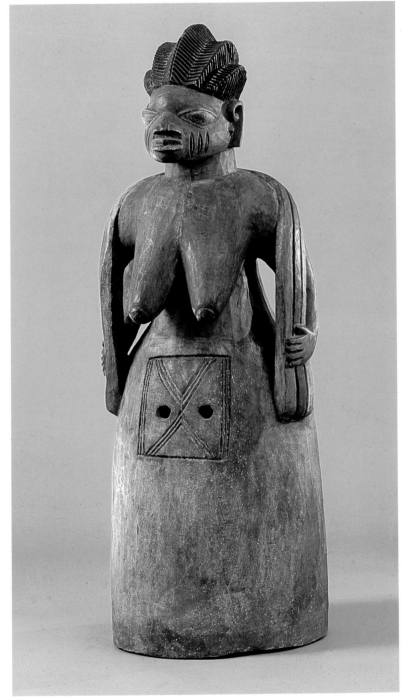

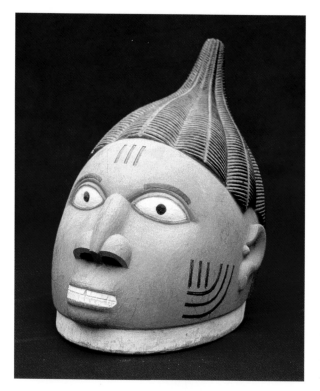

Pl. 11 A typical Ìjèbú Àgbó headdress. Note formal and stylistic similarity to Gèlèdé. Wood, pigment, h. 16 inches.

Pl. 12 Gèlèdé head-dress with dog-eared cap (*abetíajá*). Wood, pigment, h. 8³/₈ inches.

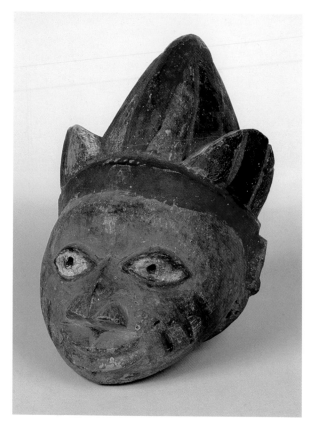

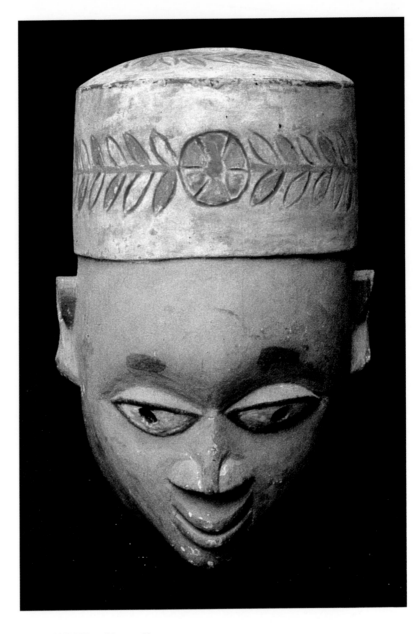

Pl. 13 Gèlèdé headdress with
embroidered hat (*filà*). Wood,
pigment, h. 9 inches.

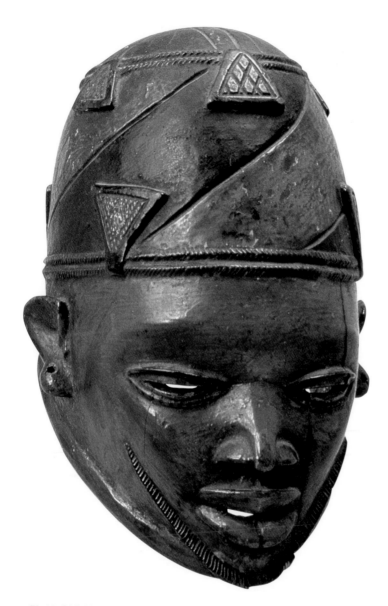

Pl. 14 Gèlèdé headdress with skull cap (*tàjíà*) adorned with Islamic amulets (*tírà*). The incorporation of Islamic decorative motifs into Yoruba art has continued for several centuries. Wood, pigment, leather, h. 7^{15}/$_{16}$ inches. Carved by Amusa Akapo of Ìgbèsà.

Pl. 15 Èfè headdress surmounted by a parrot (*odídẹrẹ́*). Because of its red tail feather, the parrot is also associated with the menses and, by extension, procreative power. On the Èfè headdress, the motif identifies the mask with Ìyá Nlá in addition to emboldening the masker to criticize antisocial elements. Note the red palm fruit (*ẹyìn*) in the parrot's beak. Wood, pigment, h. 13 inches.

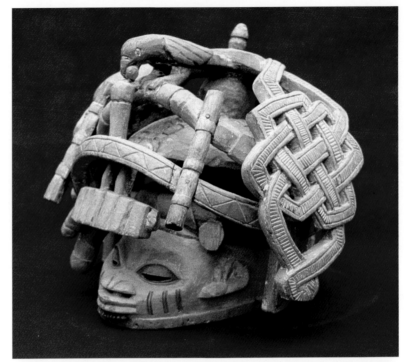

Pl. 16 Èfè headdress (àkàtà Èfè) popularly known as *Àgbàso-wúnù* (Elders-cast-away-jealousy). Sacred beads (*ìdè*) and miniature rhombs representing Orò (the collective power of the ancestors), adorn the circular disk to rein-force the image of the Èfè as a "power superior." The open mouth identifies the Èfè not only as a poet but as someone who speaks with *àṣẹ* (divine authority). Ìsàlẹ̀-Èkó, Lagos (1993).

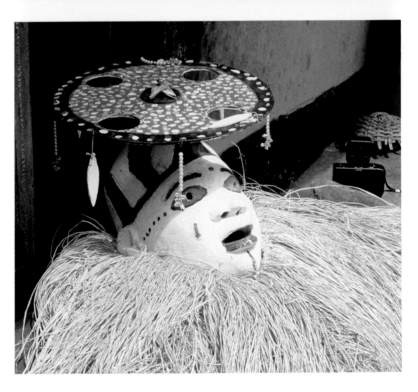

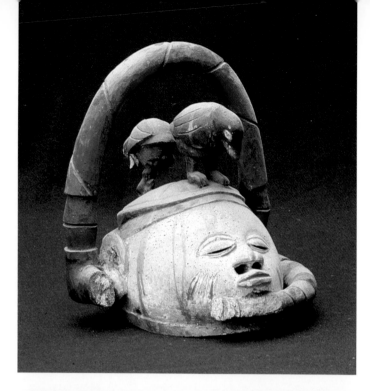

Pl. 17 Gẹ̀lẹ̀dẹ́ headdress carrying two African gray parrots (*odídẹ̀rẹ́*). Because of its ability to imitate human speech sounds, and since it reports all that transpires in the absence of its owner, the parrot has been given the nickname Ayékòótò ("the world does not like to hear the truth"), suggesting its role as a symbol of vigilance and the moral conscience of the community. Wood, pigment, h. 14 inches.

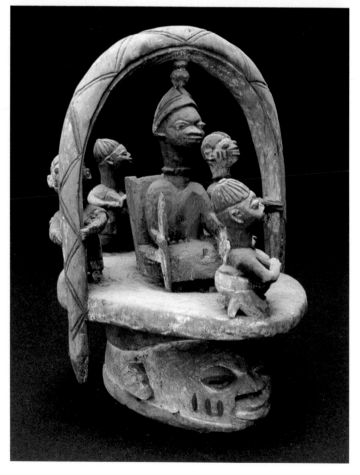

Pl. 18 Gẹ̀lẹ̀dẹ́ headdress depicting a high priest or community leader seated under an arched python—an allusion to Ọ̀ṣùmàrè, the rainbow deity associated with fertility, prosperity, and fame. Wood, pigment, h. 18 inches.

Pl. 19 Gẹ̀lẹ̀dẹ́ headdress featuring musical gourd (ṣẹ̀kẹ̀rẹ̀). The carver or masker sometimes incorporates real objects, as in this example. The musical gourd probably identified the masker as a musician (a ṣẹ̀kẹ̀rẹ̀). Since Yoruba musicians are fond of cocking their (gọ̀bi and ìkòrì) hats, the curved projection on the head atop the ṣẹ̀kẹ̀rẹ̀ may caricature this habit. However, Yoruba hunters wear their long pouchlike *adiro* hats in the same manner (see Picton 1994: fig. 1.3), and a hunter may double as a musician. A stylized female headwrap (gèlè) adorns the head below the ṣẹ̀kẹ̀rẹ̀, mirroring the downward sweep of the male headgear and emphasizing the gender interaction in Gẹ̀lẹ̀dẹ́. (The headdress with two hunters in fig. 7.29 also sports a female headwrap.) Incorporating a musical instrument here underscores the complementarity of the visual and performing arts in the Gẹ̀lẹ̀dẹ́ spectacle. Attributed to carver Mọṣudi Ọlatunji of Ìmẹ̀kọ. Wood, pigment, cowries, cord, h. 28 inches.

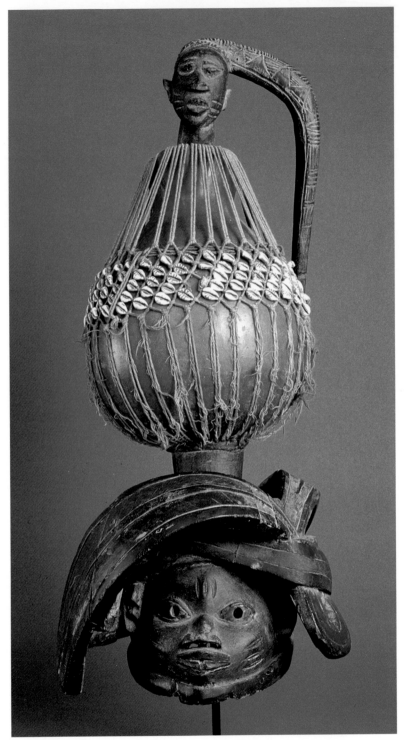

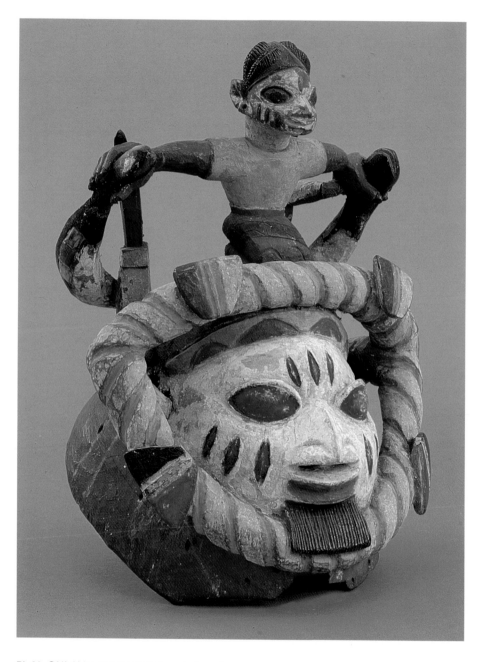

Pl. 20 Gèlèdé headdress depicting a turbaned
Moslem cleric surmounted by a figure holding
two snakes, apparently alluding to man's
attempt to tame and harness the forces of the
wilderness. Wood, pigment, iron, h. 13¹/₈ inches.

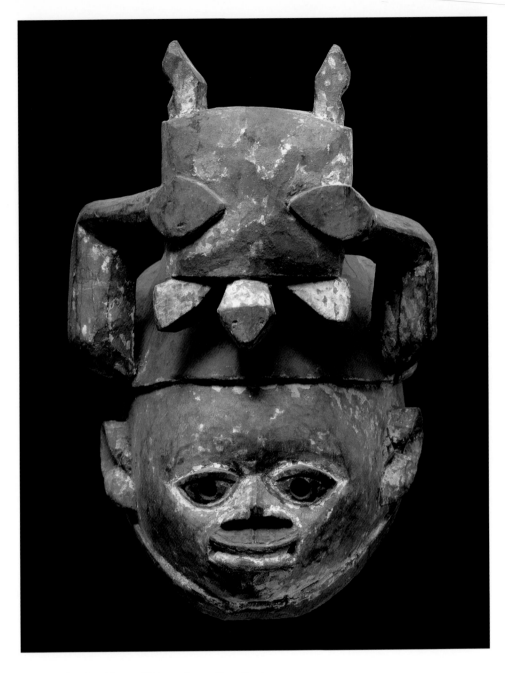

Pl. 21 Gẹ̀lẹ̀dẹ́ headdress with two pythons attempting to swallow a tortoise. This motif also occurs in the repertoire of Apidán (theatrical Egúngún) masks to warn against imprudence. In the latter, when a python succeeds in swallowing a tortoise, it chokes to death. Wood, pigment, h. 14 inches.

Orin Ìdáníl̇ẹ́kọ́: Moral Instruction

Given the concern of the Gẹ̀lẹ̀dẹ́ society with peace, moral probity, and social stability, it is not surprising that didactic themes recur in *èfẹ̀* songs. Sometimes, the Èfẹ̀ mask acts like a preacher, admonishing thieves, murderers, traitors, fornicators, adulterers, troublemakers, and other antisocial elements. In other instances, the Èfẹ̀ sings generally about the virtues of good character. The following "sermon," from Ìsàlẹ̀-Èkó (Lagos), was given in the 1950s by Òsénì Lógo (alias Ayékòfégàn).[40] The first part (lines 1-19) is significant because of the call-and-response style that commits the audience to the need for good behavior. The second part (lines 20-47) is Òsénì Lógo's reply to a popular Moslem preacher (name withheld), who had dismissed Gẹ̀lẹ̀dẹ́ as a pagan ceremony, ridiculing Òsénì Lógo during a public sermon as *Agbégijó* (He who dances with a woodcarving):

40. *Ayékòfégàn* (the world dislikes contempt).

Èfẹ̀: Ẹ jé ká ṣ'òtítọ́
Kí ayé yì lè dára
Kí ayé yì lè r'ójú
Kí ayé yì lè tòro
[5] Àìṣòtítọ́ ni í bà ilé ayé jẹ́
Ìwà burúkú ni í ba ẹbí jẹ́
Ìwà àìbìkítà ni í fa ìjọ̀gbọ̀n

.

Ẹ jẹ́ ka hù ìwà ire
Gbígbè: Ìwà, ìwà l'ànwá, ìwà
[10] *Èfẹ̀:* Ẹni ṣe rere a á rí' re
Gbígbè: Ìwà, ìwà l'ànwá, ìwà
Èfẹ̀: Ìkà á ka oníkà
Gbígbè: Ìwà, ìwà l'ànwá, ìwà
Èfẹ̀: Ìwà rere lo ngbéni í ga
[15] *Gbígbè:* Ìwà, ìwà l'ànwá, ìwà
Èfẹ̀: Ìwà rere l'ẹ̀ṣọ́ ènìyàn, ará mi
Gbígbè: Ìwà, ìwà l'ànwá, ìwà
Èfẹ̀: Ẹ ṣá ma hù 'wa rere
Gbígbè: Ìwà, ìwà l'ànwá, ìwà

.

[20] K'élégbé o p'elégbé o
K'elégbè o p'elègbè
K'alákọrorò kó wá kọ ọ̀kan ṣoṣo

.
Ng ò ma ṣ'èfẹ̀ kí á tẹ́

Ṣè bí ilé ni mo bá èfẹ̀

[25] Ibẹ̀ ni má a f'èfẹ̀ sí lọ o

Tipátipá l'ẹ̀sìn ènìyàn dúdú

Àwọn olíseráfù nwọ́n ma lọ lù ènìyàn pa o

Ni nwọ́n gbé wọn dè, ni nwọ́n re é yẹgi fún wọn o

Ẹ dákun ẹ fù ìwà pẹ̀lú o

[30] Ẹyin tí ẹ nkírun

Bí ẹ kírun ẹ fù ìwà pẹ̀lú

O ò bá à ṣe Ọlọ́ya, bí o bá mí bọ Ṣàngó, bí o kírun

Ẹ fù ìwà pẹ̀lú o

Ènìyàn ló re Haádjì

[35] Ó la kó gọmigọ dání

O mí b'ọ́mọlọ́mọ sùn

O ní o mí ṣe t'Ọlọ́run

Ènìyàn ló lọ Haádjì

O ngbowó èlé

[40] Ara wọn ni

Ọkọ olóbìrin fà 'kan l'ẹ̀wù ya

Obìrin du ká mú 'gbó

Akọ́'le Súnà, síbẹ̀ nwọ́n nhù ìwà ẹ̀ṣẹ̀ o

È wo ló kàn mí o, iná lẹ́ ma wọ̀

[45] Iná li í ṣ'ọkọ iṣu

B'ọ́lọ́rọ̀ mí sọ̀rọ̀, èwo ló kan ẹjọ́ o

È jé mi gbé igbá mi nmá a lọ o.

Èfẹ̀: Let us speak the truth

To make this world a better place,

To give this world a pleasant face,

To make this world peaceful.

[5] Deceit is spoiling the world.

Evil behavior is pulling families apart.

Reckless behavior breeds trouble

.
Let us cultivate good behavior.

Audience: Character, character is what we look for, character!

[10] *Èfẹ̀*: Goodness follows those who do good.

Audience:	Character, character is what we look for, character!
Èfè:	Evil befalls those who do evil.
Audience:	Character, character is what we look for, character!
Èfè:	Good character elevates a person.
[15] *Audience*:	Character, character is what we look for, character!
Èfè:	Good character adds beauty to a person, my dear ones.
Audience:	Character, character is what we look for, character!
Èfè:	Please be of good character.
Audience:	Character, character is what we look for, character!

.

[20] Let the chorus singers come together.

Let the chorus singers come together.

Let the big bird of "the mothers" utter just one cry

.

I will not be disgraced while performing the *èfè*

Because it is my family's tradition,

[25] And I will leave it behind in the family when I am gone.

Coercion is the trademark of African evangelism.

Evangelists of the Cherubim and Seraphim sect committed murder.

They were handcuffed and sent to the gallows.

Please cultivate good character at the same time,

[30] You Moslems who pray five times a day.

When you pray, please cultivate good character at the same time.

Be you a devotee of the tornado goddess, a devotee of the thunder deity,

 or a person who prays five times a day,

Please cultivate good character at the same time.

I know someone who performed the holy pilgrimage to Mecca

[35] Who goes about with a cudgel,[41]

Messing around with other people's daughters,

Yet he claims to be a man of God.

I know someone who performed the holy pilgrimage to Mecca

Who is a money lender.

[40] He is one of them [the exploiters].

An aggrieved husband grabbed one of them and tore his clothes.

The adulteress escaped into the bush.

They built a mosque and still engage in vices.

Why do I worry myself? You will all go to hell,

41. Wooden staff of office of Moslem preacher, but here used as metaphor for erect penis.

[45] Because it is fire that roasts the yam.
 When people go about their businesses, why can't you mind your own?
 Please, let me go about my business.[42]
 (Recorded in Ìsàlè-Èkó, 1983, 1993. My translation)

42. Chanted by two retired Èfè maskers (who wish to remain anonymous). Ìsàlè-Èkó (Lagos), 1983, and 1993.

In Ìjió, the Èfè mask digresses from a long tirade against evildoers to lash out at the lazy ones, who envy the successes of hard-working people:

Èfè: À l'óníṣẹ nṣiṣẹ
Òlẹ wá sùn, ó sùn gégé
Nígbà ó di pé onílé nkólé
Nlẹ wá pàyàyà ẹnu
Nlẹ nṣe òṣùká imú kàlè lóna oko
Tó bá ṣe pé irọ ni, kí ó yọ sí gbangba
Ègbè: Kò lè 'yọjú u!

Èfè: While others are working hard,
The lazy ones slumber away, just sleeping.
When somebody is building a house,
They will gape openly.
They will shape their noses like load-pads as they walk along farmlands.
If this is not true, please come out into the open.
Audience: He cannot come out!
 (Recorded Ìjió, 1991. My translation)

These two verses reflect the emphasis in Yoruba ethics on good character (*ìwà rere*) and hard work (*ìmúrasíṣẹ*). Since *ìwà* ultimately determines the beauty (*ẹwà*) of a person, the irreducible unit of human society (*àwùjọ ènìyàn*), it also affects the overall existence (*ìwà*) of the group as well as the extent of the harmony (*ìrépò*) within it. Hard work reinforces harmony in various ways. Not only does it generate self-sufficiency and reduce poverty, envy, and crimes but it also promotes social and material development (*ìlọsíwájú*), and, above all, happiness (*ìdùnnú*).

Orin Ìyẹnisí: Praise Singing

In the course of their performance, Èfè maskers frequently sing the praises of socialites, chiefs, and other notable members of the community. The following verse by Òsénì Lógo, the celebrated Èfè maestro of Lagos in the

1940s and 1950s, was composed (mid-1950s) in honor of one Ọlaribigbe
Ọlasẹhinde, a Lagos socialite:

> Aderibigbe yáyì l'ọ́kùnrin o
> O fì ìwà jọ bàbá ẹ̀
> À l'ójú ò ní tì ẹ o
> Ọmọ aláfẹ́ lo jẹ́
> [5] Sẹhinde o, ó dá'sọ àran ó rí regeje
> Regeje o, Sẹhinde o
> Ó dá'sọ aran o ri regeje
> Ọlọ́lá ló jẹ́
> Ó gbayì o gbẹ̀yẹ
> [10] Ó fì ìwà jọ bàbá ẹ̀
> À l'ójú ò ní tì ẹ o
> Ọmọ aláfẹ́ lo jẹ́.

> Aderibigbe is a fine gentleman.
> He is of good character like his father.
> I say, may you never suffer disgrace.
> You are a born socialite.
> [5] Sẹhinde o, he has one magnificent velvet robe.
> Yes, Sẹhinde,
> He has one magnificent velvet robe.
> He is a highly regarded man,
> Honorable and respectable.
> [10] He is of good character like his father.
> I say, may you never suffer disgrace.
> You are a born socialite.[43]

> (Recorded in Ìsàlẹ̀-Èkó, 1993. My translation)

43. Chanted by a retired Èfẹ̀ masker (who wishes to remain anonymous). Ìsàlẹ̀-Èkó (Lagos), 1993.

Orin Ìrántí: Commemorative Singing

To the Yoruba, death is not a finality but is rather a transformation from a
physical to a metaphysical existence, in which the spirit of the deceased
ancestor assumes the status of an *òrìṣà*, and also participates actively in the
affairs of the living through frequent invocation. During the annual Gèlèdé
festival and on special occasions, deceased members of the Gèlèdé society,
as well as important persons in the community who have departed to the
great beyond, are honored with songs recalling their personal virtues and

achievements. These songs are intended to console members of the deceased family and also to predispose the spirits of the dead to contribute to the well-being of their survivors.

Recorded in Ìjió in 1969, the following song honors deceased members of the Gẹ̀lẹ̀dẹ́ society, appealing to them to unite (line 10) and thereby continue as a force for unity and goodness among the living:

Mo f'orin ránti gbogbo àwọn tó ti kú
Ògúngbilé Kógilédè, ẹyin ṣá ni baba
Ẹlẹ Oníbeku, ẹ y'ọ́run, ọ̀run àyọbọ̀
Àyìnlá Aṣipale, ẹ sọ fún Kobilé Ìyálá́ṣẹ̀
[5] Ki ẹ bá ni t'ẹ́gbẹ ṣe
Àlàó Erelápá ọkọ́ yín tó jánu, l'anlò lọ baba
Oníkétu, mo pè yín, ẹyin ni baba
Èmi kò gbàgbé yín o, Ògúndìran
Mo ránti Jagun ìlú, ọmọ Erelápá, kú oru ìsàlẹ̀
[10] Ọbambẹ, kẹ péjọ lí wàrun
Ẹ wá bá ni t'ójú ẹgbẹ́
Àṣàmú Ẹlẹ Kogilédè, ẹ wá lé
Ṣedé Òkìkí, Ìyá Abíọ́lá, mo pè yín
Ọmọ Onílé Ikọrin o, ẹ dìde kó yá
[15] Ẹ bá ni m'ẹ́gbẹ́ l'ọ́wọ́
Aríbikọ́fá, ẹ má e sùn lí wàrun

.

Bàbá Ògúnrìndé o, kẹ padà wá ya'mọ titun
Àṣàmú Elede Ogbó, ẹ kú oru

.

Ọ̀run kì í ṣ'àyọ bọ̀
[20] Ẹ tètè gbó'hun tí mo sọ
Ẹ bá ni t'ẹ́gbẹ́ ṣe, kó dára
Ka má e rí 'kú ọ̀dọ́mọdé ṣinṣin. . . .

I remember you with songs, all the dead.
Ògúngbilé Kógilédè, you are our father.
Ẹlẹ Oníbeku, you have gone to heaven from where people do not return.
Àyìnlá Aṣipale, please tell Kobilé Ìyálá́ṣẹ̀
[5] To be with our society.
Àlàó Erelápá, we are still using the hoe you left behind, father.
Oníkétu, I call on you, you are our father

.

I have not forgotten you, Ogúndìran.

I also remember, the Jagun, the son of Erelápá, may your soul rest in peace.

[10] Ọbambẹ, all of you should come together in heaven

And support our society.

Àṣàmú Ẹlẹ Kogilédè, come home.

Ṣedé Òkìkí, Ìyá Abíọ́lá, I call you.

Ọmọ Onílé Ikọrin, please rise up,

[15] Lend our society a helping hand.

Aríbikọ́fá,[44] do not sleep in heaven

.

Father Ògúnrìndé, come back and reincarnate as a newborn baby.

Àṣàmú Elede Ogbó, may your soul rest in peace.

Heaven is not a place you go and come back.

[20] All of you, listen to me.

Support our society, so that it will be good.

Help prevent premature deaths. . . .

(Simmonds 1969-70:n.p. My translation)

44. A reference to Jagun Aríbikọ́fá, who reportedly introduced Gẹ̀lẹ̀dẹ́ to Ìjió from the Republic of Benin (formerly Dahomey).

The appeal to the dead to "come back and reincarnate as a newborn baby" (line 17) highlights the Yoruba belief in life after death through a perpetual cycle of living and dying, which makes it essential that the living maintain a harmonious relationship with the dead.

In many areas, the *èfè* ceremony formally comes to an end at dawn when the hyena mask, Kòrikò, suddenly appears at the marketplace (fig. 5.9).[45] In the confusion that follows, the Èfè mask withdraws from the arena. The audience disperses, though a bit exhausted, yet feeling spiritually refreshed by the performance. Since the Èfè mask is a nocturnal being (*Ajòru*), it is taboo for him to perform in daylight. Hence, as soon as it is daylight, his headdress must be covered with a piece of cloth (pl. 6).

45. See also Kerchache (1973:23). In other areas, masks representing Èṣù or any other deity perform a similar function.

Ijó Ọsán: The Diurnal Dance

Most of the people who attend the *èfè* ceremony spend a good part of the morning sleeping in order to have enough rest before the *ijó ọsán,* the afternoon dance. As a result, there is little life in the streets, especially in small towns where almost everybody is involved in the festival. Life usually returns to normal about noon, as people prepare breakfast or perform other duties. In big towns like Ìbarà, Abẹokuta, special masks such as the Ẹfọ̀n

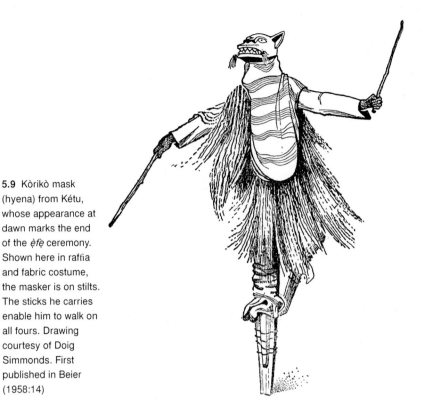

5.9 Kòrikò mask (hyena) from Kétu, whose appearance at dawn marks the end of the *èfè* ceremony. Shown here in raffia and fabric costume, the masker is on stilts. The sticks he carries enable him to walk on all fours. Drawing courtesy of Doig Simmonds. First published in Beier (1958:14)

(buffalo) and the Ògèdè (female gorilla) dance through the streets (fig. 5.10), stopping in front of the houses of important personalities to receive gifts.

The afternoon dance begins any time from about two o'clock; by this time, a good majority of the populace has had sufficient time to recover from the hangover of the *èfè* ceremony. The playing of drums in the marketplace by apprentice drummers is a signal that the dance will soon begin. Small children, some wearing discarded masks and makeshift costumes, gambol in front of the drummers, learning the basics of the Gèlèdé dance (fig. 5.11). Sometimes one or two adults may be in attendance to instruct them. Between three and four o'clock, gaily dressed masks, accompanied by friends, relatives, and elders of the Gèlèdé society, all singing and dancing, leave their various family compounds for the performance venue (fig. 5.12). Everybody is in a joyous mood; some men dress as women, and some women as men, so much so that it is sometimes difficult to differentiate the one from the other, except through the voice. In Lagos, there is usually a traffic jam as masks or their attendants dance in the middle of the street, forcing motor vehicles to slow down or stop completely. All roads leading to the

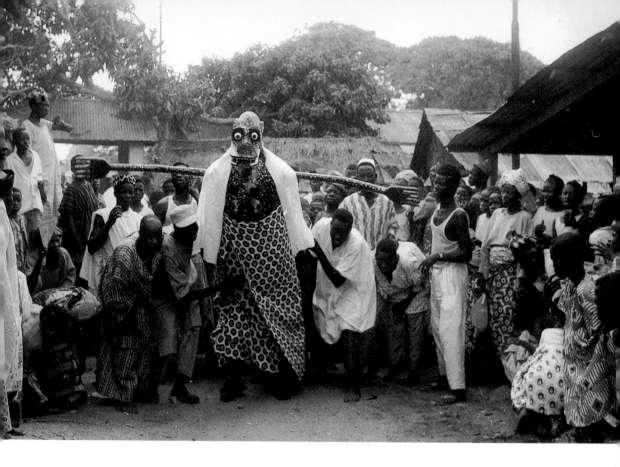

performance venue are simply impassable to motor vehicles because of the throng.

In most areas, the dance begins after the Ìyálásè and other important members of the community have taken their seats. By now, all the small children with makeshift costumes have been dispersed from the arena and the master drummers have occupied the bandstand. In Lagos (Ìsàlè-Èkó and Ìsàlègangàn), all the Gèlèdé masks enter the arena together in two rows of identical pairs and are welcomed by the drummers with the following drum text, admonishing antisocial elements:

Gèlèdé tíbóm-bóm
Tìkà, tìkà, tìbóm-bóm
Gèlèdé tìbóm-bóm
Tìkà, tìkà, tíbóm-bóm
A wí wí wí wí, ẹ lé ò gbọ́
A fọ̀ fọ̀ fọ̀ fọ̀, ẹ lé ò gbà
A gbé 'lù sílè, a tún f'ẹnu wí

5.10 Ògèdè mask (female gorilla), owned by the Agbépò family, parades the street in the morning after the èfè ceremony. The baby sash on the mask's shoulders is a symbol of maternal care, enjoining Ìyá Nlá to protect humanity with the same passion as a female gorilla nurses a newborn. Ìbarà, Abéòkúta (1958).

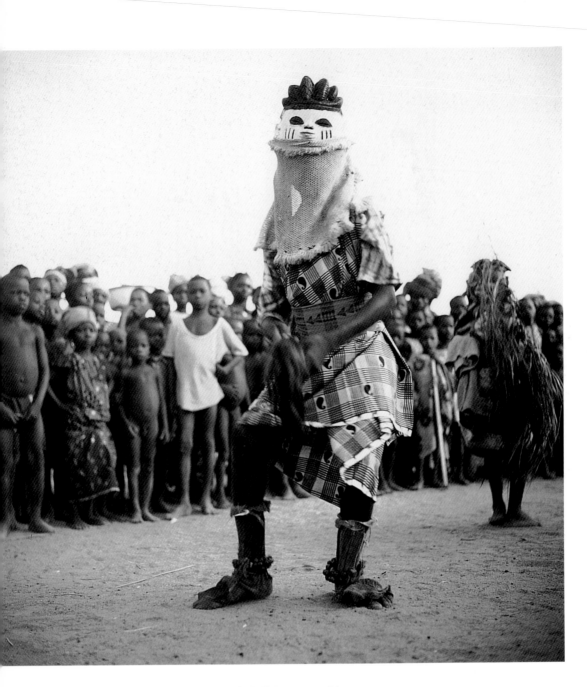

5.11 Young Gèlèdé dancers acquiring performance skills. Ìjió (1970).

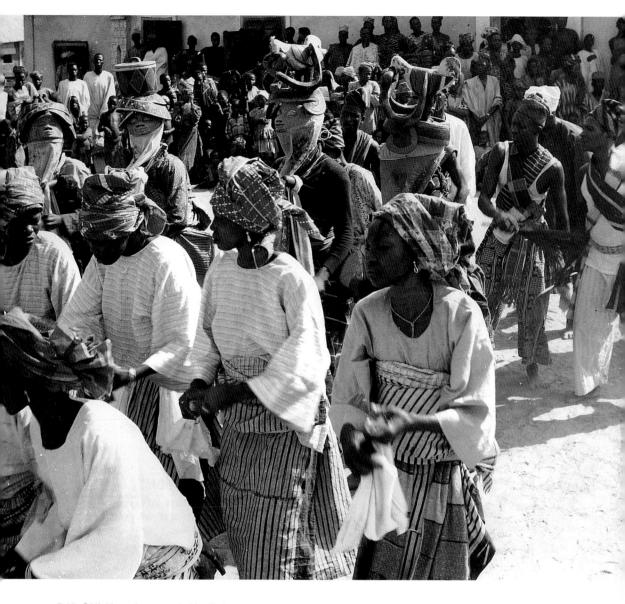

5.12 Gèlèdé masks, preceded by their entourage, parade to the performance arena. Members of the Gèlèdé chorus often wear fabrics of the same design (*aṣọ ẹbí*) to identify themselves as a social unit. Ìjió (1969).

Àpótí ṣ'alákàrà kábíáwú

Ohun tí ẹ ṣe ló nfu yín lára

Ìwà tí ẹ wù ló nbà yín lẹ́rù

A mú ni ṣì wí, a mú ni ṣì ṣọ

A mú ni t'òkèlè bọ'mú ni baba wọn

Gèlèdé tìbom-bom

Tìkà, tìkà, tìbóm-bóm

Ṣè ṣe ṣè, jìngìn, jìngìn, jìngìn

.

Gèlèdé, tìbóm-bóm

Tìkà, tìkà, tìbóm-bóm

Gèlèdé, tìbóm-bóm

Tìkà, tìkà, tìbóm-bóm.[46]

Despite all our warnings, they did not listen.

Despite all our pleadings, they refused to comply.

We stopped talking with the drums and used the mouth.

Whenever the stool gives way, the bean cake vendor will fall over
 backward.[47]

Because of your offenses you are always suspicious.

Because of your character you are always in fear.

You can make one say the wrong thing and utter the wrong word.

Your father can make one put food in the nostrils [a confusionist].

Gèlèdé, tìbóm-bóm

Tìkà, tìkà, tìbóm-bóm

Ṣè ṣe ṣè, jìngìn, jìngìn, jìngìn [sound of anklets].

(Recorded in Ìsàlè-Èkó, 1993. My translation)

46. Lines 1-4 are an onomatopoeia for the dance steps of Gèlèdé.

47. "The day of reckoning will soon come." This is a warning to antisocial elements and braggarts.

After this preliminary dance, the masks retire to a corner to wait until being called to perform. In many communities, the Bàbàláṣè says an opening prayer before the main program begins. Then the orchestra rolls out the tunes, inviting the masks. They usually dance in pairs. In Kétu, Ìmèkọ, Ìjió, and environs, the masks enter the double-arch entrance to the performance arena in a peculiar manner, doing so with their backs toward the audience, in the same way a priest enters a very sacred shrine. As earlier mentioned, this entrance, ẹnu aṣè or "gateway to the shrine," metaphorically extends Ìyá Nlá's shrine (Aṣè) to the performance arena. A few feet backward into the performance arena, the masks suddenly turn round and dance toward the drummers, picking their steps in unison to the beat. Although this man-

ner of entry is not universal today, my inquiries revealed that it was the rule in the past, the change being blamed on modernization. In any case, the order of appearance of the maskers depends for the most part on seniority and experience, with the younger and less experienced dancers performing first. Almost everywhere, there is a preliminary demonstration by fully costumed children who have mastered the basics of the dance. This is a training session before a live audience for the young ones, who will take over when the adults retire. Those who display exceptional skills are applauded and sometimes rewarded by admirers, who run to the center of the performance arena to give them money. The not-so-gifted receive words of encouragement.

When adult masks begin to perform, the drummers change the beat. The rhythm becomes faster and more complex, and the audience, more critical. The smaller drums (the *omele*) maintain a steady, though polyphonic, background rhythm, while the bigger drums (*Ìyá ìlù* and *Ọ̀sọ̀sọ̀*) perform solos and duets. These drum solos and duets, called *èkà* (phrasings) are based on well-known proverbs, aphorisms, slogans, songs, tongue-twisters, and onomatopoeia. More often, the maskers must have rehearsed the solos with the drummers during the long preparation for the festival. It suffices to say that the heart of the Gẹ̀lẹ̀dẹ́ dance is in synchronizing the jingling of the metal anklets with the *èkà*, anticipating the sequences and the stops, and ending the phrasings at the same time as the drums. As Robert Thompson was told in Kétu: "A thousand dresses, it does not matter; if you compromise the drum speech, you are not a good dancer" (Thompson 1978:59). For instance, the dancer is expected to match the following *èkà* line-by-line:

Wòrú o
Wòrú oko
Wòrú o
Wòrú odò
[5] Wòrú p'ọkà f'ẹyẹ jẹ
Mo dé'lé mo rò fún baba
Baba na Wòrú jọjọ
L'ábẹ́ ọ̀gẹ̀dẹ̀, l'ábẹ́ òrombó
Nígbàwo l'ó d'ábẹ́ aṣọ.

Wòrú o
Wòrú in the farm.
Wòrú o

Wòrú in the river.

[5] Wòrú left the corn for the birds to eat.

On getting home, I reported to father.

Father flogged Wòrú very well.

Under the banana plant, under the orange tree,

When did you get under the cloth?[48]

<div align="right">(Recorded in Igbóbì-Ṣábèé, 1972. My translation)</div>

48. "Under the cloth" alludes to the man under the Gèlèdé mask. This is a popular children's play song, with variant wordings in different parts of Yorubaland.

In the same *èkà* at Igbóbì-Ṣábèé, the orchestra welcomed a pair of female masks into the arena with the following beat:

Ẹyẹ mélo tolongo wá'yé

Tolongo

Òkọn dúdú aró

Tolongo

[5] Òkọn rèrè bí osùn

Tolongo

Ṣòṣòṣó fì'rù ba'lè

Ṣó-ó-ò!

Ṣòṣòṣó fì'rù ba'lè

[10] Ṣó-ó-ò!

Ṣòṣòṣó fì'rù ba'lè

Ṣó-ó-ò!

How many birds are coming to the world?

Tolongo,

One is as dark as indigo.

Tolongo,

[5] One is deep red like camwood ointment.

Tolongo,

Hop, hop, and perch on the ground.

Perch!

Hop, hop, and perch on the ground.

[10] Perch!

Hop, hop, and perch on the ground.

Perch!

At the beginning of the song, both masks dance gracefully and leisurely, imitating the dance motion of the womenfolk; but towards the end, there is a slight jump and a short squat in imitation of a perching bird.

One of the male masks on the other hand, is greeted with a faster beat:

Òrò yí kò ní le wò
Òrò yí kò ní le wò
Ká s'ajá mó'lè, ká s'ẹkùn mó'lè
Ká wá mú'rù ẹkùn, ká fi l'ájá l'ówó
Òrò yí kò ní le wò

It is not going to be easy
It is not going to be easy
To tether the dog, to tether the leopard
And then hand over the leopard's tail to the dog.
It is not going to be easy.

The dance is vigorous and aggressive, punctuated with sharp turns, kicks, and jumps. More often, the identity of a dancing pair determines the type of beat. For the male pair, the beat is vigorous, and the mask responds accordingly, displaying masculine virtues or "the dance of the strong" (ijó alágbára). The beat for the female, on the other hand, is usually less vigorous, and the mask responds by emphasizing feminine grace and movements (ijó jẹlẹnkẹ). This choreographic distinction represents the ideal, however, not observed everywhere and frequently ignored in Lagos, Òtà, Ìgbẹsà, and several Ẹgbádò communities where the dance of some female masks is sometimes as vigorous as the males', depending on the beat and the agility of the masker. Animal masks dance to imitate the characteristic behavior of their subjects. In Kétu, Robert Farris Thompson observed a warthog (Ìmàdò) mask respond to an ẹkà portraying the animal:

His motion was a perfect complement to the animality cited in the verse to which he danced. He fell to the earth, used his hands as forward paws, alternately kicking up either leg, then kicking up his legs together, then resting on one palm while spinning in a circle. (Thompson 1974:205)

The influence of the costume on choreography will be discussed in the next chapter. In any case, the fact that the masks dance in pairs (fig. 5.13; pls. 7a, b) accentuates the rhythm of the ẹkà and results in a simultaneous movement of both dancers' legs, so that the slightest miscalculation becomes glaring, both visually and aurally. A master dancer is recognized not only by the way he jingles his anklets in perfect unison with the drum phrasings

(èkà), but also by his creative improvisations within the dance structure (figs. 5.14a, b). Each dancing pair performs to one or two èkà, after which another pair comes in. A pair that does not measure up to expectations may have its dance time shortened by the drummers or by open ridicule from the audience. At Ìpókíá, however, a dancing pair was so good that the drummers, encouraged by the tumultuous ovation from the audience, prolonged the èkà, making it more complex so as to give the two dancers a good opportunity to display their skills. With chests pushed out, trunks slanted backward, and hands outstretched like wings, swinging rhythmically, the dancers jingled their anklets to the beat, bending, occasionally twisting the hips and rotating the shoulders, displaying all the attributes associated with only the masters: creativity, anticipation, balance, harmony, composure, ease of movement, precision, and self control. At one stage, the orchestra attempted to outwit the pair by complicating the rhythm, but the pair rose to the challenge with the result that the jingling of metal anklets soon became inseparable from the music itself, electrifying the audience. The encounter ended with a deafening cheer and many members of the audience rushed into the arena to congratulate the dancers. It took the crowd controllers some time to restore order.

Although tradition requires the masks to dance in identical pairs, variations have been introduced over the years. In some communities, masks that had earlier performed in pairs may return later to execute individual solos or pair up with different ones, sometimes in a husband-and-wife fashion. At times, members of the audience urge on a mask by mirroring his movements. To add variety to the show, some masks perform in multiples of three or four, or as a group, if they are all from the same family or compound. In Ìlaró, between ten and twelve masks dance together at times, so that the different notes of their metal anklets sound in unison, evoking the virtues of collaboration and teamwork (fig. 5.15). At regular intervals, when the masks are resting, elders of the Gèlèdé society, and men, women, and children take the floor, dancing either to the music supplied by the Gèlèdé orchestra or to the tune of dùndún and bèmbé drums, singing prayerful songs, beseeching Olódùmarè (the Supreme Being), Ìyá Nlá, the òrìsà, and all deceased ancestors to bless them with good health, long life, wealth, fertility, and, above all, happiness (figs. 5.16-5.18).

Everybody is in a joyous, celebratory mood as the music takes over the body; even the aged, the sick, the bereaved, the poor, and the distressed temporarily forget their problems. For the moment, life feels like a paradise.

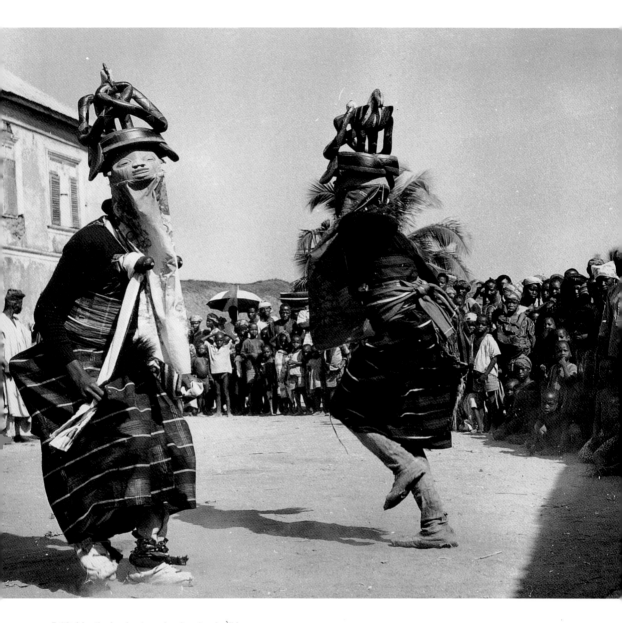

5.13 Identical pair of masks dancing in Ìjió
(1969).

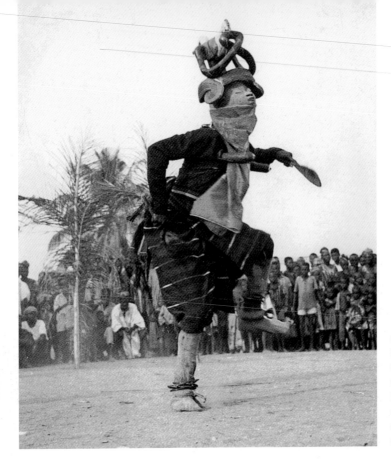

5.14 a, b Creative improvisation is one of the hallmarks of the *ẹ̀kà* dance. Many masks hold fans not only for cooling the body but also as a supplicatory symbol. Ìjió (1969).

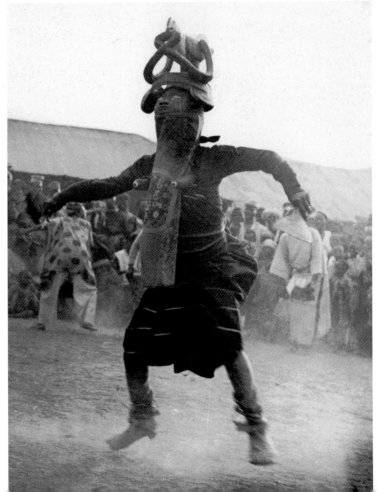

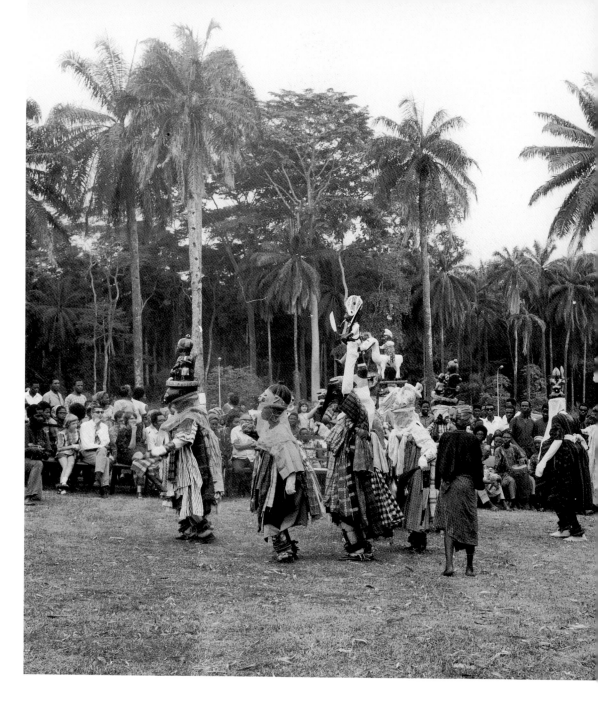

5.15 Gẹ̀lẹ̀dẹ́ masks from Ìlaró performing a group dance under the direction of their "spiritual mother" (Ìyalájà), who shakes an iron rattle to the music while the dancers jingle their anklets. The different notes sounding in unison evoke the virtues of collaboration and teamwork. At the Fourth Ifẹ̀ Festival of the Arts, Ilé-Ifẹ̀ (1971).

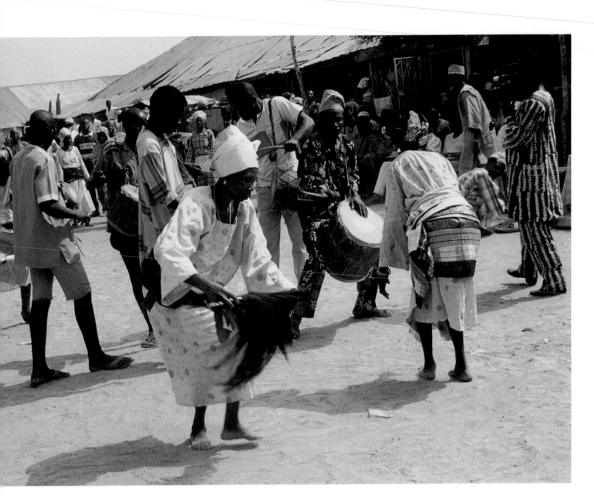

5.16 Two women dancing to *bẹ̀mbẹ́* drums during Gẹ̀lẹ̀dẹ́ festival, mirroring the emphasis on doubling in Gẹ̀lẹ̀dẹ́ choreography. Ìjió (1991).

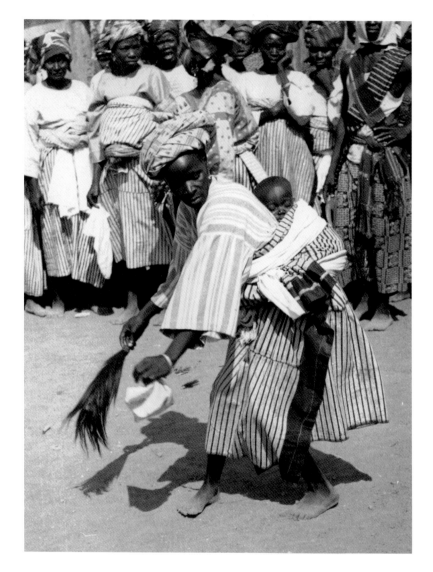

5.17 A mother dances with a horsetail whisk
during Gẹ̀lẹ̀dẹ́ festival. Two baby sashes (*ọ̀já*)
firmly secure the child on her back. The man in the
background wears *ọ̀já* (one on the waist and two
across the body) to attract Ìyá Nlá's protection and
blessings. See also figs. 5.12, 5.18. Ìjió (1969).

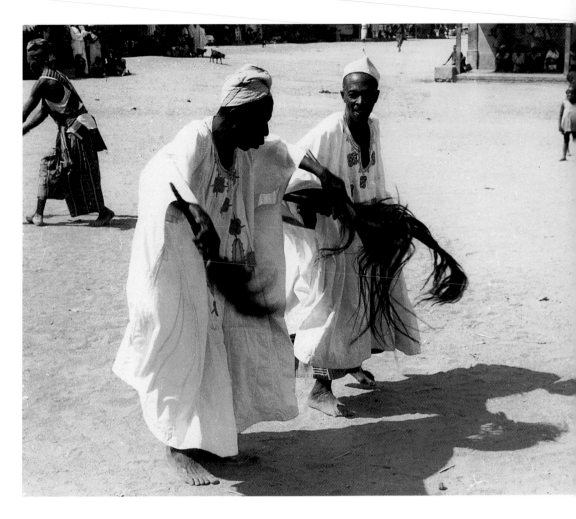

5.18 Two senior functionaries of the Gẹ̀lẹ̀dẹ́ society (holding horsetail whisks) pair up for a dance. Ìjió (1969).

This brings us to a major difference between the headdresses of Èfè and Gèlèdé masks. The motifs on Èfè headdresses are few and relatively unvaried: elaborate openwork coiffures are surmounted by some animals (especially the leopard motif), birds or figures, and are adorned on both sides with sheathed knives. The motifs on Gèlèdé headdresses, on the other hand, are more diverse, covering virtually every subject under the sun. The narrower range of motifs for the Èfè headdress can be linked with the fact that it performs only in the night, when the emphasis is on oral and aural communication.[49] To enjoy the èfè concert, one must have a good ear for music and poetry. The motifs on the wooden headdress of the Èfè are intended primarily to bolster his image as "the king of the Èfe's market." The proliferation of motifs on the headdress of the diurnal Gèlèdé is largely due to the fact that it specializes in dance and visual display. What the Èfè masker communicates *orally,* the Gèlèdé masker does *visually,* on its headdress. This functional difference is evident in the popular saying: *Adití kì í wo èfè; Afójú kì í wo Gèlèdé.* (The deaf do not attend the *èfè* ceremony; The blind do not attend the Gèlèdé dance.)

As noted earlier, the Gèlèdé masker is known as *ajógi* (he who dances the wooden image) because of his preoccupation with dancing. In the kinetics of the dance, the headdress acquires a new vitality, creating illusions of being transformed into a living entity (fig. 5.19). Its eyes fleetingly appear to be "seeing" the environment; yet the face looks uncannily dignified and tranquil, as if sensing the presence of supernatural beings among the audience who have come to judge the performance and thereby assess the community's sense of purpose. Motifs like motor vehicles, boats, airplanes, horse riders, and animals seem to heighten the motion of the dancer. Yet most of the figures on the superstructure of the headdress look unruffled, seemingly confident of the dancer's control of the situation. The sounding of drums, the buzz of human voices, and the jingling of metal anklets combine with the movements of forms in space, in a whirl of dust and colors, against the redness of the earth. A sea of heads, a mass of human bodies clad in multicolored dresses, the surrounding trees and buildings—all transform the dance venue into an unforgettable vision. And when this experience is added to that of the *èfè* ceremony of the first night, it is difficult to find any other festival in Yorubaland that rivals Gèlèdé's. Hence, the popular saying: *Ojú t'ówo Gèlèdé ti d'ópin ìran.* (The eyes that have seen Gèlèdé have seen the ultimate spectacle.)

49. According to Aṣimi Ọlatunji-Onigèlèdé, the famous Èfè masker of Ìmèkọ (1971), just as the morning light must not meet the wooden headdress still on the head of the Èfè (it must be covered with a cloth, as in pl. 6), the night must not meet the wooden headdress on the Gèlèdé masker's head. Anybody who breaks this taboo runs the risk of becoming blind. Nothing, however, prevents an Èfè poet from participating in the diurnal dances, provided he does not dress like an Èfè mask. But there is a sharp difference of opinion (in a survey I conducted) on whether an Èfè wooden headdress can be worn during the afternoon dance. Some say it could be used by somebody else, but not by the Èfè masker himself; others disagree, saying that those who do so are going against tradition. The mask on the right in plate 2 wears an Èfè headdress in daylight because, according to my Ìmèkọ informant, "the headdress has been retired from active night duty." Afọlabi Ọlabimtan has observed a new trend in the *èfè* performance: namely, in Ìlaró (in 1971), after the night concert had formally ended, the Èfè mask paraded the town accompanied by *dùndún* drummers, visiting the houses of important people and receiving gifts (Ọlabimtan 1970: 41). In other towns, the Èfè mask may perform until daylight.

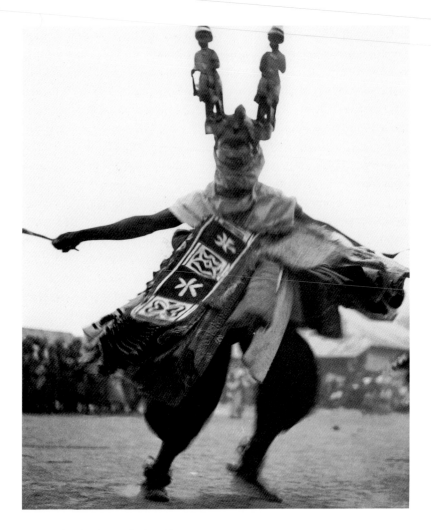

5.19 During the dance, the headdress
acquires its own vitality, creating illusions of its
transformation into a living entity. Ìjió (1969).

Indeed, participation in Gèlèdé is an intense spiritual experience: beating the drums, dancing in the costumes, receiving the blessing of the mask, or responding to the music is like being charged with divine energy. It is a feeling of the good life, to be lived and enjoyed to its fullest.

The diurnal dance takes place every day at the same time and venue throughout the duration of the festival. The dance always ends at dusk. On the last day, a special mask visits the dance venue to formally close the festival. This task is performed in many communities by a female mask dressed in an all-white attire (called *Ìyálé Yemoja* in Ìbarà and *Ìyálé Oòduà* in Ìlaró). The mask is said to represent the Ìyálàsè. In other towns, the Ìyálàsè appears in person to perform the same task, praying for the well-being of the community. In Imèko, the appearance of Sàkínní, a mask with a carved python head, marks the end of the festival. Life returns to normal the following day, although the spirit of the festival lingers on for weeks. It is as though the participants have received a new lease on life: everyone is in good spirits. Neighbors, friends, and relations greet one another:

Ẹ kú odún o
Ẹ kú ìyèdún
Kí ódun ó 'yabo o
Kí ódun ó sàn wá s'ówó
K'ó sàn wá s'ómo
À sè'yí, s' emí i o.

Happy festival!
Let us give thanks for witnessing the festival.
May the festival turn out to be female[50]
May the festival usher in more money.
May it usher in more children.
May we survive this festival and live to celebrate the next one.
(Recorded in Ìlaró, 1971. My translation)

As people return to the routine of daily life, they continuously reflect on the highlights of the Gèlèdé spectacle, analyzing the poetic eloquence of the Èfè mask and recalling the beauty of the costumes and dances of the daylight masks. Certain *èfè* songs and jokes on topical issues will soon become the talk of the town and will eventually find their way into the archives of oral tradition, to be retrieved from time to time for didactic and recreational purposes.

50. In Yoruba thought, the *female* connotes coolness and softness; and the *male*, hotness and hardness. Thus, the greeting "May the year turn out to be female" is a wish for a prosperous and peaceful year.

According to John MacAloon, the ideal spectacle should include the following distinctive features: (a) emphasis on visual sensory and symbolic codes; (b) monumentality and an aggrandizing ethos; (c) institutionalized bicameral roles of actors and audience, the one active and the other passive; and (d) a dynamic performance that stimulates excitement in the audience (1984:243-46). The Gèlèdé spectacle has three out of four of these (a, b, and d). The absence of institutionalized bicameral roles (c) is due to the fact that, as Margaret Drewal rightly points out, the Yoruba notion of the spectacle encourages audience participation (1992:15). Even in magical displays (*idán*), the actors sometimes invite spectators to test their powers. In MacAloon's view, spectacle may have negative effects on rituals or festivals that encourage the audience to take active roles in the performance (1984:268). This need not always be the case. In fact, the call-and-response aspect of the *èfè* concert and the audience's participation in the carnival-like afternoon dances add to the extravaganza, monumentality, and "affect" or dramatic intensity of the Gèlèdé spectacle, making it a memorable experience for both the actors and audience.

Ìdira

Costume Aesthetics

and Iconography

Because Ìyá Nlá is the Mother of All, the Gèlèdé mask repertoire includes as many subjects as possible—human beings, animals, plants, and deities—to reflect the variety of her offspring. The emphasis placed by the Gèlèdé society on unity and fellowship finds a unique expression in the costume of the mask. Not only does the costume consist of such elements as female headwraps and baby sashes (*òjá*) contributed by individuals with different personalities and dispositions, but the process of tying them together is no easy task. In most cases, a masker needs assistance, either from his wife or a colleague, to secure the costume firmly from the back (thus encouraging cooperation and companionship); otherwise it may fall apart during the dance. Special accessories chosen to enhance the aesthetic appeal of the costume include velvet capes, lace aprons, and appliqué panels. The quest for the "artistic" has developed into a competition among contiguous communities as they try to exceed one another in costuming and performance, because the town widely acclaimed as staging the most spectacular festival in one year often draws the largest crowd during the following year, receiving visitors from miles away. Furthermore, popular belief holds that the more impressive the festival, the more efficacious the wishes associated with it.

The two Yoruba terms for the process of putting on the Gèlèdé costume are *ìmúra* (to prepare or attire) and *ìdira* (to fortify the body). These two terms are used interchangeably; but *ìdira* (*ìdi* = tying up; *ara* = the body) conveys more vividly the phenomenon of knotting things together (i.e., headwraps, baby sashes, wooden breasts, artificial buttocks, etc.) on the body of the masker. The costume takes three main forms: the human, animal, and bird. The male mask is *ako igi*, (male/hard wood) and the female, *abo igi*, (female/soft wood). The subject matter of the animal or bird mask determines its name.

Human Costumes

The human costume exaggerates the Yoruba notion of an ideal physique, drawing attention not only to gender characteristics but also to mannerisms. The headdress sporting a hat, mustache, or beard unmistakably identifies the male mask (*akọ igi*). The masker wears a long-sleeved shirt (*èwù*), long gloves (*ìbọwọ́*), stockings (*ìbọsẹ̀*), long or short trousers (*sọ̀kòtò*), and between four and six metal anklets (*aro* or *ìkù*) on each leg. A sand pad (*ìgbékù*) tied to the ankle below the metal anklets functions as a buffer against possible bruising of the ankle bone. The masker wears a padded vest (*agbé àkàlàngbà*)[1] which is similar to a hunter's smock (*gbérí*) except that it has open sides (figs. 6.1-6.4). Then, a hoop (*àkàlàngbà*) made of cane and suspended from the shoulders has fastened round it an array of multicolored female headwraps and baby sashes. The padded vest protects the shoulders by cushioning the rope suspending the hoop. With the hoop properly suspended, a strip of cloth (*agbòjá*) holding female headwraps and baby sashes

1. The etymology of the word is *a gbé* (the support); *àkàlàngbà* (the hoop). According to my informant, Aṣimi Ọlatunji-Onígèlẹ̀dẹ́ of Ìmẹ̀kọ, the *àkàlàngbà* was adapted from the hooplike rope (*igbà*) used for climbing palm trees. Both Harper (1970:78-93) and the Drewals (1983: 95) suggest that the name *agbé àkàlàngbà* derives from two species of birds with brilliant puffed-up plumage. The two birds with names close to *agbé àkàlàngbà* are the blue turaco (*agbe*) and the horn bill (*àkàlàmàgbò*). The blue turaco, for instance, has dark indigo plumage.

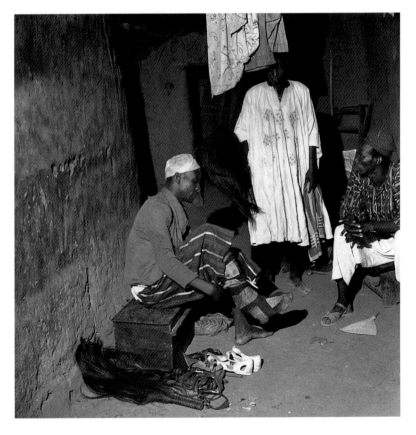

or appliqué panels is tied round the body and knotted firmly at the chest, above the hoop (figs. 6.5-6.8). This gives the masker a puffed-up appearance, especially if he wears a big robe over the hoop, or when the cloth or raffia fiber tied round the rim of the wooden mask (*ìgán-òṣà*) conceals the hoop. The headdress sits directly on the head with a forward slant, being held firmly to the chin with a rope (*ìgbàgbọ̀n*). To complete the outfit, the masker holds a horsetail whisk (*ìrùkẹ̀rẹ̀*) or a fan (*abẹ̀bẹ̀*). The final image is that of opulence (figs. 6.9-6.11). But if a flowing robe (*agbádá*) is to be worn, the hoop is eliminated, leaving only the *agbòjá* beneath the robe.

The coiffure of the headdress or the body contour easily identify the female mask, *abo igi* (figs. 6.12, 6.13). As in the male costume, the masker wears a long-sleeved dress or female blouse (*bùbá*), long gloves, stockings, sand pads, and metal anklets. A cylindrical object (*bèbè*) is tied round the lower hip to form the buttocks. In the past, short banana stems (*ìtì ọgẹ̀dẹ̀*) served this purpose. But today, objects ranging from cylindrical baskets to aluminum cans may be substituted. When covered with a women's wrapper

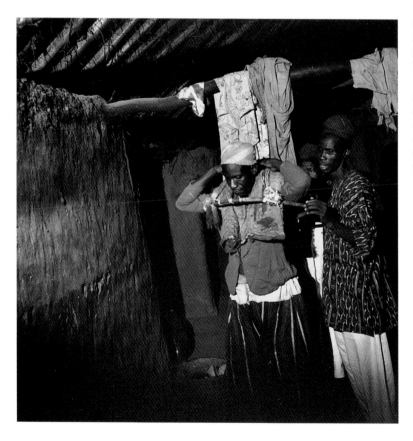

6.1 (*Opposite page*) Èfẹ̀ masker donning long stockings (*ìbọsẹ̀*). Ìjió (1969).

6.2 (*Left*) Èfẹ̀ masker wearing a padded vest (*agbé àkàlàngbà*), on which rest the ropes of the hoop (*àkàlàngbà*). Ìjió (1969).

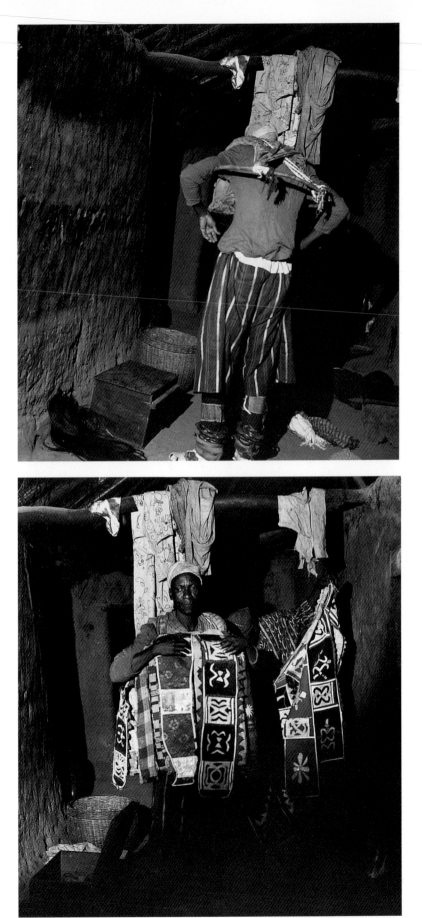

6.3 Back view of figure 6.2.

6.4 Appliqué panels (serving as a substitute for female headwraps and baby sashes) are arranged round the hoop. Ìjió (1969).

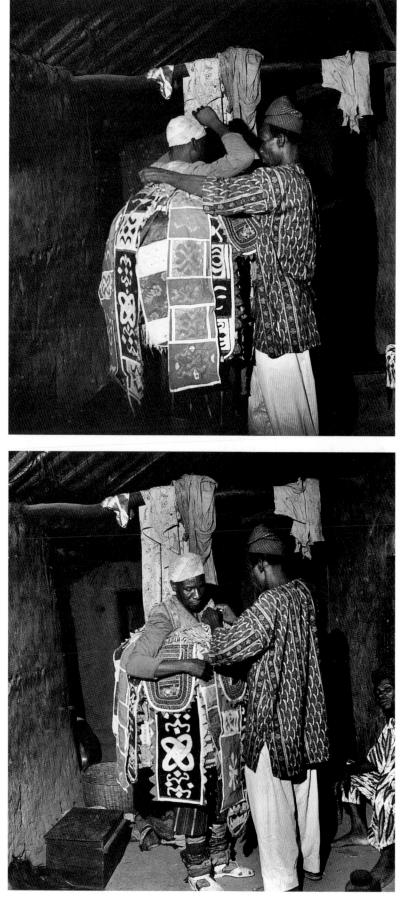

6.5 The girth of the masker increases as additional layers of appliqué panels are added to the hoop. Ìjió (1969).

6.6 Front view of figure 6.5.

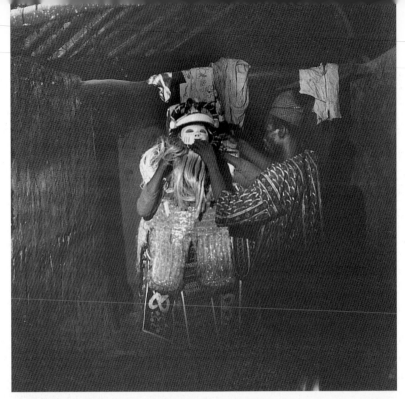

6.7 Ẹ̀fẹ̀ masker being helped to adjust the headdress. Ìjió (1969).

6.8 Ẹ̀fẹ̀ masker steps out into the night. Ìjió (1969).

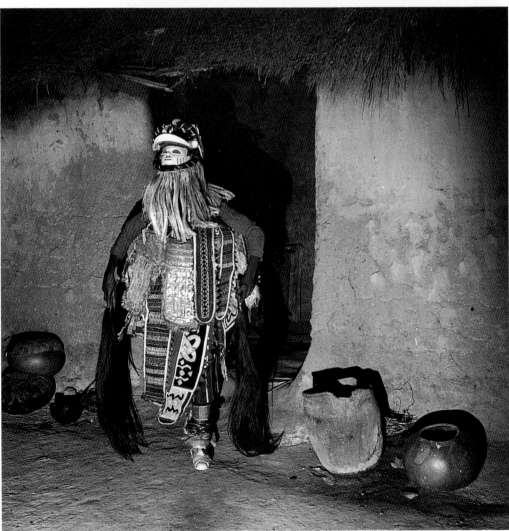

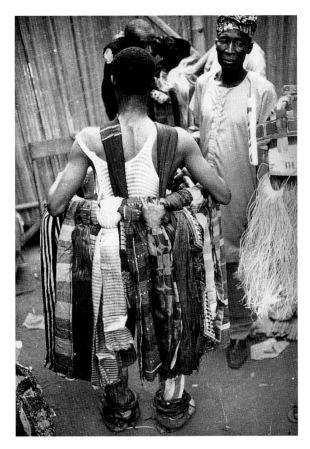 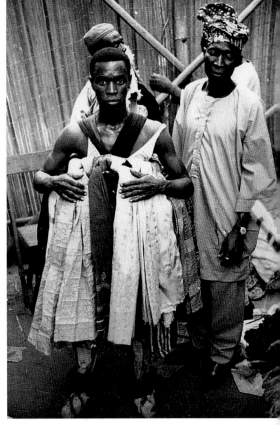

6.9 A typical male Gèlèdé masker in the process of costuming. Here the masker does not wear a padded vest, but the emphasis on social harmony finds unique expression in the costume of the mask—a blend of materials contributed by individuals with different personalities and dispositions. Igbóbì-Ṣábèé (1972).

6.10 Front view of the maskers in figure 6.9, after the addition of a second layer of female headwraps and baby sashes.

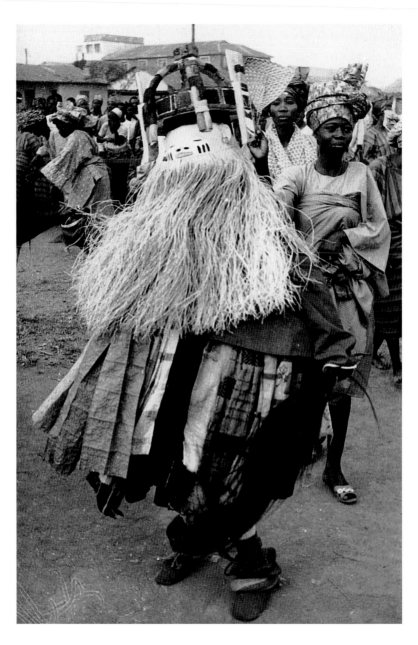

6.11 The masker in figure 6.10,
fully costumed.

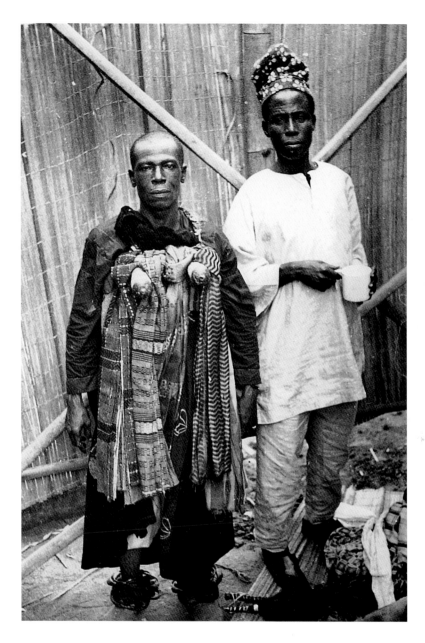

6.12 Typical female masker
in the process of costuming.
Ìgbóbì-Ṣábẹ̀ẹ́ (1972).

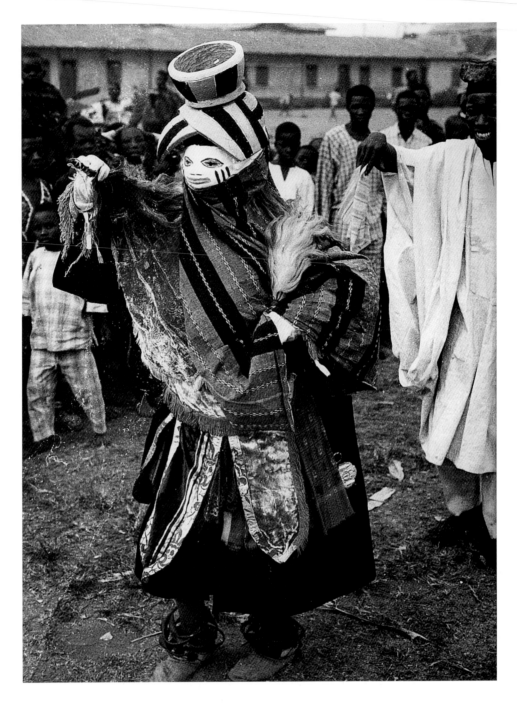

6.13 The masker in figure 6.12, fully costumed. Note the use of the horsetail whisk to complement dance movements.

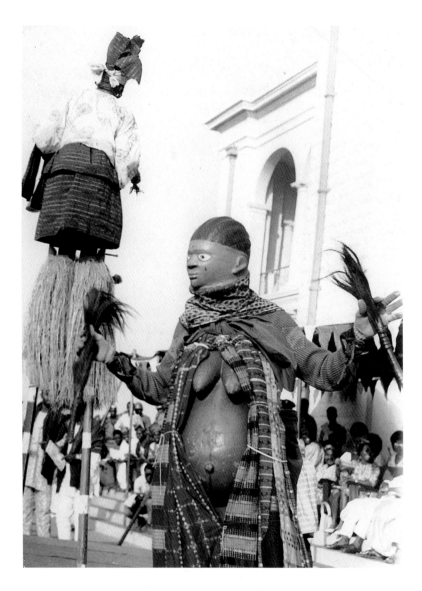

6.14 Gẹ̀lẹ̀dẹ́ mask (*Aboyún*) representing a pregnant woman. The stilt dancer (left) is an Èyò mask, not Gẹ̀lẹ̀dẹ́, and is part of the Lagos dance troupe to the All Nigeria Festival of the Arts, Ìbàdàn (1972).

(*ìró*), the cylindrical object exaggerates the rump. A pair of wooden breasts (*ọmú*) is suspended on the chest like a pendant and secured by two strings or bands of cloth at the back. At times, a breastplate with large breasts and a protruding abdomen, indicating pregnancy, replaces the small wooden breasts (fig. 6.14). This mask is called *Aboyún* (the pregnant one). Other masks carry a backplate with a baby carved on it. At times, a long strip of cloth knotted (*agbòjá*) with multicolored female headwraps and baby sashes may be tied round the body above the wooden breasts to increase the girth

of the costume. Unlike the male costume, the female costume has no hoop. The breasts may be left bare, or a big blouse (*bùbá*) may be worn. With the breasts bulging in front and the buttocks behind, the mask conjures the image of *abiyamọ*, the proverbial mother of many children. The wooden headdress sits directly on the head; as with the male masks, the masker sees through the veil tied to the rim of the headdress (fig. 4.2). The female mask also holds a horsetail whisk or fan. In Lagos and Ìṣẹri, female masks wear a special cape (*ìgbáyà*) over the blouse and an apron to match, both increasing the bulkiness of the costume (fig. 4.1).

The costumes of the two principal performers during the night concert, Ẹ̀fẹ̀ and Tètèdé, are the prototypes for the male and female masks, respectively. The bulkiness of a given mask, however, depends on the physique and the taste of each masker, as well as on the costume tradition or format of a particular community. Because of the human type or dress fashion being portrayed, some male masks do not use the hoop, while female masks from Ìmẹ̀kọ, Kétu, and Ìjió, among others, frequently ignore the use of the *àgbọ̀já* (the strip of cloth with many female headwraps) and simply fasten a couple of headwraps directly to the waist (fig. 5.13). Although a slim mask is no less important ritually than a bulky one, the latter is regarded as the ideal. Plumpness has a positive value in traditional Yoruba culture and aesthetics. Not only is it associated with fecundity, but the dance of a plump person is considered to be more graceful and satisfying than that of a slim one. For instance, whenever a plump or corpulent woman throws all of herself into the dance, her body rocks voluptuously with every movement (Lawal 1974:247). The center of attention is the hips and the buttocks, which are swung, rolled, and shaken in a tantalizing manner to the drumbeat. In the traditional past, Yoruba ladies wore strings of large beads (*ìlẹ̀kẹ̀ lágídígba*) on their waistlines to heighten the sensuousness of the buttocks, most especially during the dance. This practice has been exaggerated for theatrical effects in the female Gẹ̀lẹ̀dẹ́ costume (fig. 4.1). It will be recalled that, at Ìmẹ̀kọ, the Ẹ̀fẹ̀ mask describes Ìyá Nlá as: *Ìyàmi, Abiyamu, b'ìdí jẹ̀lẹ́nkẹ́*—My mother, the nursing mother with the rolling buttocks (Fayọmi 1982:99).

The exaggeration of the breasts underscores the Yoruba ideals of female beauty:

Funfun niyì eyín
Ẹ̀gùn gàgà niyì ọrùn

Ọmú ṣìkìṣíkíṣìkì niyì obìnrin

.

Ṣónṣorí ọmú obìnrin
Ó n gún ni l'ójú.

Whiteness is the beauty of the teeth.
Longishness is the beauty of the neck.
Full and pendulous breasts are the beauty of a woman

.

The nipples of a woman's breasts
Stick into the (men's) eyes.

(Oyeṣakin 1982:17).

In other words, a big bust not only makes a woman look more beautiful but also attracts the men. The fact that the wooden headdress sits on the head (instead of covering the face) makes the neck appear longer and adds to the height of the masker. A typical male mask looks massive and rather rotund (figs. 5.5, 6.8, 6.11), stylizing the Yoruba image of an ideal man who must be tall and well built (sìgbọnlẹ̀). Yoruba women admiringly tease big men with such nicknames as Agúnléjìká (the square-shouldered one) and Agùn t'áṣọ́ọ́lò (tall enough to display the robe to full advantage). Although it must be moderate, a protruding belly signifies wealth among the Yoruba. Hence, corpulent rich men are given appellations such as Arówóyọkùn (rich enough to have a belly) and Aríkùnjọbẹ̀ (the one with a stomach big enough to eat plenty of food). Conversely, there is a general assumption that a rich but slim-built person is probably not eating enough. Hence the popular slogan: Olówó tí ò yọ ikùn, ahun ní í ṣe. (The rich man without a protruding belly must be a miser.)

Masks from Kétu, Idàhin, Ìjió, Ìmẹ̀kọ, Ṣawọnjọ, Ajílété, and Ìgbógílà, among others, include multicolored applique panels (àpá) in their costumes to increase the girth (figs. 6.5, 6.6). Decorated with various geometric and organic patterns and attached either to the rim of the headdress, the hoop or breastplate, these panels fly outward during the dance, revealing the profusion of cloths underneath and contrasting vividly with their colors. It is important to note, however, that these panels also occur on the costumes of Egúngún masks (fig. 6.15) and on the dance skirts of Ṣàngó (thunder deity) priests, as well as on Islamic-inspired decorative leatherwork in many parts of West Africa.[2]

The costume of the Ògèdè/Alápáfújà mask is unique—a carved female

2. For a discussion of the historical implication of these colorful panels, see Drewal and Drewal (1983:91-94).

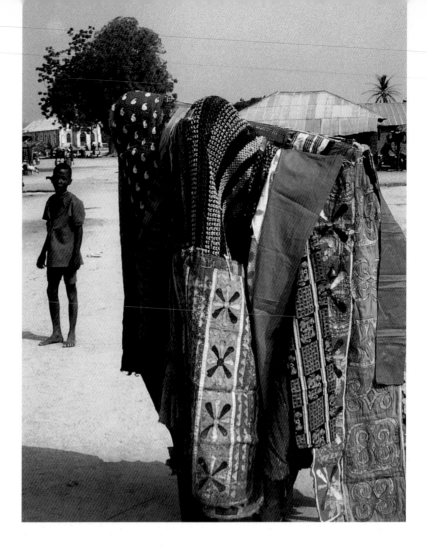

6.15 Egúngún mask with appliqué panels similar to those in Gèlèdé costumes. Ìjió (1991).

trunk with a realistic head and outspread arms. The term recalls *ijó fújà*, the spread-eagle dance style of high-society men and women. The trunk measures between three and four feet high and has a hollow large enough to accommodate a dancer, who peeps through one or two openings between or below the breasts (pl. 9). A female wrapper attached to the rim of the trunk conceals the lower limbs of the dancer. In Lagos, the mask dances, swaying and rotating to the song:

Alá-pá-á-à-fú-jà
Ken———gé!
Alá-pá-á-à-fú-jà
Ken———gé!

The one with the outspread, fashionable arms
Ken———gé!
The one with the outspread, fashionable arms
Ken———gé!

Sometimes, the arms are movable (pl. 9), and one of the mask's attendants manipulates them with strings—to the delight of spectators. Occasionally, a female figure is represented carrying an image on the head or holding a baby sash (*òjá*) across her shoulders to identify her as a nursing mother (pl. 10).[3] Most of the figures without outstretched arms, however, are usually not danced in public but are kept inside the Gèlèdé shrine (placed over an inverted pot) to represent Ìyá Nlá, although some informants say that figure is not her portrait as such but just an honorific image.

3. Illustrated in Celenko (1983: pl. 99).

6.16a, b Ògèdè/Alápáfújà mask from Ìbóòrò (1982).

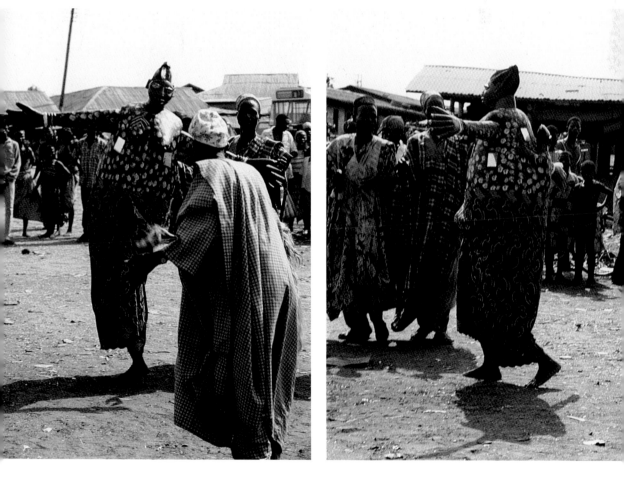

Animal Costumes

The costume of most animal masks takes either a human male or female form while the headdress identifies the species. The costumes of the hyena, buffalo, and ram masks, however, sometimes take the shape of an animal. For example, the hyena (Kòrikò) mask of Lagos wears a skin-tight animal dress with a tail. Quite often the masker crawls on all fours, like a real animal. On the other hand, the Kòrikò mask from Kétu (also called Ayóko) walks on stilts and wears a human male costume, part fabric, part raffia fiber (fig. 5.9).[4]

The costume of the Ẹfòn (buffalo) mask from Ìjió is virtually the same as that of any other human male mask (fig. 6.17), the only difference being that, when dancing, the mask mimes the actions of a buffalo, crawling and keeping the headdress close to the ground. In Ìbarà, Abẹ́òkúta, however, the buffalo mask has a different costume (fig. 6.18). Shaped like a tent and

4. Illustrated in Beier (1958:14).

6.17 A pair of Ẹfòn masks (buffalo) dancing, sometimes crawling on all fours to imitate the action of the animal. Ìjió (1969).

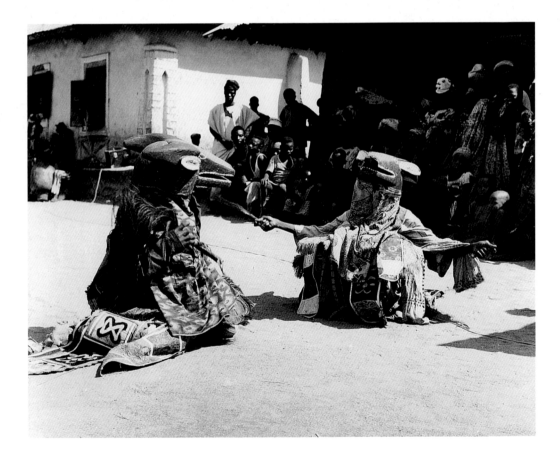

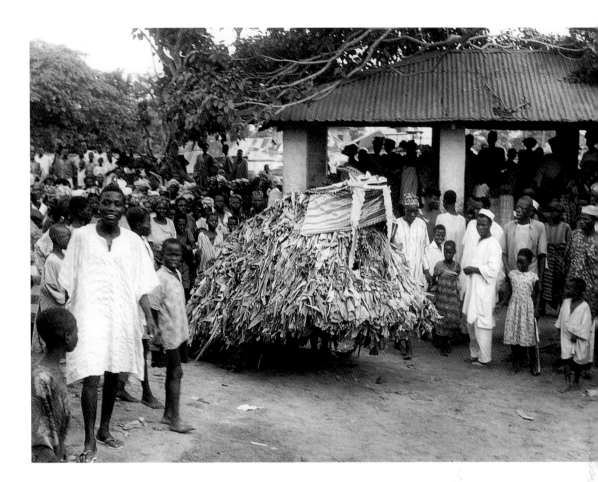

covered with banana leaves, this mask is borne on the shoulders of the masker, who walks upright, stooping occasionally, dancing to the song:

Ẹfọ̀n,
Ẹranko dìgbò dìgbò.
Ẹfọ̀n,
Ẹranko dìgbò dìgbò

.

Buffalo,
The rushing and butting animal.
Buffalo,
The rushing and butting animal

.

(Recorded in Ìbarà, Abẹ́òkúta, 1982. My translation)

6.18 The Ẹfọ̀n mask (buffalo) parades the streets in the morning after the *ẹ̀fẹ̀* ceremony, sweeping away evil forces. Ìbarà, Abẹ́òkúta (1958).

In Yoruba mythology, the buffalo is sacred to Ọya, the Yoruba goddess of the tornado and the river Niger, and one of the mythical daughters of Yemọja (the manifestation of Ìyá Nlá in Ìbarà). As a symbolic refuse collector, the Ẹfọ̀n mask purifies the community, symbolically sweeping away with the action of a tornado all pestilence and other "undesirable" elements.

Another important animal mask is the Ògèdè (the female gorilla). It is exactly like the Alápáfújà except that the head is a stylization of the gorilla's (fig. 5.10). As a result, both names (Ògèdè and Alápáfújà) are used interchangeably. Yoruba folktales identify the female gorilla as a familiar of Ìyá Nlá with supernatural powers to outwit hunters and tear them into pieces. She is fiercest when nursing a small baby and will fight tooth and nail to protect it from danger. Little wonder that many Ògèdè masks carry babies on the back (figs. 6.16a, b, 6.19) or in the bosom, apparently to implore Ìyá Nlá to protect humanity just as the female gorilla looks after its baby. At Ìbara and Ìbóòrò, the Ògèdè mask dances to the following song:

Ògèdè,
Gbangba l'àṣá á ta.
Ògèdè,
Gbangba l'àṣá á ta.

Ogèdè,
The kite hovers about in the open.
Ògèdè,
The kite hovers about in the open.

<div align="right">(Recorded in Ìbarà, Abẹokuta, 1982. My translation)</div>

This song, according to my informants, alludes to the fact that the female gorilla, fierce and ferocious, roams the forest with confidence. The swiftness and boldness with which the kite descends from the sky to pick up a chicken, even before the very eyes of its owner—implied in the spread-eagle pose of the Ògède—hint at the invisible method with which an àjẹ́ attacks an unsuspecting victim. Another interpretation given for this song is that the height of the Ògèdè mask makes it visible from a great distance; and when it dances, its outstretched arms give an impression of a kite hovering in the sky. According to an Ìbarà informant, the female gorilla is associated with Ìyá Nlá because she is ferocious and caring at the same time, and because she gives birth easily and safely through her big, hairy vagina—a phenomenon that recalls one of Ìyá Nlá's praise-names: Onírun abẹ́ òṣíkí (the one with much hair on her private part).

6.19 Gorilla body mask (Ògèdè) with a baby on the back. The carver, Michael Labọde, stands in the background. Ìdòfòyí, Ayétòrò (1971).

Since the horse (ẹṣin) symbolizes power and prestige, it is a popular motif in Yoruba art. The equestrian statue honors culture heroes, warriors, kings, important chiefs, and deified ancestors. In Gèlèdé, the equestrian motif appears not only on headdresses (fig. 7.48), but also as costumed figures. The equestrian costume is usually a horse-shaped wooden frame without legs, covered with fabrics (fig. 6.20). An opening in the middle accommodates a fully dressed masker, who lifts the outfit with suspenders and mimics the movement of a horseman. In 1953, Dogá (Duga)[5], one of the master carvers of Ìmẹ̀kọ, created an unusual equestrian Gèlèdé that caused so much excitement in the town that one of the children of the late Chief Isiaka, in whose memory the ceremony was performed, wrote to William Bascom:

> Duga and the other wood-carvers at Meko carved many kinds of Gelede masks when we made the ceremony of Gelede for my late father. . . . People came from many towns to see the display. . . . Duga for the ceremony carved a horse of wood and gave it four wheels to walk on, and he made it so that four people

5. Ever since William Bascom first documented the works of this artist in the 1940s, he has been referred to as "Duga." But according to Ganiyu, the son of the artist, the correct name is "Dogá."

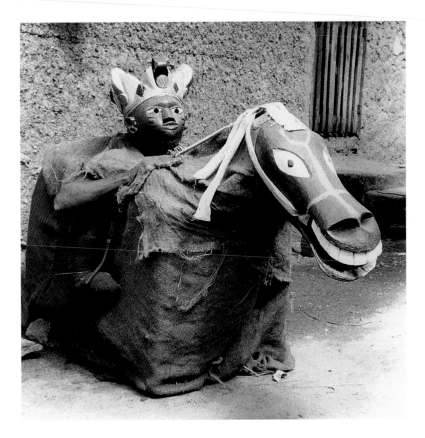

6.20 Horse mask (Gèlèdé Ẹlẹ́ṣin). Attributed to carver Sunday Oloyede. Ìbarà, Abẹ́òkúta (1964).

could be hidden in the mat with which he covered round the horse. Two people pushed it forward and two people pushed it backward. He trained the people to push it as if it were alive, and he trained the rider to dance with it as if he were riding a live horse. (Bascom 1973b: 77-78)

The similarity of the equestrian Gèlèdé to the horseman of the *Carreta-Meboi* carnival parade (illustrated in Laotan 1961:158), introduced to Lagos in the nineteenth century by Brazilian repatriates, certainly suggests some relationship. For instance, the architectural style introduced by these repatriates spread through the whole of Yorubaland. Yet the question of whether the Brazilian *Carreta-Meboi* might have influenced Gèlèdé must await a more detailed investigation, given the possibility that the equestrian Gèlèdé might have developed directly from the traditional Yoruba equestrian statue, popularized by artists in the ancient Yoruba kingdom of Old Òyó, which rose to political ascendancy between the seventeenth and nineteenth centuries owing partly to its cavalry power.

Bird Costumes

The most popular bird mask is Ẹyẹ Òrò (the mystical bird), which symbol-
izes Ìyá Nlá's aspect as the leader of "the-wielders-of-bird-power" (*Awọn
ẹlẹyẹ*). At Ìlaró, this mystical bird mask is called Òṣòṣòbí. The masker,
enveloped in a sheet of white cloth, walks with a stoop to look like a bird
(illustrated in Drewal and Drewal 1983: pl. 3). The headdress, painted white
and with a pointed red beak, hints at the deadly blow of the witch bird. The
mask appears only in the night at the beginning of the *èfè* concert accompa-
nied by the song:

> Ẹyẹ òrò o
> Ẹyẹ òrò mbọ̀
> Òṣòṣòbí i ẹyẹ òrò mbọ̀
> Òsan l'aláyé nsayé
> [5] Òru l'onígbà nlò'gba
> Bí'lẹ̀ yí ò tú o
> Ayé rẹ l'awa njẹ
> Òṣòṣòbí i ẹyẹ òrò mbọ̀

> The mystical bird,
> Here comes the mystical bird,
> Òṣòṣòbí, the mystical bird is coming.
> The owner of the world operates in the afternoon.
> [5] The owner of the epoch operates after midnight.
> If this earth does not disintegrate,
> It is due to your influence.
> Òṣòṣòbí, the mystical bird is coming.
>
> (Recorded in Ìlaró, 1971. My translation)

Costumed in the presence of elderly women inside the Gèlèdé shrine,
this mask is expected to clear the way for a successful *èfè* concert.[6] Although
birds such as the hornbill and the ostrich do feature on headdresses, the
costume more typically takes the form of a male or female human mask.

6. I am grateful to Chief
Ọjẹlabi Ọlabimtan (the
Ọmọṣẹyùn of the Gèlèdé
society of Ìlaró) for this
information.

Symbolism of Costume Motifs

In order to appreciate the full significance of the Gèlèdé costume, we must
be aware of the meanings of its constituent elements. These are: the head-

dress (*igi*); the female headwrap (*gèlè*); the baby sash (*òjá*); the hoop (*àkàlàngbá*); the breasts (*òmú* or *oyòn*); the pectoral plate (*igi àyà*); the buttocks (*bèbè*); the metal anklet (*ìkù, aro, ajadí*); the colored panels (*àpá, wàbì, aṣo gbàláà*); the horsetail whisk (*ìrùkèrè*); and the fan (*abèbè*).

Details of the morphology and iconography of the headdress will be considered in the next chapter. Suffice it to say at this point that although it does not strictly conceal the identity of the dancer, the headdress nevertheless provides him with enough cover to perform his thematic role without inhibitions. Thus, the animal masker acts out his part to the best of his ability and expects public admiration if he performs well. Similarly, the headdress emboldens the Èléfè to project the collective wishes of the community in his utterances and to criticize antisocial elements without fear of reprisal or molestation after the performance. In other words, the headdress depersonalizes the masker, identifying him with the institution of Gèlèdé rather than as an individual.

The Headwrap, Baby Sash, and Hoop

Such is the significance of the female headwrap (*gèlè*) and baby sash (*òjá*) in Gèlèdé iconography that a costume is deemed incomplete without them. To begin with, both cloths have similar dimensions—about twelve inches wide and six feet long. Consequently, a Yoruba mother often uses her headwrap to secure a baby on her back, and she sometimes uses the baby sash as a casual headgear. Being worn on the head (*orí*), the locus of individual life force, the *gèlè* partakes of the vital force of the female. Therefore, the multiplicity of headwraps on the Gèlèdé mask not only charges the masker with "maternal" power but also transforms the costume into a sacrificial offering (*ètùtù*), reminding us of the dual-purpose ritual for stimulating fertility while combating infant mortality (*Àbíkú*).

As we observed in chapter 3, the headwrap functioning as *òjá* (baby sash) is sacred to deities of small children (*òrìṣà olómowéwé*). For example, Lálúpon women eager to have children offered their headwraps as sacrifice to Ègbé, the tutelary goddess of spirit children (Simpson 1980). In another ritual (mentioned in the divination verse *Odù Òfún Òwòrìn*), the people of Àwáyè offered 1,400 headwraps as sacrifice to minimize *Àbíkú* or infant mortality (Verger 1968:1478-82). Note as well the *òjá* on the costumes of the male and female Elérìkò (Àbíkú) masks in figure 3.11. In these instances, the meaning of the *òjá* is clear. It conveys the boundless love, care, nurture, devotion, and indulgence that a child should expect from its mother. Its

importance as an instrument for attracting spiritual benevolence is evident
in the following Ifá divination verse (from Odù *Ogbèwáàtè*):

Òjá, awo ìgbàlà
A dífá fún ètùtù
Eyí tí í ṣ'ọmọ Ogbèwáàtè
.
Ọpẹ́lọpẹ́ ètùtù
[5] Ètùtù làwa n ṣe níhàà bẹ̀ taa fí n dolówo
Njẹ́ kí lẹ n ṣe níhàà bẹ̀ tẹẹ a fi n dọlọ́mọ
Ọpẹ́lọpẹ́ ètùtù
Ètùtù làwá n ṣe níhàà bẹ̀ ta a fí n dọlọ́mọ
.
Emi lẹ̀ ẹ́ ṣe níhàà bẹ tẹẹ a fí jogbó-jatọ́
.
[10] Ọpẹ́lọpẹ́ ètùtù
Ètùtù làwa n ṣe níhàà bẹ̀ taa fi jogbó-jatọ́
Ètùtù làwá á ṣe nílẹ̀ yí ká tó ríree.

"Baby sash, the secret of deliverance."
Thus declared the Ifa oracle for Ritual,
The off-spring of Ogbèwáàtè.
.
Thanks to Ritual.
[5] It is Ritual that we perform in order to become rich.
What do we do in order to have children?
Thanks to Ritual.
It is Ritual that we perform in order to have children.
.
What do we do in order to live long and be blessed?
.
[10] Thanks to Ritual.
It is Ritual that we perform in order to live long and be blessed.
It is Ritual that we perform to receive the blessings of this world.

 (Ọpẹfeyitimi 1982: 9-10. My translation)

It follows, therefore, that the headwraps and baby sashes on the Gèlèdé
costume signify to Ìyá Nlá humanity's desire for what the Yoruba regard as
the three cardinal blessings: Wealth (*ire owó*), Children (*ire ọmọ*), and Good-

health-and-long-life (*ire èmi gígùn*). (It will be recalled that the Ẹfẹ̀ mask of Ìjió emphasized these blessings in his parable of the three friends fighting over seniority. See chap. 5, pp. 130-32.) In addition, the *òjá* functions as a kind of safety belt, symbolically placing the masker in the same position as a child on its mother's back (fig. 5.17), and invoking the popular Yoruba taboo: *Ọmọ kì í jábọ́ lẹ́hìn ìyá a rẹ̀*. (A child must not fall off its mother's back.) It also reminds Ìyá Nlá and the *àjẹ́* of their maternal obligations.

After trying on a male costume myself, I discovered that the attachment of headwraps and baby sashes to the hoop (*àkàlàngbà*) has a structural function as well. Although it increases the girth of the masker, communicating the abundance that the people expect from Ìyá Nlá, the loaded hoop increases the force of gravity of the masker, stabilizing his motion and simultaneously providing a good leverage during the dance.

The Breasts, Pectoral Plate, and Buttocks

In addition to conveying sex appeal, the wooden breasts of the female mask recall the full breasts of a nursing mother from which milk flows inexhaustibly to nourish the baby in the critical stages of its life, complementing the message of the *òjá* concerning maternal care and nurture. As earlier noted, sometimes the carved breasts form part of a pectoral plate (*igi àyà*) with a protruding stomach to indicate pregnancy (*oyún*) (fig. 6.14). According to an informant, this motif embodies a prayer:

> Oyún kì í wúwo
> Kí olóyún má le è gbe e
> Wẹ́rẹ́wẹ́rẹ́ ni ti ẹdá
> Morú wẹ́rẹ́; Mo bi wẹ́rẹ́
> Ni í ṣ'awo Àsòkalẹ̀ Ànfààní
> Agbó, Atọ́ ni í ṣ'awo Ògbóni
> Àbọrú, Àbọyè ni ti Babaláwo
> Ki á gbọ́ ohùn ìyá
> Ki á gbọ́ ohùn ọmọ.

> Pregnancy is never too heavy
> For a pregnant woman to carry.
> The *ẹdá* delivers easily.[7]
> "I offer Easy Delivery as sacrifice; I receive Easy Delivery in return"
> Is the secret behind Smooth Childbirth.

7. The brown bush rat, known for fast breeding.

Longevity and Prosperity are the secrets of the Ògbóni society.
Positive Sacrifice and Positive Result are the secrets of the diviner.
May we hear the healthy voice of the mother.
May we hear the healthy voice of the new baby.[8]

8. I am grateful to Chief Amudaniyu Atapupa, the late Bàbáláṣè of Ìsàlè-Èkó Gèlèdé society, for this information.

(Atapupa, interview, 1972. My translation)

In some cases, the carved pectoral plate has a flat stomach with a baby doll attached to it. The doll is held by the masker in the same way a nursing mother suckles a child—apparently to influence Ìyá Nlá to be as generous to humanity as a nursing mother is to her child.

While the exaggerated buttocks (*bèbè*) of the female mask have clear sexual implications, they also mirror the Yoruba belief that wide hips and big buttocks allow for easy and safe delivery, thus encouraging a woman to have as many children as she wants. Needless to say, human survival depends on the continuous births of children to replace lives lost through old age and premature deaths. Choreographically, the *bèbè* influences the posture of the masker during the dance, making him push his waist backward to complement the forward thrust of the wooden breasts.[9]

9. I had this experience when learning to dance in a female costume.

The Metal Anklet

Another important element in the Gèlèdé costume is the metal anklet, made of iron or brass. As noted in chapter 3, anklets similar to Gèlèdé's constitute the most sacred symbol on some altars dedicated to deities of small children (*Ẹgbẹ́, Ẹgbẹ́ Ọ̀gbà, Ẹgbẹ́run, Òrìṣà Olómitútù*) so as to minimize infant mortality (*Àbíkú*). In addition, smaller versions of the anklet are put on the legs of children identified as *Àbíkú*, so that the jingling will prevent their heavenly companions or spirit doubles from coming close enough to entice them back to the spirit world. According to diviner Babaláwo Fatoogun (citing the Ifá divination verse, *Odù Atẹnïnu Ìlosùn*), the tradition of using metal anklets to combat infant mortality started with Ìyá Jànjàsá, one of the ringleaders of spirit children, who once paid a visit to Earth. She entered the womb of a pregnant woman and was eventually born as a beautiful baby girl. A diviner later identified her as an *Àbíkú*, recommending to her parents that the only way to stop her from dying prematurely was to anchor her to the living world with metal anklets. This was done, and the jingling of the anklets scared away her heavenly partners. Ìyá Jànjàsá lived to old age.[10] It is not surprising, therefore, that Yoruba herbalists sometimes put metal anklets on the legs of seriously ill patients to facilitate recovery.

10. Interview with Awo Babalọla Fatoogun, Ilé-Ifẹ̀, 1987. Although some informants identify Ìyá Jànjàsá as the female leader of spirit children and Elérìkò as the male leader, the two names are used interchangeably.

Also, some priests and priestesses wear metal anklets not only as a symbol of their priesthood but to protect them from the potential hazards of frequent and close interaction with supernatural forces.

On the Gẹ̀lẹ̀dẹ́ costume, the metal anklet ostensibly functions as a dance instrument, jingling in unison with the drumbeats. Given the ritual associations of the anklet, however, and the fact that the Gẹ̀lẹ̀dẹ́ performance is believed to bring the masker in very close contact with the àjẹ́ and other invisible, sometimes dangerous forces, it is apparent that the metal anklet has a protective function, as well. Responding to Robert Farris Thompson's inquiry about the significance of the anklet in Gẹ̀lẹ̀dẹ́, a Kétu informant replied: "If you have a child, and the mother dies, you put iron bangles on the ankles of that child. This is done so that the dead mother will not come to that child in dreams. The baby makes a sound with iron bangles, *woyo-woyo-woyo,* so that the dead mother will not come down and cause it death or fill its mind with dreams" (1974:204). In other words, the metal anklet performs the same function as it does on the legs of an *Àbíkú.*

The Colored Panels, Horsetail Whisk, and Fan

The colored appliqué panels are both decorative and symbolic. Although their swirling enhances the beauty of the mask during the dance, the motion is expected to neutralize negative forces and purify the air, just as it does on the Egúngún costume from which they have been adapted.[11]

11. According to Chief Fagbemi Ajanaku (1971), the *àpá* panels were first used by the Egúngún mask to repel pestilence and witchcraft, and they have the same implication in the costume of Ṣàngó priests. See also Thompson (1974:219-21).

So too, the horsetail whisk (*ìrùkẹ̀rẹ̀*) or hand fan (*abẹ̀bẹ̀*) held by the mask (figs. 5.5, 6.13) has both practical and aesthetic functions. Typically used by kings (fig. 1.5), chiefs, and sometimes priests to acknowledge greetings or ovations, and in dance contexts to accentuate body movements (figs. 5.16-5.18), the horsetail whisk symbolizes success and high status derived from public recognition of an individual's contribution to a given community. But as the following incantation implies, it generates charisma as well:

Ìlú mo bá dé ng kà ṣàì j'énìyàn
Ó dá ko kúkúndùkú tí í ṣ'Ọlójà iṣu
Òun ìrùkẹ̀rẹ̀ tí í ṣ'ọmọ Olókun Ṣẹníadé
Nwọ́n ní b'ó bá yẹ 'rùkẹ̀rẹ̀ tán, t'ó dẹ̀ 'rùkẹ̀rẹ̀ lọ́rùn
[5] Ó d'ẹni à-gbé-jó, ó d'ẹni à-gbà-yẹ̀wò
À-gbéjó l'à á gbé 'rù ẹṣin; à-gbà-yẹ̀wò ni tì 'rùkẹ̀rẹ̀
T'orí t'ìrù l'ajá fi í yọ̀ m'oluwa rẹ̀
Gbogbo ara l'Òrìṣà fi í fẹ́ràn ẹtù

Gbogbo ara l'Òrìṣà fi í fẹ́ràn àfín.

[10] Gbogbo ọ̀tọ̀kùlú kì í péjọ s'awọ ẹkùn nù, ohun rere ni nwọ́n fi í ṣe:

Gbogbo ọ̀tọ̀kùlú kì í bá 'yọ̀ ṣ'ọ̀tá.

Ojú kì í r'árẹwà k'ó má ki i.

Gbogbo eṣinṣin ní í pó bo 'yín.

Any town I visit, may I not fail to gain recognition as a respectable
 person.

Thus declared the oracle to *kúkúndùkú,* the king of yams

And the horsetail whisk, the offspring of Olókun Sèniadé, the goddess
 of the sea.

It was proclaimed that after the horsetail whisk had been honored and
 blessed,

[5] It would be transformed into something to dance with, into
 something admirable.

We dance with the horsetail;[12] it is with admiration that we behold
 its whisk.

A dog uses both head and tail to welcome its owner.

Wholeheartedly, the Òrìṣà [Ọbàtálá] loves the guinea fowl.

Wholeheartedly, the Òrìṣà loves the albino.[13]

[10] Never will celebrities throw away a leopard skin, for it is used
 to achieve goodness.

Never will celebrities ignore the table salt.

Never will the eyes fail to greet the beautiful one.

Flies will always cluster around feces.

<div align="right">(Fabunmi 1972:7. My translation)</div>

12. Also used as a metaphor for the wagging tail of a trotting horse.

13. It will be recalled that Ọbàtálá created deformed beings and albinos while under the influence of alcohol. As a result, all such people are sacred to the deity.

Although the day-to-day function of the fan is to cool the body (in fact, an attendant usually accompanies a Gèlèdé mask, fanning the costume), it is also a symbol of calm, grace, kindness, and sociability—virtues associated with leadership and divinity. As a result, chiefs carry leather fans as part of their paraphernalia of office, and the praise-names of goddesses such as Yemọja and Ọṣun describe the divinities as holding magnificent (soothing) fans. But the fan has a dual symbolism. At the primary level of divinity and leadership, it signifies the powers to cool tension, solve problems, or provide relief. At another level, it connotes humility and supplication, as implied in the name *abẹ̀bẹ̀,* meaning, "the one who begs for a favor." (See Apter 1992:109.) Certainly, as a function of Gèlèdé ritual powers, the fan often held by the Èfè and other masks keeps the peace with Ìyá Nlá and the *àjẹ́.* Indeed, the ritual use of the fan embodies the following incantation:

Bi ooru bá mú,
Abẹ̀bẹ̀ l'a fi í bẹ̀ ẹ

When the heat strikes,
We use the fan to beg [cool] it.

<div align="right">(Apter 1992:109)</div>

Nocturnal and Diurnal Costumes

There is a striking difference between the costumes of the night and the afternoon masks. The costumes of a good majority of the night masks are less colorful, being dominated either by white fabrics (as in the Ọ̀ṣọ̀ṣọ̀bí mask of Ìlaró and the Great-Mother masks (Ìyá) of Kétu, Kove, and the Ọ̀họ̀rí) or by raffia fiber/palm fronds/banana leaves, as in the costume of Ọ̀gbàgbá (refuse collector), Ayóko (jackal) of Kétu, and Gbogbolàkìtàn (refuse collector) of Ìlaró, among others. The reason for this is not hard to find: during the *èfè* night, the main preoccupation is with ritual and verbal utterances in the form of invocations, songs, and jokes—all of which are made in an ambiance of partial darkness. Elaborate and highly colorful costumes would seem to be superfluous under the circumstance, more so when many of the night masks make only a brief ritual appearance on stage before disappearing into the darkness. The only exceptions are the Ẹ̀fẹ̀ and Tètèdé masks. These two are the principal performers of the night and they stay long enough on stage for the eyes to wander over the details of their costumes. For this reason these two masks have very elaborate and colorful costumes; that of the Ẹ̀fẹ̀, especially, is perhaps the richest of all Gẹ̀lẹ̀dẹ́ masks, evidently to accord with its image as the star of the night: *Ọba l'ójà* Ẹ̀fẹ̀ (the king of the èfè's market). In daylight, on the other hand, creative expression is clearly visible and makes greater impact than it does at night. Small wonder, then, that many of the diurnal masks have colorful and elaborate costumes meant to be admired for their artistry.[14]

14. The Ẹfọ̀n (buffalo) mask of Ìbarà, Abẹ́òkúta, is one of the few exceptions to this rule, because it is covered with banana leaves. It comes out early in the morning but retreats before noon.

Influence of Costume on the Masker's Behavior

The costume's influence on the masker's behavior is conspicuous during performance. As noted earlier, the male mask emphasizes masculine char-acteristics in his dance movements, while the female projects the feminine. Now and then, the female mask kneels down to greet the elders, and, if car-rying a doll, she attempts to breastfeed it or rock it to sleep with maternal

care. The prostitute mask (aṣẹ́wó) walks carelessly, sometimes making seductive gestures to admirers. Masks depicting foreigners, especially Europeans, frequently mimic their gait and dance steps. Those representing Moslem clerics sometimes hold prayer beads and praying mats, occasionally chanting short verses from the Koran. Looking majestic in his colorful costume, the Èfẹ̀ mask swaggers up and down the performance arena like "a dignified king, come from another world" (Thompson 1974:201). Animal masks walk on all fours, sometimes pawing the earth. The equestrian masker posts seriously, as if riding a live horse. These are conscious efforts by the maskers to excel as performing artists and to impress the audience (human and supernatural), unlike Egúngún maskers who, as spirit mediums, cannot be held personally responsible for all their actions, which at times may include the execution of condemned criminals.

In summary, there is no doubt that the Gẹ̀lẹ̀dẹ́ costume has both visible and invisible, aesthetic and supra-aesthetic functions. To the eye, the costume is beautiful; the combination of colors and artifacts, ingenious; the dance, delightful. The coquettish behavior of the female mask sometimes provokes laughter. Yet there is much more to the costume than meets the eye. This point becomes clearer if one is privileged to watch the masker in the process of putting on the outfit—a process known as ìmúra (being accoutered) or ìdira (being fortified). Armament of some sort is first suggested by the padded vest (agbé àkàlàngbà), which recalls a hunter's or warrior's jacket of a similar design known as gbérí, another name for agbé àkàlàngbà.[15] The only difference between the two is that, whereas the hunter's/warrior's jacket is always covered with charms, the agbé àkàlàngbà is not. Also looking like armor is the hoop (àkàlàngbà) with various headwraps and baby-sashes knotted round it, as though to insulate the body of the masker from dangerous forces.[16] Some female masks wear wooden breastplates that, though indicative of pregnancy (fig. 6.14), also shield the body; those without breastplates sometimes have additional layers of head ties and baby sashes (fig. 6.10). When we combine these features of the costume with the wooden headdress and the "protective," ritual function of the metal anklet, a typical Gẹ̀lẹ̀dẹ́ mask begins to look like an armored personage, except that it carries no weapon. The mask holds only a ceremonial horsetail whisk (fig. 6.8) or a hand fan, emblematic of its role as an emissary of peace who has come to plead for a rancor-free world—a world where humanity may live happily in togetherness (àṣùwàdà).

15. For an illustration of a hunter's padded vest (gbérí), see Williams (1973:150, fig. 2). For a discussion of Yoruba war dresses, including gbérí, see Smith (1973:235).

16. In some areas, the hoop is called agbòjá.

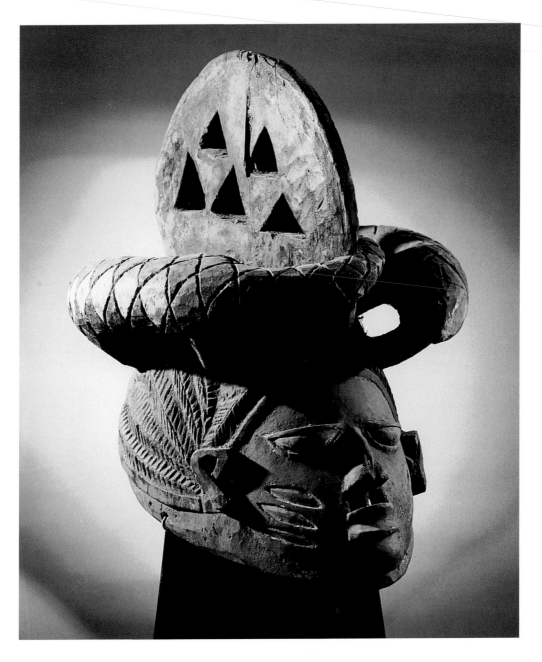

7.1 Gèlèdé headdress with a hair style called *agògo* (high crest), adorned with two pangolins (*arika*). Compare the high crest with that of the Elérìkò mask in figure 3.11. Carved by Michael Labode of Ìdòfòyí, Ayétòrò. Wood, pigment, h. 13 inches.

Igi Gèlèdé

Sculpted Messages

on Headdresses

The generic name for the wooden headdress is *igi* Gèlèdé (Gèlèdé wood-carving), although there are subtypes with special names, such as those mentioned below. As noted earlier, the designation of the masker as *Arugi* (wood carrier) and *Agbérù* (load bearer) betrays the derivation of the mask from an ancient tradition of dancing with statues on the head still continued by some women during Gèlèdé ceremonies (fig. 3.6). As the last part of the costume to be worn, the headdress fits on the head like a cap, tilted slightly forward to cover a part of the face. The raffia or transparent cloth fitted to the rim allows the masker to see through. A typical headdress is an ideal-ized human head with a calm face. More often, the head carries a super-structure—a round or square tray (*àtẹ*), displaying genre scenes and sculpted messages. The subject represented determines the name of the mask. For example, the headdress in figure 7.24 is called Gèlèdé *onílù* (Gèlèdé with drummers) because of the musicians on the superstructure.

Although the general public judges a mask on the basis of its performance in the dance arena, the quality of its costume and headdress also draws at-tention. The motifs on the headdress cover practically all aspects of Yoruba life and belief. The top hierarchy of the Gèlèdé society determines the mo-tifs on the headdresses of special masks such as Èfẹ̀, Tètèdé, Ìyá (mother mask), Ọ̀ṣọ̀ṣọ̀bí (bird mask), Agbéná (fire carrier), and Kòrikò (hyena). In theory, the Bàbálá́ṣẹ̀ (chief priest) must approve the motifs on all other head-dresses before they can be worn in public. But given the emphasis of Gèlèdé on humor, there is little or no censorship. Almost every theme receives ap-proval: the funnier, the merrier. In most cases, the approval of the Bàbálá́ṣẹ̀ is taken for granted.

Depending on their resources, individuals or families will go to any length to make their headdresses as attractive, prestigious, or humorous as pos-sible. Some go for the ingenious and witty, using puppetry or extreme caricatures; some focus on the erotic; others use the motifs to embody messages, wishes, or prayers, or simply to memorialize their ancestors. Such novel items as decorated calabashes, musical instruments, leaves, or

unusual fabrics may be incorporated to win attention (pl. 19). The assemblage is done by the carver or masker. Only outside the performance arena does the general public have ample time to appreciate at close range the beauty of the headdress and costume, so some maskers (in big cities like Lagos) leave home early enough in the afternoon to have time to visit with friends and relations before going to the performance arena. Others leave the arena before the formal ending (that is, as soon as they have performed) so they can parade the streets (ìwóde) before darkness falls. It is not unusual to see maskers with innovative headdresses or costumes unmasking in public for recognition.

Usually a client tells a carver what to depict on the headdress. According to Ganiyu Şekoni Dogá, the son of the late Master Dogá of Ìmèkọ and now himself a famous carver, some clients request that their headdresses be carved indoors—away from public gaze—so that they will have the desired impact when seen for the first time during the festival. As the masks often dance in pairs, two friends or twins may choose the same motif. According to a dancer from Kétu, "Once my friend and I give a particular theme to the carver, he is under obligation not to do the same thing for another client." The frequent dance rehearsals deepen the relationship between the pair, creating a lifelong partnership and uniting their families.

Both the carver and the masker share the honor for the most sensational headdress because some members of the public can easily identify "hands" or individual styles of famous local carvers. The painters (akunbẹ) are the most knowledgeable in this respect, since they discuss the styles and names of carvers while assembling or painting the headdresses. Thus, during the festival, a painter will disclose the name of the carver of any headdress that arouses public interest, and soon the information will spread all over the town, even to neighboring towns. Hence some master carvers often receive commissions from other towns. Consequently, while it is possible to identify local styles within the Gèlèdé corpus, not all the headdresses found or used in a given community are necessarily made there. For instance, in Ìlaró, Ìgbógílà, Ajílété, Igbóbì-Şábèé, Ìmáàlà, Ìjió, and Lagos, I observed headdresses that were attributed to carvers living elsewhere. Or, in some instances, local carvers had made copies to replace damaged headdresses originally carved elsewhere.[1] Although this complicates the task of using purely formal criteria to assign headdresses to a "style area," or to a famous carver whose works are well documented, we have enough field data to make some fairly accurate attributions—thanks to the efforts of the field staff of the National Museum, Lagos; the late Kenneth Murray; Ekpo Eyo; Frank Willett;

1. In Ajílété I saw a headdress imported from Kétu and its replica by a local carver. Both were identical, so much so that they seemed to have come from the same hand.

William Fagg; Robert Farris Thompson; Kevin Carroll; T. J. H. Chappell; John Picton; and Henry Drewal. With the exception of a few pieces, a good majority of the masks now in public and private collections cannot be dated with any degree of certainty. As wood deteriorates quickly in the tropics, it seems unlikely that any of the old masks still in use is more than two or three hundred years old.

Typology

The endless variety of the motifs and their combination makes it extremely difficult to attempt a watertight typology of Gèlèdé headdresses, as some fall under more than one category. Although the local terms for their classification may vary from one community to another, the following are the most recurrent: (1) *Orí Ènìyàn* (human head); (2) *Ìyá* (Great Mother head); (3) *Igi Èfè* (Èfè headdress); (4) *Olójú Méjì* (double face); (5) *Elérù* (head with superstructure); (6) *Onídòfòyí* (two human heads connected by snakes); (7) *Orí Eye* (bird head); and (8) *Orí Eranko* (animal head).

Orí Ènìyàn: Human Head

Headdresses in this category can be divided into three subgroups; namely, those with hairdos (figs. 7.1-7.6); those with hats or wraps (pls. 12-14, figs. 7.7-7.9); and those carrying small objects or creatures (fig. 7.10, pl. 17). The hairdos are often copied from life. Featured in figures 7.2, 7.3, 7.4 are *sùkú* (braid or basket weave), *panumó* ("close your mouth"), and *òjòmpetí* (rain dripping on the ears), respectively. While a female hairdo may suggest that a given headdress was originally worn with a female costume, this should not be taken for granted. For instance, some Yoruba male priests (especially those of Sàngó) braid their hair in the female style, so that headdresses representing such priests might have had female hairdos. The headdress in figure 7.6 depicts a royal messenger (*ìlàrí* or *emesè*), who sometimes wears a special hairdo that leaves a part of the head completely shaven. It may very well be that this piece was used by the character portrayed, although we are not certain. In figure 7.1, a pangolin motif (*arika*) combines with the *agògo* hairstyle to create a unique design. The *agògo* hairstyle is worn mostly by priests and priestesses, especially by devotees of the thunder deity Sàngó. The hairdo in figure 7.5 is a variation of the *agògo* style.[2] The hats vary from the dog-eared cap (*abetíajá*) to European hats (*àketè*) and the Moslem turban (*láwàní*). Masks with European hats often represent

2. This hairdo is very popular in Lagos where it is known as "fell out"—a slang term for the downward sweep of the stylized scarf that sometimes adorns the back of the headdress.

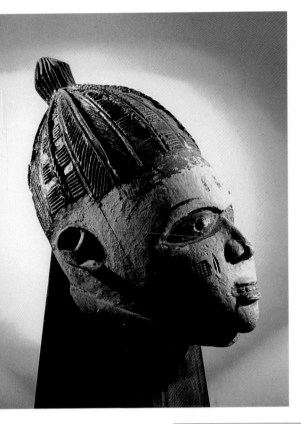

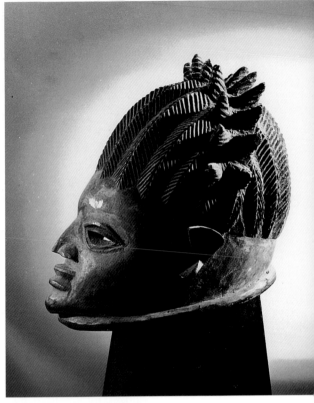

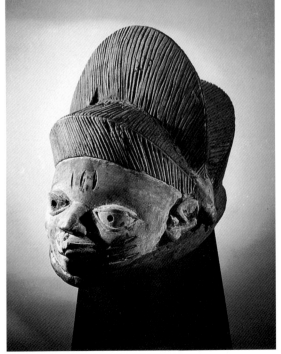

7.2 (*above*) Gẹ̀lẹ̀dẹ́ headdress with hair style called *ṣùkú* (braid). Wood, pigment, h. 11¹/₂ inches.

7.3 (*above*) Gẹ̀lẹ̀dẹ́ headdress with hair style called *panumọ́* (close your mouth). Wood, h. 10¹/₂ inches.

7.4 Gẹ̀lẹ̀dẹ́ headdress with hair style called *òjòmpetí* (rain dripping on the ears), popularly associated with the devotees of Ṣàngó, thunder deity. Wood, Pigment, h. 8¹/₂ inches.

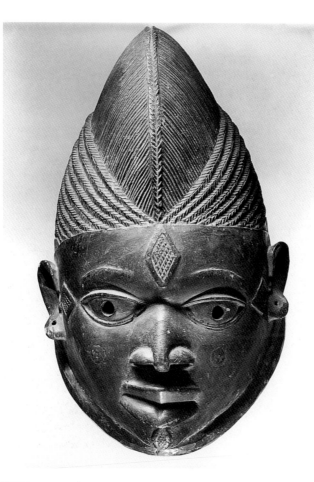

7.5 Gèlèdé headdress with a variation of the *agògo* hairstyle called "fell out" in Lagos. Wood, pigment, h. 8²/₃ inches.

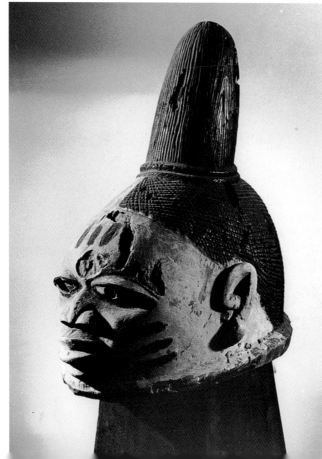

7.6 Gèlèdé headdress with hairstyle representing a royal messenger (*ìlàrí*). Wood, pigment, h. 12 inches.

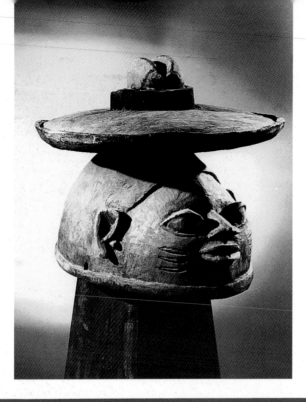

7.7 Gẹ̀lẹ̀dẹ́ headdress with European hat (àkẹtẹ̀). Wood, pigment, h. 8¹/₂ inches.

7.8 (*below*) Gẹ̀lẹ̀dẹ́ headdresses with face covered with a veil apparently representing an Egúngún (spirit of the living dead). Compare with figure 7.34. Wood, pigment, h. 10¹/₂ inches (left), 10¹/₂ inches (right).

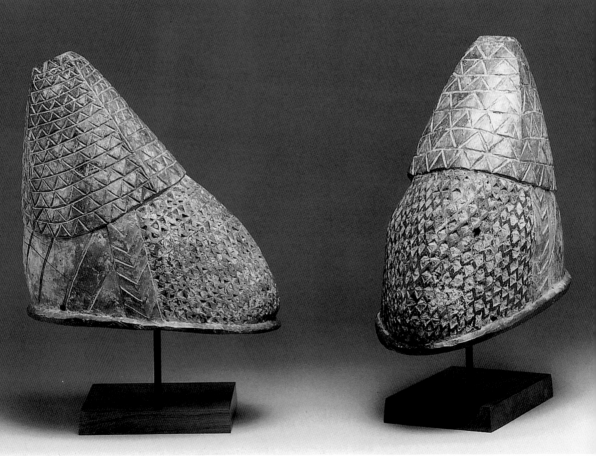

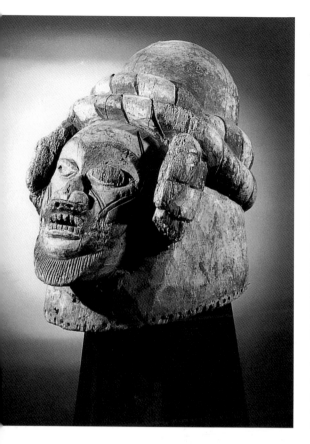

7.9 (*left*) Gèlèdé headdress representing a Moslem cleric (*Àlùfáà*). The depiction of functionaries of other religions such as Islam and Christianity (figs. 7.39, 7.40) bespeaks the desire of the Gèlèdé society to encourage persons of different religious persuasions to live together amicably. Wood, pigment, h. 11¹/₂ inches.

7.10 Gèlèdé headdress with a bird motif identified by many informants as a pigeon (*eyelé*), associated with peace, love, and honor. Wood, pigment, h. 9¹/₂ inches.

white missionaries, colonial officers, or acculturated African elites, while those with turbans depict Moslem clerics or people from the northern parts of Nigeria. The turban sometimes identifies the masker himself as a Moslem (Harper 1970:78). In general, a hat (*fìla*) indicates maleness, and a stylized headtie (*gèlè*), femaleness. The pair in figure 7.8 is very interesting because of the concealed face. That the concealment alludes to an Egúngún mask is evident from a comparison with the superstructure of figure 7.34. Headdresses in the third subgroup carry small representations on top, such as horns, celts, iron gongs, animals, birds, and snails (fig. 7.10, pl. 17).

Ìyá : Great Mother Head

This is a human head with pronounced facial features. A strip of wood jutting out of the chin gives the headdress a "visor cap" appearance (figs. 7.11, 7.12). Sometimes the nose and the mouth are elongated into a beaklike form,

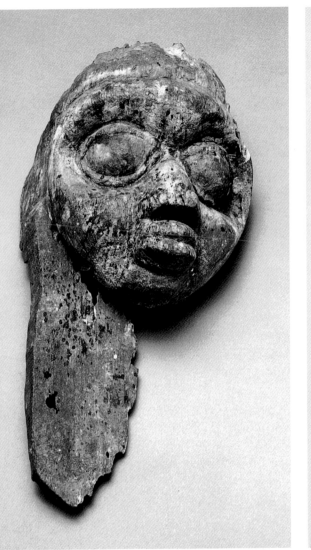

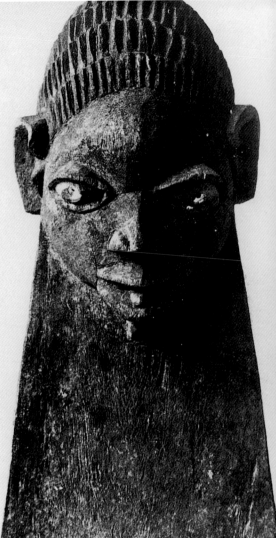

7.11 Bearded Great
Mother headdress
(Ìyá). Wood, encrusta-
tions, feather, h. 15^{15}/$_{16}$
inches, w. 8^{9}/$_{16}$ inches.

7.12 Bearded Great
Mother headdress
(Ìyá). Wood, pigment.
From Clouzot and
Level (1926: pl. 38).

hinting at the transcendental power of sniffing and sucking associated with the àjẹ́.[3] Almost always painted white (the costume that goes with it is also white), the headdress symbolizes the Great Mother, Ìyá Nlá. The horizontal projection is a stylized beard. In Yoruba culture, the beard is a symbol of wisdom, experience, and advanced age. Hence the popular saying: *Ewú l'ogbó; ìrùngbọ̀n l'àgbà; mámu l'àfojúdi* (Gray hair bespeaks old age; the beard bespeaks maturity; the moustache betrays insolence.) The beard, of course, is a male attribute; a woman must not have it. The slightest trace of hair on a woman's chin immediately draws suspicions that she is an àjẹ́, and people avoid her if possible.[4] To forestall such an embarrassment, women who grow hair on the chin pluck or shave it off as soon as they notice it. Little wonder that the bearded Great Mother mask comes out only at night and when all lights in the performance arena must be extinguished; for it displays the forbidden (fig. 5.4). In Kétu, the masker usually does not wear the Ìyá headdress; it is hand-borne and covered with cloth, which further increases the mystery associated with its visage. After the festival, the headdress is wrapped in white cloth and kept in the Gẹ̀lẹ̀dẹ́ shrine.

3. For a typical example, see Drewal and Drewal (1983: pl. 19).

4. See also ibid.:71.

Igi Ẹ̀fẹ̀: Ẹ̀fẹ̀ Headdress

In this group are headdresses worn by the Ẹ̀fẹ̀ mask during the night concert. They occur in three main forms. In the first category are headdresses characterized by elaborate headgear and complex openwork design (figs. 7.13-7.17, pl. 15). Emphasis is placed on the interplay of mass and void, light and shadow, and cool and bright colors. In figure 7.13, what begins as a turban develops into an openwork headgear with a crisscross (*okùn àmílà*) that joins a crescent on the forehead and terminates on a wallet-shaped object at the back (fig. 7.14). Strapped to the sides of the crisscross are four sheathed knives, the vertical thrust of which complements the curvilinearity of the headgear. Surmounting the mask is the figure of a spotted leopard. The leopard's white color complements the whiteness of the human face, thereby holding the entire composition together. The headdresses in figures 7.15-7.17 and plate 15 are variations on the same theme. In many cases, a crescent motif hangs above the human face while a bird or leopard motif stands at the apex (fig. 7.13). Quite often, the headgear metamorphoses into snakes in various actions or positions; now and then, a bird attacks a snake; a leopard holds an animal in its mouth (fig. 7.15). The significance of these motifs is discussed later.

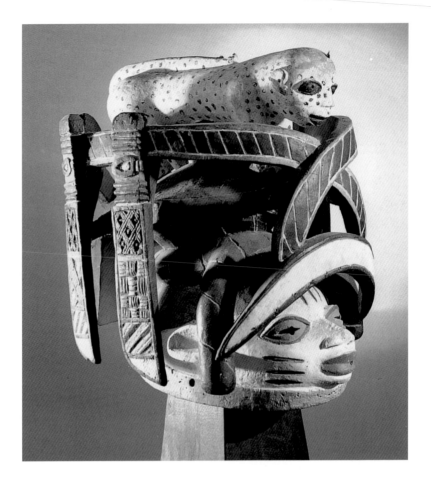

7.13 Ẹ̀fẹ̀ Headdress with leopard, sheathed matchets, and crescent motifs, all emphasizing the power of the mask to challenge and counteract the forces of darkness. Wood, pigment, h. 15 inches.

7.14 Back view of figure 7.13.

7.15 Ẹ̀fẹ̀ headdress with the leopard motif holding prey in its mouth, recalling the role of the Ẹ̀fẹ̀ mask as exposer of antisocial behaviors. The carved crisscross design represents Islamic talismanic belts (*óndè*) worn on the chest or waist. Wood, pigment. Igbóbì-Ṣábẹ̀ẹ́, Lagos (1972).

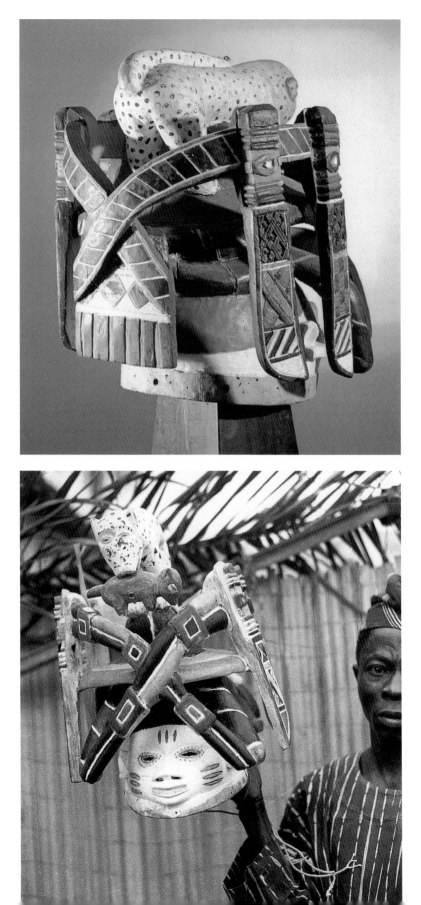

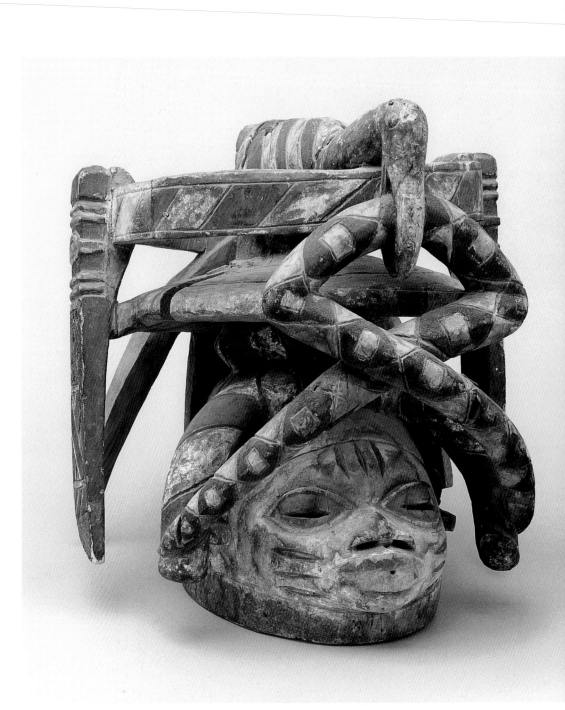

7.16 Ẹ̀fẹ̀ headdress surmounted by a bird holding a snake in its beak, hinting at the need for caution and prudence in life. Wood, pigment, h. 14⁷/₈ inches.

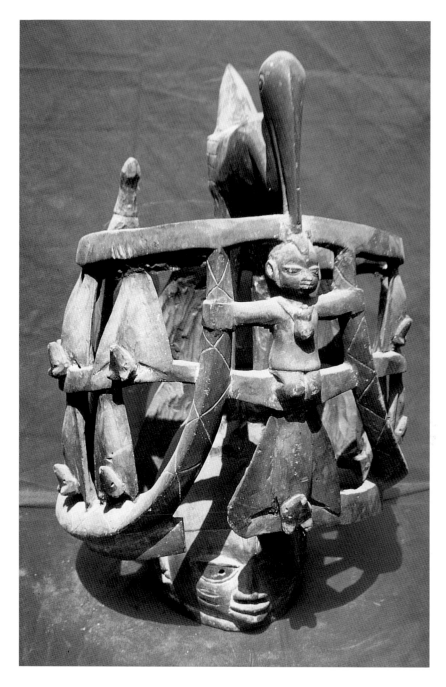

7.17 Ẹ̀fẹ̀ headdress with ground hornbill
(àkàlà), human being (ènìyàn), and bat
(àdọ́n) motifs, all reinforcing the theme of
vigilance. Wood, pigment.

The second group of Èfè headdresses consists of carved human heads with wide brims. The headdresses in this category are called *Àkàtà, Àtẹ,* or *Òrìjí* and are found mainly among the Àwórì and Ẹgbádò. The form ranges from a head wearing a pith helmet (as in the Èfè headdress of Ìbarà, Abẹòkúta) to a head surmounted by a round tray fringed with beads and carved miniature symbols of Orò, as in the headdresses of Lagos Èfè (pl. 16). The implications of the Orò symbols will be discussed later. The example in figure 7.18 is from Ìlaró, where the Èfè and Ajákùenà masks wear the same type of headdress. A piece of cloth fixed to the brim of the hat conceals the face of the masker. The human face in the middle of the tray has a carved red parrot tail feather on the forehead and wears a special cap called *abetíajá* (the dog-eared). When the headdress is in use, its rim is decorated with stringed palm nuts, beads, shells, and small mirrors.

Èfè headdresses known as Àgàṣa constitute the third category. They are found mainly among the Òhòrí. Painted with horizontal or diagonal stripes, a typical *Àgàṣa* has two bladelike vertical projections called matchets (*àdá*), and sometimes ears (*etí*) issuing out of a bearded human head (fig. 7.19). The inspiration for the *Àgàṣa* mask seems to have come from the headdress of the Etíyẹrí (long-eared) Egúngún mask commonly found in Abẹòkúta and environs.[5]

Olójú Méjì: The Double Face

This is a headdress with two faces placed side by side (fig. 7.20).[6] In Ìbóòrò, this headdress represents Eyinni, the local patron goddess of twins. Among the Òhòrí, a similar headdress is called *Àgàṣa Ìbejì* (mask for twins), but each head has a vertical projection.

Ẹlérù: Head with Superstructure

Meaning "load carrier," the term *Ẹlẹrù* designates a headdress with a major superstructure (figs. 7.21-7.55, pls. 18-20). The superstructure may project directly from the top of the human head or may rest on a round platform (*àtẹ*). Hence, another name for this category is *Alátẹ,* (tray carrier). Both the human head and the superstructure are often carved from a single piece of wood, although it is not uncommon to find the two carved separately and then nailed together. The resultant image (i.e., head portage) reminds us of the Àwòyó song (chap. 3, pp. 39, 58) commemorating the archetypal dance of Yemọja. Most of the themes on the superstructure can be divided into the following subcategories:

5. Illustrated in Thompson (1971b: ch.15, pl. 9).

6. For another illustration, see Drewal and Drewal (1983: pl. 149).

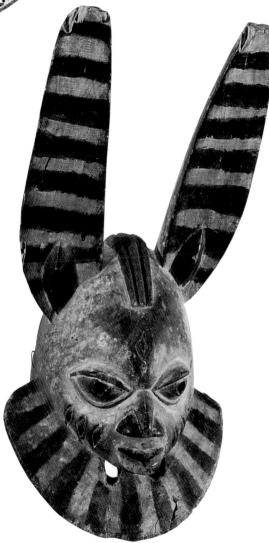

7.18 Èfè/Ajákùẹnà headdress with brim (*Àkàtà*). Although this example is worn by the Ajákùẹnà, the mask that summons the Èfè of Ìlaró to the performance arena, the Èfè has the same type of headdress (illustrated in Drewal and Drewal 1983: pl. 13). The red projection on the forehead represents the red tail feather of a parrot. The brim has several holes for suspending mirrors, palm nuts, and cowrie shells. Wood, pigment. Ìlaró (1971).

7.19 Èfè headdress found mainly among the Ọ̀họrí. Identified as *àdá* (matchets), the two bladelike projections hint at the power of the mask to challenge, or cut through, the forces of evil. The correct name for this category of Èfè headdresses is *igi Àgàṣa*, not *Apasa* as stated in most publications on Gẹ̀lẹ̀dẹ́ masks. Wood, pigment, h. 18 inches.

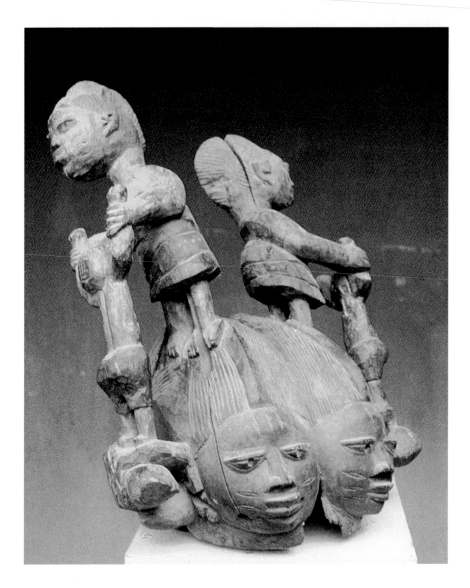

7.20 Gẹ̀lẹ̀dẹ́ double-faced headdress
associated with twins. Each child is placed
on a pangolin, an important element in
charms used to prevent infant mortality and
to protect the body against infection,
witchcraft, and other ills. Wood, pigment.

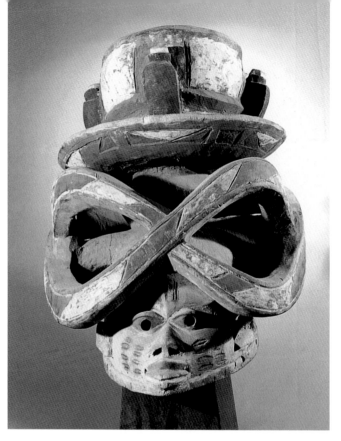

7.21a, b Gẹ̀lẹ̀dẹ́ headdress featuring a food hawker. The interlaced design is a stylized female head-wrap (*gẹ̀lẹ̀*). Wood, pigment, h. 12 inches.

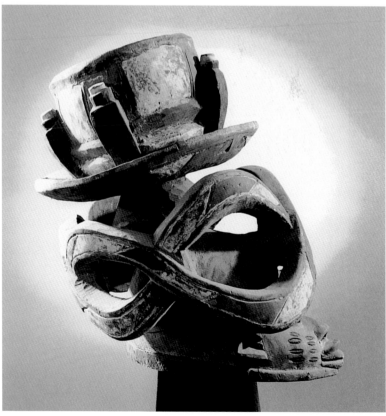

Food Hawker/Ritual Bowl Carrier

Almost all the headdresses in this subcategory represent a female hawker, displaying the product for sale on a tray, bowl, or inside a basket (figs. 7.21-7.23). The carver takes extra care to represent as faithfully as possible both the container and the product. The fact that the female food hawker is one of the most popular themes on Gèlèdé headdresses not only underscores the vital role played by women in traditional Yoruba economy—for they are the main link between the producer and the consumer—but it also links them to Mother Nature as the source of all food. On the headdress of the Tètèdé mask, the theme of the food hawker is sometimes modified into an *arugbá*, a female carrier of ritual objects (figs. 7.21, 7.23), to emphasize her role as a forerunner who clears all obstacles on the path of the Èfè mask before the latter appears for the night concert. This is why the Tètèdé mask of Ìlaró is called *Ajákùenà* (The one who cuts the tangles on the path).

7.22 Gèlèdé headdress featuring a plantain hawker and a bird. Carved by Tèla of Ìmèko. Wood, pigment, h. 15¹/₄ inches.

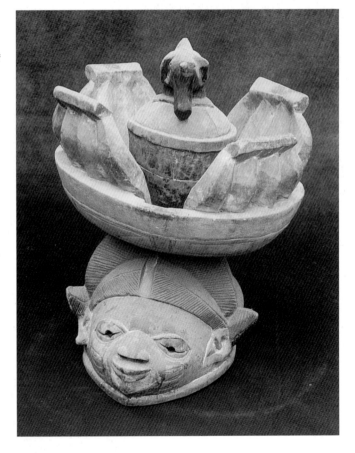

Traditional and Modern Occupations

Almost all the headdresses in this subcategory depict male occupations such as blacksmithing, drumming, hunting, calabash carving, palm fruit harvesting, lorry driving, tailoring, and carpentry (figs. 7.24-7.33, pl. 19). The characters are represented as busy at work or simply holding the tools of their trades. The headdress in figure 7.28 is one of the few exceptions. Instead of showing human figures, it features a hurricane lantern and a ring of bullets to represent hunting. Its companion piece, photographed in Ìmẹ̀kọ by Kevin Carroll (1967: pl. 99) has two Dane guns (missing in fig. 7.28) flanking the lantern. Although a masker need not be practicing the profession depicted on his mask, frequently he does. According to one masker who identified the motifs on his mask with his profession:

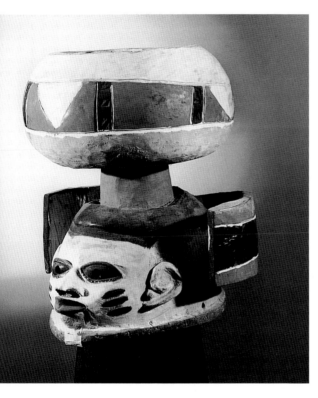

7.23 Gẹ̀lẹ̀dẹ́ headdress featuring a hawker carrying a calabash. Wood, pigment, h. 14 inches.

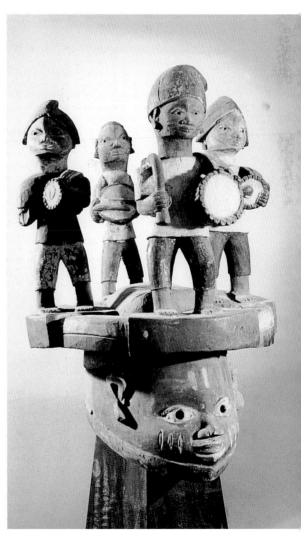

7.24 Gẹ̀lẹ̀dẹ́ headdress from Ìlaró featuring drummers (*onílù*). Wood, pigment, h. 20 inches.

7. Interview with a
Gèlèdé masker, who
wished to remain
anonymous. Ìlaró, 1971.

I carry a headdress showing a tailor, not only to publicize myself and my profession but also to implore "the owners of the world" to let me get enough jobs to do, so that my family and I will not suffer.[7]

It goes without saying, therefore, that some of the "occupational" headdresses do have a "public relations" function, especially in a culture such as that of the Yoruba, where it is customary to explain business failures or accidents on duty as due to the evil machinations of the àjẹ́ or jealous enemies.

Religious Personages

Some headdresses feature masks, priests, and priestesses, to recognize publicly their contributions to the spiritual well-being of the community (figs. 7.34-7.40). The person in figure 7.36 is an ẹlẹ́gùn Ṣàngó (Ṣàngó's possession priest) holding two rams, the sacred food of the thunder god. The object in front of the priest is a carved representation of the thunderbolt that Ṣàngó hurls down from the sky during thunderstorms. Behind the priest is a gourd rattle (ṣẹ́rẹ́) for summoning the spirit of Ṣàngó in the shrine. Figure 7.37 features another Ṣàngó priest, this time in full regalia. The heftiness of the figure evokes the popular image of Ṣàngó as a powerful and aggressive deity. The seated male in figure 7.38 is a diviner (babaláwo) consulting the Ifá oracle. The figure on top of the headdress in figure 7.34 is an Egúngún mask holding a medicinal gourd (àdó) and wearing a charm-studded kilt (apẹ́tẹ́).[8]

8. For other masks
depicting the Egúngún,
see Bascom (1973a: pl.
52), and Drewal and
Drewal (1983: pl. 119).

Although it is not certain whether these headdresses were once worn by the characters represented, the fact remains that priests of other Yoruba òrìṣà are members of the Gèlèdé society, and several informants assert that nothing prevents them from reflecting their priestly role on their headdresses if they decide to "dance" Gèlèdé. Nevertheless, the depiction of Christian and Islamic priests (figs. 7.39, 7.40) on some headdresses not only acknowledges their presence in the community but is also intended, according to one informant, to elicit their goodwill, so that people of different religious persuasions can live together in harmony.

Commemorative Portraits

As observed earlier, the dead are honored during the èfè concert to incline them to honor their living descendants. Masks featuring portraits of the deceased parade the streets after the concert, receiving gifts from relatives and former friends of the deceased. Figure 4.1 shows a memorial portrait

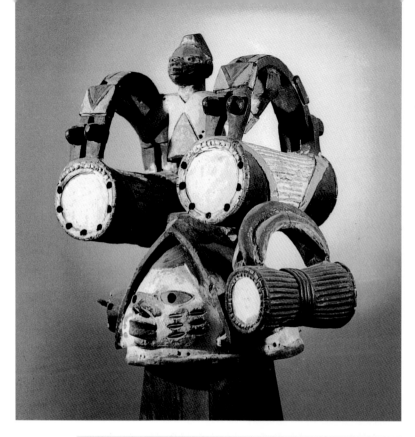

7.25 Gẹ̀lẹ̀dẹ́ head-
dress from Ìmẹ̀kọ
featuring a human
figure and *dùndún*
drums. Wood, pig-
ment, h. 16 inches.

7.26 Gẹ̀lẹ̀dẹ́ head-
dress featuring
calabash carvers
(*afíngbá*). Wood,
pigment, h. 16 inches.

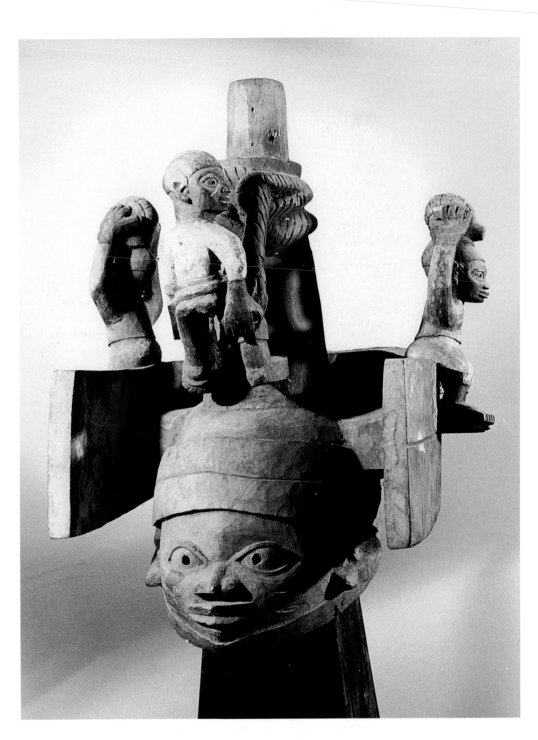

7.27 Gẹ̀lẹ̀dẹ́ headdress featuring palm fruit harvesters. The top of the palm tree is missing. In some instances, real palm leaves may be attached. Wood, pigment, h. 16 inches.

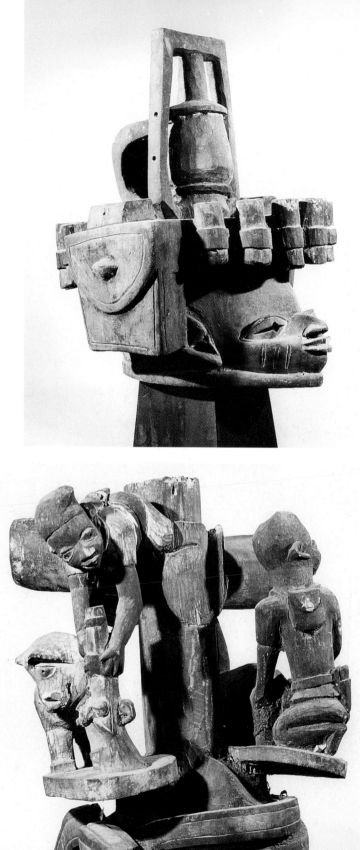

7.28 Gẹ̀lẹ̀dẹ́ head-dress, probably from Ìmẹ̀kọ, featuring a hurricane lantern, bullets, and bags to symbolize hunting. Two guns (missing in this piece) originally flanked the lantern. Wood. Pigment.

7.29 Gẹ̀lẹ̀dẹ́ head-dress from Ìmẹ̀kọ (back view) featuring two hunters (ọlọ́dẹ), a tree, and two animals (second at front). The top section is missing. Note stylized female headtie (gẹ̀lẹ̀) on head below figures. Wood, pigment, h. 20 inches.

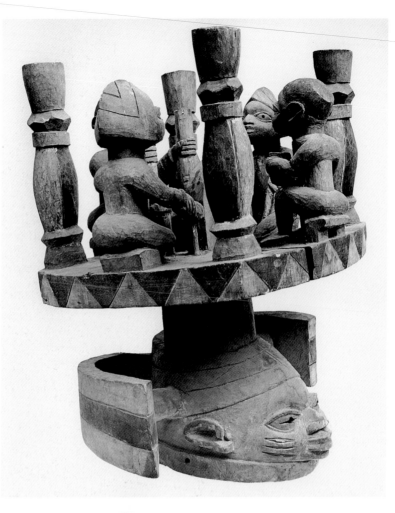

7.30 Gèlèdé head-dress featuring black-smiths (*alágbèdé*), emphasizing their vital role in traditional Yoruba culture as makers of tools essential to agri-culture, town planning, lumbering, building, warfare, and art. Wood, pigment, h. 23½ inches.

7.31 Detail of figure 7.30.

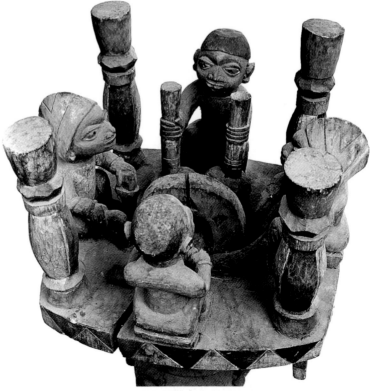

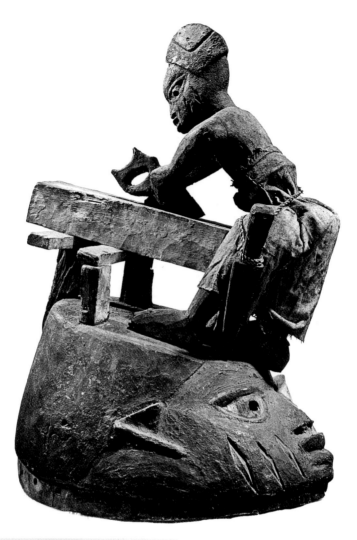

7.32 Gẹ̀lẹ̀dẹ́ head-dress featuring a carpenter (*kápíntà*). Wood, pigment, fabric, cord, metal, h. 14¹/₂ inches.

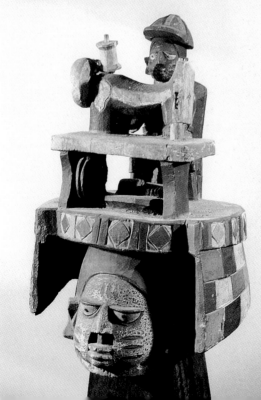

7.33 Gẹ̀lẹ̀dẹ́ head-dress featuring a tailor (*aránṣọ*). Carved by Michael Labọde of Ìdòfòyí, Ayétòrò. Wood, pigment, h. 17¹/₄ inches.

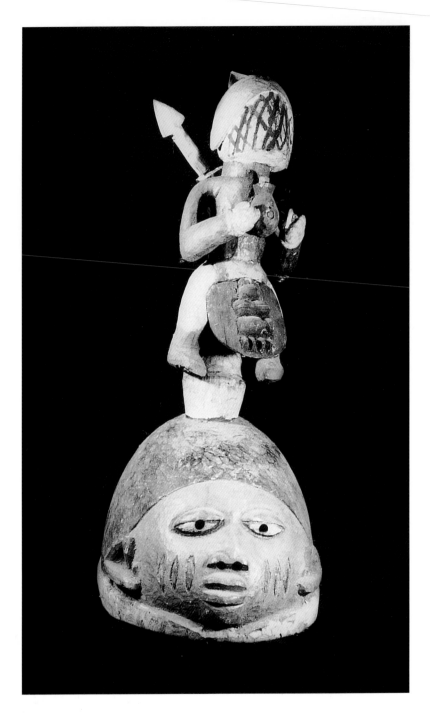

7.34 Gẹ̀lẹ̀dẹ́ head-
dress featuring an
Egúngún mask.
Compare with figure
7.8. Wood, pigment,
h. 20 inches.

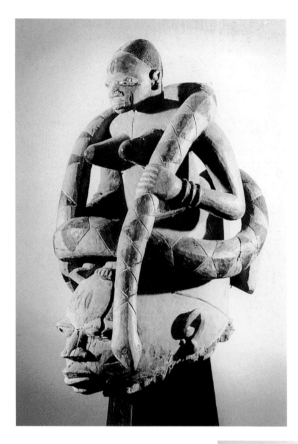

7.35 Gèlèdé head-dress featuring a female devotee of Ògún, the iron deity. The devotees of Ògún (Ológún) sometimes carry (coiled round their neck or arm) pet snakes dedicated to the iron deity. Wood, pigment, h. 16³/₄ inches.

7.36 Gèlèdé headdress featuring a Ṣàngó possession priest (elégùn) holding two sacrificial rams. In front of the figure is a representation of a celt, which the thunder god, according to popular belief, hurls down from the sky whenever lightning strikes. Behind the figure is a representation of a gourd rattle (ṣẹ́rẹ́) used to summon the spirit of Ṣàngó during worship. Carved by Mọṣudi Ọlatunji of Ìmẹ̀kọ. Wood, pigment, h. 18¹/₂ inches.

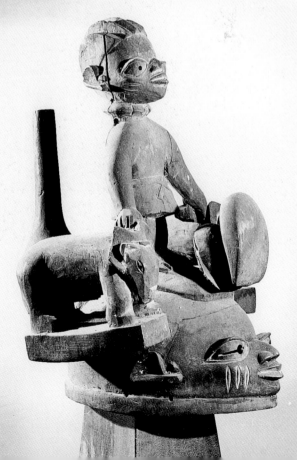

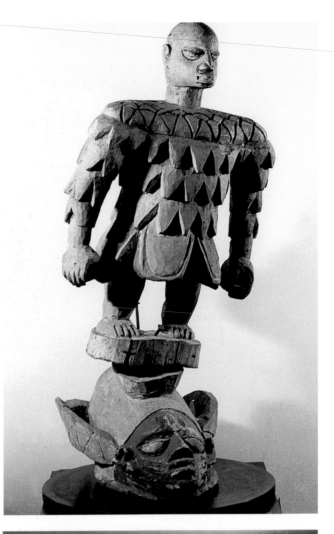

7.37 Gẹ̀lẹ̀dẹ́ head-dress featuring a Ṣàngó possession priest (ẹlẹ́gùn) in full regalia. Carved by Ogunbiyi of Àgọ Ṣàṣà. Wood, red pigment, iron, h. 30¹/₂ inches.

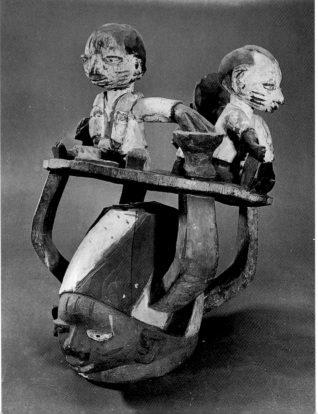

7.38 Gẹ̀lẹ̀dẹ́ head-dress featuring diviner (babaláwo). Wood, pigment.

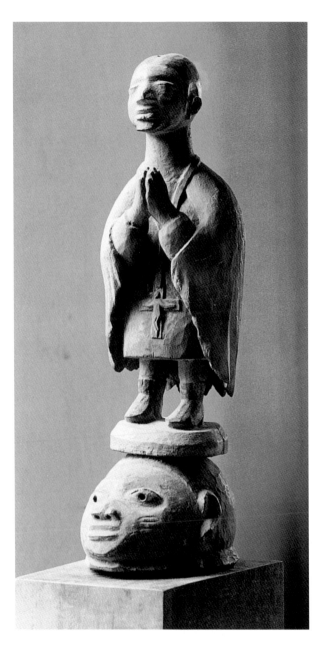

7.39 Gẹ̀lẹ̀dẹ́ headdress
featuring a Catholic priest.
Wood, pigment.

portrait of the late Màmà Ibidunni Onílẹ̀gbálẹ̀ of Ìsàlẹ̀-Èkó, Lagos. The fish motif alludes to the fact that she was a successful fish merchant during her lifetime.[9] According to carver Ganiyu Ṣekoni Dogá, the headdress in figure 7.40 was carved by his father, the famous Master Dogá of Ìmẹ̀kọ.[10] The Moslem cleric represents the late Àlùfáà Àsànte, a prominent community leader in Ìmẹ̀kọ. Here, Àlùfáà Àsànte sits in front of a canoe being paddled to the Islamic paradise (àlùjọ́nọ̀). The circular object in his hand represents prayer beads (tẹ̀sìbíù); the kettles on both sides of the canoe are to ensure that Àlùfáà Àsànte has enough water for ablutions. Contrary to what one might expect in the representation of an official of a religion such as Islam which is hostile to traditional Yoruba beliefs, this is not a negative portrayal of Àlùfáà Àsànte. Rather, it is a public recognition of his personal worth and contributions as one of the leaders of the Ìmẹ̀kọ community. As a lesson in tolerance, it gives testimony to the fact that the Gẹ̀lẹ̀dẹ́ society practices what it preaches.

9. Also illustrated in Thompson (1971b:ch. 15, pl. 5).

10. Studied by Bascom (1973b:490-505).

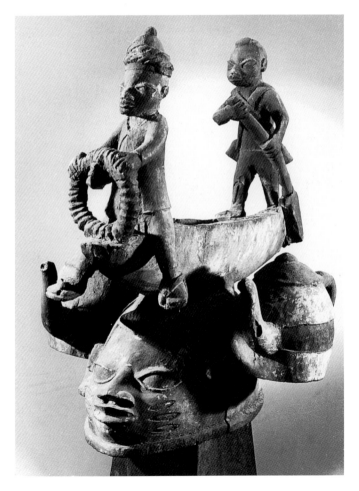

7.40 Gẹ̀lẹ̀dẹ́ headdress featuring a Moslem cleric (àlùfáà) being paddled to àlùjọ́nọ̀ (paradise). Carved by Dogá of Ìmẹ̀kọ. Wood, pigment, h. 17¹/₂ inches.

Several headdresses in the National Museum, Lagos, show figures whose bearing suggests that they are important people (figs. 7.41, pl. 18). Unfortunately, we do not know their names. Suffice it to say that the representation of such dignitaries on Gèlèdé masks is not only an index of honor but it carries the implication that through diligence, hard work, good character, and selfless service to the community, any individual or commoner can attain a similar position of honor.

Satire

Since its ultimate aim is to create an atmosphere conducive to peace, happiness, and tranquillity, Gèlèdé does not target the *àjé* alone. It also admonishes thieves, conspirators, prostitutes, Casanovas, murderers, swindlers, and

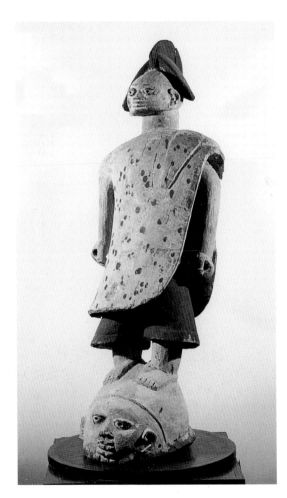

7.41 Gèlèdé headdress featuring an elder wearing a dog-eared cap (*fìlà abetíajá*). The depiction of community leaders implies that, through emulating their good character, others may attain similar positions of honor. Wood, pigment, h. 33 inches.

the corrupt in general, whose overt or covert activities are not in the overall interest of the community. Thus at Ajílété, a headdress featured a thief arrested by a policeman (Thompson 1971b: ch.14/6); another at Ìmèkò depicted a burglar who lost his forearm while attempting to break into a house. Figures in various poses satirize sexual promiscuity and other indecent behaviors (figs. 7.42, 7.43). A Casanova is sometimes represented by a puppet whose oversize phallus is activated with a string. At Pobe, a seducer of women was portrayed with three daggers on his head "to protect himself from the vengeance of husbands" (Fagg 1951:125-26). The joke here is that, to the Yoruba, Casanovas usually meet their deaths, not from physical attacks by irate husbands, but through *mágùn* ("Don't mount!"), a special charm that causes those who attempt to mate with other people's wives to develop fatal epileptic fits. A dagger will therefore not protect Casanovas against *mágùn*.[11]

11. For more information on *mágùn*, see Awolalu (1979:77-78).

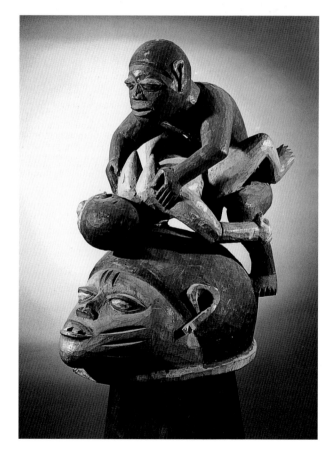

7.42 Gèlèdé headdress featuring a mating couple. Although motifs such as this satirize sexual promiscuity and immoral behavior, they also embody a prayer for a fruitful union of the male and female elements in nature. Wood, pigment, h. 15 inches.

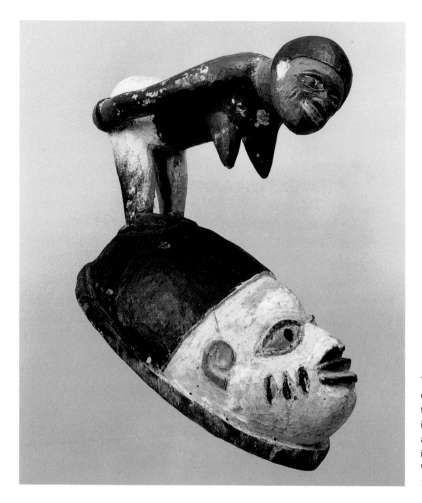

7.43 Gèlèdé head-dress featuring a female figure display-ing her private parts, apparently satirizing indecent behavior. Wood, pigment, h. 13³/₄ inches.

Aspects of Life in the Town and Forest

Headdresses may depict lives in the town and the forest in any thematic way that happens to catch the imagination of the carver or his client (figs. 7.44-7.55). Such themes include a bird fighting a snake, two snakes attempt-ing to swallow a porcupine, a mother suckling her child, a man with an umbrella, a horseman, or animals in various actions. Practically anything may be represented. Ulli Beier recorded the following themes from the Daagbe and Bánigbe areas of Ìtakété in the Peoples Republic of Benin:

> [A] man smoking a pipe; an angel; a black nurse with two white children; four men fighting with guns and matchets; a Catholic priest; a monkey with a huge hernia; a decorative arrangement of four matchets; four skulls; a jackal and birds

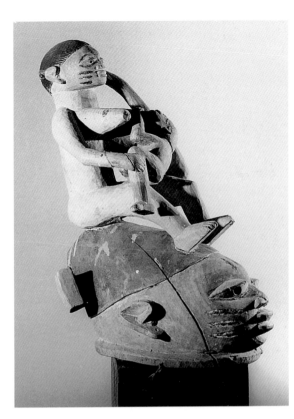

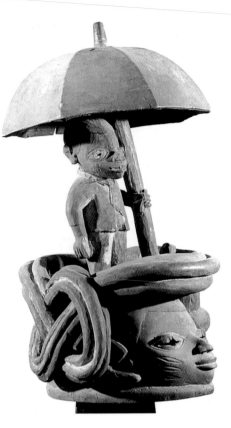

7.44 Gẹ̀lẹ̀dẹ́ headdress featuring a nursing mother (*abiyamọ*), alluding to the generosity that humanity expects from Ìyá Nlá, the Mother of All, and to the slogan *Ọmú ìyá dùn ú mu* (Mother's breast milk is sweet), popularized by Ògbóni members, who recite it three times when paying homage to the Earth goddess. Wood, pigment, h. 22 inches.

7.45 Gẹ̀lẹ̀dẹ́ headdress featuring a man under an umbrella (*agboòrùn*). The umbrella motif, as a shelter from the sun or rain, signifies the prayer to Ìyá Nlá to shelter her offspring from evil. Carved by Mọṣudi Ọlatunji of Ìmẹ̀kọ. Wood, pigment, h. 22$\frac{1}{2}$ inches.

7.46 (*right*) Gẹ̀lẹ̀dẹ́ headdress featuring two ladders and four parrots. Wood, pigment, h. 17$\frac{1}{4}$ inches.

7.47 (*far right*) Gẹ̀lẹ̀dẹ́ headdress featuring two arched pythons (*erè*) representing the rainbow (Òṣùmàrè). A priestess of the deity stands under the inner arch. Some Yoruba liken the colored arc of the rainbow to *òjá*, the baby sash that lends color and ritual efficacy to the Gẹ̀lẹ̀dẹ́ costume and spectacle. Carved by Oguntade Iji of Ìlárá, Ẹ̀gbádò. Wood, pigment, h. 23$\frac{1}{2}$ inches.

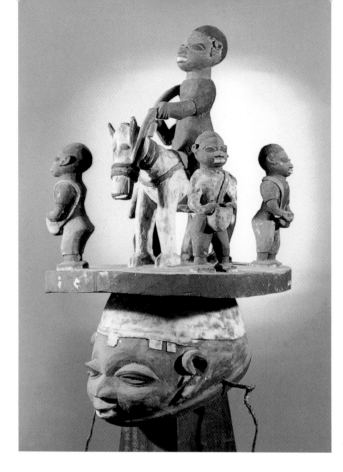

7.48 Gèlèdé headdress featuring equestrian figure (*ẹléṣin*) accompanied by drummers. Attributed to carver Oguntade Iji of Ìlárá, Ègbádò. Wood, pigment, h. 22½ inches.

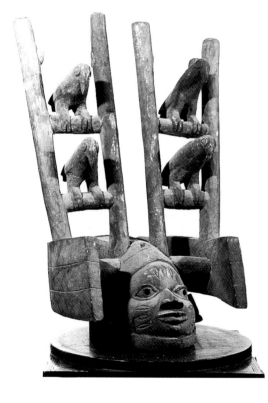

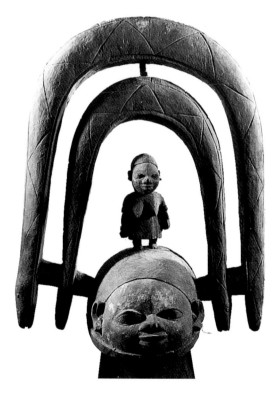

7.49 Gèlèdé head-
dress emphasizing
the spiral movement
of snakes (*ejò*) associ-
ated with dynamism
and regeneration.
Wood, pigment, h. 17
inches.

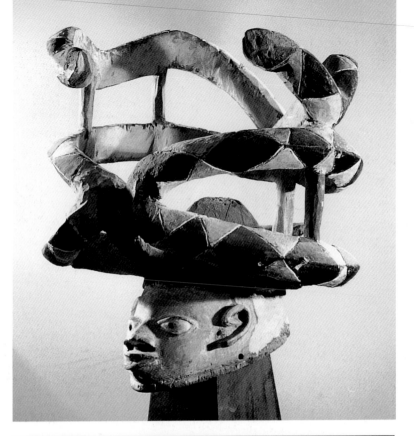

7.50a Gèlèdé head-
dress featuring a cock
and a snake locked in
a fight to the end
(*àjàngbilà*). Struggling
to free itself, the snake
bites the right leg of
the cock, twisting its
tail round the left leg—
another variation on
the theme of caution.
Wood, pigment, h. 13
inches.

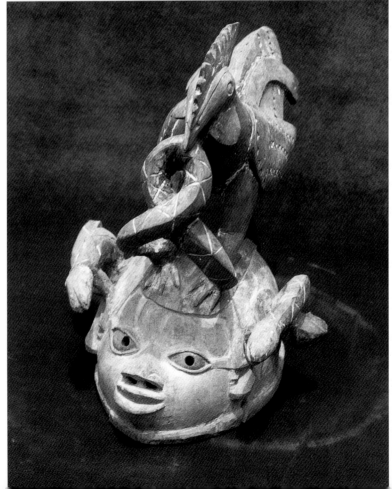

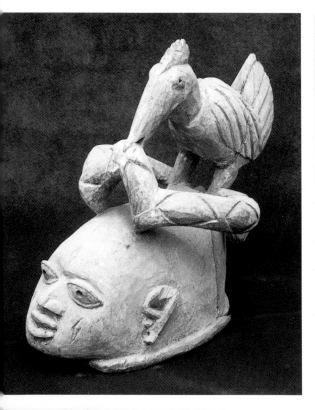

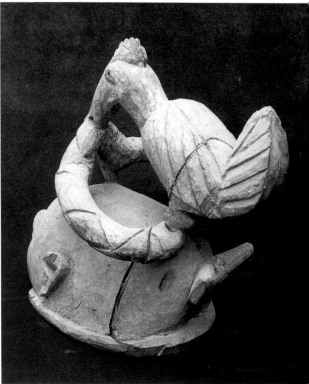

7.51a, b (*above*) Gèlèdé headdress featuring a fowl (*adìe*) pecking at a snake, which in turn seizes the fowl by the leg, recalling the popular Yoruba proverb: A fowl perches on a rope; the rope feels uneasy; the fowl also feels uneasy. Describing a mutually perilous encounter, this proverb warns of the dangers of violence within society's delicate balance. Wood, pigment, h. 8 inches.

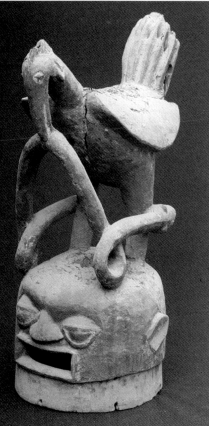

7.50b Ẹpa headdress with a bird and snake motif similar to the one in fig. 7.50a. Some Ekìtì and Ìgbòmìnà informants interpret the motif in this context as a visual metaphor for potential crisis (*ìṣòro*), which could be prevented through prudence, divination, and rituals, among others. Pigment, wood.

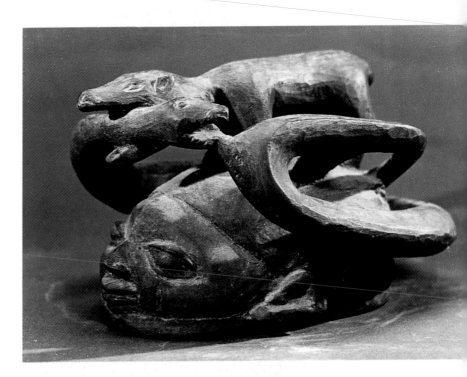

7.52 Gẹ̀lẹ̀dẹ́ head-dress featuring an animal attacking a snake, expressing the theme of caution. Wood, pigment.

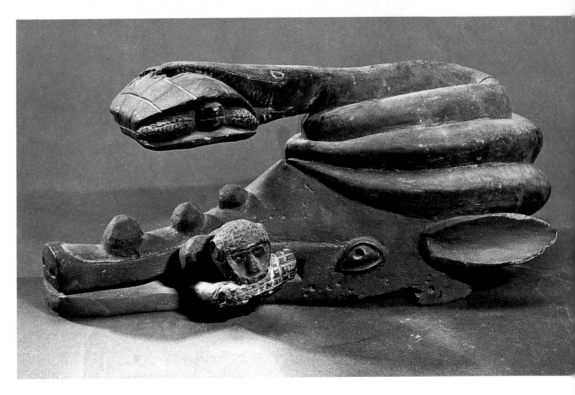

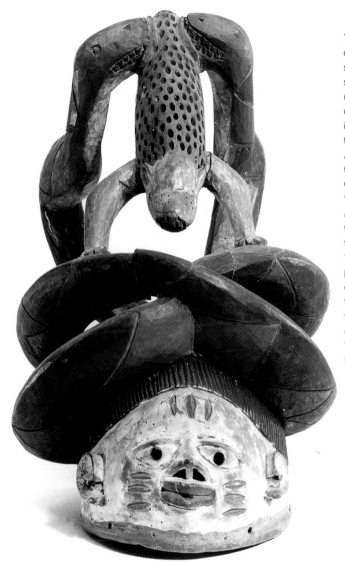

7.54 Gèlèdé head-dress featuring two snakes attempting to swallow a porcupine (oòrè) along with the quills. (Quills can be inserted in holes on the porcupine's back.) According to a divination verse, Èsù and Òrúnmìlà forced the "powerful mothers" to agree to a pact limiting their power. One of the injunctions is that "nobody eats a porcupine along with the quills." The motifs on this headdress therefore seem to warn all evildoers of nemesis. Wood, pigment, h. 18¹/₂ inches.

7.53 (*left*) Gèlèdé headdress featuring a pig (elédè) holding a monkey in its mouth; the monkey is eating maize. The python on the top of the pig attacks a tortoise. The two themes constitute a warning against foolhardiness. First, the Colobus monkey (edun) is sacred to the Yoruba because of its association with twins and the river goddess Òsun. The motif of the monkey eating maize identifies the animal as a creature that must not be killed for any offence (Abimbola 1976:203). Thus, the pig attacking the monkey is inviting the wrath of Òsun, one of the matrons of spirit children. Second, the python attacking the tortoise recalls one of the limitations on the power of the àjé, namely, that "nobody eats a tortoise with the shell." Wood, pigment, l. about 17 inches.

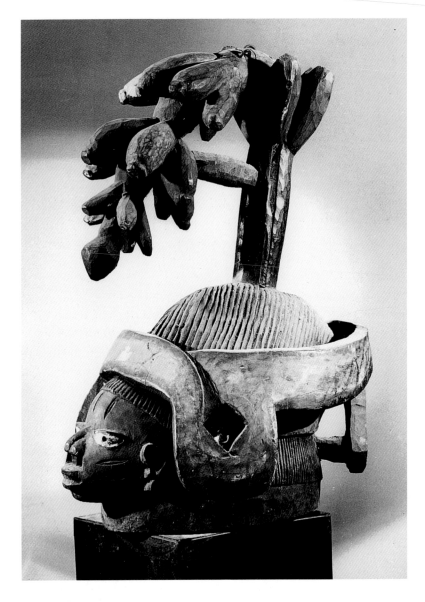

7.55 Gèlèdé headdress featuring a banana
stalk (*ògèdè*). The banana plant plays an
important role in Yoruba ritual, partly because
of its water-laden stem and partly because it
fruits in clusters. As a result, it symbolizes
fecundity. But because of its ephemeral life,
the plant is also associated with infant mortality
(Àbíkú), and hence, is used in rituals aimed at
its reversal. Carved by Michael Labọde of
Ìdòfòyí, Ayétòrò. Wood, pigment, h. 21¼ inches.

eating a snake; a man catching an antelope by the hind legs; two dundun drums; "aroni," a forest creature reputed to have one leg; two snakes and a bird trying to eat the same tortoise; a coiled python rearing its head; a couple of wrestlers; a woman standing on one leg and covering her sex with one hand; a shango priest; a woman in obscene position; a tree with fruit dangling from it (carved from one piece) and snake coiling round it. (Beier 1958:16)

Onídòfòyí: Two Heads Connected by Snakes

This horizontal headdress consists of two human heads, about five to seven feet apart, linked by two or more intertwined snakes (fig. 7.56). In Ìdòfòyí (Ayétòrò), informants identified the male head with Onídòfòyí (the tutelary god of snakes in the town) and the female with Agbojo, his wife. The headdress requires two experienced maskers of the same height to dance it, necessitating much practice because of the special skills involved in anticipating each other's movements during the dance. This headdress is found mainly in Ìdòfòyí (Ayétòrò), Ìmáàlà, and neighboring towns. In a unique example documented by the Drewals, the two heads are joined by a network of snakes, tortoises, crocodiles, monkeys, and human figures (1983: pl. 126).

Orí Ẹyẹ: Bird Head

In this subcategory are the heads of various birds (see Drewal and Drewal 1983: pls. 24, 25, 141, 142). Some, like Òṣòṣòbí and Àgbìgbò (fig. 7.57), are associated with àjẹ́. Others are depicted just for fun.

Orí Eranko: Animal Head

In this subcategory are the heads of various animals such as the hyena, buffalo, pig, and ram (figs. 5.9, 6.17, 6.18, 7.53, 7.58).

7.56 Gèlèdé headdress, called Onídòfòyí, featuring two heads connected by snakes. The head on the right represents Onídòfòyí, the tutelary deity of snakes in the town, while the female head, on the left, is that of Agbojo, his wife. This headdress requires two maskers of approximately the same height to dance with it. Carved by Michael Labọde of Ìdòfòyí, Ayétòrò. The piece was photographed in his workshop (1971). Wood, pigment.

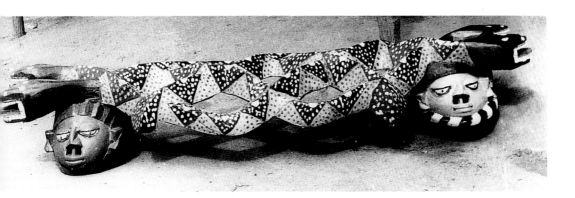

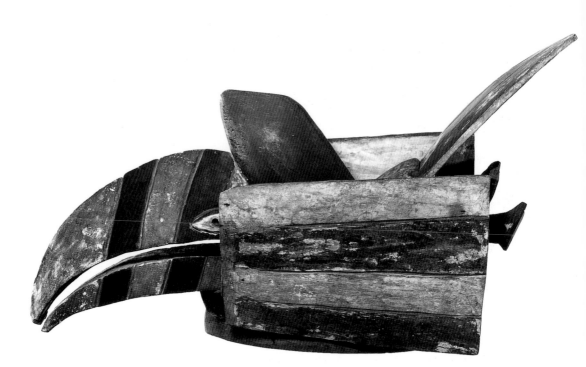

7.57 Gẹ̀lẹ̀dẹ́ headdress representing Àgbígbò, believed to be an evil bird and a familiar of the "powerful mothers." During the festival, the dance of the Àgbígbò mask is expected to neutralize evil forces in the community.

Facial Marks

A good majority of the headdresses have facial adornments, ranging from lineage marks (*ilà ìdílé*) to decorative tattoos (*ilà ara*), these being incised or painted on. The lineage marks may or may not reflect those on the face of the masker himself. The carver will include the marks on the face of his client only when specifically requested to do so. Otherwise, he simply adorns the headdress with the facial marks most popular in the community. A memorial portrait, however, bears the marks on the face of the subject as indicated by the patron. These marks are very important because they rein-

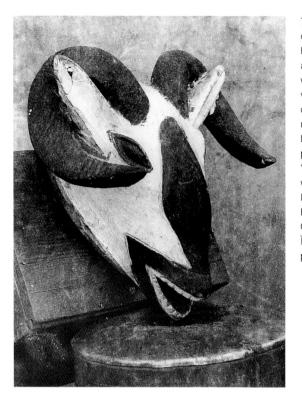

7.58 Gèlèdé head-dress representing the head of a ram (àgbò), an animal associated with thunderstorms, vigilance, virility, and dynamism. It also recalls one of the limitations on the power of the àjé, that "nobody eats a ram with the horns." Photographed in the house of Aṣimi Qlatunji-Onígèlèdé, Ìmèkọ (1971). Wood, pigment.

force the social and spiritual oneness of the community, of the living and the dead, and of the human and the divine.[12] Now and then, a mask may have two vertical marks on the forehead—one red and the other white—to identify it or the owner with Òrìṣà Oko, the deity of agriculture, whose devotees wear similar marks on the forehead. Although practically all Yoruba lineage marks are represented in the Gèlèdé mask corpus, those shown in figs 7.59-7.64 are the most common.

12. For more information on Yoruba lineage marks, see Johnson (1921:106-9); Daramola and Jeje (1975:77-82).

Color

Color is applied to the headdresses in a functional or decorative manner to increase their visual appeal. The body is often painted brown, black, or yellow-ochre. The hair is almost always black. The eyeball is usually white and is either dotted with black or pierced to indicate the pupil. Sometimes the eyeball is slit open. Dresses and headgear are brightly colored and are patterned to suggest fabrics. Because white signifies the sacred, it is the

7.59 Placed on each cheek and sometimes on the forehead, these three short, vertical lines are called *pélé*. They are very popular among the Ọ̀yọ́, Ẹ̀gbá, Ẹ̀gbádò, Kétu, and several communities in southwestern Yorubaland who regard them as a "gem" on the human face. Hence, those who have the mark on the face are given the nickname *Péléyẹjú* (*Pélé* fits the face).

7.60 Called *àbàjà,* these three short horizontal lines adorn each cheek. The mark is popular in more or less the same areas as the *pélé*.

7.61 Called *àbàjà mẹ́rin* and placed on each cheek, these four short, horizontal lines are found mainly among the Ọ̀yọ́ and the people of Ọ̀yọ́ descent who now live in southwestern Yorubaland. The pairing of masks is said to signify royal lineage.

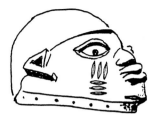

7.62 Called *Àbàjà Olówu*, three *pélé* and *àbàjà* marks are combined here, the one on top of the other. Àbàjà Olówu is associated with the people of the ancient kingdom of Òwu, destroyed during the Yoruba civil wars of the nineteenth century. Most of the refugees have since settled among the Ẹ̀gbá, Ẹ̀gbádò, Àwórì, Ìjẹbú, and Ọ̀yọ́.

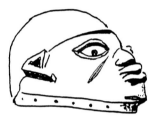

7.63 Called *Ìbààmú,* this diagonal line is cut on one side of the face, between the corner of the eye and nose. Although it is a lineage mark among the Ọ̀yọ́ (especially the Ìbàdàn and Ògbómọ̀ṣọ́), it is commonly associated with *Àbíkú* children in some non-Ọ̀yọ́ areas. Once a child is so identified, the *ìbààmú* is cut on its face to scare away its spirit companions. Occasionally, a headdress with the *ìbààmú* on both sides of the face may be used to represent a non-Yoruba.

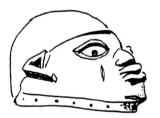

7.64 Known by different names in different communities, this short vertical mark on the cheekbone (and sometimes on the forehead) is popularly called *ìdòko.* In southwestern Yorubaland, it is found mainly among the Àwórì, Ànàgò, and related groups, although variations of the mark abound all over Yorubaland.

13. Illustrated in
Drewal and Drewal
(1983: pl. 3).

predominant color of the Great Mother mask and other masks associated
with her, such as the Ọ̀ṣọ̀ṣọ̀bí bird mask of Ìlaró and the Ìyálé Yemọja mask
of Ìbarà.[13] Quite often the face of the Èfè headdress is painted white (figs.
7.13, 7.15, pl. 16), not only to emphasize the role of the Èfè masker as the
link between the physical and spirit worlds but also to enhance visibility at
night. The white color may also be used to distinguish daylight masks rep-
resenting priests of deities such as Ọbàtálá and Ọrúnmìlà, to whom the color
white is sacred (fig. 7.38). The color red sometimes identifies a headdress
with Ṣàngó (thunder deity) because red is sacred to that òrìṣà (fig. 7.37),
while a combination of red and white dots may refer to Ṣọ̀pọ̀nọ́ (the small-
pox deity). But generally, any color or combination of colors may be used
for sheer pictorial effects.

As already mentioned, all old headdresses are repainted before the festi-
val. The color scheme of an old headdress may be retained if the relevant
colors are available, but quite often the exact colors cannot be found. And
there is sometimes even the need to give an old headdress a "face lift" to
avoid monotony. According to carver Ganiyu Ṣekoni Dogá, Painting Su-
pervisor (Olórí Akunbè) of one of the Gèlèdé societies in Ìmèkọ, the new
color scheme will always harmonize or contrast well with any costume
because the latter consists of wrappers, female headties, baby sashes, and
appliqué panels of different colors (pls. 4-8). But the costumes of certain
masks like the Ẹfọ̀n (buffalo) of Ìbarà, Abẹokuta—made of banana leaves—
and those representing the Great Mother (Ìyá)—made of white cloth—
always remain constant because of their ritual implications.

Although a new or repainted headdress is sometimes blessed by the Ìyáláṣè
or Bàbáláṣè before being worn, great care is taken so that no sacrificial matter
soils its appearance, as cleanliness and beauty are major factors in the Gèlèdé
display. Hence, the Gèlèdé mask in Ìmèkọ is termed *Márìndòtí,* meaning
"Ever-Neat" (Fayọmi 1982:30). This concern with beauty and neatness dif-
ferentiates Gèlèdé from other major Yoruba masks, such as Egúngún and
Ẹpa, whose headdresses are sometimes swamped with heavy layers of sacrifi-
cial matter.

Symbolism

In line with the dualism that runs through other aspects of the culture, Yoruba
aesthetics embrace the outer and the inner. As earlier mentioned, outer or
external beauty is *ẹwà òde,* and inner beauty or intrinsic worth is *ẹwà inú.*
The truly beautiful combines both qualities to an appreciable degree. Simi-

larly, a full appreciation of a work of art (iṣẹ́ ọnà) requires the use of one's "outer" and "inner" eyes, known as ojú òde and ojú inú, respectively. Although qualities such as thoughtfulness, insight, and creativity are also covered by the term, ojú inú is mainly a metaphor for the analytic eye that enables an individual to see beyond the surface, to relate visual to verbal imageries.[14] According to Michael Labọde, a famous carver of Gẹ̀lẹ̀dẹ́ headdresses in Ìdòfòyí, Ayétòrò, ojú òde enables an individual to recognize the actions on a typical Gẹ̀lẹ̀dẹ́ headdress, but ojú inú allows him to decipher the concealed message. He adds that one acquires ojú inú through familiarity with Yoruba folklore, myths, proverbs, and wise sayings, and that the best way to gain this familiarity is by moving with and listening to elders. The experience also helps an individual to develop etí inú (inner ear) with which to analyze the spoken word as well as drum languages (Labọde, interview, 1971). The following Yoruba proverb underscores the importance of knowledge, experience, and insight in the interpretation of art forms: Bí òwe, bí òwe l'á nlùlù ògìdìgbó: Ọlọ́gbọ́n ní í jo, Ọ̀mọ̀ràn ní í mọ̀ ọ. (The language of the slit wooden drum is proverbial: Only the wise know how to dance it, Only the astute can understand and interpret it.)[15]

Taking a cue from Mr. Labọde's remark, I showed photographs of Gẹ̀lẹ̀dẹ́ headdresses to carvers and elders of Gẹ̀lẹ̀dẹ́ societies in different towns and asked them to comment on the symbolism. In almost all cases, informants related the motifs to folklore, proverbs, wise sayings, popular songs, or Ifá divination verses.

Bird motifs

The frequency of the bird motif on Gẹ̀lẹ̀dẹ́ headdresses is not surprising, given the popular belief that the "powerful mothers" change into birds at night (thus the nickname, ẹlẹ́yẹ—wielder of bird power) to wreak havoc on sleeping and unsuspecting victims. No doubt, many of the motifs are aimed at localizing and controlling this power. The meaning of a particular motif, however, depends on the name of the bird, its behavior, and associations in Yoruba rituals and folklore.

Àgbìgbò, the big-headed gray hornbill (fig. 7.57) is a popular motif on Gẹ̀lẹ̀dẹ́ headdresses because of its association with evil. According to the Ifá divination verse (Odù Ọ̀bàrà Méjì), the tuft of hair on the bird's head is a coffin that it carries about to deposit on the doorsteps of selected victims, who will die shortly after (Abimbọla 1976: 211-13). To members of the Gẹ̀lẹ̀dẹ́ society, it is the àjẹ́ who send the bird to specific individuals. On

14. For a discussion of the concept of ojú inú, see Abiọdun (1990:75-76).

15. Also cited by Apter (1992:213), quoting Rowland Abiọdun.

sighting the bird, some Yoruba elders advise that one should sing the following song to disarm it:

Àgbìgbò
O kú ẹrù orí
Àgbìgbò
O kú ẹrù orí, Àgbìgbò

Àgbìgbò,
We greet you and your headload.
Àgbìgbò,
We greet you and your headload, Àgbìgbò
(Recorded in Ìsàlè-Èkó, Lagos, 1974. My translation)

During the Gèlèdé festival, the drummers use the same song to welcome masks with Àgbìgbò headdresses to the performance arena. This song, according to popular belief, lightens the load on the bird's head, preventing it from depositing the coffin within a given town.

Unlike the gray hornbill, the pigeon (ẹyẹlé) has a positive image in Yoruba thought, being admired for its dignified bearing, elegant plumage, and agility (Awolalu 1979:106-7). In Ifá divination rituals, the bird symbolizes honor and prosperity; when offered as sacrifice, it is expected to attract both virtues (Abimbọla 1976: 206). This is implied in the popular saying: Tòtún tòsì l'ẹyẹlé fi nkó ire wálé. (The pigeon attracts goodness into a house from the right and the left.) As a result, the bird is a popular pet among the Yoruba. Because it is fond of laying and hatching two eggs at a time, the Yoruba associate the bird with twins (Abimbọla 1976:206) and, by extension, with equilibrium and good luck. Moreover, the pigeon, to the Yoruba, is a symbol of absolute devotion; for, rather than escape as other pets would do, it stays put if the house of its owner is burning. If not rescued, the bird perishes with the house (Adeoye 1989:9). This attribute of the pigeon is portrayed in the following saying:

Adìẹ ní í bá onílé jẹ
Tí í bá onílé mu
Tí í di ọjọ́ ikú onílé
Tí í yẹ orí
Ṣùgbọ́n ẹyẹlé kì í bá onílé jẹ
Kí ó bá onílé mu

Kí ó di ojọ́ ikú
Kì ó yẹrí

It is the chicken who eats with the landlord,
Who drinks with the landlord,
Who, on the day misfortune befalls the landlord,
Runs away.
But the pigeon never eats with the landlord,
Never drinks with the landlord.
On the day of disaster,
It never runs away.

(Adeoye 1989: 8. My translation)

The pigeon forms an important part of the sacrifices offered to Ìyá Nlá and the *àjẹ́* because, as one elder of the Gẹ̀lẹ̀dẹ́ society put it, *Lẹ́yẹ, lẹ́yẹ là á bá ẹyẹlé.* (The pigeon always commands respect and honor.) In other words, the reputation of the bird as a symbol of peace, humility, and absolute devotion obliges the recipient of a sacrifice to honor the wishes associated with it. The pigeon motif on the Gẹ̀lẹ̀dẹ́ headdresses (fig. 7.10) is expected to endear the masker to the hearts of all.

The African gray parrot (Odídẹrẹ́) is one of the most popular bird motifs on Gẹ̀lẹ̀dẹ́ headdresses (pls. 5, 15, fig. 7.46). It has three main functions: to seek the goodwill of the *àjẹ́;* to reinforce the image of the Èfẹ̀ mask as a "news reporter"; and to admonish evildoers.

According to informants, the parrot motif is a very effective means of seeking the indulgence of the *àjẹ́* because the bird is one of Ìyá Nlá's favorite pets. Its red tail feather (*ìkóódẹ*) is linked with menstrual blood and fertility; hence the nickname of the bird: *Odídẹrẹ́, ọmọ à fìdí ṣ'òwò èjẹ̀* (The gray parrot, offspring of the one with the menses). According to the divination verse (*Odù Ogbè Ìyọ́nú*), the *àjẹ́* decorated their hair with the parrot's red tail feathers when they first arrived on earth (Verger 1965:184). Thus at Ìbarà, Abẹokuta, the headdress of the mask representing Ìyálé Yemọja (the chief priestess of Ìyá Nlá) has a crown of red parrot feathers.[16] In Ìlaró, Ìyá Nlá is popularly called Alakàá Ìkó (owner of a chamber full of red parrot feathers) because of her fondness for the red parrot feather. Although elders of the Gẹ̀lẹ̀dẹ́ society are reluctant to disclose exactly why Ìyá Nlá and the *àjẹ́* love the tail feather of the parrot, its blood-red color is obviously one of the principal reasons. Blood (*èjẹ̀*) contains the vital force (*àṣẹ*) that sustains life and which the *àjẹ́* relish to augment their own power. The association

16. For illustrations, see Drewal and Drewal (1983: pl. 146).

17. Part of the power of the red tail feather of the parrot apparently derives from the shortened form of its name *ìkó* which means "a collector." Hence the chant: *Ìkó, kí ẹ fi kó ire wá.* (*Ìkó*, please collect goodness.) See Verger (1965:184). The converse is: *Ìkóòdẹ̀, bá mi kó ibi lọ.* (The red parrot feather, help to collect and carry evil away.) See Verger (1972:18). The word *ìkó* is also implicated in *Ìkóríta* (an intersection of three roads). The "crossroads" has a special significance in Yoruba rituals, as it is the domain of Èṣù.

of the feather with blood may also explain why it is a popular ingredient in Yoruba herbal medicine. For instance, it is a vital part of the medicine for curing "black menstruation" (Buckley 1985:9). Many Yoruba keep the parrot as a pet partly because of its tail feather, plucking it periodically for sale to herbalists.[17]

According to the late Chief Fagbemi Ajanaku, not only does the red color of the parrot's tail feather suggest some kind of power but it is the center of attraction in the bird's otherwise gray plumage, thus giving it a dignified presence (Ajanaku, interview, 1971). This phenomenon is evident in the following sayings:

Odídẹré kì í tí
Láwùjọ ìkó

The gray parrot never suffers disgrace
In the company of its red tail feathers.

(Simpson 1980:86)

A kì í bínú odídẹré
Ti oun ti ìkóódẹ ìdí rẹ̀
Bi á bá bínú odídẹré
Ìkóódẹ rẹ̀ a tàn yẹbẹyẹbẹ

We do not grudge the parrot
Together with its red tail feathers.
When we grudge the parrot,
Its red tail feather glows with irresistible appeal.

These two sayings help to explain why the red tail feather of the parrot is considered an effective palliative (*oògùn ìyọ́nú*) when dealing with the "powerful mothers."[18]

18. Sometimes, the color of the parrot's tail feather is used as a metaphor for the red palm oil (*epo*) associated by the Yoruba with "coolness" or *èrọ̀* (that which soothes). Hence, the parrot is also known as *odídẹré, ọmọ a fidí ṣepo* (the parrot, offspring of the one with red palm oil at the tail).

One other reason for the popularity of the parrot among the Yoruba is the bird's ability to imitate human speech and so to report to its owner whatever transpired in his or her absence. As a result, many Yoruba keep the bird in the house to play the role of a spy. Small wonder, the bird's motif recurs on the headdress of the Èfè (pls. 5, 15, fig. 5.6), identifying the mask as a watchdog or news reporter, and, by extension, as a symbol of the moral conscience of the community. Since antisocial elements dislike the bird for reporting what it has seen and heard, the gray parrot is popularly known as

Ayékòótó (the world does not like the truth).[19] The following verse from the Ifá divination verse (*Odù Ogbèsé*) sheds more light on the use of the parrot motif in Gèlèdé to admonish evildoers:

19. See also Abraham (1958:83).

Awọn ìbàjé-dẹwà Awo Òdìdè
Lí díá fún Odídẹrẹ
Ọmọ a fìdí sòwò èjè
Èyin a ṣe ìbàjé
[5] Ìbàjé kò dé ibìkan
Ìbàjé Òfé di ẹwà fún Odídẹrẹ

"Evil-turned-into-beauty is the secret of Òdìdè"
Thus declares the oracle to the gray parrot,
Offspring of the one with the menses.
All you evildoers,
[5] Evil does not pay.
The evil perpetrated by the Òfé bird, instead, brought beauty to the
 gray parrot.

(Babayẹmi and Adekọla 1987:132)

According to this verse, the gray parrot (also called *òdìdè* or *oòdè*) was once betrayed by a close relation, the evil-minded Òfé bird, who infected him with the leprosy virus. Noticing the changes on its body, the gray parrot consulted Òrúnmìlà, the oracular deity, who gave him a special medicine that arrested the disease, ironically transforming his body into a thing of beauty. The lesson of this fable is twofold: the evil men do lives after them, and God has a miraculous way of protecting the innocent and transforming trials into triumphs.[20]

20. For another version of this story see Bascom (1980:425-29).

Sometimes, the gray parrot on the Èfè headdress holds in its beak a palm fruit (pl. 15) from which the Yoruba extract the red palm oil for cooking, for making analgesic ointments, and for appeasing the gods (when offered as sacrifice). Because of its red color, the palm oil is, in certain ritual contexts, a metaphor for blood. It will be recalled that an *èfè* song, an *iwúre* from Ìmèkọ, eulogizes the *àjé* as "the famous one of the night, who has water in the house but uses palm oil for her laundry" (see translation, p. 129, line 39). This is a euphemism for the *àjé's* lust for human blood. The palm fruit (*ẹyìn*) in the beak of the parrot deepens this euphemism. Informants explained the significance as follows: one, it implores the *àjé* to drink red palm oil instead of human blood; two, it signifies the maxim: *Ìkòkò ti nṣe ẹyìn, ẹyìn ní nfọ́ ọ* (The pot used for processing palm fruits will eventu-

ally be broken by palm fruits), which is a warning to antisocial elements that "those who live by the sword shall die by the sword;" and, three, it identifies the gray parrot as one of the few birds with a beak strong enough to crack the hard nut of the palm fruit—just as the Èfè mask has the àṣẹ (divine authority) to admonish antisocial elements in public.

Figure 7.17 is another variation on the "watchdog" theme. Dominant motifs on this Èfè headdress are the ground hornbill (Àkàlà), a human figure (Ènìyàn), and fruit bats (Àdọ́n). Yoruba folklore portrays the ground hornbill as a carrier of messages and sacrifices. Hence the common saying: *Bí a ò r'ígún, a ò gbọdọ̀ ṣ'ẹbọ, bí a ò r'ákàlà, a ò gbọdọ̀ ṣ'orò.* (We should not offer sacrifices in the absence of the vulture; neither should we perform any ritual in the absence of the ground hornbill.)[21] The extraordinary vigilance of the hornbill is implied in the saying: *Bí òkú bá kú láyé, àkàlà á mọ̀ lọ́run.* (If there is any death on Earth, the ground hornbill will know in Heaven.)[22] The human figure below the hornbill echoes the same theme of vigilance. The figure, probably the Èfè masker himself, watches on as though from an observatory, making a mental note of the goings on in the community. Below the figure and surrounding it are fruit bats hanging upside down, recalling the Yoruba proverb: *Àdọ́n d'oríkodò, o nwòṣe ẹyẹ.* (The fruit bat hangs upside down, watching the birds.) This means that nothing is hidden in this world, because somebody is watching.[23] In effect, both the ground hornbill and fruit bat motifs have been used here to underscore the roles of the Èfè mask as a detective and as a mediator between the human and spirit worlds.

Animal Motifs

Although many animal motifs feature on headdresses, the most popular ones are the leopard (Ẹkùn), pig (Ẹlẹ́dẹ̀), warthog (Ìmàdò), snake (Ejò), porcupine (Oòrẹ̀), pangolin (Arika), tortoise (Alábahun), the jackal (Kòrikò or Ayóko), and the ram (Àgbò).

The leopard motif (figs. 7.13-7.15) identifies most Èfè headdresses, proclaiming the mask as the "king" during the night concert. According to an informant (Atapupa, interview, 1972), it would be a costly mistake for anyone to underrate the Èfè because the mask sings and jokes. In his view, the leopard motif signifies the proverb: *Yíyọ́ ẹkùn t'ojo kọ́; ẹni f'ojú d'ọba, àwó á wo.* (The cautious gait of the leopard is not an act of cowardice; whoever defies the king will be totally crushed.) In other words, the leopard motif signifies the divine authority of Ìyá Nlá, investing the Èfè with the preroga-

21. See also Abimbọla (1975:73).

22. See also Iko (n.d.:40).

23. See also Abraham (1958:15). According to some informants, the àjẹ́ sometimes turn into bats when holding their nocturnal meetings. This notion stems from the popular belief that an àjẹ́ whose soul has left the body usually sleeps while resting her legs on the wall (in an upside-down position)—reminiscent of a fruit bat hanging from the branch of a tree.

tive to speak the mind of the community and criticize anybody, however important (including the *ọba*), without any fear of personal reprisal. It is a warning to those individuals who might harbor ill feelings against the masker for daring to ridicule them in public. Instead of seeking revenge, such individuals must take the criticism in good faith and join the crowd in laughing away the matter. At times, a leopard is represented not devouring its prey, but just holding it in the mouth (fig. 7.15), as if displaying it for all to see, recalling the popular proverb—*Gbangba d'ẹkùn, kedere bẹ ẹ wò* (When the leopard is out, it will be visible to all)—often used to describe a matter that can no longer be kept from public knowledge, or the moment an evildoer is caught in the act and cannot escape.[24] It is like being cornered by a leopard, an animal portrayed in some Ifá divination verses as a terror to the *àjẹ* (Verger 1976-77:280-81). It will be recalled that Ajénifújà, the Èfè masker of Ìsàlẹ̀-Èkó, introduces himself as a leopard, whose sudden appearance mesmerizes even those who are carrying weapons (see p. 125, line 8). To further reinforce the image of the mask as a power superior, Èfè headdresses from Ìsàlẹ̀-Èkó (pl. 16) have attached to their round trays (*àtẹ*) carved miniature rhombs (the bull-roarers) representing Orò, a nocturnal spirit associated with the Ògbóni society and representing the collective power of departed ancestors. The Orò has the reputation of consuming condemned criminals without leaving a trace.[25] Incidentally, Orò is also believed to have the power to cure barrenness and prevent *Àbíkú* (see also Simpson 1980:53), which reinforces the view that Gẹ̀lẹ̀dẹ́ began as a fertility ritual.

In Ìmẹ̀kọ and Ìjió, the motifs of the parrot and the leopard appear together on the headdress of the Èfè (fig. 5.6, pl. 5), as if to emphasize the power of the mask against the forces of darkness (see also Fayọmi 1982: pls. 2, 3). What is particularly intriguing about many Èfè headdresses is that the motif of a crescent moon (*oṣù*) often appears above the face of the headdress (fig. 7.13).[26] According to some elders of the Gẹ̀lẹ̀dẹ́ society, this symbol indicates that the Èfè performs only in the night and that the moon (when it shines) enables everyone to see clearly and to enjoy the performance (Drewal and Drewal 1983:89). *Kedere* is the Yoruba word for the brightness of the moon, and this word also occurs in the proverb regarding the "visibility" of the leopard. Thus, the Èfè mask is like the moonlight that dissolves darkness to expose evil. Indeed, one of the Èfè in Ìsàlẹ̀-Èkó (Lagos) is called Abóṣùpálà, meaning "the-one-who-comes-with-the-moon." The following Ifá divination verse (*Odù Èjìogbè*), often cited by Yoruba elders to admonish evildoers, amplifies the message embodied by the crescent moon motif on the headdress of the Èfè:

24. See also Delanọ (1966:70).

25. Orò rhombs also appear on another Èfè mask from Ìsàlẹ̀-Èkó (Drewal and Drewal 1983:98, pl. 45). The mask in question is known locally as Ajénifújà (wealth begets luxury). A standard Orò rhomb produces an eerie sound when whirled on a string. It is used to impose a curfew, usually at night during special rituals, or when a criminal condemned to death by the Ògbóni court is being led away for execution.

26. For other examples, see Drewal and Drewal (1983: pls. 32, 38) and Celenko (1983: pl. 97).

Igbó biribiri
Òkùnkùn birimù birimù
Ẹni ó bá mòṣe òkùnkùn
K'ó mọ́ mọ̀ d'óṣùpá lóró
[5] Ohún ṣeni à á rìnru
Òkùnkùn kò yẹ ọmọ ẹèyàn

.

Ìkà, ro rere
Ohun tí ọgẹ̀dẹ̀ ṣe f'ágbẹ̀ l'ó pọ̀
Ro rere
[10] Ìkà, ro rere

Impenetrable Forest.
Pitch black darkness.
Those who operate in darkness
Should not attempt to hurt the moon.
[5] Why should one walk in the dark?
Shady business does not speak well of a person.

.

The wicked ones, please cultivate good thoughts.
The banana plant always brings profit to the farmer.
Cultivate good thoughts.
[10] The wicked ones, please cultivate good thoughts.

(Abimbọla 1977a: 8-9. My translation)

Although, among the Yoruba, the crescent moon motif generally indicates "newness" and hence, regeneration (implied in the saying: *Lọ́tun, lọ́tun là á b'óṣù*, meaning "the new moon is forever rejuvenated"), the women associate it with the menses (literally, *nkan oṣù*, "sign of the moon"), because they use the waxing and waning of the moon as a calendar for the menstrual cycle (G. J. A. Ojo 1966:174).[27] This probably explains not only the Yoruba belief that Yemọja controls the cycle and uses the crescent moon to renew it, but also the recurrence of the crescent moon as a motif in the arts of Gẹ̀lẹ̀dẹ́ and Ògbóni (Celenko 1983: pls. 92, 97), given the association of both societies with Mother Nature and their concern with fecundity and the perpetuation of life on Earth.

The frequency of the snake motif (*ejò*) on Gẹ̀lẹ̀dẹ́ headdresses underscores its importance in Yoruba thought (figs. 7.35, 7.47, 7.49-7.54, pl. 20). Although the Yoruba fear the snake because of its poisonous bite, they value

27. The popular Yoruba name, Alébíọṣù (as distinct as the new moon), alludes both to the prominence of the new moon and to its regenerative power. For more details, see Lawal (1995:47).

its fast spiral movement and its ability to shed an old skin to reveal a new one, both suggesting dynamism and renewal. Moreover, the fact that many snakes live in holes and some in the water hints at otherworldly connections, so that the Yoruba regard them not only as mediators between the physical and spiritual realms but also as embodiments of supernatural forces. There is a general belief that snakes rarely attack unless provoked. Thus most snakebites are interpreted as a manifestation of witchcraft or retributive justice. Some Yoruba keep snakes in shrines or dedicate them to various deities with a view to reducing the incidence of snakebites in the community and harnessing the snake's dynamic and regenerative power for spiritual well-being. Most of the snake motifs on Gèlèdé headdresses function in this context. The arched python motif (pl. 18, fig. 7.47) is very popular on Gèlèdé headdresses because it signifies Òṣùmàrè, the rainbow deity, associated with fertility, regeneration, and prosperity (Idowu 1962:34-36). Although the divination verse (Odù Ìrosùn) compares the rainbow's momentary appearance in the sky to "an abiku who dies soon after he is born" (Bascom 1980:52), its rich colors and high visibility symbolize stardom and fame. Hence, the rainbow deity is much patronized by celebrities.[28] Incidentally, some Yoruba not only identify the deity as an òrìṣà olómowéwé but they liken its colored arc to an òjá, the baby sash (Adeoye 1989:376, 378; Bascom 1980:385), which, as we have seen, lends color and ritual efficacy to the Gèlèdé costume and spectacle.[29]

One of the most recurrent themes on Gèlèdé headdresses is that of two fighting animals (fig. 7.52). Many informants identified this motif as either ìjàkadì (combat) or àjàngbilà (fight to the end). In one example, what looks like the poisonous stink rat (Asínrín) bites the body of a snake, while the latter strikes back (H. Drewal 1974b: pl. 11). Sometimes, a bird fights a snake or carries it in its beak (figs. 7.16, 7.50a, 7.51). On one headdress, a snake seizes a crocodile, which in turn attacks another snake. According to art historian Rudolf Wittkower, the bird-and-snake motif has been inspired by real-life observations of struggles between the two creatures: "The most powerful bird [the eagle] was fighting the most dangerous of reptiles. The greatness of the combat gave this event an almost cosmic significance" (1977:16). Jacques Bernolles has suggested that the occurrence of the bird and snake motif on Gèlèdé might indicate a relationship of some sort with similar representation in ancient India, arguing that it represents the struggle between the elements of the sky (bird) and the earth (snake/serpent) (1973:26, 32). This hypothesis is weakened by the fact that many Gèlèdé headdresses depict two terrestrial animals in a similar struggle. Henry and

28. Fame (okìkí) is implicated in the popular Yoruba phrase: olókìkí bi Òṣùmàrè (as famous as the rainbow).

29. In some incantations, the snake is described as Akáwéréké-má-ṣèé; Anàgbàlàjà-má-kákò; òjá f'orí pitú (the unbreakable coil; the unbendable one; the "baby sash" with a phenomenal head.) See Fabunmi (1972:71).

Margaret Drewal, on the other hand, suggest that this theme may very well symbolize the competing forces in the Yoruba cosmos. This is more likely, though the Drewals do not elaborate. When I showed photographs of the theme to informants in the field, however, a majority interpreted it as a visual metaphor for *èsò* (carefulness) or *pèlépèlé* (caution). I did not grasp the full import until a Kétu elder related the theme to a popular Yoruba proverb: *Adìe bà l'ókun. Àra kò ro okùn. Àra kò ro adìe.* (A fowl perches on a rope. The rope feels uneasy;[30] the fowl also feels uneasy.) Describing a tense situation, a strained relationship, or a mutually destructive encounter between two stubborn parties, this proverb is often used by the Yoruba to plead for caution in a risky venture, as the outcome is unpredictable. With this proverb in mind, the theme of fighting creatures becomes more meaningful. As the two creatures are rendered in such a way that it is difficult to predict which will survive the combat, this theme seems to warn of the dangers of violence in human society and appeals for a peaceful solution to all problems. For life is so delicate.

The bird-and-snake motif occurs on other Yoruba art forms as well, especially on Epa headdresses (fig. 7.50b) and on figurated Ifá divination cups (Fagg and Pemberton 1982: pl. 63). But no consensus exists as to its meaning in these non-Gèlèdé contexts. While some informants (in Òyó, Èkitì, and Ìgbómìnà areas) identify the motif as a metaphor for potential crisis or trouble (*ìjògbòn, ìsòro*), which could be averted through prudence, divination, and rituals, others perceive it as a carver's record of a natural event with no more than a decorative function.

Certain individuals resort to the use of force because they think that they can overpower their supposedly weaker opponent. It often turns out in the end, however, that the aggressor has miscalculated and is overwhelmed by the concealed and lethal power of the seemingly defenseless opponent. The dangers inherent in arrogance, tyranny, wickedness, foolhardiness, or social injustice are exemplified by the motif of a snake attempting to swallow a porcupine or tortoise (pl. 21, figs. 7.53, 7.54), whose sharp quills or hard shell will in the long run destroy the predator.[31] Hence, the popular warning: *Kíkéré l'abéré kéré, kì í se mímì f'ádìe.* (Small as a needle may be, a fowl must not swallow it.)

Asked for the meaning of the snake-and-tortoise motif in figure 7.53, elders of the Gèlèdé society sang different versions of the following song:

30. The Yoruba sometimes refer to the snake as *okùn ilè* (literally, "earth-rope").

31. The quills in figure 7.54 have been removed; but the same headdress is illustrated in Drewal and Drewal (1983:136) with the quills still in place. A similar mask, formerly in the Paul and Ruth Tishman Collection, has had its quills removed (Drewal 1981: pl. 62).

Ikú ló nwá
Ikú ló nwá
Erè tí ó gbé alábahun mì
Ikú ló nwá

It is inviting death,
It is inviting death,
The python that swallows a tortoise,
It is inviting death.[32]

It will be recalled that the Èfè mask of Ìjió, when admonishing the àjẹ́, likened himself to a piece of wood that cannot be eaten by a snail, a bunch of ẹ̀kùnkùn leaves that cannot be eaten by a monkey, a piece of rag that cannot be chewed by the vagina, and the knot of a tree that cannot be crushed by a leper's hand (chap. 5, p. 117, lines 23-26). Defying these injunctions may lead to catastrophe. At any rate, the Èfè's admonition echoes *Odù Ìdì Méjì*, the Ifá divination verse on the pact limiting the powers of the *àjẹ́* (see chap. 2, p. 31), which says that Èṣu and Ọrúnmìlà forced the *àjẹ́* to agree that nobody eats a tortoise with the shell, a ram along with the horns, a porcupine along with the spines, nor a fowl along with the feathers. Thus the representation on Gẹ̀lẹ̀dẹ́ headdresses of pythons attempting to swallow a tortoise or porcupine (or of birds attempting to swallow a scorpion) says much more than meets the eye. It extends a covert warning to predators, oppressors, and intimidators to beware of retributive justice. The porcupine, in particular, cautions against misadventure; hence the aphorism: *Ìpẹ́ òòrẹ kì í jẹ́ ká tẹ òòrẹ mọ́lẹ̀. Kakaka ní í ta ni bí i ọfà àmújà.* (The porcupine's spine warns everyone not to step on the porcupine. It stings violently like a warrior's arrow.)

The pangolin motif (Arika) is popular on Gẹ̀lẹ̀dẹ́ headdresses (figs. 7.1, 7.20) for three main reasons. first, it is an important ingredient in herbal preparations (*oògùn arẹmọ*) for curing barrenness and preventing *Àbíkú*. Second, the pangolin, on sensing danger, coils into a hard ball with the scaly body shielding its most vulnerable parts—the head and soft belly. This protective attribute makes the animal an active ingredient in charms used for immunizing the body against gunshots, sharp weapons, and witchcraft. Third, because the pangolin curls up immediately when confronted—an instinct sometimes equated with shyness (*ìtìjú*)—parts of the animal, especially the scales, could be added to charms worn on the body to instill respectfulness in others, gain the favor of the *àjẹ́*, or mesmerize opponents

32. Kacke Gotrick (1984:89-90) has documented a similar song—daring the python to swallow a tortoise—among the Apidán, a subcategory of Egúngún masks that specializes in satire, using human, animal, and mythological characters for entertainment and didactic purposes. According to one Apidán masker, the encounter between the two creatures is intended to show that neither can harm the other (ibid.). But when the python succeeds in swallowing the tortoise, it chokes to death—a lesson on imprudence (ibid.: 90; citing Adedeji 1969).

into diffident submission. An incantation usually accompanies such charms. In the following example, the gloss of the pangolin skin is required to elicit magically admiration in the beholder and so deter or neutralize potential hostility:

Ìpé arika kì í jé kí a rí arika ká rojú.
Kí arika ká wọn lẹ́nu kò!

The pangolin's scales will not allow anyone to frown at the pangolin.
Like the pangolin, let everyone's mouth "curl" into silence![33]

33. I am grateful to Lamidi Fakẹyẹ for bringing this incantation to my attention.

Pigs (Ẹlẹ́dẹ̀) and warthogs (Ìmàdò) are often portrayed in Yoruba proverbs and folklore as dirty, crude, destructive, rapacious, and uncivilized. One of the proverbs runs thus:

Ìmàdò ìbá ṣe bí ẹlẹ́dẹ̀, a bà ìlú jẹ́;
Ẹrú ìbá j'ọba, ènìyàn ìbá tí kù kọn.

If the warthog were to behave like the pig, it would destroy the town;
If a servant were to become king, he would not spare the soul of a
 single free-born.[34]

34. See also Lindfors and Owomoyela (1973:8). Although the warthog is portrayed in this proverb as more refined than the pig, the two have similar characteristics.

The depiction of these animals on Gèlèdé headdresses therefore reflects, among others things, the Yoruba resentment toward those people of low birth who abuse the positions of authority in which they may unexpectedly find themselves.

The jackal/hyena mask (Ayóko/Kòrikò) appears only at dawn to signal the end of the èfè ceremony. Two explanations have been offered for this. One is that the hyena is a scavenger that eats up everything; hence its appellation: Kòrikò, ajegun jẹran; ajẹran japó. (The hyena, eater of flesh and bones; eater of flesh and all the entrails.)[35] It always shows up to clear the remnants of what a big killer like the leopard has left behind. That is why the animal is associated with the last part of anything. The other explanation is that the appearance of the hyena is symbolic of a successful èfè concert: the jokes cracked by the Èfè mask have been such that even the laughing hyena has come out of the forest to join the audience! It signifies the most appropriate point at which to stop the concert; for a good performance must end at the right time. Hence, the popular saying: Kiun l'ọbẹ̀ oge, which means, "A delicious soup must be just enough."[36]

35. See also Gbadamọsi (1964:45).

36. One Yoruba proverb (Delanọ 1966:71) portrays the hyena as a symbol of gratitude, for he once burst into tears on being told of his appointment as the aṣípa (secretary of all animals). None of my informants, however, linked the representation of the hyena in Gèlèdé to this proverb.

Although the ram motif (fig. 7.58) in Yoruba art usually alludes to Ṣàngó, the thunder deity, to whom the animal is sacred, according to Aṣimi Ọlatunji-Onígèlèdé of Ìmèkọ, its representation on Gèlèdé headdresses also signifies strength, bravery, virility, and dynamism—virtues desired by all people, especially men aspiring to public office. In addition, it recalls one of the limitations placed on the powers of the àjé, i.e., that nobody eats a ram along with the horns. One noticeable aspect of the animal motifs in Gèlèdé is an emphasis on the wild species—leopards, snakes, buffalos, warthogs, hyenas, and female gorillas—all of which are linked with some mystical forces in the forest. Yoruba hunters' tales abound with strange happenings in the deep forest when wild animals become immune to bullets, change into demons, or suddenly render themselves invisible only to deal lethal blows on the bewildered hunter from behind (see also G. J. A. Ojo 1966:168).[37] Only seasoned hunters with powerful medicine should therefore venture into certain forests. In any case, by representing these animals on Gèlèdé headdresses as instruments of moral enlightenment, the Gèlèdé society attempts in part to domesticate the wild so as to make safer all parts of the living world.

37. These hunters' tales have become the subject of several novels by Fagunwa, the famous Yoruba writer (1938; 1949; 1954).

Plant Motifs

Carved representations of plants are few, as real twigs are frequently attached to headdresses if needed to supplement a particular theme.[38] Of the few plants depicted (such as the palm tree, the cocoa tree, and the cactus), the most popular is the banana (ògèdè) (fig. 7.55).[39] As noted earlier, the first Gèlèdé costumes were reportedly made from banana leaves. Moreover, masks like the Ẹfòn (buffalo) of Ìbarà, Gbogbolàkìtàn (refuse collector) of Ìlaró, and Ògbàgbá (the herald) of Kétu still use the same material. The banana plant (especially the plantain) embodies the idea of fecundity apparently because it has a soft stem, stalk, and leaf, and because it grows in clusters and its fruits are in bunches. Its high power of regeneration is implied in the common saying: B'ọ́gèdè bá kú, a f'ọmọ rè ró'pò. (The banana is always survived by offspring.) Those that grow in swamps and marshy areas are held to be particularly fertile: hence the popular saying: Ògèdè kì í gbé'tí odò kó y'àgàn (The banana plant by the riverside is never barren.) Because a typical banana cluster has a mixture of dead and new leaves as well as old and young plants, a Yoruba riddle portrays the plant as: Ìyá ràbàtà, ojojúmọ́ ló n jí ṣ'òwò àkísà. (The fat woman who always deals in rags.)[40] The "rags" here refer to the baby's diapers found in the room of a nursing

38. William Bascom once had in his collection a mask with a palm tree and with holes for real palm fronds. I am grateful to Roy Sieber for this information.

39. For other examples, see Drewal and Drewal (1983: pls. 144, 145).

40. See also Abraham (1958:332).

mother. Because her fruits grow in bunches, she is, like Ìyá Nlá, a mother of small children (ìyá ọlọ́mọwẹ́wẹ̀).

The curious thing about the banana is that it leads an ephemeral life. It dies shortly after producing fruits, although a young sucker grows to replace the mother. To ensure this survival process, the plant initially develops many suckers, but only a few of them grow into maturity. At any rate, the ephemeral life of the banana reminds the Yoruba of the cycle of deaths and rebirths associated with the spirit children (Àbíkú or Ará'gbó). Hence, banana suckers constitute an important part of the ritual aimed at stopping infant mortality. Moreover, many Yoruba view the banana grove as a rendezvous of the àjẹ́, whose placation is necessary if the Àbíkú ritual is to succeed. I once witnessed a ritual, called ẹbọ ayẹpínùn (redemptory sacrifice), for an Àbíkú child at Ìdíróko, near Ọ̀tà: the stem of a young banana plant was buried as a substitute for the body of the child, to break the covenant between it and its heavenly companions.[41] Thus, these notions about the banana clearly show that its depiction on Gẹ̀lẹ̀dẹ́ headdresses is a metaphor for fecundity, regeneration, and deliverance.

Man-made Objects

Since the headdress mirrors all aspects of Yoruba life, the subjects represented range from household utensils such as mats, plates, pots, lanterns, baskets, and mortars to knives, weapons, and musical instruments. Since the turn of the century, elements of modern technology have been included to reflect the dynamics of change. One man-made object that recurs on many male headdresses (especially those used by the Ẹ̀fẹ̀) is the sheathed matchet or knife (figs. 7.13, 7.15, 7.16). In ordinary situations, the iron cutlass (àdá) is a male symbol; hence the saying: Ọkùnrin l'àdá. (The matchet is masculine.) But most importantly, it is the sacred symbol of Ògún.

The contribution of iron to the development of human civilization is evident in one Yoruba myth: when the òrìṣà first arrived on the Earth, the primeval jungle was so thick as to be impenetrable, but Ògún used his iron cutlass to cut a path through it (Idowu 1962:85-86).[42] In short, Ògún's iron has enabled humanity to transform the surface of the Earth from a primeval jungle into what it is today: a comfortable environment and an ordered society where the individual is subject to a set of values without which a given community cannot hold together. Despite the fact that Ògún, as portrayed in myths, is fierce, restless, and belligerent, he hates liars, traitors, thieves, and all those who break the ethical code. To swear falsely on an iron imple-

41. For more information on substitutionary rituals, see Idowu (1962:123-24); Awolalu (1979:158-59).

42. It would appear that Ògún (iron deity) was once associated with the polished stone ax before the Yoruba acquired the knowledge of iron-working; for stone axes constitute the most sacred symbol in some shrines dedicated to the deity. Although the polished stone ax is now commonly linked with Ṣàngó (who hurls it down from the sky during thunderstorms), the thunder deity depends on Ògún for its production. Little wonder, tradition requires the inhabitants of a house struck by lightning to seek refuge in a blacksmith's workshop. See Johnson (1921:35); Williams (1973:140).

ment is to incur the wrath of Ògún. Thus Ògún is not only a symbol of industry and invention but also a guardian of human morality, on which depend social stability and progress. To this end, the matchet motif combines with those of the leopard and parrot on the Èfè headdress to proclaim the Gèlèdé crusade for a just and humane society, in which every individual will have the opportunity to develop his or her potential without the excruciating fear of witchcraft and other antisocial practices. Even aspects of modern technology—as we shall see in the next chapter—are utilized in this crusade.

Human Motifs

Most of the human motifs are explicit in their actions. For instance, the Christian and Islamic clerics in figures 7.39 and 7.40 are praying for the social and spiritual well-being of the community. A common theme in Yoruba art, the nursing mother (fig. 7.44) is an appeal to all the deities in general and to Mother Nature in particular to provide humanity with all the necessities of life. This theme recalls the popular slogan: *Ọmú ìyá dùn u mu* (mother's breast-milk is sweet), used by the Ògbóni when paying homage to Mother Earth. At this point, the frequency of the "mating couple" in Gèlèdé takes on a new meaning (fig. 7.42). While it may be read, at one level, as a lampoon against sexual promiscuity, the motif, at a much deeper level, reflects the Gèlèdé concern for a fruitful union of the male and the female. To the Yoruba, sexual impotence and barrenness not only generate social tension, they threaten the very existence of any community. It is not enough, however, for a community to be able to reproduce itself; its survival also depends on how well it is able to harness its human and natural resources. The representation of the major occupations on Gèlèdé headdresses, therefore, means much more than acknowledging their contributions to the life of the community. It inspires respect for the dignity of labor, as well. For hard work is the only insurance against hunger. Placating the *àjé* alone is not enough to guarantee all the good things of life. An individual must work hard: *Òrìsà tí ngbe ọlẹ kò sí. Nitorí apá ẹni ni í gbe ni.* (No *òrìsà* supports a lazy person. Your hand is your greatest supporter.)[43]

43. Delanọ (1966:30).

Although the Yoruba believe that the fate of each individual is predetermined in heaven, and that one is born into the physical world with either a good or bad destiny, nonetheless success or failure in life depends for the most part on how well one makes use of one's head and talents (Lawal 1985:101). Hence the popular saying: *Isẹ ni oògùn isẹ.* (Hard work is the

44. See also Lindfors and Owomoyela (1973:51).

medicine for poverty.)[44] To be indolent and irresponsible is to invite failure that soon turns into a malady. This malady not only brings distress and shame to oneself and one's family but often tempts an individual to engage in antisocial behaviors that could mitigate against the well-being of the community. It goes without saying, therefore, that the ultimate goal of the Gèlèdé society is to produce an ideal character, or what the Yoruba call *omolúwàbí:* a hard-working, well-behaved, modest, honest, respectful, and godly person who is always considerate in his or her dealings with others.[45]

45. On the concept of *Omolúwàbí*, see Abimbola (1975b:389-420); Awoniyi (1975: 357-84); and Adeoye (1979:77-78).

In summary, there is no doubt that the Gèlèdé headdress along with the costume is visual art and poetry rolled into one, sometimes harmonizing with the drum texts and audience participation to maximize the impact of the Gèlèdé spectacle. This interrelationship of the visual, verbal, and the musical is eloquently expressed in headdresses depicting drummers or musical instruments (figs. 7.24, 7.25, pl. 19). The headdress is to the costume what the head (*orí*) is to the human body. It is an index of identification and the essence of the masker's personality as long as he is inside the mask. In spite of the comical representations that often appear on the headdress, the face below the superstructure remains serene, as if stressing the paradox that is life—and the need to live life with special care.

Ojú Inú

Critical Perspectives on Gẹ̀lẹ̀dẹ́

The Yoruba term *ojú inú* (the inner eye), as mentioned earlier, refers to the analytical attitude that enables an individual to go beyond surface appearance to the essence of a given subject. As Rowland Abíọdun has aptly put it, *ojú inú* connotes "a special kind of understanding of a person, thing or situation, and is not usually derived from a common source" (1990:75). In other words, it is an insight gained from both deductive and inductive reasoning. The quality of one's *ojú inú* depends on knowledge (*ìmọ̀*), intellect (*òye*), experience (*ìrírí*), wisdom (*ọgbọ́n*), and power of reasoning (*làákàyè*). The very existence of these terms in the language shows that the Yoruba are aware that any subject or event is open to critical analysis with a view to revealing concealed meanings or truths. Needless to say, the acceptability of any analysis depends, to a large extent, on the degree of its probability. In this chapter, I will use *ojú inú* to examine the nature of Gẹ̀lẹ̀dẹ́ in an attempt to shed more light on its significance.

From Àbíkú to Àbíyè: Gẹ̀lẹ̀dẹ́ and Spirit Children

Reacting to my 1978 article that first drew attention to a possible connection between Gẹ̀lẹ̀dẹ́ and spirit children (Lawal 1978), Henry and Margaret Drewal reported that none of the Gẹ̀lẹ̀dẹ́ participants they subsequently interviewed confirmed the relationship (1983:271n. 7). It should be mentioned, however, that informants interviewed by Ibitokun (1981:55-56, 63n. 3) linked Gẹ̀lẹ̀dẹ́ with Àbíkú and fertility rites. Unfortunately, the Drewals were not aware of Ibitokun's article when they wrote their book. In any case, given the symbolic nuances involved and the fact that the Gẹ̀lẹ̀dẹ́ tradition has over the years undergone several modifications to reflect local concerns and conditions, not all informants will perceive its origin and ramifications in the same way. Moreover, in a culture such as that of the Yoruba, where knowledge has both esoteric and exoteric levels, a researcher must look beyond popular or "official" explanations for independent evidence, either to confirm widely held views or to point up unanswered questions. It is this "looking beyond" that the Yoruba call *ojú inú,* as it yields data not commonly perceived. Second, the framing of a question determines the responses

of an informant. For example, asking informants whether Gèlèdé is related to spirit children will automatically draw a negative answer because of the popular association of spirit children with Àbíkú (born to die), whereas the goal of Gèlèdé is Àbíyè (born to live). Yet, and without having the negative image of Àbíkú in mind, scores of "participants" trace the origin of Gèlèdé to dances associated with òrìsà olómowéwé. Henry and Margaret Drewal, as will be demonstrated below, also collected several data, both oral and visual, relating Gèlèdé to twins and òrìsà olómowéwé. The point is that òrìsà olómowéwé is a complex of several deities—including Egbé, Ewúrù, Ìbejì (twins), Ìbeta (triplets), Ará'gbó, Egbé Ògbà (heavenly/spirit companions), Eyinni, Olókun, Koórì, Kónkóto, Dàda, Òrìsà Olómitútù (water deities), and Olómoyoyo. All these deities are associated with Ìyá Nlá, who (as Yemoja or Yewajobí) is popularly known as Ìya Olómo Wéwé, that is "The Great Mother of Small Children" (Adeoye 1989:226).[1] A close examination of Gèlèdé iconography and performance reveals the following correspondences with spirit children, especially twins:

1. The story in the Ifá divination verse (Odù Ìwòrì Méjì) stating that Yewajobí put metal anklets on the legs of the eponymous Èfè and Gèlèdé immediately identifies them as spirit children. The metal anklet (aro) worn by spirit children is a smaller version of Gèlèdé's. Moreover, anklets as big as Gèlèdé's constitute the principal symbol on many shrines dedicated to òrìsà olómowéwé (figs. 3.3, 3.4).

2. The testimony of Ìyá Yemoja of Ìbarà that Gèlèdé are spirit children to Yemoja corroborates the account given in the above-mentioned divination verse (Odù Ìwòrì Méjì).

3. Both Gèlèdé and spirit children are associated with music and the dance.

4. Gèlèdé masks usually dance in identical pairs. In Pobe (Republic of Benin), a dancer explained to the Drewals, "It is because women give birth to twins as children. That is why there are two masks" (Drewal and Drewal 1983:134).

5. As already noted, both Kétu and Ìlóbí traditions link Gèlèdé to a succession dispute between twin brothers. In Ìlóbí, it is associated with Àbíkú and twins (Ibitokun 1993:32-34).

6. There are numerous allusions to twins in Gèlèdé. For example: (a) In the village of Owo, north of Badagry, and in other places near the Nigeria/Republic of Benin border, William Fagg observed in the 1950s several wooden puppets associated with Gèlèdé and said to represent "a man, Aíbo, and a woman, Taiwo" (Fagg and Pemberton 1982:17). Àíbo is another name for Kéhìndé, the last born (and yet the senior) of twins (Abimbola

1. It should be pointed out, however, that Òsun (the deity of the Òsun River) shares this attribute with Yemoja. It suffices to say that the òrìsà olómowéwé complex also includes river goddesses and other deities associated with fertility.

1982:89). The name *Taiwo* (or *Táyé*) identifies the first born of twins; (b) Some female masks have their wooden breasts or breastplates carved in the form of twin statuettes (H. Drewal 1974b: pl. 2; Kerchache 1973:24); and (c) Among the Ọ̀họ̀rí, there are special Gẹ̀lẹ̀dẹ́ headdresses called Àgàṣa Ìbejì which have two faces representing twins.[2] Similar double-faced masks (but without vertical projections like the Ọ̀họ̀rí type) abound in several Ẹ̀gbádò towns and are identified with twins (Herold 1967: pl. 27). At Ìbóòrò, such masks are associated with Eyinni, the local goddess of twins, in whose honor the annual Gẹ̀lẹ̀dẹ́ festival is celebrated.

2. For illustration, see Drewal and Drewal (1983: pl. 43).

7. For some obscure reasons (which seem to go beyond the popular belief that twins love dancing), mothers of twins (*awọn ìyá ìbejì*) are the chief celebrants during the annual Gẹ̀lẹ̀dẹ́ festival in many towns, and both mothers of twins and Gẹ̀lẹ̀dẹ́ masks dance together in the marketplace.[3] In one example from Ìlaró, a woman carrying a tray containing twin statuettes dances along with a Gẹ̀lẹ̀dẹ́ mask (Drewal and Drewal 1983: pl. 160). In the same town, not only do some informants assert that "Twins and Gẹ̀lẹ̀dẹ́. . . [are] the same" (ibid.:252), but certain families hold the annual rites for twins as part of the Gẹ̀lẹ̀dẹ́ festival (ibid.:250-52). Figure 8.1 shows a mother of twins from Igbóbì-Ṣábẹ̀ẹ́ who sponsored a Gẹ̀lẹ̀dẹ́ ceremony in honor of her children. It is interesting to note that the two principal Gẹ̀lẹ̀dẹ́ societies in Lagos Island have connections with twins. The first, based in Ìsàlẹ̀-Èkó, was introduced from Kétu between the late eighteenth and early nineteenth centuries by the Oníl̀ẹgbál̀ẹ family, whose name is popularly associated with twins (see also Taiwo 1980:104; Sọwande and Ajanaku 1969:50; Babalọla 1966:107). The second, based in the Tinúubú-Ọ̀ńọ́là area of Lagos, was introduced from Ìlaró about the mid-nineteenth century by Taiwo Olowo (a.k.a. Daniel Conrad Taiwo).

3. See also ibid.:229-30.

8. Opinion is divided as to the real identity of the two principal masks, Èfẹ̀ and Tètèdé, who perform on the eve of the annual Gẹ̀lẹ̀dẹ́ festival. While some informants hold that Tètèdé is the wife of Èfẹ̀ (Harper 1970:81), others regard the same mask as Èfẹ̀'s twin sister, the name Tètèdé meaning "the early comer). According to Ibitokun, an indigene of Kétu (1993:99n. 16):

> Tètèdé in Kétu dialect means Táyé [Táíwò], the first of a twin to be born who comes to taste the world first and report back to its other brother or sister still in the womb. Kẹ́hìndé, he-who-comes-last, is the second child to be born. Tètèdé is Táyé, Èfẹ̀ is Kẹ́hìndé.

Èfẹ̀ and Tètèdé represent the male and female aspects of Gẹ̀lẹ̀dẹ́, respectively. As the senior, Èfẹ̀ is the spokesman; hence, the mask sings and

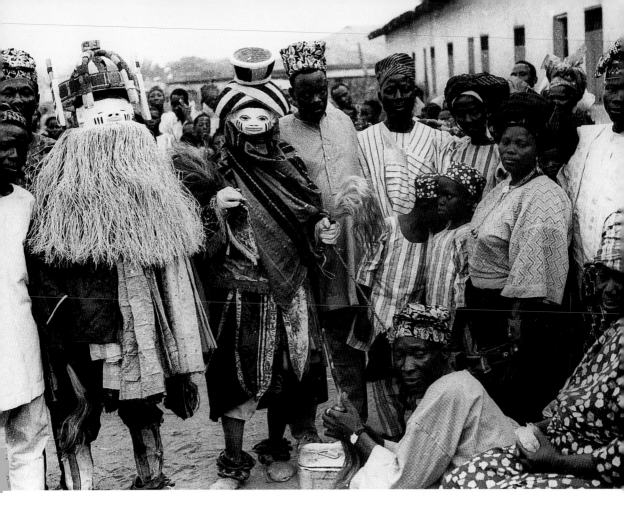

8.1 A mother of twins who sponsored a Gẹ̀lẹ̀dẹ́ ceremony in honor of her twin boys and deceased parents. The twins wear identical dress, which instantly identifies them in public. Igbóbì-Ṣábẹ̀ẹ́ (1972).

comments on current affairs during the nocturnal èfè ceremony. Being the junior, Tètèdè is not all that vocal; she symbolizes the dance which is emphasized by the diurnal masks. The association of the *voice* with the senior and the *dance* with the junior in Gẹ̀lẹ̀dẹ́ has a parallel in the Yoruba conception of twins:

Taiyelolu loni'jo o
Omokẹhinde l'awoko.

Taiyelolu [the junior] is the dancer,
Omokẹhinde [the senior] is the singer.

(Taiwo 1980:108)

Although the Ifá divination verse (*Odù Ìwòrì Méjì*) does not identify them specifically as twins, nevertheless Èfè and Gẹ̀lẹ̀dẹ́ are characterized in the

same way; the one being the senior and the singer, the other the junior and the dancer.

9. In Kétu, certain songs pertaining to the origin of Gèlèdé suggest that it is closely related to Egúngún. In one song by the Tètèdé mask, Gèlèdé is identified as one of the three children of the same mother; the first inherited the "cloth" and became Egúngún; the second got "the bloody blouse" and became the *àjé;* the third got the voice and the dance and became Gèlèdé (Beier 1958:10).[4] In another song that traces the origin of Gèlèdé to Ìlóbí, the Èfè mask identifies himself as "atokun, the child of Oje/Egúngún" (Drewal and Drewal 1983:227-28). Both songs tend to relate Gèlèdé to triplets, who also belong in the spirit children category. The first two of triplets bear the same names as twins; the last one is known as Eta-Òko. If female, the last child (sometimes called Ató) is usually initiated into the Egúngún Society. Moreover, Egúngún is regarded as one of the principal guardians of twins/triplets because "he" was a father of twins (Abimbola 1982:77).[5] The thrust of the songs is that Gèlèdé has both spirit children and *àjé* connections. This recalls a myth collected by William Bascom stating that Gèlèdé herself was an *àjé* (Bascom 1969a:95).

10. The first Gèlèdé costume is reported to have been made from banana leaves; and even to this day, important masks such as Gbogbolàkìtàn (refuse carrier) of Ìlaró, Efòn (buffalo) of Ìbarà, and Ògbàgbá of Kétu have banana leaves in their costumes. As already mentioned, like Ìyá Nlá, the banana plant is a symbol of fertility and regeneration. The plant is also associated with *Àbíkú* because of its ephemeral life.

11. The wood of the *ìrókò* tree (*Chlorophora excelsa*) is regarded in some Gèlèdé communities as the most appropriate material for carving the Great Mother headdress called Ìyá, the most sacred in the Gèlèdé corpus. The base of the *ìrókò* tree is believed to be a rendezvous for spirit children and the *àjé*.[6]

12. During the *èfè* ceremony in Ìmèko, the chorus singers assure the Èfè mask of the support of spirit children:

Ará Igbó wà líhìn e
Ará Igbó wà líhìn e
Asòrò-bí-enikàwé.

Forest beings [spirit children] are behind you,
Forest beings [spirit children] are behind you,
You, who speak like a man-of-the-books.

 (Fayomi 1982:94. My translation)

4. The term Gèlèdé in this context refers to Èfè (the singer) and Gèlèdé (the dancer).

5. Another principal guardian of twins is Sàngó, the deity of lightning and thunder.

6. See also Yerkovich (1973:96-97).

And at Ìjió, the Ẹ̀fẹ̀ mask declares:

Mo d'ọmọ kékeré
Èṣù lẹ́hìn mi.

I have become a small child
Èṣù follows me.

(Harper 1970:86. My translation)

Although it sometimes refers to a thorn in one's flesh, the phrase "Èṣù follows me" is a metaphor for the Yoruba belief that twins enjoy the protection of Èṣù, and to ill-treat them is to incur the wrath of the divine messenger. A male or female child born immediately after twins is called *Ìdòwú*. And because a typical Ìdòwú is very aggressive and always taking sides with twins, the Yoruba regard him or her as Èṣù incarnate. Hence, Ìdòwú's appellation: *Èṣù lẹ́hìn Ìbejì* (the Èṣù that follows twins) (Ṣowande and Ajanaku 1969:52-53).

13. As we have seen, some Ẹ̀fẹ̀ masks openly challenge the *àjẹ́* in their opening incantations, which reminds us of the popular Yoruba belief that the *àjẹ́* would dare not harm the Ará'gbó, most especially twins:

Àjẹ́ ó ti ṣ'Èjìrẹ́, Mobọ́lanlé?
What can a witch do to the honored twins?

(Ọlayemi 1971:20-21)

7. This verse is also featured in the praise poems of the *àjẹ́*.

T'óṣó, t'àjẹ́ nforíbalẹ̀ fún èjìrẹ́; afínjú àdàbà tí njẹ l'áwùjọ àṣá.[7]
Both wizards and the *àjẹ́* honor twins; the famous doves who dine in the company of kites.

(Daramọla and Jeje 1967:283. My translation)

Indeed, twins themselves are believed to possess some mystical powers:

Táyélolú ṣ'àjẹ́ kò sé; Kẹhìndé ṣ'àjẹ́ gbàrà a.
Táyélolú practices his own "witchcraft" openly; so does Kẹhìndé.[8]

(Ibid. My translation)

8. This derives from the belief that parents who do not pamper their twins will not only lose them but will also incur their wrath, which may lead to terrible consequences.

The belief that twins are powerful in their own right and immune from the *àjẹ́* would seem to have been harnessed as a subtle defense mechanism in Gèlèdé iconography (fig. 7.20), especially in the synchronized dance of

paired, identically costumed masks (pl. 7a,b, figs. 5.13, 5.14a,b, 8.3, 8.4). It probably explains the confidence behind the statement by one Gèlèdé masker that "the witches cannot harm anybody inside the [Gèlèdé] society" (Beier 1958:6), for there is a popular notion that any àjé who kills twins will not only lose her power but will die an ignominious death (see also Abimbola 1982:77).

According to Henry and Margaret Drewal, "References to twinning in Gèlèdé do not indicate a direct or formal link with the cult of twins, yet they do tend to support our hypothesis of eighteenth-century Gèlèdé origins among Ketu peoples" (1983:231). As we have seen, their hypothesis rests on two points: one, the succession dispute in Kétu that led one of the twins to establish a new dynasty in Ìlóbí, where Gèlèdé was founded; and two, the assumption that twin infanticide stopped in Yorubaland in the eighteenth century, which, from a review of available data, seems too late a date for the origin of Gèlèdé. At any rate, given the additional facts now adduced linking Gèlèdé with spirit children (including twins), the parallels are too close to be coincidental.

Robert Farris Thompson hit the point when he likened the pairing tendency in Gèlèdé to "comradeship." (1974:204). This term is crucial to a full understanding of twinning in Yoruba thought. According to the Yoruba ontology of Being, every living person has a heavenly comrade or spirit double (enìkejì). The association of heavenly comrades is called Egbérun or Egbé Ògbà. Before being born, an individual enters into an accord with his or her spirit double (i.e., to live on Earth for a specified period, engage in a certain occupation, obey certain taboos, and so on). The Àbíkú are those who promised to stay on Earth for a short period and who must return at the appointed time, otherwise their heavenly comrades or spirit doubles will harass them. Unfortunately, an individual, on being born, forgets all about the accord; but so long as the contract is honored, there will be harmony between the earthly and heavenly pair (Idowu 1962:173; Prince 1964a:93). Offending one's spirit double or heavenly comrade may cause it to withdraw its spiritual protection. In Yoruba religion, the individual usually venerates the spirit double through the worship of his or her own orí (inner head), although it may be pacified separately during crisis periods. Women who worship the spirit double as a special divinity (Egbé Ògbà) are often suspected of manipulating it for evil purposes (Abimbola 1977b:161n. 3).[9] For, if alienated from the spirit double that otherwise provides spiritual protection, an individual succumbs easily to witchcraft.[10] Twins are called Èjìré, the intimate two (Lawal 1989:12), because they are difficult to put asunder.

9. According to popular belief, the àjé entice spirit children with gifts, so that they can run special errands for them such as stealing into the womb of a targeted woman and dying no sooner than they are born, only to return to the same woman to repeat the process. That is why the rituals for stopping infant mortality include placatory offerings to the àjé.

10. Hence the prayer Kí orí mi má gba àbòdì (May my "inner head" not accept bribes) is very popular among the Yoruba.

Their partnership was so close in heaven that one could not leave the other behind; as a result, both were born together. As Marilyn Houlberg has observed:

> In the case of twins, the spirit double has been born on earth. Since there is no way of telling which is the heavenly being and which is the mortal, both are treated as sacred from birth. As one 45-year-old man from Ibadan commented, "We do not think of each twin as having its own spiritual counterpart in heaven; they are the counterparts of each other." Thus, everything that is done for one must be done for the other. (Houlberg 1973:23)

Although I have met some informants who hold the view that twins and triplets have heavenly comrades, the consensus is that, because twins are united in body and soul, their "togetherness" is a source of strength, both physically and spiritually, and confers a powerful immunity against witchcraft. This togetherness is discernible in Gẹ̀lẹ̀dẹ́ when two identically costumed masks dance in unison.[11]

The emphasis on the identical pair in Gẹ̀lẹ̀dẹ́ is significant (figs. 8.3, 8.4), given the fact that identical dress in Yoruba culture usually identifies a duo as twins (figs. 8.1, 8.2). Of all spirit children, twins are the most respected and honored, being regarded as the favorites of Ìyá Nlá and the protégés of the òrìṣà (most especially Egúngún and Ṣàngó), all of whom they could influence on behalf of their parents or any individual who treats them well. This is why twins are called the "owners of the door of prosperity" (Abimbọla 1982:73-75). Thus, by adopting the image of spirit children in general (through the use of the metal anklet) and that of twins in particular (emphasized by identical costumes and paired dancing), the Gẹ̀lẹ̀dẹ́ not only seeks from Ìyá Nlá and the àjẹ́ the respect, honor, and preferential treatment normally accorded this category of children (Lawal 1978:69) but also attempts to turn Àbíkú (born to die) into Àbíyè (born to live).

Àwọn Ìyá Wa: Mother-and-Child Diplomacy in Gẹ̀lẹ̀dẹ́

As we have seen, Ìyá Nlá epitomizes the procreative power of the female and also the innate kindness, love, and devotion with which she nurses the child from birth to adolescence. Gẹ̀lẹ̀dẹ́ celebrates this phenomenon in order to perpetuate it at the physical and metaphysical levels. But then, Ìyá Nlá is a jealous and unpredictable goddess, giving and taking life at the same time. Her earthly disciples, the àjẹ́, have a similar bent. Dealing with them therefore requires tact and diplomacy. This is why the Yoruba use the eu-

11. For a different but related interpretation, see Drewal and Drewal (1983:136). Because the masks dance in identical pairs, Robert Plant Armstrong (1981: 74) has related Gẹ̀lẹ̀dẹ́ to twins. But he perceives the relationship in a "syndetic" sense, that is, "as two things or estates coexisting with the result that a reduction of single clarity results." However, since Armstrong is only looking at paired elements in the context of "mythoforms" in human culture and does not attempt to explain the possible relationship between Gẹ̀lẹ̀dẹ́ and twins, there is no need to discuss his hypothesis here.

phemism Àwọn Ìyá Wa (Our Mothers) for the àjẹ́, in order to foster a mother-and-child relationship with them—a relationship also emphasized in the preponderance of metal anklets (aro), female headwraps (gèlè), and baby sashes (òjá) on the Gẹ̀lẹ̀dẹ́ costume. These motifs, as noted earlier, not only have a prophylactic function in the rituals of Àbíkú but also signify the indulgence that a spirit child should expect from its mother. This indulgence underlies the giving of pet names to spirit children, names such as Dúró-orí-kẹ́ (Wait-and-see-how-you-will-be-pampered) and Dúrójayé (Stay-and-enjoy-this-world).[12] In fact, the element of pampering resonates in the very name G-ẹ̀-lẹ̀-d-ẹ́, sometimes interpreted as "a phenomenon treated with indulgence." Gẹ̀lẹ̀dẹ́ is thus a symbol of reciprocal affection; namely, the placating of Ìyá Nlá so that she can, in return, grant her children some indulgence.

No doubt, the Gẹ̀lẹ̀dẹ́ society provides an umbrella for individuals from different families to interact as children of Ìyá Nlá, just as Ògbóni members relate to one another as Ọmọ Ìyá, (children of the same mother). One social implication of the Ọmọ Ìyá or Àwọn Ìyá Wa strategy is that it obliges the

12. For more on Àbíkú names, see Adeoye (1972:38-39).

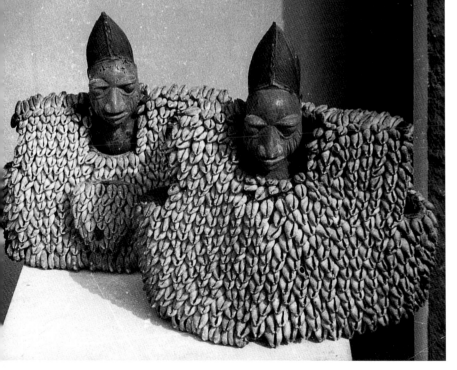

8.2 A pair of twin statuettes (ère ìbejì) adorned with identical cowrie vests, emphasizing the fact that even though twins are physically double, they are spiritually one.

8.3 A pair of Gẹ̀lẹ̀dẹ́ masks from Ìlaró wearing identical costumes, a phenomenon that identifies a duo as twins in Yoruba culture. Fourth Ifẹ̀ Festival of the Arts, Ilé-Ifẹ̀ (1971).

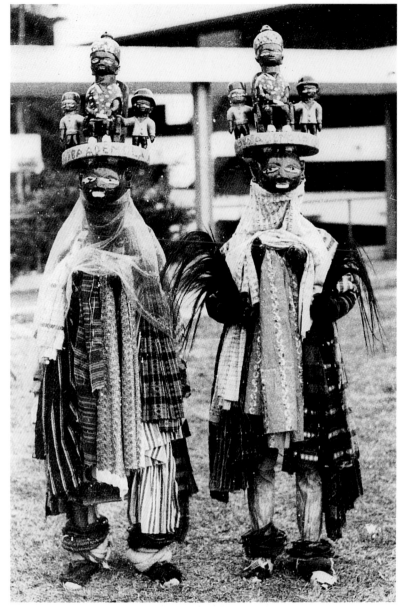

8.4 (*right*) A pair of identically costumed Gẹ̀lẹ̀dẹ́ masks from Ìmẹ̀kọ. Apart from identifying a duo as twins, identical costume links Gẹ̀lẹ̀dẹ́ with the Yoruba notion of spirit-double (*enìkejì*), emphasizing the benefits of togetherness at the material and spiritual levels of existence.

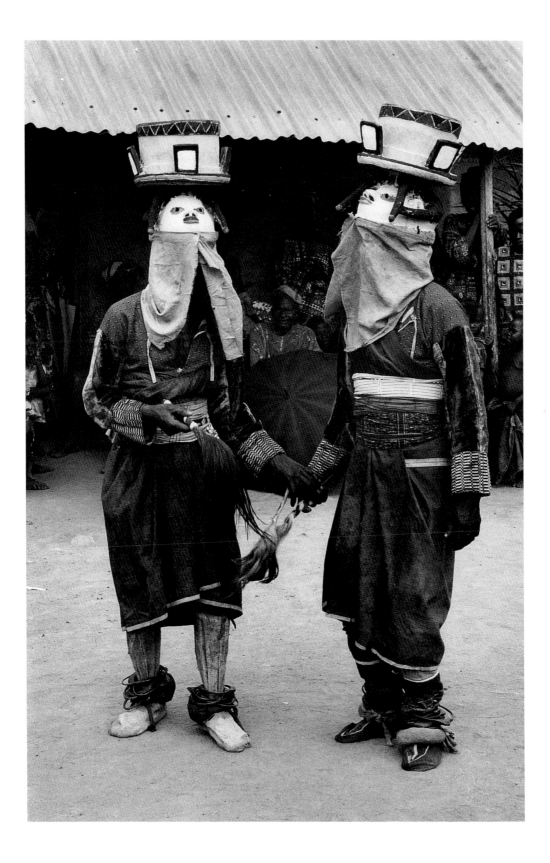

13. Ordinarily, this name is borne by individuals who have benefited tremendously from their mother's influence or have gained the right of succession to an important office through the female line.

women to be content with their roles as mothers who do not compete with their sons for political power (Lawal 1978:69)—a strategy also apparent in the popular phrase Ànjọlá Ìyá (We enjoy mother's grace), from which the name Ọláìyá (Mother's Grace) derives.[13] Since all daughters are potential mothers, is the Àwọn Ìyá Wa concept not then a subterfuge for sustaining male domination of the kingship institution? I sought the opinions of several women on this point. Surprisingly, almost all of them, both young and old, literate and nonliterate, saw nothing wrong with a concept that in fact gives pride of place to motherhood as the substratum of both the social and political institutions. In the words of an old woman from Ìlaró: "Does the king fall from the sky? Is he not from a woman's womb?" A food seller at the Ìsábọ̀ market, Abẹ̀òkúta, felt that the king in and of himself is not as important as the glory attached to the office, because all members of the royal family, both male and female, partake of this glory, which places the king's mother in a particularly influential position. A middle-aged lady in Ìgbógílà asserts that if "our mothers" (referring to the àjẹ́) do not approve the choice of the kingmakers, there will be no king, the allusion here being to the important role played by women in kingship rituals, which puts some in a position to "poison" an unpopular candidate. Other women drew my attention to the fact that the power of the Yoruba king is not absolute; he rules in consultation with a council of elders (known as Ògbóni in some areas, and by different names in others). There are always women on such councils. One of them is the Ìyálóde. As the head of the women in a given town, the Ìyálóde is a powerful figure. She commands much respect in the council because she has all the women behind her (Awẹ 1977:144-60). And should the women go on strike, there would be no food and water in the house, all the markets would be closed and, as one woman jocularly put it: "The men will go to bed at night without removing their trousers!" The following account by Raymond Prince is reminiscent of an incident that occurred in Abẹokuta in the late 1940s:

> On one recent occasion in town A the women of the town had risen in revolt against the payment of certain taxes, which they considered to be unfair. Their power was so great that they forced the ruling chief of the town to retire to the provinces for a year. They camped in hordes in front of the chief's palace, singing and causing a disturbance. When police were sent to disperse them, the women brandished their menstruation cloths. This caused the police to take to their heels, for it is believed that if a man is struck by a woman's menstrual cloth he will have bad fortune for the rest of his days. (Prince 1961:798)

It is widely held that the Yoruba had many female kings in the past.[14] The fact that there is none today is because, as one woman in her late seventies put it, the women gradually lost interest in the position. According to her, the decision by the women not to compete with the men for the kingship was of their own volition, not imposed by the men.[15] There is nothing the men can force the women to do against their will, for women will always win in the end. Alluding to *Ìkúnlè Àbiyamọ,* the sacred moment of childbirth, she summarized the power of the female in Yoruba culture with the popular saying: *Kò sí oun tí òròmọdìẹ lè fi ìyá è ṣe, àfibí kì bá ṣe pé ìyá ẹ ló yée lẹ́yin.* (There is nothing a chick can do to its mother, unless it was not the mother who laid it as an egg.) (See also the homage by the Ẹ̀fẹ̀ of Ìlaró, p. 123, line 87.)

This brief survey corroborates the observations made by other scholars of Yoruba culture that the Yoruba female is not as powerless politically as the male dominance of the kingship would suggest. The very focus of Ogbóni and Gẹ̀lẹ̀dẹ́ on Mother Nature is a clear indication that male dominance of the political arena is not absolute or self-sustaining. Among the Yoruba, power (*agbára*) has dual aspects—namely, the physical and spiritual, the public and private, the hard and soft, the male and female—one complementing the other. Life itself depends on this dualism. The men represent the visible or physical aspect of power; the women, its generative or mystical aspect. The latter is the most awesome of all powers, objectified in the Yoruba concept of the *àjẹ́,* and is one which the male establishment endeavors to regulate through Gẹ̀lẹ̀dẹ́. Many communities confer the title *Ìyá Ọba* (the official Mother of the king) on an influential woman—usually suspected to be a benevolent *àjẹ́*—so that she can use her occult powers to protect the king.[16] As the bird motif emblematizes the *àṣẹ* (divine authority) as well as the mystical powers of the *àjẹ́,* it adorns the crown (*adé*) of the Yoruba king (fig. 1.5), not only to proclaim him as the deputy of the gods (*Aláṣẹ èkejì òrìṣà*) but also to enable him to harness the powers of "the mothers" (*Àwọn ìyá wa*) for the public good (Babayemi 1986:13; Thompson 1972:253-54).[17]

An important aspect of the *èfẹ̀* concert, hardly emphasized in the literature on Gẹ̀lẹ̀dẹ́, is that the Ẹ̀fẹ̀ mask, exploiting his spirit child status, openly admonishes the *àjẹ́.* Given the fear that the "powerful mothers of the night" instill in the mind of the general public, no one else would dare to challenge them openly except this "child of the night," as the Ẹ̀fẹ̀ mask of Ìjió once identified himself (Harper 1970:86). This aspect of the *èfẹ̀* ceremony suggests that Gẹ̀lẹ̀dẹ́ is much more than a glorification of female power; it is an

14. For example, two of the ancient kings (Ọ̀ni) of Ifẹ̀ have been identified as female; Adó-Èkìtì has had one (Beier 1955:1-2); Old Ọ̀yọ́, one (Smith 1988: 32); and Akurẹ, three (Afọnja 1986:142). In some cases, princesses relinquished to their sons or brothers their rights to the throne. For a survey of female rulers in pre-colonial Yorubaland, see Afọnja (1986: 142-43).

15. Harold Courlander, however, has documented a legend to the effect that the city of Iléṣà once had a female king called Aderẹmi. In the time of peace she governed well, but could not cope when Iléṣà was invaded. As a result, the people of Iléṣà decided that henceforth they would have a warrior chief (male) as their ruler (1973: 114-16).

16. Erelú, the most senior female member of the Ọ̀gbóni, performs this function in Ọ̀tà (a town regarded throughout Yorubaland as the haven of "witches"). In the past, to prevent the king's natural mother from exercising an undue influence on her son, some Yoruba kingdoms sent her into exile, banned her from the palace, or simply asked her to commit suicide. An *Ìyá Ọba* was then appointed for the new king. In Old Ọ̀yọ́, where the

Aláàfin's natural
mother must kill her-
self, the *Ìyá Ọba* was
an extremely powerful
figure, being the sole
custodian of sacred
symbols affecting the
king's life which she
could use to eliminate
him should he offend
her. To minimize the
latter possibility, *Ìyá
Ọba* was expected to
commit suicide at the
death of the Aláàfin
(Johnson 1921:48-49,
56, 63).

17. His Highness
Solomon Babayẹmi is
the reigning Olúfì
(king) of Gbọ̀gán.

exercise in diplomacy (*ọgbọ́n ìṣèlú*), in its use of tact to deal with a delicate problem in the interests of peace and social harmony. The recurrence of the snake and tortoise or porcupine motif on Gẹ̀lẹ̀dẹ́ headdresses is significant in this respect. While the mask publicly acknowledges the power of life and death which the "powerful mothers" wield over the community, this motif warns the "bad eggs" among them of nemesis!

Certainly, the mother-and-child symbolism in Gẹ̀lẹ̀dẹ́ strikes a sensitive chord in the womenfolk, since it testifies to their vital contributions to humanity. During any Gẹ̀lẹ̀dẹ́ ceremony, there are many sideshows at the performance venue as women of all ages, some pregnant, some carrying babies on their back (fig. 5.17) dance spiritedly to Gẹ̀lẹ̀dẹ́ music because its rhythm is thought to have a tonic effect on "body and soul." Bubbling with filial love, the men mingle and dance freely among the women, all celebrating the sanctity of motherhood.

Ìran Gẹ̀lẹ̀dẹ́: The Sacred, the Profane, and the Social Order

As Sidney Kasfir has rightly observed, masking in Africa mediates between play and ritual, being "a transformational process which, when enacted as ritual, reflects the cosmic order, and when enacted as play, belongs to the social order. But in most African cultures, these domains are not institutionally separated as they are in the West." (1988:5). This observation also applies to the Gẹ̀lẹ̀dẹ́ spectacle (*ìran* Gẹ̀lẹ̀dẹ́). As we have seen, it is a quest for individual and corporate survival through the propitiation of the female principle personified as Ìyá Nlá. This quest is evident in the aesthetics and iconography of costume, especially in the headdress, the female headwrap, the baby sash, and the metal anklet. The rituals inside Ìyá Nlá's shrine or by the river (or in both places), and the emphasis on satire and public display during the festival suggest that Gẹ̀lẹ̀dẹ́ has as much to do with religion as with education and aesthetics. The spectacle (*ìran* Gẹ̀lẹ̀dẹ́) is a blend of the spiritual and the secular, the serious and the trivial, of art-for-life's-sake and art-for-art's-sake.

As noted earlier, the Gẹ̀lẹ̀dẹ́ masker is not a spirit medium like his Egúngún counterpart. Hence, he does not have to hide his identity. The fact that tradition requires the Èfè masker to put on his costume inside Ìyá Nlá's shrine underscores his liminal status during the night concert. Nonetheless, the masker clearly identifies himself as a human being (though with spirit connections) during his performance by paying homage to Ìyá Nlá, the *àjẹ́*, the principal *òrìṣà*, his own ancestors, and all retired performers. The Èfè mask

of Ìmèkọ underscores his ambiguous personality when he identifies himself by name, then goes on to speak with the voice of Ìyá Nlá, and uses the same voice, at the next moment, to satirize Ìyá Nlá as "the nursing mother with the rolling buttocks, who badly needs a male partner!" In Ìlaró, the Èfè mask, while paying homage to Èṣù, jocularly asks the audience to remove his trousers should he fail to pronounce the complex, tongue-twisting names of the deity correctly! The afternoon masks are even more down to earth in their behavior. Between performances, some remove their headdresses in order to get fresh air or to have a drink. In the literature on African art, there is a tendency to generalize that the masker undergoes a "metamorphic transformation," becoming one with the spirit represented by the mask. According to one scholar: "The African Negro sees in the mask not only a means of escaping from realities of daily life, but above all a means of participating in the many-sided life in the universe, creating new realities beyond the human ones" (Monti 1969:15). The self-conscious attitude of the Gèlèdé masker, however, suggests that metamorphic transformation is not always the case. There is therefore an urgent need for more detailed studies of African masks with regard to the different forms, meanings, and contexts.

Masking in Gèlèdé is ritual (ètùtù) and play (eré) at the same time. The ritual is aimed at promoting fertility, longevity, and prosperity; and the play, to entertain and socialize. The masker is Arugi or Ajógi, a performer animating the costume, *consciously* playing a specific role for which he expects praise and admiration from fellow humans and, by extension, the blessings of Ìyá Nlá and the àjé, if his performance is adjudged to be good. Asked to explain the drastic change in behavior while performing under the costume, many Gèlèdé maskers trace their inspiration (ìmóríyá) to the ritual context, the music, and the audience. The ritual context evokes the numinous; the music stimulates the body; the audience-consciousness creates a strong desire in the performer to make a good impression. The festive mood also contributes to performance. Thus it is difficult to draw a dividing line between the sacred and the secular in Gèlèdé. It is certainly this absence of a dividing line that gives the Gèlèdé festival its dramatic intensity, enabling every member of the community to participate freely, regardless of personal, social, political, religious, or ideological differences.

Alessandro Falassi (1987:2) has defined a typical festival as:

A periodically recurrent, social occasion in which, through a multiplicity of forms and a series of coordinated events, participate directly or indirectly and to various degrees, all members of a whole community, united by ethnic, linguistic,

religious, historical bonds, and sharing a worldview. Both the social function and the symbolic meaning of the festival are closely related to a series of overt values that the community recognizes as essential to its ideology and worldview, to its social identity, its historical continuity, and to its physical survival.

The Gẹ̀lẹ̀dẹ́ festival not only fits squarely into this definition, it has almost all the features isolated by Falassi as "quantitatively ever-recurrent and qualitatively important in festive events" (1987:3-6). These are: (1) a rite of valorization that formally opens the festival—the equivalent of the rituals inside Ìyá Nlá's shrine on the eve of the annual festival; (2) a delimited and consecrated area for a special celebration—the *ojú agbo* or dance arena demarcated by the double-arch entrance in Gẹ̀lẹ̀dẹ́; (3) a modification of daily time to accommodate special ceremonies—during the Gẹ̀lẹ̀dẹ́ festival, there is a disruption of normal activities; (4) rites of purification to rid the community of evil—"refuse carrier" masks such as Gbogbolàkìtàn and Àgbìgbò are used for ritual cleansing; (5) "rites of passage" to mark a transition from one stage to another—the equivalent of *ìdira* or the formal costuming of the Èfè mask inside the Gẹ̀lẹ̀dẹ́ shrine and the *ìjoyè* during the festival, when new officials of the Gẹ̀lẹ̀dẹ́ society are formally installed; (6) rites of reversal, when men dress as female or vice versa—in Gẹ̀lẹ̀dẹ́, the female masks (*abo igi*) are worn by men; some of their attendants engage in cross-dressing; (7) rites of conspicuous display, when sacred objects normally concealed in shrines are exhibited in public—in Gẹ̀lẹ̀dẹ́, certain headdresses and torso masks normally kept inside the shrine may be "danced" in public during the festival; (8) rites of conspicuous consumption in the form of feasts—the equivalent of *àsè ọdún* in Gẹ̀lẹ̀dẹ́ when important Gẹ̀lẹ̀dẹ́ families, the Ìyálásẹ̀, and senior chiefs feast the public; (9) ritual dramas—the equivalent of the nocturnal concert and daylight dances in Gẹ̀lẹ̀dẹ́; (10) rites of exchange featuring public acts of pacification or thanksgiving for a grace received—the equivalent of votive offerings presented to Ìyá Nlá during the annual festival; (11) rites of competition involving a display of skills—the equivalent of the *ẹ̀kà* in Gẹ̀lẹ̀dẹ́ when masks dance before an orchestra; and (12) a rite of devalorization that formally brings the festival to an end—the equivalent of "closing" masquerades like Ìyálé Yemọja (of Ìbarà) and Ìyálé Oòduà (Ìlaró) in Gẹ̀lẹ̀dẹ́ which appear on the last day of the festival.

With regard to festive behavior during public celebrations, some scholars have singled out symbolic inversion as the most important aspect, while others have interpreted such reversals as no more than an intensification of daily life in a more stylized form (Turner 1982:11-26; Falassi 1987:1-10).

Both inversion and intensification are present in Gèlèdé. Because of its concern with social stability, however, Gèlèdé discourages extreme reversal behaviors and the type of topsy-turvy that characterizes the Egúngún celebration, when opposing factions engage in a violent power tussle, or the Òkè-Ìbàdàn festival, when youths parade the streets shouting obscenities that sometimes degenerate into public disorder. By emphasizing love, fellowship, fun, and artistic creativity, the Gèlèdé festival attempts to foster what Victor Turner has called a spirit of *communitas* that holds conflict in abeyance during a period of ritualized action (1982:17). But although the spirit of *communitas* generated by the annual festival is expected to endure, in reality it reduces the frequency of, but does not necessarily prevent, conflicts. As we have seen, the Yoruba cosmos is a dynamic interplay of opposites mediated by Èsù, the divine trickster. In such a situation, conflict is inevitable. Even within and among the various Gèlèdé societies in a given community, frictions do occur as a result of land disputes, chieftaincy tussles, offensive comments by the Èfè mask, and rivalry on the dance arena, among other provocations. In recent times, some Gèlèdé groups have become involved in contemporary party politics. As Ulli Beier once observed in the Republic of Benin: "In the Porto-Novo area different Gelede groups joined in political campaigns at one time. They joined different parties, sang abusive songs about each other, and encounters of hostile masks and their followers sometimes ended in fights" (1958:18). Similar incidents occurred in Lagos in the early 1960s when Gèlèdé groups supporting the late Chief Obafemi Awolowo, leader of the defunct Action Group party, abused his opponents. In the following song from Kétu (composed in the 1960s), the Èfè mask sues for peace, drawing public attention to the dangers inherent in the bitter political rivalry engulfing the town:

Òdómudé/Alàgbà ìlú
È fuyè sórìn m
Àlàyé n mó fé í se fú yín } 2ce
A kò níjà ara ini
[5] Ègbún bí àbúròó bí là í se

.
Ìjà kò pò bí amújàwú
Toyè yí ló soni dolíjà ara ini
Ègbé méjì kò burú laìhinrin ìlú.

.
Èdè li kò yédè
[10] Akórìínra kì yó. } 2ce

Lítorí oyè ọba Òyìnbó gbé sọ nnẹ̀, A kò kù túmù kàn
Lẹ̀gbún fu n dọ̀tá àbúrò
Lọmú dọ̀tá i baba.

Toyè Òyìnbó kò tó jà o, ará mi un
[15] O leè jọ́mu i tìẹ
Là fẹ́ i ká foté fu lẹ̀ẹ̀míàn.

Ẹ̀ fọ̀tẹ̀ nne o
Ọmu i Kétu ẹ nde ká ṣèlú ini kọ́ dáa
A kò níjà ara ini

Youths/elders of the town,
Do consider my song.
My intention is to explain, } 2ce
Not to fight anybody.
[5] We are all of the same family.

We were never in conflict
Until the dawn of the current electoral politics.[18]
Ordinarily two different associations are not of themselves bad in a
 community.
All the quarrel is based on inadequate understanding. } 2ce
[10] One who hates suffers deprivation.

Why should the little-understood political institution introduced by the
 Europeans
Set brothers against brothers?
And parents against children in our midst?

This European creation is not enough cause for a duel.
[15] Let us vote for your own child today,
And Tomorrow let my own child take the turn.
Let everybody forget it all.
Children of Kétu, come around. Let us work for the common good of the
 community.
We have no cause to fight among ourselves.

(Aṣiwaju 1975:248-53)

18. The electoral tussle was between Gabriel Adelakun of the Parti Républicain du Dahomey (P.R.D.) led by Sourou Migan Apithy and Fayọmi Adeleke of the Union Démocratique du Dahomey (U.D.D.) led by Justin Ahọmadegbe. For details, see Aṣiwaju (1975:253-54).

These divisive incidents, however, are exceptions rather than the rule in Gèlèdé. Even so, the Yoruba view of life is pragmatic enough to recognize the inevitability of conflicts in a community of diverse characters, temperaments, and interests. Hence, the popular saying: *Àgbépọmájà kòsí; ká jà kó má tán ni kò da.* (Disagreements cannot be avoided in a society; but refusing to bury the hatchet is not good.) (Akiwọwọ 1986a:115). The mechanisms for resolving conflicts in Yorubaland are therefore as important as those for minimizing or preventing them. Gèlèdé performs both functions effectively because it combines elements of the sacred and the profane. By interrelating all members of a given community as the children of Ìyá Nlá, who rewards good behavior and punishes misdeeds or actions detrimental to communal oneness, Gèlèdé promotes what Ralf Dahrendorf calls "a consensus of values" (1959:161; quoted by Rhoads 1991:282), minimizing the need for the use of force to ensure compliance with the social order.

Ayé Ò Dúró S'ójúkan: Tradition and Change in Gèlèdé

The involvement of Gèlèdé in party politics aptly illustrates the impact of change in Yorubaland. In the Yoruba language, tradition translates as *àṣà* (customs) or *ìṣẹ̀dálẹ̀* (ancestral creations). Like many other African groups, the Yoruba believe in the power of tradition as it links the past with the present, the living with the dead, the human with the divine, and the present with the future. Tradition unites and defines the cultural identity of a group. As pointed out earlier in the discussion on the origin of Gèlèdé, the emphasis on precedents in Ifá divination indicates a strong belief by the Yoruba in the existence of a cosmic process that can be influenced with a repetition of archetypes: *Ẹ ṣe é bí wọ́n ti nṣe é, kí ó ba à lè rí bí o ti nrí.* (Follow precedents in order to obtain the same result.) In Yoruba woodcarving, for example, tradition is maintained through the apprenticeship system. A pupil artist follows the style of his master which in itself has been inherited from the past. As a result, there is a recognizable Yoruba artistic style, though with individual and regional variations. The very fact that these variations do exist in Yoruba art and culture as well as in the language (which has many dialects), shows that the Yoruba world view is not so static as it seems. The popular saying: *Ayé ò dúró s'ójúkan; ayé nyí lọ* (The world does not stand still; the world rolls on) underscores the Yoruba recognition of the inevitability of change (*àyípadà*) in nature and culture.[19] As the divine trickster and the custodian of *àṣẹ* (the power to make things happen), Èṣù is the agency of change. An aspect of Èṣù (as noted earlier) inheres in all things,

19. See also G. J. A. Ojo (1966:196-97).

both animate and inanimate, charging them with existential power and at the same time subjecting them to change. Èṣù is associated with the rhythm of time, motion, and statis, the beginning and the end, the old and the new, the positive and the negative, life and death, north and south, east and west, and all the ups and downs of human existence (*ìwà*). On the other hand, the divination deity, Ọ̀rúnmìlà, signifies tradition and the Yoruba quest for stability, social harmony, and the predictable in life. Èṣù represents the opposite that must be reconciled in the existential process of time, which does not stand still. To resolve this dialectic, Èṣù is integrated into the Ifá divination system, providing Ọ̀rúnmìlà with the enabling power not only to relate the present with the past, but also to predict the future:

Bí oní ti rí
Ọ̀la kì í rí bẹ́;
Ni babaláwo fi n dífá ọrọrún.

Today's events
Will be different tomorrow;
That is why the diviner consults the oracle every five days.

(Abimbọla 1977a:*vii*. My translation)

In other words, the diviner must consult the oracle (Ọ̀rúnmìlà) regularly to keep pace with change (fig. 7.38). As a result, the Yoruba do not resist change but, rather, seek to reconcile the old with the new in a cumulative process that has enabled their culture to survive the vicissitudes of time. A close examination of Yoruba art, including Gẹ̀lẹ̀dẹ́ headdresses and costumes, reveals a syncretistic use of several Islamic decorative motifs (figs. 5.5, 7.15, 7.40, pl. 14), confirming what William Bascom and Melville Herskovits have called "the additive rather than substitutive" nature of the cultural exchange between African and foreign cultures which has been going on for ages (1965:6).

Since the turn of the century, a wind of change has been blowing across Africa. European colonialism, Western education, modern technology, rapid urbanization, party politics, the adoption of a money economy, and intensive evangelization by Islam and Christianity have all combined to disrupt the old order, precipitating a sociocultural metamorphosis of unprecedented proportions. Like their counterparts in other parts of Africa, the Yoruba are rapidly adjusting to the changes. Although many of them now profess either Islam or Christianity, they have not totally severed connec-

tion with their traditional beliefs. The fear of witchcraft remains strong. Both literate and nonliterate Yoruba still patronize herbalists, diviners, and priests of traditional religion in times of crisis (Dọpamu 1979:3-20; Abimbọla 1991:51-58). Some modern hospitals combine Western with traditional Yoruba medicine. The complexity and competitiveness of modern living have led some to resort to the use of good-luck charms (àwúre or oògùn) to aid them in reaping the advantages of the new era while avoiding the disadvantages. Although Western medicine has reduced the high rate of infant mortality formerly identified with the Àbíkú (born to die) phenomenon, modern technology has introduced new causes of death. Automobile accidents, plane crashes, boat tragedies, and several hazards associated with the highly mechanized occupations are claiming human lives at an alarming and unprecedented rate. Some Yoruba so dread the risks associated with these new facilities that they would willingly revert to their old traditions of long-distance travel by foot, canoe, or on horseback. Unfortunately, these old traditions became obsolete during the colonial period, following the introduction of motorized vehicles which drastically reduced into a few hours a journey that formerly took several days. So it is that many Yoruba have accepted the hazards of modern technology with a fatalistic resignation, rationalizing these as the price to be paid for modernization (Lawal 1993:12).

Further complicating the situation is the Yoruba belief that every effect has a cause, so that there is a tendency to view most accidents or tragedies as the machinations of enemies. At times, a diviner attributes the cause to a displeased ancestor or òrìṣà, advising the client to offer sacrifices. In fact, many of the traditional deities have found new roles in modern technology. For instance, since iron is sacred to Ògún (the deity of war, hunting, and industry), all mechanical devices made of iron, most especially motor vehicles, come under the responsibility of that òrìṣà.[20] A new vehicle must receive the blessing of Ògún to minimize the chances of its being involved in road accidents. Hence, most Yoruba professional motor drivers and all those who deal with mechanical devices now set aside a special day every year (ọdún Ògún àjọbọ) for appeasing Ògún. Àjà, the deity of the whirlwind, can cause an aircraft to crash if he is displeased, and Yemọja or Olókun can overwhelm the modern steamship. Therefore Yoruba air pilots and ship captains are advised to seek the goodwill of the appropriate deity to ensure a *bon voyage*. Incurable illnesses or inexplicable accidents are still being blamed on the àjẹ́. Another major concern is the rising wave of violent crimes in both the urban and rural areas. In short, the enormity of the problems of survival in the industrial age is forcing many Yoruba to bolster their lives

20. See also Barnes (1980:6).

with traditional medicine and rituals, or to seek the protection of Ìyá Nlá through Gèlèdé.

Of all Yoruba masks, none reflects the dynamics of change in Yorubaland as effectively as does Gèlèdé. The headdress, especially the one with a superstructure (*elérù*) captures the interplay of tradition and modernity in a unique way. In almost every headdress in this category, the face below the tray has stereotypical features and lineage marks which preserve the Gèlèdé style and identity and link the present with the past. On the other hand, the superstructure reflects in a variety of idioms, ranging from the naturalistic to the schematic, the changes occurring in the Yoruba world. Images of Europeans and their technological achievements testify to both the positive and negative impact of colonialism and Westernization. During the colonial era, the Yoruba did not hide their resentment of colonial policies on taxation, military conscription, and chieftaincy matters. Although mass protests occasionally resulted in violent riots like those that occurred at Ìtakété (1905), Kétu (1911-15), Ọ̀họ̀rí-Ìjè (1914-15), and among the Ẹ̀gbádò (1953-54), physical confrontation with the colonial administration was avoided as much as possible because of the brutal force deployed in dealing with such revolts (Aṣiwaju 1976:134-35). Rather, many communities in southwestern Yorubaland waited for the opportunity provided by the Gèlèdé festival to air their protest and ridicule the Colonialist Other. As noted earlier, the Ẹ̀fẹ̀ mask of Kétu in the 1920s criticized the policy of the French colonial administration requiring taxpayers to wear tax receipts around the neck for identification. Another Kétu mask, Alaro Apa, criticized the French conscription policy in Africa during World War II, telling his audience that he refused to enlist in the French Army because he did not ask Adolf Hitler to start the war in the first place (Aṣiwaju 1975:228-29). To Alaro Apa—and I have heard some Yoruba World War II veterans express a similar view—Africans ought not to have been involved in the two World Wars because Hitler's imperial ambition was no different from the military escapades that led to the partitioning of Africa into European colonies (Lawal 1993:15).

Unfortunately, the scarcity of concrete data makes it difficult to reconstruct the specific contexts of most caricatures of the European to be found on Gèlèdé headdresses. It suffices to say that these caricatures, in many instances, ridicule those peculiarities that differentiate the European from the Yoruba, such as the pointed nose, long mustache, tight-fitting dress, and wide-brimmed hats. Nonetheless, the image of the European is not always negative. The headdress frequently depicts European inventions such as airplanes, steamships, motor cars, bulldozers, motorcycles, clocks, sewing

machines, lanterns, guns, and other mechanical devices (figs. 7.33, 8.5-8.7). Although the Gèlèdé audience always admires the skill with which the carver has captured the essence of the subject, the representation of these inventions on the mask has more than entertainment or novelty value. To this day, the traditional or nonliterate Yoruba still view as a kind of witchcraft the scientific feats behind the invention of electricity, the radio, the television, and the motor vehicle. Hence, they always wonder when the Yoruba might use their own witchcraft in the same way. As a Yoruba king once put it, in a letter to Henry and Margaret Drewal (1983:203):

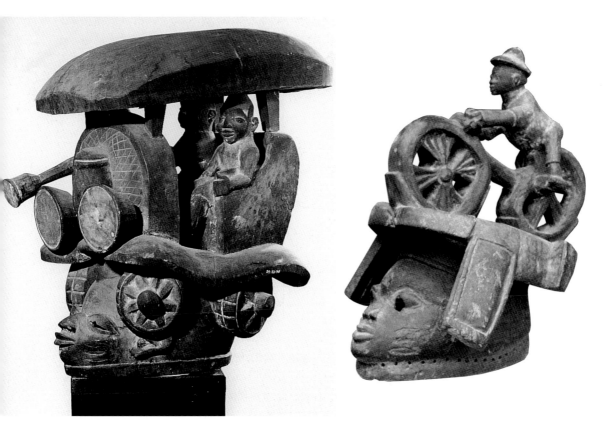

8.5 Gèlèdé headdress featuring a lorry. Carved by Samuel Laaroye of Ìmèkọ. Wood, pigment, h. 20 inches.

8.6 Gèlèdé headdress featuring a motorcyclist. Wood, pigment, h. 17¹/₄ inches.

8.7 Gẹ̀lẹ̀dẹ́ head-dress featuring an airplane. Although reportedly collected in the former "Abẹ̀òkúta province," this piece seems to have been carved by Michael Labọde of Ìdòfòyí, Ayétòrò. Compare the openings below the nose with figs. 7.1, 7.33, and 7.55—works that Labọde recognized as his from photos I showed him in 1971, thereby independently confirming the records of the National Museum, Lagos. Ayétòrò was part of the former "Abẹ̀òkúta province." Wood, pigment, h. 14¹/₂ inches.

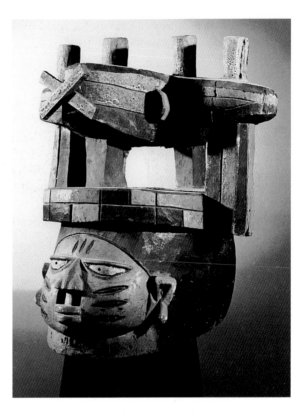

> The ajẹ [destructive mothers] change into birds and fly at night. If they used that knowledge for good, it might result in the manufacture of airplanes or something of the sort. They can go to Lagos and back in very short minutes. They can see the intestines of someone without slaughtering him, they can see a child in the womb. If they used their power for good, they would be good maternity doctors.

In other words, the representation on Gẹ̀lẹ̀dẹ́ headaddresses of the technological achievements of the Colonialist Other poses a challenge to the àjẹ́ and local geniuses to channel their powers in a socially viable direction. It also embodies an entreaty to Ìyá Nlá to let these new contraptions be more beneficial and less harmful to her children.

Although some maskers wear Western shirts, trousers, and canvas boots under the array of headwraps and baby sashes of the costume, and although synthetic colors are beginning to replace the indigenous ones on the headdress, the traditional image of Gẹ̀lẹ̀dẹ́ is still intact, reflecting a desire to adapt to change without losing much of one's cultural identity. Even where

Islamic clerics, Christian missionaries, European colonial officers, and other "stranger elements" living in Yorubaland are portrayed on simple head-dresses (i.e., those without superstructures), the style is unmistakably Gèlèdé (fig. 8.8).

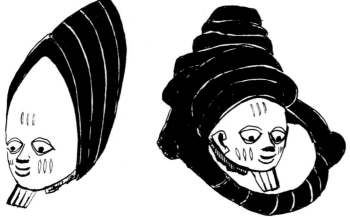

8.8 The retention of the Gèlèdé visage in spite of the Islamic accoutrements illustrates the additive nature of change.

In short, the constant feature of the "Gèlèdé visage," particularly the face below the superstructure, tallies with the Yoruba endeavor, through the divination deity Òrúnmìlà, to stabilize the social order in a world of continuous change, epitomized by Èṣù, the deity of transformation, and mirrored in diverse forms on the superstructure (fig. 8.9).

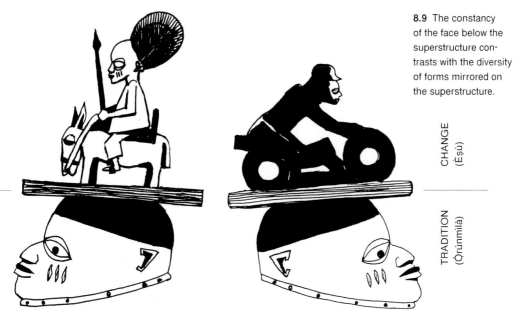

8.9 The constancy of the face below the superstructure contrasts with the diversity of forms mirrored on the superstructure.

SUPERSTRUCTURE

BASE

CHANGE (Èṣù)

TRADITION (Òrúnmìlà)

To reflect the increasing mechanization of urban life, some headdresses feature battery-powered devices replacing the traditional puppets manipulated with strings. In l978, near the Jànkara Market, Lagos, I saw two Gẹ̀lẹ̀dẹ́ masks, each displaying on their headdresses a Taiwan-made, battery-powered toy soldier in camouflaged uniform firing a machine gun! Subsequent inquiries revealed that both maskers had once served in the Nigerian Army. Allen Roberts has also documented a headdress carved by Ìrókò of Daagbe (Republic of Benin) which has flashlight bulbs fitted into the eyes and mouth of the human face (fig. 8.10). A switch wired to batteries concealed inside the headdress allows the masker to flash the lights on and off (Roberts 1992:58).

Another significant Gẹ̀lẹ̀dẹ́ development is that some carvers have started scrapbooks containing newspaper articles and photographs of Yoruba art in local and foreign museums, from which they derive inspiration. I know of a particular carver who has a copy of a government-sponsored publication (Willett 1960) which he uses for reference purposes. Others, especially those in the urban areas, visit local museums to familiarize themselves with works from different parts of Yorubaland. The headdress illustrated in figure 8.11 seems to have been carved by one of these eclectic artists. It has been inspired by an Ẹpa headdress of the *jagunjagun* (warrior) variety from eastern Yorubaland (fig. 8.12). These few examples are enough to suggest that the Gẹ̀lẹ̀dẹ́ tradition has not been static. Over the centuries, in response to

8.10 Janus-faced Gẹ̀lẹ̀dẹ́ headdress representing the human and bird aspects of the *àjẹ́*. The eyes and mouth are fitted with flashlight bulbs, switched on and off by the masker during performance— an innovative incorporation of modern technology into the Gẹ̀lẹ̀dẹ́ tradition. Wood, pigment, raffia, flashlight bulbs.

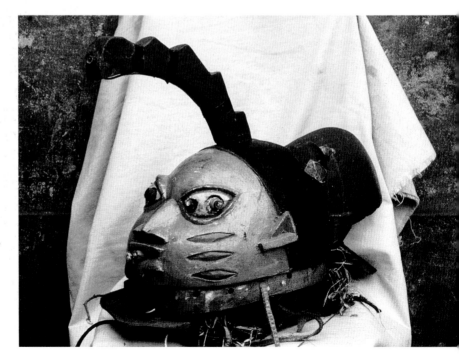

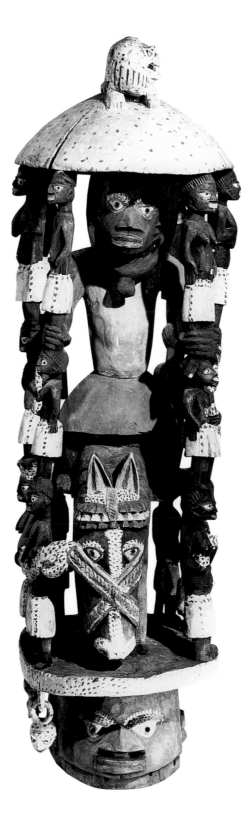

8.11 Gẹ̀lẹ̀dẹ́ headdress
influenced by Ẹpa
headpiece of the
jagunjagun (warrior)
variety. Compare with
figure 8.12. The animal
motif at the apex seems
to have been influenced
by heraldic sculpture of
the lion. This stylized
motif was in vogue in
Yorubaland from the
turn of the century to
the late 1950s, adorning
palaces, the umbrella
finials of Yoruba kings,
and the prestigious
mansions of rich
farmers and merchants.
Wood, pigment, h. 52$^1/_2$
inches.

the dynamics of change, it has been absorbing influences in an *additive* rather than a *substitutive* manner. The wide variety within the mask corpus shows that the artist has not been content with repeating blindly forms handed down over the generations. An integral element that encourages innovation and provides regular impetus for artistic excellence is the annual festival, an occasion for public display of talents that brings fame to those adjudged to be virtuosos and trendsetters.

8.12 Ẹpa headdress from northeastern Yorubaland depicting an equestrian warrior (*jagunjagun*) surrounded by attendants. Head-dresses such as this would seem to have influenced the creation of the example in figure 8.11. Wood, pigment.

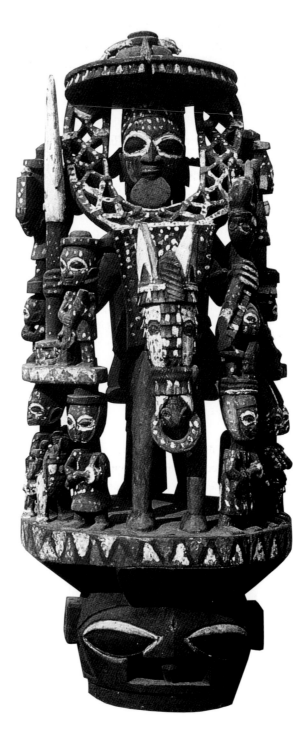

Conclusion

From the evidence presented in this book, there is little doubt that the Gèlèdé mask, now worn exclusively by men, had a humble origin in ritual dances originally performed by women in honor of Mother Nature to ensure fertility, prevent premature deaths (Àbíkú), and promote social and spiritual well-being. The principal elements of the Gèlèdé costume—the female headwrap (gèlè), baby sash (òjá), and metal anklets (aro)—also feature prominently in fertility and Àbíkú rituals, testifying to a genetic relationship. The Gèlèdé mask placates the àjé, the "powerful mothers of the night," because of the belief that they are in league with spirit children, have the power to kill, and can cause infertility in men and women.

The Yoruba have two methods for dealing with the àjé: namely, force and dissuasion. The Egúngún and Orò societies use force; the Gèlèdé, dissuasion. The less aggressive position of Gèlèdé is in keeping with the Yoruba adage: Èsò l'ayé (The world is fragile) which draws attention to the delicate and unpredictable nature of human existence and the virtue of prudence in the resolution of human problems. For much more can be achieved in life through peaceful means than through brute force; hence the adage:

Oun a bá f'ẹsò mú kì í ni ni l'ára
Oun a bá f'agbára mú ní í le koko.

Anything handled with care becomes easier;
Anything handled with force becomes harder.

Gèlèdé resorts to "Mother-and-Child" diplomacy when dealing with the àjé, for the sake of peace and social harmony. It employs poetic humor in the visual and performing arts to create a relaxed atmosphere for addressing politically sensitive and serious issues that might otherwise become explosive or be considered sacrilegious. For example, in the following song (cited earlier), the Gèlèdé society of Ìmèkọ admonishes Ìyá Nlá and the àjé without sounding offensive:

Gently, gently, descends the night
Gently, gently, sets the sun
Gently, gently,
Great Mother, Mother of All.
Ògún 'Jàyè,
The world is fragile.
Mother,
Life should not be lived with force.

The following *èfè* song from Kétu rings a similar note:

Slowly, slowly, the night descends on the world.
Slowly, slowly, the sun follows its course.
Let us live gently in this world.
In the world of the king, we don't take by force.
My memory stings me, my mother, words come rushing to my mind.
Gently, gently, the rat dances in the night.

(Beier 1958:9)

These songs suddenly turn sarcastic in view of the fact that Ìyá Nlá (in her aspect as Òdù, the grand matron of the *àjé*) reportedly fell from grace for wielding her power recklessly.[1] According to the Ifá divination verse (*Òdù Òsá Méjì*), a part of which was cited in chapter 2, the Supreme Being (Olódùmarè) warned Òdù to be careful with her power after she had boasted that she would use it to fight all those who would not see eye-to-eye with her. The following gives the gist of what eventually happened:

Há! àgbà tí ó bá se àsejù tí tè nítè
A d' ífá fún Òdù
Nígbàtí Òdù dé'lé aiyé
He! nwón ní ìwo Òdù
Nwón ní, ò bá lè sóra rè
[5] Kí o sì se sùrù
Kí o má yájú
Òdù ní èétirí?
Nwón ní nítorí agbára rè tí Olódùmarè fun un.
Nwón ní nítorí kí aiyé má ba r'ìdí rè
[10] Òdù ní hówù!
O ní kò sí nkankan.
O ní nwon kò ní lè r'ìdí rè

1. As noted earlier, Ìyá Nlá is an elusive figure. So too is Òdù, the first female deity (according to this divination verse). Some informants identify Òdù as the wife of Òrúnmìlà, the divination deity; but Màmá Moromisalu, the late Ìyá Yemoja of Ìbarà, Abéokuta, disagreed with this identification, insisting that she is not. Others claim that only after Òdù divorced Obàtálá did she marry Òrúnmìlà and later, Òrìsà Oko (agriculture deity). Since we are dealing with a myth, the exact identity of Òdù is not so important as the fact that she represents the primordial female in Yoruba cosmology who has different names in different communities. But the first female *òrìsà* is everywhere called Ìyámi (My Mother, the *àjé*), suggesting that the different names may refer to different aspects of the same phenomenon.

O ní on nikan ló lọ ọ̀dọ Olódùmarè.

[15] Lọ rèé gba agbára tí kó ṣe ojú gbogbo awọn tí nwọ́n jọ mbọ̀ s' áyé,

Kò ṣe ojú wọn rárá.

Nígbàtí nwọ́n sọ bẹ́ẹ̀ fún Òdù tán,

Nwọ́n ní kó rúbọ.

Òdù ní rárá!

[20] O ní on kò ní rúbọ.

Ẹbọ kí obìrin ó rí agbára gbà bọ̀ láti ọ̀dọ Olódùmarè l'ó rú

.

Kí aiyé ó má fi rí 'dì rẹ̀

Kò rúbọ rẹ̀.

L'ó bá nlọ

[25] Ó mú Eégún jáde

Ó mú Orò jáde.

Gbogbo nkan, kò sí ohun tí kì ṣe nígbà ná a.

Ni Ọ̀bàìsà wá ní, hẹn!

Oní tí ó jẹ́ pé on ni Olódùmarè kó aiyé lé lọ́wọ́

[30] Kó jẹ́ pé obirinbìrìn yìí ni yió gba aiyé náa,

Àti ìká Eégún ni

Àti ìká Orò ni

Àti ìká gbogbo òrìṣà ni

On kò gbọdò wọ ọ̀kankan nínú rẹ̀

[35] Há! Obìrin yìí ni yió wá gba gbogbo aiyé náa.

Ni Ọ̀bàìṣà bá lọ rèé ké sí babaláwo

Ọ̀rúnmìlà l'ó lọ ké sí níjọ́ náa. . . .

"Ah! The elder who commits excesses will be disgraced."

Thus declared the Ifá oracle to Òdù,

When Òdù arrived on earth.

Eh! they said. You Òdù,

They said. You must take care

[5] And also be patient.

Do not be saucy.

Òdù asked, Why?

They said, It is because of the power which Olódùmarè has given her,

So that people may not know her secrets.

[10] Òdù exclaimed, Well!

She said, There is no problem.

She said nobody can uncover her secrets.

She said she was the only one who went to Olódùmarè

[15] To receive the power, and it was not in the presence of the others
 whom she accompanied to the Earth.

It was not in their presence.

After giving this warning to Òdù

They advised her to offer sacrifices.

Òdù refused bluntly!

[20] She said she would not offer sacrifices.

Instead she offered sacrifices that would cause Olódùmarè to give
 power to women.

.

But that people should not know her secrets,

She did not offer this kind of sacrifice.

She went her way.

[25] She brought out the Egúngún mask.

She founded the Orò society.

Everything; there was nothing she could not do at that time.

Òbàìsà wondered

Even though Olódùmarè put the physical world in his care;

[30] An ordinary woman has taken it over.

The sacred shrine of Egúngún,

The sacred shrine of the Orò society,

And the sacred shrines of all the *òrìsà;*

He is now forbidden to enter any of them.

[35] Ah! it means that it is this woman who has taken over the affairs of
 the Earth.

Then Òbàìsà consulted the Ifá divination priest;

It was Òrúnmìlà that he consulted. . . .

(Verger 1965:206-8. My translation)

The story goes on to say that Òdù became so drunk with power that any-
one who dared to look her in the face ran the risk of being blinded. Wor-
ried, Òbàìsa (Òbàtálá), the artist deity, consulted the oracular deity Òrúnmìlà,
who advised him to offer sacrifices and exercise restraint. Òbàìsa complied.
After some time, Òdù approached him, requesting that both of them should
live together in the same house, so that he could observe all her activities.
Òbàìsa agreed. One day, the latter took one of the snails he had offered as
sacrifice and began to drink its fluid. He offered Òdù a part of the fluid; she
accepted and drank it. The snail fluid softened her heart and she revealed all

her secrets to Ọ̀bàìṣa. In the end, she relinquished to him all the secrets of both the Egúngún and Orò societies previously controlled by the women-folk, decreeing that henceforth men should keep them (ibid.:208-18).[2] But she advised the men always to seek the blessing and cooperation of the women in all activities, because the women are the most powerful and the mothers of all. To ignore them is to invite failure. Hence, the popular Ifá divination song:

> Ẹ kúnlẹ̀ o, ẹ kúnlẹ̀ f'óbìrin o
> Ẹ, obìrin l'ó bí wa, k'áwa tó d'ènìyàn
> Ọgbọ́n aiyé t'obìrin ni
> Ẹ kúnlẹ̀ f'óbìrin
> [5] Ẹ, obìrin l'ó bí wa, k'áwa tó d'ènìyàn.

> Offer respect, offer respect to women.
> Yes, it was a woman who gave birth to us before we became somebody.
> The "secrets of the world" belong to women.
> Offer respect to women,
> [5] Yes, it was a woman who gave birth to us before we became somebody.
> (ibid.:218. My translation)

Because of the use of the mask to pacify the "powerful mothers," Ulli Beier sees Gẹ̀lẹ̀dẹ́ as a reflection of the conscience of the men towards the women, "dating from the changeover from matriarchal to patriarchal society" (1958:7). There is some evidence to support this hypothesis. For instance, many Yoruba address the "powerful mothers" as Ẹnyin ni nwọ́n kó 'lé aiyé lé lọ́wọ́ (Fabunmi 1972:3); that is, "The physical world was commited to your charge." This imagery is reinforced by the divination verse Odù Ọsá Méjì, which alleges that the Supreme Being (Olódùmarè) gave to Òdù (the first female) the most powerful àṣẹ in the form of a bird enclosed in a calabash (the Yoruba symbol of the universe). Indeed, this divination verse also states categorically that "the men used wits and strategies to snatch power from the women" (Verger 1965:214). Furthermore, the fact that the mythical ancestor of the Yoruba, Odùduwà (Oòduà), is venerated in southwestern Yorubaland as female (The Great Mother) and as male (The Great Father) in other areas, has led some scholars to suggest that the male aspect is a later development (Idowu 1962:26-27; Belasco 1980:96).[3] But since the probability that Oòduà was originally a goddess does not necessarily imply that a female-dominated political system once prevailed among the Yoruba,

2. Robin Poynor (1974) has also documented oral traditions in Ọ̀wọ̀ attributing the origin of certain Egúngún masks to women. Similarly, the Ijo (Nigeria), Dogon (Mali), Senufo (Côte d'Ivoire), and Mende (Sierra Leone) trace the origin of some of their masks to women.

3. Belasco has suggested that the prominence of female goddesses and Gẹ̀lẹ̀dẹ́ in southwestern Yorubaland "seems correlated with the incompleteness of centralized authority there, in contrast with rigorous witchcraft enforced by the Orò and apparently associated with the more centralized polities" (1980:103). While this is plausible, the fact still remains that the Ògbóni society, an important political and religious organization all over Yorubaland, including highly centralized polities, has a female focus. Even at Old Ọ̀yọ́, one of the most powerful Yoruba kingdoms between the sixteenth and eighteenth centuries, women performed important ritual, administrative, and political functions (Johnson 1921:43, 45, 55, 65; Babayemi 1986:12-14). Thus, the reasons for the prominence of Gẹ̀lẹ̀dẹ́ in southwestern Yorubaland seem to go beyond the absence of centralized polities in the area. Since Gẹ̀lẹ̀dẹ́ is associated with the

this issue is not as simple as it seems. It requires further investigation, more so when other traditions strongly suggest that the men have been in control from time immemorial.[4] Space limitations will not allow a full discussion of the issue here, as it belongs in the realm of social anthropology. What is most important to us in the above-mentioned divination verse is the allegorical use of the two principal characters, Òbàìsà and Òdù, to illustrate the triumph of prudence over arrogance and recklessness, and to underscore the necessity for gender collaboration in any human enterprise. The lesson is in line with the ideals of Gèlèdé and reverberates in many of its songs and artistic representations.

In summary, given its various functions, there is no doubt that Gèlèdé means much more than a changeover from matriarchal to patriarchal leadership. It is a multivalent symbol. Apart from its concern with human increase and social well-being, among others, it is a lesson on the virtues of love, respect, patience, restraint, tolerance, self-discipline, social justice, and diplomacy in human relations. During the "Gèlèdé spectacle," these virtues are dramatized for moral enlightenment, aesthetic enjoyment, and spiritual fulfillment.

As noted earlier, the Yoruba existential ethos is that all the creations in the universe will continue-in-being only when they remain in sociation (àsùwàdà) and at peace with one another. Yet not only is the Yoruba cosmos a delicate balance of opposites, but every creation has a different character and destiny. Thus, at the human level, existence (ìwà) is a dynamic

water (Olókun and Yemoja), the proximity of this area to the Atlantic Ocean, the Lagos lagoon, and many rivers such as Yewa, Ògùn, Wémé, Opara, Ofikì, and Oyán—all believed to be inhabited by goddesses—might also have contributed to the emphasis on the female principle (Yai: n.d. personal communication).

4. For instance, another Ifá divination verse (Odù Òsétúa) alleges that sometimes in the past, all the male òrìsà forbade Òsun (goddess of the river bearing that name) from the rituals they performed in the sacred forest. Yet it was Òsun who prepared their food. Feeling slighted, she used the magical power of the "ancestral mother" (àse Ìyámi) to thwart the efforts of all the male òrìsà. However, when the male òrìsà discovered that Òsun had been making things difficult for them, they invited her to accompany them to the sacred forest so she could be introduced to the secrets of Egúngún, Orò, Orúnmìlà, and others. But Òsun refused. Instead, she gave the condition that if all the òrìsà could use their power to ensure that the baby she was expecting would be a male child, then the child would represent her at the ceremonies in the

sacred groves (another form of "Oláìyá!"). Òsun eventually had a male child called Òsétùa, who not only was introduced to all the sacred rites but also assumed part of the responsibilities of Èsù as the bearer of offerings to Olódu-`marè. This appeased Òsun. For details, see dos Santos and dos Santos (1971:50-84) and Adeoye (1989:203-5). This story would seem to suggest that the men have been in control of Yoruba society from the beginning. But then, Òsun is regarded as one of the offspring of Yemoja; and given the fact that she is alleged to have used the magical power of the "ancestral mother," it is possible that this story refers to a later episode in mythical time, more so when several other Yoruba myths link the origins of Egúngún and Orò with women.

process of reconciling conflicting interests so as to preserve a given community as a unit and prevent it from being thrown into a state of disintegration (*àìṣùwàdà*). It is in this context that the Gèlèdé plays a vital role not only as a reliever of the tension associated with the dialectics of existence but also as an artistic therapy for antisocial behavior. As one Ifá divination verse succinctly puts it: *Ìwà ni oògùn aye* (Character is the best medicine for surviving in this world) (Delanọ n.d.:23). Character defines the human being (*ènìyàn*), the one specially selected by the Supreme Being to develop the earth. By advocating caution (*èsò*) in human conduct and emphasizing character (*ìwà*) as the essence of beauty (*ẹwà*), existence (*ìwà*), and immortality (*àìkú*), Gèlèdé epitomizes the Yoruba ethos of *Ìfọgbọntáayéṣe*. As Moses Makinde aptly puts it:

> Ifogbontaayese is . . . [in] . . . Yoruba philosophical thought, the conscious employment of human knowledge, reason and wisdom for the understanding and improvement of the world (both mental and physical), of the human relationship to the physical world and to fellow human beings, and the improvement of the general condition of people on earth. (1988:71).[5]

As an artistic manifestation of *Ìfọgbọntáayéṣe*, Gèlèdé uses *ẹwà* (beauty) to foster *ìwà* (good character and qualitative existence) in its bid to refine and harmonize the diverse elements that constitute the world. This quest for social concord is evident in the "Gèlèdé spectacle," as well: in the colorful headdress of the mask and its variegated costume which blend disparate headwraps, baby sashes, and other items contributed by persons of different characters and destinies; in the orchestration of the music which combines proverbial solos with complicated, assorted dance rhythms; in the paired dancing of the daylight masks which requires the two dancers to synchronize the jingling of their metal anklets with the music; and, above all, in the close rapport between audience and performers. Gèlèdé is Art for Humanity's Sake, a paradigm of Unity in Diversity.

5. Moses Makinde's discussion of *ifọgbọntáayéṣe* (1988: 71-73) is the most comprehensive to date. However, in an attempt to relate it to contemporary philosophy, Makinde suggests that the term be expanded to provide a framework for the "unity of the sciences," in which the human interest takes priority over every other consideration in the quest for mechanization. While acknowledging the positive side of modern technology, Makinde laments its dehumanizing aspects. To correct this anomaly, he calls for "profound thinking in all academic disciplines," especially the social sciences, and the development of cultural strategies that would make the modern world a better place for humankind (ibid.: 71-72). Lawuyi and Taiwo (1990:70-72) disagree with this perspective, arguing, among others, that profound thinking and philosophical thoughts in the modern sense "can actually lead to a condemnation of [the] traditional values" (ibid.:71) being championed by Makinde. But as we have seen, Gèlèdé does not resist change and in fact welcomes modern technology so long as it contributes to human well-being.

Glossary
of Yoruba Terms

Àbíkú Literally, "born to die," a child thought to have spirit companions to whom it will return after a short sojourn on Earth. If a woman loses several children in a row, the Yoruba believe that the soul of the same child has been going to and returning from the same mother

Àbílà Literally, "born to live and prosper," a synonym for *Àbíyè*

Àbíyè Literally, "born to live," a prayer to neutralize *Àbíkú;* also used as a title by female members (*Erelú*) of the Ògbóni society

Abo igi Female Gèlèdé mask

Àbùdá The essential nature of a person or creature

Àdá A matchet (machete)

Adárin Those who initiate songs, or lead singers

Adé Beaded crown with veil and bird motifs

Agbégi A woodcarver

Agberin Chorus singers in a call-and-response style; also called *Alágbè, Abánirò, Akódan, Akíjèélé,* and *Elégbè*

Agbérù Literally, "load bearer;" a Gèlèdé masker

Àgbìgbò The big-headed gray hornbill, associated with evil

Agbòjá Strip of cloth holding female headwraps and baby sashes, tied round the body of the Gèlède masker to increase his girth

Agemo The chameleon; a masking society among the Ìjèbú

Àìsùwàdà Disintegration or dismemberment

Ajákùenà The name of the Tètèdé mask in Ìlaró, meaning "the path-clearer"

Àjàngbilà A fight to the end; unresolvable conflict

Àjé A female with special powers that can be used for good or evil; often translated as "witch;" also known as "My Mother"

Ajógi Literally, "dancer of the wooden image," another name for the Gèlèdé masker

Ajogun Negative forces in the Yoruba cosmos; also called *Alájogun*

Ajòru Literally, "nocturnal being," another name for the Èfè mask

Àkàlà The ground hornbill; also called *Àkàlàmàgbò*

Àkàlàngbà A hoop for holding female headwraps, baby sashes, or appliqué panels, used by male Gèlèdé masks

Àkàtà Èfè A type of Èfè headdress with a brim

Akíjẹ́ẹ́lẹ́ An attendant shaking an iron rattle in front of a Gẹ̀lẹ̀dẹ́ mask

Akódan An attendant shaking a brass rattle (in the *ẹdán Ògbóni* style) in front of a Gẹ̀lẹ̀dẹ́ mask

Akọ igi A male Gẹ̀lẹ̀dẹ́ mask

Àpá Colorful appliqué panels used by Gẹ̀lẹ̀dẹ́ masks

Ará'gbó Literally, "a being of the forest," a spirit child

Ará òrun Spirits of deified ancestors

Aro A metal anklet

Àrokò A symbolic message; visual metaphor

Arugi Literally "a wood carrier," another name for the Gẹ̀lẹ̀dẹ́ masker

Àṣà Customs; tradition

Àṣẹ Divine authority or "the power to make things happen"

Aṣẹ̀ Literally, "divine source," the Gẹ̀lẹ̀dẹ́ shrine or altar

Àsè Ọdún Large meals cooked for communal feasting during Gẹ̀lẹ̀dẹ́ festival dedicated to Ìyá Nlá (Mother Nature)

Aṣọ Ẹbí Literally, "family dress," costumes of the same fabric design worn by a social group to project "oneness"

Àṣúé Incantation

Àṣùwà Clustering, or a community of beings

Àṣùwàdà Togetherness, or peaceful coexistence

Àtẹ A tray

Atọ́kùn A mask guide or attendant

Awo Secrecy

Awọbòwà A person outwardly beautiful but inwardly vile

Awọn alayé Figuratively, the superpowers of the physical world

Àwòrán "Picture," a contraction of *àwòránti*, a visual reminder or abstraction

Àwùjọ ènìyàn Civilized society, subject to self-imposed rules and conventions

Àwúre A good-luck charm

Ayé Literally, the physical world; figuratively, the good and evil inherent in the physical world; also refers to the *àjẹ́*

Ayékòótọ́ Another name for the African gray parrot, meaning, "the world does not like the truth"

Àyípadà Change

Bàbáláṣẹ̀ The chief male priest of Gẹ̀lẹ̀dẹ́

Babaláwo A diviner and priest of Ọ̀rúnmìlà, the divination deity

Bàtá A conical drum sacred to Ṣàngó, the thunder deity

Bèbè A cylindrical object used by female Gẹ̀lẹ̀dẹ́ masks to exaggerate the buttocks

Bèmbé A large, double-faced cylindrical drum

Bòlòjó Gèlèdé music, or a Gèlèdé singing group

Dàda One of the patron deities of small children; name of child born with knotted hair

Dùndún A pressure drum in the shape of an hourglass

Ẹbọ Sacrifice or ritual

Èdá A living creature, or the "essential nature" of a person or thing

Ẹdan The brass staff of Ògbóni society; another name for Ilè

Èfè A nocturnal concert; humor; night mask

Ẹgbé Ordinarily, a social association. At the religious level, it refers to the patron goddess of spirit children, a child with spirit companions, or an association of heavenly comrades also called *Ẹgbé Ògbà* or *Ẹgbérun*

Egúngún An ancestral spirit represented by a mask

Ẹkùn A leopard

Ẹlégbé A child with spirit companions

Elérìkò A mask representing a heavenly comrade or a patron deity of spirit children

Ẹléyẹ Figuratively, "wielder of bird power"; another name for the *àjé*

Emèrè A demonic child

Ẹnìkejì A spirit double

Ènìyàn A human being (literally, "the specially selected one"); sometimes pronounced *eníyán* to describe the wicked ones, or those working against human goodness

Ẹnu Aṣè A double-arch entrance made of palm leaves, meaning "entrance to the shrine"

Ẹranko Ordinarily, an animal, but figuratively, a person who lacks good character, i.e., "an animal in a human skin"

Ère An image; applies to any sculptured mask or figure. See *Igi*

Erèé Black-eyed beans, a favorite food of twins and spirit children

Ère Ìbejì A statuette dedicated to a deceased twin

Erelú A female member of the Ògbóni society; also called *Erelú Àbíyè*

Eríwo The lord of secrets

Èṣò Fragile; a situation or an object that should be handled with caution or care; synonym for *pèlépèlé*

Èṣù The trickster and messenger of all the *òrìṣà*, also called *Èṣù Ẹlégbára;* the agency of change

Ètùtù A ritual performed to pacify a deity or the *àjé*

Ẹwà Beauty (*ẹwà inú* = inner beauty; *ẹwà òde* = outer beauty)

Ẹ̀wà Black-eyed beans

Gbérí Padded hunter's or warrior's vest, modified in the Gẹ̀lẹ̀dẹ́ costume to buffer the weight of the hoop holding female headwraps, baby sashes, or appliqué panels. The modified version is called *agbé àkàlàngbà*

Gẹ̀lẹ̀ A female headwrap, called *òjá* when used to hold a baby on the back (baby sash)

Ìbejì Twins

Ìbẹta Triplets

Ifá A divination system associated with Ọ̀rúnmìlà

Ìfọgbọ́ntáayéṣe Literally, "using wisdom to remake/improve the world;" also means the application of skills, ethics, diplomacy, religious ideals, and creativity to foster peace and social harmony

Ìgán òṣà Cloth or raffia attached to the rim of the headdress like a mane

Ìgbàgbọ̀n The chord that fastens the headdress to the chin

Ìgbàjá The ritual of tying baby sashes (*òjá*) round a sacred tree to reinforce a prayer for a healthy child, or to prevent infant mortality (*àbíkú*)

Igi A carved headdress; specific to Gẹ̀lẹ̀dẹ́

Ìjàkadì Combat

Ijó òsán An afternoon dance

Ìjoyè The formal installation of a chief

Ìkóódẹ The red tail feather of the African gray parrot; also called *Ìkó* and *Ìkórídẹ*

Ìkù A metal anklet

Ìkúnlẹ̀ abiyamọ Literally, "the kneeling (supplicatory) pose of a mother"; figuratively, it refers to the sacred moment of childbirth when a mother's life is on the line. Yoruba women invoke this critical moment not only to ask for special favors, but also to curse those who disrespect motherhood, or who have little or no regard for human life.

Ilẹ̀ Earth goddess venerated by the Ọ̀gbóni society; sometimes called *Ẹdan*

Ilé ayé Physical world

Ìmóríyá Inspiration. Literally, "that which stimulates the head"

Ìpilẹ̀ṣẹ̀ Root, foundation, or source

Ìrẹ́pọ̀ Harmony

Ìwà Existence or character; *ìwà rere* = good character

Ìyá Jànjàsá Chief among heavenly comrades

Ìyálá̀ṣè̀ Highest female priest of Gè̀lè̀dé

Ìyámi Ordinarily, *ìyá mi* (two words) means "my [biological] mother," but when condensed to *ìyámi* (one word), it means "my [powerful/mysterious] mother"; the latter is often used to invoke the benevolence of the *àjé̀*; sometimes pronounced *ìyàmi* ("my woe") to allude to the *àjé̀*'s potential for evil

Ìyámi Ò̀ṣòrò̀ngà Figuratively, "my powerful/mysterious mother, the swift one"; cognomen of the founder of witchcraft and another name for the *àjé̀*; often used for addressing *Ilè̀*, the Earth goddess; also pronounced *Ìyàmi Ò̀ṣòrò̀ngà*

Kàràgbá A calabash face mask

Ké̀hìndé Literally, "the last to come;" the name of the senior of twins, also called *Àibo*

Kónkóto Deity of spirit children

Koórì Another deity of spirit children

Lágídígba Female waist bead

Ọba Yoruba king

Ọ̀bàrìṣà Literally, "king of the *òrìṣà*," another name for Ọbàtálá, the artist deity and molder of the human image from clay; also called *Ọ̀bàìṣà*

Odídẹré̀ The African gray parrot; also called *Ò̀dìdè̀*

Odù The two hundred and fifty-six volumes of the Ifá divination text

Ò̀dù One of the names of the first female deity in the Yoruba pantheon; also refers to a big pot

Odùduwà The creator of the Earth, identified as male in some parts of Yorubaland and as female in others; also called *Oòduà*

Ọfọ̀ Incantation; also called *ògèdè* or *àyájọ́*

Ọgbọ́n Wisdom or cunning

Ò̀gbóni A society dedicated to the worship of the Earth goddess; also called *Ò̀ṣùgbó*

Ò̀gún Iron and war deity and patron of hunters, warriors, blacksmiths, and all professions involving the use of iron implements

Ọjà A market

Ọ̀já A baby sash; a female headwrap used to carry the baby on the mother's back

Ò̀kòtó A seashell or periwinkle

Ọláìyá Mother's Grace

Olódùmarè The Supreme Being

Olókun The deity of the sea and all waters

Olómitútù A generic name for water deities associated with spirit children

Ọmọlúwàbí A cultured and well-behaved person

Ọnà Art or design

Oníṣègùn A medicine man or herbalist

Oògùn Medicine or charm

Orí Literally, "the head," the locus of the life force

Òrìjí Another name for the headdress worn by the Èfè mask of Ìlaró

Orí inú Literally, "inner head," the controller of human destiny

Orí òde Literally, "outer head," the physical head or face

Òrìṣà Lesser deities, concerned with human affairs

Òrìṣà Ọlómọwéwé A generic name for patron deities of small (and spirit) children

Orò A nocturnal being representing the collective power of the ancestors, used in imposing curfews on special occasions; symbolized by the bull-roarer

Òrun Heaven

Òrúnmìlà A divination deity; also called *Ifá*

Oṣó Sorcerer; wizard; a man with powers comparable to those of an *àjé*

Pèlépèlé Caution; synonym for Èsò

Ṣàngó The thunder deity

Ṣaworo Another name for the metal anklet

Táíwò A contraction of *Tọ́ Ayé wò,* meaning the first to taste the world; the name given to the firstborn of twins (the junior)

Táyé Abbreviation of *Táíwò*

Tètèdé Literally, "the first to come," the mask that precedes the Èfè. Hence the name is regarded as a synonym for *Táíwò,* the firstborn of twins

Yewájọbí. Another name for Yemọja, the mother of all waters

Bibliography

Abímbọlá, W. 1971. "The Yoruba Concept of Human Personality." In *La Personne en Afrique Noire*. Colloques Internationaux du Centre National de la Recherche Scientifique, no. 544:73-89. Paris: Centre National de la Recherche Scientifique.

——. 1975a. *Sixteen Great Poems of Ifá*. UNESCO.

——. 1975b. "Ìwàpèlé: The Concept of Good Character in Ifá Literary Corpus." In *Yoruba Oral Tradition: Poetry in Music, Dance and Drama*, edited by W. Abímbọlá. Ilé-Ifè, Nigeria: Department of African Languages and Literatures, University of Ifè.

——. 1976. *Ifá: An Exposition of the Ifá Divination Corpus*. Ìbàdàn, Nigeria: Oxford University Press.

——. 1977a. *Awọn Ọmọ Ojú Odù Mérèèrìndínlógún*. Ìbàdàn, Nigeria: Oxford University Press.

——. 1977b. *Ifá Divination Poetry*. New York, London, Lagos: Nok Publishers.

——. 1977c. "Traditional Yoruba Religion." In *Contemplation and Action in World Religions*, edited by Y. Ibish and I. Marculescu. Seattle: University of Washington Press.

——. 1979-80. "Ìdánilékọ̀ lórí Koórì (Òrìṣà Ewé)," *Oòduà, A Journal for the Association of Yoruba Scholars* (University of Ifè, Ilé-Ifè, Nigeria) 2:6-23.

——. 1982. "From Monster to King and Divinity: Stories of Ìbejì in the Ifá Literary Corpus." Paper presented at International Conference on Èrè Ìbejì, National Museum, Lagos, Nigeria.

——. 1991. "The Place of African Traditional Religion in Contemporary Africa: The Yoruba Example." In *African Traditional Religions in Contemporary Society*, edited by J. K. Olupọna. New York: Paragon House.

Abíọdun, R. 1975. "Ifá Art Objects: An Interpretation Based on Oral Tradition." In *Yoruba Oral Tradition: Poetry in Music, Dance, and Drama*, edited by W. Abímbọlá. Ilé-Ifè, Nigeria: Department of African Languages and Literature, University of Ifè.

——. 1983. "Identity and the Artistic Process in Yoruba Aesthetic Concept of Ìwà." *Journal of Culture and Ideas* 1(1):13-30.

——. 1987. "Verbal and Visual Metaphors: Mythical Allusions in Yoruba Ritualistic Art of Orí." *Word and Image Journal of Verbal-Visual Inquiry* 3(3):252-70.

——. 1990. "The Future of African Art Studies: An African Perspective." In *African Art Studies: The State of the Discipline*. Symposium organized by the National Museum of African Art, Smithsonian Institution, Washington, D.C.

Abiodun, R., H. J. Drewal, and J. Pemberton, editors. 1994. *The Yoruba Artist: New Theoretical Perspectives on African Arts.* Washington and London: Smithsonian Institution Press.

Abraham, R. C. 1958. *Dictionary of Modern Yoruba.* London: University of London Press.

Adedeji, J. A. 1967. "Form and Function of Satire in Yoruba Drama." *Odù, University of Ifẹ̀ Journal of African Studies* 4(1):61-72.

——. 1969. "The Alárìnjó Theatre: The Study of a Yoruba Theatrical Art from its Earliest Beginnings to the Present Time." Ph.D. diss., University of Ìbàdàn, Nigeria.

——. 1970. "The Origin of the Yoruba Masque Theatre: The Use of Ifá Divination Historical Evidence." *African Notes* 6(1):70-86.

——. 1972. "Folklore and Yoruba Drama: Ọbàtálá as a Case Study." In *African Folklore,* edited by R. M. Dorson. Bloomington: University of Indiana Press.

Adeoye, C. L. 1972. *Orúkọ Yoruba.* Ìbàdàn, Nigeria: Oxford University Press.

——. 1979. *Àṣà Ati Ìṣe Yoruba.* Oxford: Oxford University Press.

——. 1989. *Ìgbàgbọ́ àti Ẹ̀sìn Yoruba.* Ìbàdàn, Nigeria: Evans Brothers.

Adewale, S. A. 1988. *The Religion of the Yoruba: A Phenomenological Analysis.* Ìbàdàn, Nigeria: Department of Religious Studies, University of Ìbàdàn.

Afọnja, S. 1986. "Women, Power and Authority in Traditional Yoruba Society." In *Visibility and Power: Essays on Women in Society and Development,* edited by L. Dube, E. Leacock, and S. Ardener. Delhi: Oxford University Press.

Agiri, B. A. 1975. "Yoruba Oral Tradition with Special Reference to the Early History of the Ọyọ Kingdom." In *Yoruba Oral Tradition: Poetry in Music, Dance and Drama,* edited by W. Abimbọla. Ilé-Ifẹ̀, Nigeria: Department of African Languages and Literatures, University of Ifẹ̀.

Ajanaku, F. 1972. "Orí, Ìpín àti Kádàrá, Apá Kèjì." *Olókun* 10:11-13.

Ajibọla, J. O. 1979. *Òwe Yoruba.* Ìbàdàn, Nigeria: University Press Limited.

Ajuwọn, B. 1984. "Myth and Principle of Predestination in Yoruba Folk Culture." *New York Folklore* 10(1-2):89-98.

Akinjogbin, I. A. 1967. *Dahomey and Its Neighbours.* Cambridge: Cambridge University Press.

Akiwọwọ, A. A. 1983a. *Àjọbí and Àjọgbé: Variations on the Theme of Sociation.* Inaugural Lecture Series 46. Ilé-Ifẹ̀, Nigeria: University of Ifẹ̀ Press.

——. 1983b. "Understanding Interpretative Sociology in the Light of the Oríkì of Ọ̀rúnmìlà." *Journal of Culture and Ideas* 1(1):139-57.

——. 1986a. "Àṣùwàdà-Ènìyàn." *Ifẹ̀: Annals of the Institute of Cultural Studies* (University of Ifẹ̀, Nigeria) 1:113-23.

——. 1986b. "Contributions to the Sociology of Knowledge from an African Oral Poetry." *International Sociology* 1(4):343-58.

——. 1991. "Responses to Makinde/Lawuyi." *International Sociology* 6(2):243-51.

Alade, M. 1972. "Orí, Ìpín àti Kádàrá. Apá Kíní." *Olókun* 10:8-10.

Apter, A. 1992. *Black Critics and Kings: The Hermeneutics of Power in Yoruba Society.* Chicago: University of Chicago Press.

Armstrong, R. P. 1981. *The Powers of Presence: Consciousness, Myth, and Affecting Presence.* Philadelphia: University of Pennsylvania Press.

Aṣiwaju, I. A. 1975. "Èfè Poetry as a Source for Western Yoruba History." In *Yoruba Oral Tradition: Poetry in Music, Dance and Drama,* edited by W. Abimbọla. Ilé-Ifè, Nigeria: Department of African Languages and Literatures, University of Ifè.

———. 1976. *Western Yorubaland Under Colonial Rule, 1889-1945: A Comparative Analysis of French and British Colonialism.* London: Longman.

Awẹ, B. 1977. "The Ìyálóde in the Traditional Yoruba Political System." In *Sexual Stratification: A Cross-Cultural View,* edited by A. Schlegel. New York: Columbia University Press.

Awolalu, J. O. 1979. *Yoruba Beliefs and Sacrificial Rites.* London: Longman.

Awoniyi, I. A. 1975. "Ọmọlúwàbí: The Fundamental Basis of Yoruba Education." In *Yoruba Oral Tradition: Poetry in Music, Dance and Drama,* edited by W. Abimbọla. Ilé-Ifè, Nigeria: Department of African Languages and Literatures, University of Ifè.

Babalọla, S. A. 1966. *The Content and Form of Yoruba Ìjálá.* Oxford: Clarendon Press.

———. 1967. *Awọn Oríkì Orílè.* Glasgow: Collins.

———. 1970. "Onjẹ Fún Ojú," *Olókun* 9:39-40.

Babatunde, E. D. 1988. "The Gèlèdé Masked Dance and Kétu Society: The Role of the Transvestite Masquerade in Placating Powerful Women while Maintaining the Patrilineal Ideology." In *West African Masks and Cultural Systems,* edited by S. L. Kasfir. Vol. 126 Tervuren; Belgique: Musée Royal de L'Afrique Centrale.

Babayẹmi, S. O. 1980. *Egúngún Among the Ọ̀yọ́ Yoruba.* Ìbàdàn, Nigeria: Board Publications.

———. 1986. "Ọ̀yọ́ Palace Organization: Past and Present." *African Notes* 10(1):4-24.

Babayẹmi, S. O. and O. O. Adekọla. 1987. *Ìṣèdálè Àwọn Odù Ifá, Apá Kèji.* Ìbàdàn, Nigeria: Institute of African Studies, University of Ìbàdàn.

Baldwin, D., and C. Baldwin. 1976. *The Yoruba of Southwestern Nigeria: An Indexed Bibliography.* Boston: G. K. Hall.

Barber, K. 1991. *I Could Speak Until Tomorrow: Oríkì, Women, and the Past in a Yoruba Town.* Edinburgh: Edinburgh University Press.

Barnes, S. 1980. *Ògún: An Old God for a New Age.* Philadelphia: Institute for the Study of Human Issues.

Bascom, W. R. 1969a. *The Yoruba of Southwestern Nigeria.* New York: Holt, Rinehart and Winston.

———. 1969b. *Ifá Divination: Communication between Men and Gods in West Africa.* Bloomington: Indiana University Press.

——. 1969c. "Creativity and Style in African Art." In *Tradition and Creativity in Tribal Art,* edited by D. P. Biebuyck. Berkeley and Los Angeles: University of California Press.

——. 1973a. *African Art in Cultural Perspective.* New York: W. W. Norton.

——. 1973b. "A Yoruba Master Carver: Duga of Mẹkọ." In *The Traditional Artist in African Societies,* edited by W. L. d'Azevedo. Bloomington: Indiana University Press.

——. 1980. *Sixteen Cowries: Yoruba Divination from Africa to the New World.* Bloomington: Indiana University Press.

Bascom, W. R., and M. J. Herskovits, editors. 1965. *Continuity and Change in African Cultures.* Chicago: University of Chicago Press.

Bay, E. G. 1985. *Asen: Iron Altars of the Fon People of Benin.* Atlanta: Emory University Museum of Art and Archaeology.

Beidelman, T. O. 1971. "Nuer Priests and Prophets: Charisma, Authority and Power among the Nuer." In *Translation of Culture,* edited by T. O. Beidelman. London: Tavistock.

Beier, H. U. 1954. "Spirit Children among the Yoruba." *African Affairs* 53:213, 328-31.

——. 1955. "The Position of Yoruba Women." *Presence Africaine* n.s. (1-2):39-46.

——. 1956. "Ọ̀bàtálá Festival." *Nigeria Magazine* 52:10-28.

——. 1958. "Gẹ̀lẹ̀dẹ́ Masks." *Odù, A Journal of Yoruba and Related Studies* 6:5-23.

——. 1959. *A Year of Sacred Festivals in One Small Yoruba Town.* Lagos: Nigeria Magazine Publications.

——. n.d. "Before Odùduwà." *Odù, A Journal of Yoruba and Related Studies* 3:25-32.

Belasco, B. I. 1980. *The Entrepreneur as Culture Hero: Preadaptations in Nigerian Economic Development.* New York: Praeger.

Ben-Amos, P. 1989. "African Visual Arts from a Sociological Perspective." *African Studies Review* 32(2):1-54.

Bernolles, J. 1973. Note sur les Masques de la Société Guèlẹ̀dẹ́ de Save (Dahomey Central)." *Études Dahoméennes* n.s. (numéro spécial):23-35.

Beyioku, A. F. 1946. "Historical and Moral Facts about the Gẹ̀lẹ̀dẹ́ Cult." A letter, dated January 16. Archives, Nigerian Museum. Lagos, Nigeria.

Biebuyck, D. 1972. "The Kindi: Aristocrats and their Art Among the Lega." In *African Art and Leadership,* edited by D. Fraser, and H. M. Cole. Madison: University of Wisconsin Press.

——. 1973. *Lega Culture: Art, Initiation and Moral Philosophy among a Central African People.* Berkeley: University of California Press.

Biobaku, S. O. 1952. "An Historical Sketch of Ẹ̀gbá Traditional Authorities." *Africa* 22(1):35-49.

Blier, S. P. 1987. *The Anatomy of Architecture: Ontology and Metaphor in Batammaliba Architectural Expression.* Cambridge: Cambridge University Press.

——. 1988. "Words about Words about Icons: Iconologology and the Study of African Art." *Art Journal* 47(2):75-87.

——. 1990. "King Glele of Danhome: Divination Portraits of a Lion King and Man of Iron." *African Arts* 23(4)42-53, 93.

Boone, S. A. 1986. *Radiance from the Waters: Ideals of Feminine Beauty in Mende Art.* New Haven: Yale University Press.

Brain, R. 1980. *Art and Society in Africa.* London: Longman.

Brink, J. T. 1977. "Bamana Kota-TLon Theatre." *African Arts* 10(4)36-37, 61-65, 87.

Buckley, A. D. 1985. *Yoruba Medicine.* Oxford: Clarendon Press.

Campbell, J., and C. Muses. 1991. *In All Her Names: Explorations of the Feminine in Divinity.* New York: Harper.

Carroll, K. 1967. *Yoruba Religious Carving.* London: Geoffrey Chapman.

——. 1973. "Art in Wood." In *Sources of Yoruba History,* edited by S. O. Biobaku. Oxford: Clarendon Press.

Celenko, T. A. 1983. *A Treasury of African Art from the Harrison Eiteljorg Collection.* Bloomington: Indiana University Press.

Chappell, T. J. H. 1974. "The Yoruba Cult of Twins in Historical Perspective." *Africa* 44:250-65.

——. 1977. *Decorated Gourds in North-Eastern Nigeria.* London: Ethnographica Publishers.

Clouzot, H. and A. Level. 1926. *Sculptures Africaines et Océaniennes.* Paris: Libraire de France.

Cole, H. M. 1969. "Art as a Verb in Iboland." *African Arts* 3(1)33-41, 88.

——. 1982. *Art and Life among the Owerri Igbo.* Bloomington: Indiana University Press.

Cole, H. M., and D. H. Ross. 1977. *The Arts of Ghana.* Berkeley: University of California Press.

Cordwell, J. M. 1952. "Some Aesthetic Aspects of Yoruba and Benin Culture." Ph.D. diss., Northwestern University, Evanston, Illinois.

Courlander, H. 1973. *Tales of Yoruba Gods and Heroes.* Greenwich, Connecticut: Fawcett.

Dahrendorf, R. 1959. *Class and Class Conflict in Industrial Society.* Stanford: Stanford University Press.

Daramọla, O., and A. Jeje. 1967. *Àwọn Àṣà àti Òrìṣà Ilẹ̀ Yoruba.* Nigeria: Onibọn-Oje Press and Book Industries.

de Castro, Y. A. P. n.d. "Religious Terminology and Everyday Speech Vocabulary of an Afro-Brazilian Cult Group." Manuscript. Salvador, Bahia, Brazil.

Delanọ, I. O. 1966. *Òwe L'Ẹṣin Ọ̀rọ̀: Yoruba Proverbs, Their Meaning and Usage.* Ìbàdàn, Nigeria: Oxford University Press.

——. n.d. "The Yoruba Family as the Basis of Yoruba Culture." *Odù, Journal of Yoruba and Related Studies* 5:21-28.

Dọpamu, P. A. 1979. "Yoruba Magic and Medicine and Their Relevance for To-day." *Journal of the Nigerian Association of Religious Studies* 4:3-20.

dos Santos, J. E., 1976. *Os Nago e a Morte.* Petropolis: Editora Vozes.

dos Santos, J. E., and D. M. dos Santos. 1971. *Èṣù Bara Láróyè: A Comparative Study.* Ìbàdàn, Nigeria: Institute of African Studies, University of Ìbàdàn.

Drewal, H. J. 1974a. "Èfè: Voiced Power and Pageantry." *African Arts* 7(2):26-29, 58-66.

——. 1974b. "Gèlèdé Masquerade: Imagery and Motif." *African Arts* 7(4):8-19, 62-63, 95-96.

——. 1977. "Art and the Perception of Women in Yoruba Culture." *Cahiers d'Etudes Africaines* 17(4):545-67.

——. 1979. "Pageantry and Power in Yoruba Costuming." In *Fabrics of Culture: The Anthropology of Clothing and Adornment,* edited by J. M. Cordwell and R. A. Schwarz. The Hague: Mouton Publishers.

——. 1980. *African Artistry: Techniques and Aesthetics in Yoruba Sculpture.* Atlanta: High Museum of Art.

——. 1981. "Mask (Gèlèdé)." In *For Spirits and Kings: African Art from the Paul and Ruth Tishman Collection,* edited by S. Vogel. New York: Metropolitan Museum of Art.

——. 1984. "Art, History, and the Individual: A New Perspective for the Study of African Visual Traditions." *Iowa Studies in African Art* 1:87-114.

——. 1986. "Flaming Crowns, Cooling Waters: Masquerades of the Ìjèbú Yoruba." *African Arts* 20(1):32-40, 99.

——. 1989a. "The Meaning of Òṣùgbó Art: A Reappraisal." In *Man Does Not Go Naked: Textillien und Anderen Landern,* edited by B. Englebrecht and B. Gardi. Basel: Basler Beitrage Zur Ethnologie.

——. 1989b. "Art and Ethos of the Ìjèbú." In *Yoruba: Nine Centuries of African Art and Thought,* edited by H. J. Drewal, J. Pemberton, and R. Abiọdun. New York: Center for African Art.

Drewal, M. T. 1992. *Yoruba Ritual: Performers, Play, Agency.* Bloomington: Indiana University Press.

Drewal, M. T., and H. J. Drewal. 1975. "Gèlèdé Dance of the Western Yoruba." *African Arts* 8(2)36-45, 78-79.

Drewal, H. J., and M. T. Drewal. 1983. *Gèlèdé: Art and Female Power Among the Yoruba.* Bloomington: Indiana University Press.

Drewal, H. J., J. Pemberton, and R. Abiọdun. 1989. *Yoruba: Nine Cen-turies of African Art and Thought.* New York: Center for African Art.

Durkheim, E. 1915. *Elementary Forms of the Religious Life: A Study in Religious Sociology.* London: George Allen and Unwin.

Eliade, M. 1954. *The Myth of the Eternal Return.* New York: Pantheon Books.

Ellis, A. B. 1894. *The Yoruba Speaking Peoples of the Slave Coast of West Africa.* London: Curzon Press.

Evans-Pritchard, E. E. 1937. *Witchcraft, Oracles and Magic among the Azande.* Oxford: Clarendon Press.

Fabunmi, M. A. 1972. *Àyájọ́ Ìjìnlẹ̀ Ohùn Ifẹ̀.* Ìbàdàn, Nigeria: Onibọnoje Press.

Fadipẹ, N. A. 1970. *The Sociology of the Yoruba.* Ìbàdàn, Nigeria: University of Ìbàdàn Press.

Fagg, W. 1951. "De l'Art des Yoruba." *L'Art Nègre (Présence Africaine)* 10-11:103-35. Paris: Editions du Seuil.

Fagg, W., and J. Pemberton. 1982. *Yoruba Sculpture of West Africa.* New York: Alfred A. Knopf.

Fagunwa, D. O. 1938. *Ògbójú Ọdẹ Nínú Igbó Irúnmalẹ̀.* Lagos, Nigeria: CMS Bookshop.

——. 1949. *Ìrèké Oníbùdó.* Edinburgh: Nelson.

——. 1954. *Ìrìnkèrindò Nínú Igbó Elégbèje.* Edinburgh: Nelson.

Fajana, A. 1966. "Some Aspects of Yoruba Traditional Education." *Odù, University of Ifẹ̀ Journal of African Studies* 3(1):66-128.

Falassi, A, editor. *Time Out of Time: Essays on Festival.* Albuquerque: University of New Mexico Press.

Fayọmi, G. O. 1982. "Gèlèdé ní Ilú Imẹ̀kọ-Ẹ̀gbádò-Kétu." B.A. thesis. Department of African Languages and Literatures, University of Ifẹ̀, Ilé-Ifẹ̀, Nigeria.

Fernandez, J. W. 1966. "Principles of Opposition and Vitality in Fang Aesthetics." *The Journal of Aesthetics and Art Criticism* 25(1):53-64.

Fọlayan, K. 1967. "Ẹ̀gbádò to 1832: The Birth of a Dilemma." *Journal of the Historical Society of Nigeria* 4(1):15-35.

——. 1975. "Yoruba Oral History: Some Problems and Suggestions." In *Yoruba Oral Tradition: Poetry in Music, Dance and Drama,* edited by W. Abimbọla. Ile Ifẹ̀, Nigeria: Department of African Languages and Literatures, University of Ifẹ̀. Ilé-Ifẹ̀.

Forde, D., editor. 1954. *African Worlds.* London: Oxford University Press.

Fraser, D. 1972. "The Symbols of Ashanti Kingship." In *African Art and Leadership,* edited by D. Fraser and H. M. Cole. Madison: University of Wisconsin Press.

Galembo, P. 1993. *Divine Inspiration: From Benin to Bahia.* Albuquerque: University of New Mexico Press.

Gates, H. L., Jr. 1988. *The Signifying Monkey.* New York: Oxford University Press.

Gbadamosi, B. 1964. *Oríkì.* Ìbàdàn, Nigeria: Mbari Publications.

Gotrick, K. 1984. *Apidán Theatre and Modern Theatre.* Goteborg: Almqvist and Wiksell International.

Griaule, M. 1952. "Le Savoir des Dogon." *Journal de la Société des Africanistes* 22 (1-2):27-42.

Griaule, M., and G. Dieterlen. 1954. "The Dogon." In *African Worlds,* edited by D. Forde. London: Oxford University Press.

Hallen, B., and J. O. Sọdipọ. 1986a. *Knowledge, Belief and Witchcraft: Analytic Experiments in African Philosophy.* London: Ethnographica.

——. 1986b. "A Comparison of the Western 'Witch' with the Yoruba 'Àjẹ́': Spiritual Powers or Personality Types?" *Ifẹ̀: Annals of the Insititute of Cultural Studies.* University of Ifẹ̀, Nigeria, (1)1-7.

Harley, G. W. 1950. "Masks as Agents of Social Control in Northeast Liberia." *Peabody Museum Papers* 32:2.

Harper, P. 1970. "The Role of Dance in the Gẹ̀lẹ̀dẹ́ Ceremonies of the Village of Ìjió." *Odù, A Journal of West African Studies* n.s. (4):67-94.

Herold, E. 1967. *The Art of Africa: Tribal Masks from The Naprstek Museum, Prague.* London: Paul Hamlyn.

Herskovits, M. J., and F. S. Herskovits. 1933. "An Outline of Dahomean Religious Belief." *Memoirs of the American Anthropological Association* no. 41.

Heyden, M. V. 1977. "The Ẹpa Mask and Ceremony." *African Arts* 10(2):14-21, 91.

Hirschman, A. O. 1970. "The Search for Paradigms as a Hindrance to Understanding." *World Politics* 23:329-43.

Holloway, J. E., editor. 1990. *Africanisms in American Culture.* Bloomington: Indiana University Press.

Horton, R. 1960. *The Gods as Guests.* Lagos, Nigeria: Nigeria Magazine Publications.

Houlberg, M. H. 1973. "Ìbejì Images of the Yoruba." *African Arts* 7(1):20-27, 91.

——. 1979. "Social Hair: Yoruba Hairstyles in Southwestern Nigeria." In *Fabrics of Culture: The Anthropology of Clothing and Adornment,* edited by J. M. Cordwell and R. A. Schwarz. The Hague: Mouton Publishers.

Hountondji, P. 1983. *African Philosophy: Myth and Reality.* Bloomington: Indiana University Press.

Hunt, C. M. 1979. *Ọ̀yọ́túnjí Village: The Yoruba Movement in America.* Washington, D.C.: University Press of America.

Ibitokun, B. M. 1981. "Ritual and Entertainment: The Case of Gẹ̀lẹ̀dẹ́ in Ẹ̀gbádò-Kétu." *Nigeria Magazine* 36:55-63.

——. 1987. "The Praise-Names of 'Our Mothers' in Ẹ̀fẹ̀ Performances: Classifications and Analysis." *Nigeria Magazine* 55:11-13.

——. 1993. *Dance as Ritual Drama and Entertainment in the Gẹ̀lẹ̀dẹ́ of the Kétu-Yoruba Subgroup in West Africa.* Ilé-Ifẹ̀, Nigeria: Ọbáfẹ́mi Awólọ́wọ́ University Press.

Idowu, E. B. 1962. *Olódùmarè: God in Yoruba Belief.* London: Longman.

Iko, A. n.d. *Yoruba Proverbs: 600 Proverbs Translated into Idiomatic English.* Ìbàdàn, Nigeria: Ayọrinde Printing Works.

Johnson, S. 1921. *The History of the Yorubas.* Lagos, Nigeria: CMS Bookshops.

Kasfir, S. L., editor. 1988. "Masquerading as a Cultural System." In *West African Masks and Cultural Systems.* vol.126. Tervuren, Belgique: Musée Royal de L'Afrique Centrale.

Kerchache, J. 1973. *Masques Yorouba, Afrique.* Paris: Galerie Jacques Kerchache.

Kyerematen, A. A. Y. 1964. *Panoply of Ghana.* New York: Praeger.

Ladele, T. A. A., et al. 1986. *Àkójọpọ̀ Ìwádí Ìjìnlẹ̀ Àṣà Yoruba.* Nigeria: Macmillan.

Laman, K. 1957. *The Kongo.* 2 vols. Uppsala: University of Uppsala.

Lambo, J. O. 1961. "Growth of African Children." Conference Report: First Pan-African Psychiatric Conference, Abẹ́òkúta, Nigeria.

Lamp, F. 1985. "Cosmos, Cosmetics, and the Spirit of Bondo." *African Arts* 18(3):28-43, 98.

Laotan, A. B. 1961. "Brazilian Influence on Lagos." *Nigeria Magazine* 69:156-165.

Law, R. C. 1977. *The Ọ̀yọ́ Empire, c. 1600-c. 1836: A West African Imperialism in the Era of the Atlantic Slave Trade.* Oxford: Clarendon Press.

Lawal, B. 1970. "Yoruba Ṣàngó Sculpture in Historical Retrospect." Ph.D. diss., Indiana University, Bloomington: Indiana.

———. 1971. *Gẹ̀lẹ̀dẹ́ Masks: Catalogue of an Exhibition.* Ilé-Ifẹ̀, Nigeria: Institute of African Studies, University of Ifẹ̀.

———. 1974. "Some Aspects of Yoruba Aesthetics." *British Journal of Aesthetics* 15(3):239-49.

———. 1977. "The Living Dead: Art and Immortality among the Yoruba of Nigeria." *Africa* 47(1):50-61.

———. 1978. "New Light on Gẹ̀lẹ̀dẹ́." *African Arts* 11(2):65-70, 94.

———. 1981. "The Role of Art in Òrìṣà Worship, among the Yoruba." In *Proceedings of the First World Conference on Òrìṣà Tradition,* edited by W. Abimbọla. Ilé-Ifẹ̀, Nigeria: Department of African Languages and Literatures, University of Ifẹ̀.

———. 1983. "In Honour of Our Mothers: The Religious and Aesthetic Significance of Gẹ̀lẹ̀dẹ́." Paper presented at the Second International Congress on Òrìṣà Tradition and Culture. Salvador, Brazil.

———. 1985. "Orí: The Significance of the Head in Yoruba Sculpture." *Journal of Anthropological Research* 41(1):91-103.

———. 1987. *Art for Life's Sake, Life for Art's Sake.* Inaugural Lecture Series 70. Ilé-Ifẹ̀, Nigeria: Ọbáfẹ́mi Awólọ́wọ̀ University Press.

———. 1988. Form and Meaning in *Ère Ìbejì.* Paper presented at International Conference on Yoruba Twin Statuettes (*Ère Ìbejì*), University of Maryland, College Park, Maryland.

———. 1989. "Pair of *Ère Ìbejì* in the Kresge Art Museum." *Kresge Art Museum Bulletin* 1(4):10-15.

———. 1993. *Ọ̀yìbó: Representations of the Colonialist Other in Yoruba Art, 1826-1960.* Discussion Papers in the African Humanities, AH no. 24. Boston: African Studies Center, Boston University.

———. 1995. "*À yà Gbó, À yà Tọ́:* New Perspectives on *Ẹdan* Ògbóni." *African Arts* 28(1):36-49, 98-100.

Lawuyi, O. B., and O. Taiwo. 1990. "Towards an African Sociological Tradition: A Rejoinder to Akiwọwọ and Makinde." *International Sociology* 5:57-73.

Layton, R. 1991. *The Anthropology of Art.* Cambridge: Cambridge University Press. 2nd edition.

Lederer, W. 1968. *The Fear of Women*. New York: Harcourt Brace Jovanovich

Leighton, A. H., et al. 1963. *Psychiatric Disorders among the Yoruba*. Ithaca: Cornell University Press.

Lindfors, B., and O. Owomoyela. 1973. *Yoruba Proverbs: Translation and Annotation*. Athens: Ohio University Press.

Lucas, J. O. 1948. *The Religion of the Yorubas*. Lagos, Nigeria: CMS Bookshop.

MacAloon, J. J. 1984. "Olympic Games and the Theory of Spectacle in Modern Societies." In *Rite, Drama, Festival, Spectacle: Rehearsal Toward a Theory of Cultural Performance*, edited by J. J. MacAloon. Philadelphia: Institute for the Study of Human Issues.

MacGaffey, W. 1993. "The Eyes of Understanding: Kongo Minkisi." In *Astonishment and Power*. Washington, D.C.: Smithsonian Institution Press.

Makinde, M. A. 1985. "A Philosophical Analysis of the Yoruba Concept of 'Orí' and Human Destiny." *International Studies in Philosophy* 17(1):53-69.

——. 1988. "Àṣùwàdà Principle: An Analysis of Akiwọwọ's Contributions to the Sociology of Knowledge from an African Perspective." *International Sociology* 3(1):61-76.

Maquet, J. 1972. *Africanity: The Cultural Unity of Black Africa*. London: Oxford University Press.

Matthews, C. 1991. *Sophia: Goddess of Wisdom*. London: Mandala.

McClusky, P. 1984. *Praise Poems: The Katherine White Collection*. Seattle: Seattle Art Museum.

McGuire, H. C. 1980. "Woyo Pot Lids." *African Arts* 13(2):54-56, 88.

Mercier, P. 1952. *Le Ase du Musée d'Abomey*. Dakar: Institut Français d'Afrique Noire (I.F.A.N.).

Merlo, C. 1975. "Statuettes of the Àbíkú Cult." *African Arts* 8(4):30-35, 84.

Messenger, J. C. 1973. "The Carver in Anang Society." In *The Traditional Artist in African Societies*, edited by W. L. d'Azevedo. Bloomington: Indiana University Press.

Middleton, L., and E. H. Winter, 1963. *Witchcraft and Sorcery in East Africa*. London: Routledge and Kegan Paul

Mọlade, T. 1973. "The Concept of Àbíkú." *African Arts* 7(1):62-64.

Monti, F. 1969. *African Masks*. London: Paul Hamlyn.

Moore, S. F., and B. G. Myerhoff, editors. 1977. *Secular Ritual*. The Netherlands: Van Gorcum.

Morton-Williams, P. 1956a. "The Egúngún Society in Southwestern Yoruba Kingdoms." *Proceedings of the Third Annual Conference of the West African Institute of Social and Economic Research*, Ìbàdàn, Nigeria, 90-103.

——. 1956b. "The Àtíngà Cult among the Southwestern Yoruba: A Sociological Analysis of a Witch-Finding Movement." *Bulletin l'IFAN*, series B, 18(15):315-34.

——. 1960a. "Yoruba Responses to the Fear of Death." *Africa* 30(1):34-40.

——. 1960b. "The Yoruba Ògbóni Cult in Ọ̀yọ́." *Africa* 30(4):362-74.

——. 1964. "An Outline of the Cosmology and Cult Organization of the Ọ̀yọ́ Yoruba." *Africa* 34(2):243-61.

Moulero, T. 1970. Le Guèlèdé. Manuscript. Porto Novo, Benin.

Mudimbe, V. Y. 1988. *The Invention of Africa: Gnosis, Philosophy, and the Order of Knowledge.* Bloomington: Indiana University Press.

Nunley, J. W. 1987. *Moving with the Face of the Devil: Art and Politics in Urban West Africa.* Chicago: University of Illinois Press.

Obiechina, E. 1992. "Multiple Perspectives: The Dilemma of the African Intellectual in the Modern World." *Liberal Education* 78(2):16-21.

Odugbẹsan. C. 1969. "Femininity in Yoruba Religious Art." In *Man in Africa,* edited by M. Douglas and P.M. Kaberry. London: Tavistock.

Ogunbọwale, P. O. 1966. *Àṣà Ìbílẹ̀ Yoruba.* Ìbàdàn, Nigeria: Oxford University Press.

Ojo, G. J. A. 1966. *Yoruba Culture: A Geographical Analysis.* London: University of London Press.

Ojo, J. O. 1976. "Yoruba Customs from Òndó." *Acta Ethnologica et Linguistica.* No. 37, Wien.

Ojo, J. R. O. 1973a. "The Symbolism and Significance of Ẹpa-Type Masquerade Headpieces." *Man* n.s. (13):455-470.

——. 1973b. "Ògbóni Drums." *African Arts* 6(3):50-52, 84.

——. 1974. "Ẹpa and Related Masquerades among the Èkìtì Yoruba of Western Nigeria." M. Phil. thesis, University of London.

Okeṣola, A. 1967. "Àgbó Festival in Àgbówá." *Nigeria Magazine* 95:293-300.

Ọlabimtan, A. 1970. "An Introduction to Ẹ̀fẹ̀ Poems of the Ẹ̀gbádò Yoruba." Paper presented at the School of Oriental and African Studies, University of Lagos, Nigeria.

——. 1972. "Gẹ̀lẹ̀dẹ́." *Olókun* 10:37-41.

Ọlatunji, O. 1984. *Features of Yoruba Oral Poetry.* Ìbàdàn, Nigeria: University of Ìbàdàn Press.

Ọlayẹmi, V. 1971. *Orin Ìbèjì.* Ìbàdàn, Nigeria: Institute of African Studies, University of Ìbàdàn.

Olupọna, J. K. 1991a. *Kingship, Religion, and Rituals in a Nigerian Community.* Stockholm: Almqvist & Wiksell International.

——., editor. 1991b. *African Traditional Religions in Contemporary Society.* New York: Paragon House.

Omari, M. S. 1991. "Completing the Circle: Notes on African Art, Society, and Religion in Ọ̀yọ́túnjí, South Carolina." *African Arts* 24(3):66-75, 96.

Ọpẹfeyitimi, A. 1982. "Rituals in Yoruba Belief: An Objective Appraisal." Ilé-Ifẹ̀, Department of African Languages and Literature Seminar Series, University of Ifẹ̀.

Ottenberg, S. 1972. "Humorous Masks and Serious Politics among the Afikpo Ibo." In *African Art and Leadership,* edited by D. Fraser and H. M. Cole. Madison: University of Wisconsin Press.

——. 1975. *The Masked Rituals of Afikpo.* Seattle: University of Washington Press.

Oyeṣakin, A. 1982. "The Image of Women in Ifá Literary Corpus." *Nigeria Magazine* 141:16-23.

Parrinder, G. 1967. *The Story of Kétu,* edited by I. A. Akinjogbin. Ìbàdàn, Nigeria: Ìbàdàn University Press.

——. 1970. *Witchcraft: European and African.* London: Faber and Faber.

Pemberton, J. 1975. "Èshu-Ẹlẹ́gba: the Yoruba Trickster God." *African Arts* 9(1):20-27, 66-70, 90-91.

Phillips, R. B. 1978. "Masking in Mende Sande Society Initiation Rituals." *Africa* 48(3):265-77.

Picton, J. 1994. "Art, Identity, and Identification: A Commentary on Yoruba Art Historical Studies." In *The Yoruba Artist: New Theoretical Perspectives on African Arts,* edited by R. Abiodun, H. J. Drewal, and J. Pemberton. Washington and London: Smithsonian Institution Press.

Prince, R. 1961. "The Yoruba Image of the Witch." *The Journal of Mental Science* 107(449):795-805.

——. 1964a. "Indigenous Yoruba Psychiatry." In *Magic, Faith and Healing,* edited by A. Kiev. New York: Free Press.

——. 1964b. *Ifá: Yoruba Divination and Sacrifice.* Ìbàdàn: Ìbàdàn University Press

Rhoads, J. K. 1991. *Critical Issues in Social Theory.* University Park: Pennsylvania State University Press.

Richards, J. V. O. 1974. "The Sande Mask." *African Arts* 7(2):48-51.

Roberts, A. F. 1986. "Duality in Tabwa Art." *African Arts* 19(4):26-35, 66.

——. 1992. "Chance Encounters, Ironic Collage." *African Arts* 25(2):54-63, 97-98.

Sarpong, P. 1971. *The Sacred Stools of the Akan.* Ghana: Ghana Publishing Corporation.

Sieber, R. 1977. "Some Aspects of Religion and Art in Africa." In *African Religion: A Symposium,* edited by N. S. Booth. Lagos: Nok Publishers.

Sieber, R., and R. A. Walker. 1987. *African Art in the Cycle of Life.* Washington, D.C.: Smithsonian Institution Press.

Simmonds, D. 1969-70. "Gẹ̀lẹ̀dẹ́, a Yoruba Masquerade." Unpublished field notes, Ìbàdàn, Nigeria.

Simpson, G. E. 1980. *Yoruba Religion and Medicine in Ìbàdàn.* Ìbàdàn, Nigeria: Ìbàdàn University Press.

Sinnot, E. W. 1961. *Cell and Psyche: The Biology of Purpose.* Chapel Hill: North Carolina University Press.

Smith, R. S. 1973. "Yoruba Warfare and Weapons." In *Sources of Yoruba History,* edited by S. O. Biobaku. Oxford: Clarendon Press.

——. 1988. *Kingdoms of the Yoruba.* Madison: University of Wisconsin Press.

Ṣọwande, F., and F. Ajanaku. 1969. *Orúkọ Àmútọ̀runwá.* Nigeria: Oxford University Press.

Speed, F. 1968. *Gẹ̀lẹ̀dẹ́: A Yoruba Masquerade* (color film). Produced for the Insti-

tute of African Studies, University of Ifẹ̀, Ilé-Ifẹ̀, Nigeria.

Stevens, P. 1966. "Òrìṣà-Nlá Festival." *Nigeria Magazine* 90:184-99.

Taiwo, O. 1980. "Twins in Ìjẹ̀búland." *Nigeria Magazine* 132-33:103-9.

Thompson, R. F. 1971a. "Sons of Thunder: Twin Images among the Ọ̀yọ́ and other Yoruba Groups." *African Arts* 4(3).

———. 1971. *Black Gods and Kings: Yoruba Art at UCLA.* Berkeley and Los Angeles: University of California Press.

———. 1972. "The Sign of the Divine King: Yoruba Bead-Embroidered Crowns with Veil and Bird Decorations." In *African Art and Leadership,* edited by D. Fraser and H. M. Cole. Madison: University of Wisconsin Press.

———. 1973. "Yoruba Artistic Criticism." In *The Traditional Artist in African Societies,* edited by W. L. d'Azevedo. Bloomington: Indiana University Press.

———. 1974. *African Art in Motion.* Berkeley and Los Angeles: University of California Press.

———. 1978. "Gẹ̀lẹ̀dẹ́ Mask." In *Twenty-five African Sculptures,* edited by J. Fry. Ottawa: National Galleries of Canada.

———. 1983. *Flash of the Spirit: African and Afro-American Art and Philosophy.* New York: Vintage Books.

———. 1993. *Face of the Gods: Art and Altars of Africa and the African Americas.* New York:Museum of African Art.

Turner, V., editor. 1982. *Celebration: Studies in Festivity and Ritual.* Washington, D.C.: Smithsonian Institution Press.

Vansina, J. 1984. *Art and History in Africa.* London: Longman.

———. 1985. *Oral Tradition as History.* Madison: University of Wisconsin Press.

Verger, P. 1957. *Notes Sur le Culte des Òrìṣà et Vodun.* Dakar: Institut Français d'Afrique Noire (I.F.A.N.).

———. 1965. "Grandeur et Décadence du Culte de Ìyámi Òṣòròngà (Ma Mère la Sorcière) chez la Yoruba." *Journal de la Société des Africanistes* 35(1):141-243.

———. 1966. "The Yoruba High God—A Review of the Sources." *Odù, University of Ifẹ̀ Journal of African Studies* 2(2):19-40.

———. 1968. "La Société Ẹgbé Ọrun des Àbíkú, les Enfants qui Naissent pour Mourir Mantes Fois." *Bulletin de l'I.F.A.N.* (Dakar) 30, series B.4:1448-87.

———. 1972. "Automatisme Verbal et Communication du Savoir chez les Yoruba." *L'Homme, Revue Française d'Anthropologie* 12:2.

———. 1976-77. "The Use of Plants in Yoruba Traditional Medicine and Its Linguistic Approach." Ilé-Ifẹ̀, Nigeria: Department of African Languages and Literatures, Literature Seminar Series, University of Ifẹ̀.

———. 1981. *Orixas: Deuses Iorubas Na Africa E No Novo Mundo.* São Paolo, Brazil: Corrupio.

Vogel, S., editor. 1981. *For Spirits and Kings: African Art from the Paul and Ruth Tishman Collection.* New York: Metropolitan Museum of Art.

Ward, E. 1938. "The Yoruba Husband-Wife Code." *Anthropological Series,* no. 6.

Washington, D.C.: Catholic University of America.

Waterman, C. A. 1990. *Jùjú: A Social History and Ethnography of an African Popular Music.* Chicago: University of Chicago Press.

Wescott, J. 1962. "The Sculpture and Myths of Èshu-Ẹlẹ́gba, the Yoruba Trickster." *Africa* 32(4):337-54.

Willett, F. 1960. *The Sculpture of Western Nigeria.* Ìbàdàn: Ministry of Information, Ìbàdàn.

——. 1967. *Ifẹ̀ in the History of West African Sculpture.* London: Thames and Hudson.

——. 1993. *African Art: An Introduction.* Revised. London: Thames and Hudson.

Williams, D. 1964. "The Iconology of Yoruba Ẹdan Ògbóni." *Africa* 34(2):139-65.

——. 1973. "Art in Metal." In *Sources of Yoruba History,* edited by S. O. Biobaku. Oxford: Clarendon Press.

Wittkower, R. 1977. *Allegory and the Migration of Symbols.* Boulder: Westview Press.

Wolff, N. H. 1979. "Concepts of Causation and Treatment in the Yoruba Medical System: The Special Case of Barrenness." In *Systems African Therapeutic,* edited by Z. A. Ademuwagun, et al. Waltham, Massachusetts: Cross Roads Press.

Yemitan, O., and O. Ogundele, 1970. *Ojú Òṣùpá, Apá Kíní.* Ìbàdàn, Nigeria: Oxford University Press.

Yerkovich, S. 1973. "Nature and Ideas: The Involvement of the Ìrókò Tree (African Oak) in the Development of the Yoruba World View." *Yoruba, Journal of the Yoruba Studies Association* 1(1):86-104.

Interviews with Author

Adeleke, R. 1977. Ìjió, Nigeria.

Adeniji, D. 1972. Ìbàdàn, Nigeria.

Adeṣina, S. A. (King). 1971. Ìbarà, Abẹ́òkúta, Nigeria.

Àghòbí masker from Ọ̀wọ̀. 1972. Ilé-Ifẹ̀, Nigeria.

Ajanaku, F., Chief (late head of divination chiefs). 1971. Lagos, Nigeria.

Akinbami, S., Chief. 1972. Agọ́ Ìlóbí, Ajilété.

Atapupa, A., Chief. 1972. Ìsàlẹ̀-Ekó, Lagos, Nigeria.

Ayọrinde, I. 1972. Igbóbì-Ṣábẹ̀ẹ́, Lagos, Nigeria.

Elewude, J. 1984. Ilé-Ifẹ̀, Nigeria.

Fatoogun, B. 1989-90. Ilé-Ifẹ̀, Nigeria.

Labọde, M. 1971. Ìdòfòyí, Ayétòrò, Nigeria.

Moromisalu, M. (late Ìyá Yemọja of Ìbarà), 1971. Ìbarà, Abẹ́òkúta, Nigeria.

Ọlabimtan, O., Chief. 1971. Ìlaró, Nigeria.

Ọlatunji-Onígèlẹ̀dẹ́, A. 1971. Ìmèkọ, Nigeria.

Ọlayiwọla, A. 1972. Igbóbì-Ṣabẹ̀ẹ́, Lagos, Nigeria

Poynor, R. 1974. Personal communication to author, August 30.

Yai, O. n.d. Personal communication to author.

Credits

1.6, 3.3-3.5, 3.7, 3.9-3.13, 4.1-4.4, 4.6, 5.1, 5.3, 5.5-5.7, 5.15, 5.16, 6.9-6.15, 6.19, 7.10, 7.15, 7.17, 7.18, 7.20, 7.22, 7.34, 7.50, 7.51a, 7.51b, 7.56, 7.58, 8.1-8.3, 8.5, 8.12; Allen F. Roberts and Mary Kujawaski Roberts: 8.10; Eric Robertson: pl. 1; Phaedra Siebert: 7.19; Doig Simmonds: 4.5, 5.11-5.14, 5.17-5.19, 6.1-6.8, 6.17, 7.39; Frank Speed: 7.1-7.4, 7.6-7.8, 7.13, 7.14, 7.21a, 7.21b, 7.23-7.29, 7.33, 7.35-7.37, 7.40-7.42, 7.44-7.49, 7.55, 8.6, 8.7; Robert Farris Thompson: 1.4; Sarah Wells: pl. 21

Line Drawings

Babatunde Lawal: 1.2, 4.8, 7.59-7.64, 8.8, 8.9; Doig Simmonds: 5.9

Musical Notation of Gèlèdé Drum Text

Christopher Brooks: p. 88

Index